How to Read World History in Art

How to Read World History in Art

Flavio Febbraro and Burkhard Schwetje

Abrams, New York

Translation
Donald Pistolesi

Editing
Christopher Dell

Design
Bruno Scrascia

Typesetting
Anagram, Ghent

Colour separations
Die Keure, Bruges

Acknowledgments

It would have been impossible to carry out this project without the help of a great number of people who supported us with their suggestions, ideas and material.

We wish to extend special thanks to Alexandra Wetzel (Turin), who contributed her vast knowledge of Asian history and culture; Anna Ferrarese (Turin), who shared her expertise in classical Antiquity; and Vasiliki Tsamakda (University of Munich) and Bente Bjornholt (University of Sussex), who helped in interpreting the miniatures of the Codex Skylitzes Matritensis.

Invaluable assistance was also provided by Olivier Bouzy (Centre Jeanne d'Arc, Orléans), Anna Mangano (Museo del Risorgimento, Milan), Okamura Yukinori (Maruki Gallery for the Hiroshima Panels, Higashimatsuyama), Evgenia Petrova (Russian Museum, St Petersburg), the Servizio Attività educative dei Musei Civici di Venezia, Alexander Gray Associates (New York) and the Museo de America (Madrid).

We would also like to thank Stefano Zuffi (Milan), who warmly supported the project from the outset and contributed to its growth with his ideas. Finally, we are deeply grateful to our editor, Peter Ruyffelaere, for believing in this book and for the keen interest with which he followed it every step of the way.

Flavio Febbraro,
Burkhard Schwetje

Cataloging-in-Publication Data has been applied for and may be obtained from the Library of Congress.
ISBN 978-0-8109-9683-0

Printed and bound in China
10 9 8 7 6 5 4 3 2 1

Abrams books are available at special discounts when purchased in quantity for premiums and promotions as well as fundraising or educational use. Special editions can also be created to specification. For details, contact specialmarkets@abramsbooks.com or the address below.

THE ART OF BOOKS SINCE 1949

115 West 18th Street
New York, NY 10011
www.abramsbooks.com

Cover: Eugène Delacroix, *28 July: Liberty Leading the People* 1830. Oil on canvas, 260 x 325 cm. Paris, Musée du Louvre

CONTENTS

PREFACE

The relationship between art and historical events has always been fundamental. Princes, monarchs and powerful figures of every period have used art to glorify their exploits and hand down to posterity an image of their own choosing. The same exploits have also been recorded in texts and poetry, so it is no coincidence that our journey through history as represented in art begins with the stele of the Code of Hammurabi and reliefs from the Temple of Ramses II, in which writing and sculpture come together to celebrate the military and civilian virtues of sovereign rulers. Direct contact with power has always been one of the main motivations for artists of all periods to give an account of history – albeit through the distorting lens of the legitimization and glorification of their masters. On the other hand, since for thousands of years artists worked in service to others, it is logical to expect them to have obliged such requirements.

This fundamental link between artist and patron not only glorifies monarchs and rulers, but also often leads to a rereading of the past. Artists took examples from history, using them to justify and exalt the present. Raphael did so in depicting the (possibly fictitious) encounter between Attila and Pope Leo the Great, providing a fantasy setting for an event that flattered the Church of Rome for its ability to curb violence through holiness. The same occurs with Constantine, whose triumphal arch reuses material from earlier times to proclaim him heir to Rome's imperial tradition. Not to mention the cases of Charlemagne (an idealized portrait of whom was created more than five hundred years after the emperor's death to be paraded at the coronation of every German sovereign) or Joan of Arc (who was painted by Ingres in the mid-19th century as a popular heroine and saint). Art often uses history for its own ends, as if history were a malleable material to be shaped to the preferred 'narrative'.

Until the 18th century, the representation of history was strongly conditioned by the close relationship between artist and patron, but towards the end of that century substantial changes took place. The French Revolution, and to some

extent the American War of Independence just before it, heralded the era of militant art – art with the intention of glorifying the social and political changes in progress, art that took sides. If art often made ideological use of history, from this time on artists were frequently not only painters and sculptors but also fervent revolutionaries, intellectuals involved in the historical events of their time and theoreticians of a new artistic language able to describe the dawning era. Such a discourse supported all the 19th century's national and middle-class revolutions and led to the groundbreaking works that accompanied the Bolshevik Revolution and to the epic murals that extol the emancipation of the Mexican peasant.

With the 18th century came the emergence of art that denounced history's violence and atrocities. Although the prints of Jacques Callot in the 17th century had already portrayed the violence of the Thirty Years War in a matter-of-fact way, his art remained anchored to a moralistic vision that interpreted brutality as the consequence of a lack of discipline. It was with Goya that we find an actual denunciation of the horror of war. From then on, and especially in the 20th century, it becomes almost impossible to find an artist inclined to laud conquest and military victories, unless fulfilling the propaganda requirements of a totalitarian military regime.

However, there is no reason to think that art records only History with a capital 'H' – the adventures and feats of warriors and military leaders, battling armies and duelling heroes. Although this characteristic can be found everywhere – in the art of Arabia, Persia, China and India as well as in that of Europe – art can also tell us of everyday human history, such as the economic and social changes brought on by industrialization, urban life in the Middle Ages or the feeling of precariousness that permeated European society during the Great Plague of the 14th century.

These are some of the thoughts and considerations that accompanied our journey through art and history. It is important to note that we did not set out to compile a conventional history illustrated with works of art. For this reason, some decisive historical events have not been included because they left little or no trace in art. On the other hand, some minor historical occurrences are included, since they inspired great masterpieces of art – a good example is Uccello's paintings of the 15th-century Battle of San Romano, an event that warrants only a footnote in the local history in Renaissance Tuscany. Nevertheless, such works can give us a great deal of important information about contemporary warfare in general.

This book investigates the complex relationship between art and history and demonstrates over and over again how art has retold and reinterpreted historical 'facts'. This process has seen the creation of many works that have come to symbolize a particular historical episode. Good examples of this are the paintings of Jacques-Louis David, 'official' painter to the French Revolution, and Picasso's great canvas *Guernica*, which summarizes the destructive force of modern warfare and the blind violence of totalitarian ideologies.

The works are presented in chronological order according to the events they depict. As a rule, each event is treated in a two-page spread and a single work of art. In some cases, because of a work's aesthetic value or complexity, four pages have been given to a single event and work. And some events are represented through two or three works of art that express various takes on the same event, either because they were made from different points of view or because they reflect differing interpretations of the same event over the centuries.

We hope you enjoy your journey!

Turin, March 2010
Flavio Febbraro
Burkhard Schwetje

1792 BC THE CODE OF HAMMURABI

Stela of the Code of Hammurabi

1792–1750 BC. Paris, Musée du Louvre

The first collection of laws

During his long reign (1792–1750 BC), the Babylonian ruler Hammurabi collected the sentences that he himself had pronounced, thus giving rise to a body of law that has come down to us in its entirety. Hammurabi had this 'code' engraved on a basalt stela, which he probably exhibited at Sippar, the sacred city of Shamash, the sun-god and god of justice. Copies were placed in the other cities of the kingdom and could be consulted in public, ensuring both that the law was known, and that it was impossible to plead ignorance of a particular prohibition or sanction. Since the almost 300 sentences are the result of the jurisprudence of the sovereign, who sometimes contradicted himself, they do not represent a cohesive body of law. Nevertheless, the stela is an exceptional source for the knowledge and understanding of the social structure of the Babylonian civilization.

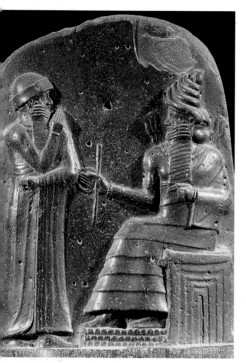

Divine investiture Seated on a throne, Shamash, the god of justice, is handing over to Hammurabi the rod and the ring, symbols of power. The sovereign's right to dictate laws is thereby legitimized by the divinity.

Social classes and punishments

Classes
The code singles out three classes of subjects: freemen, semi-free men who have no property, and servants. The laws and punishments correspond to the subject's legal status.

Lex talionis ('an eye for an eye')
The code often refers to the *lex talionis*, or the principle that the punishment to be inflicted on the guilty party should be equivalent to the damage caused. For example, if a man kills another man's son, his son would be killed in turn.

Intentionality
Hammurabi's verdicts make no distinction as to whether or not injury occurred wilfully. For example, if two people die in the collapse of a house, the architect is responsible just as if he had killed them with his own hands.

The stela, 2.25 metres tall, was removed by an Elamite prince in the 12th century BC and taken as war booty to Susa, Iran, where it was found by French archaeologists in the early 20th century and transferred to the Louvre. It is made from a single block of black basalt. The upper part includes a depiction of King Hammurabi with the god Shamash. Below that, the body of the text runs on all four sides. The text is divided into three parts. It begins with a prologue that glorifies Hammurabi's role as a pacifier and judge, and ends with a poetic epilogue that praises his virtues. The central, and largest, section contains 282 paragraphs with the king's legal decisions.

The script The text is written in Akkadian with cuneiform characters. The writing proceeds from top to bottom and right to left. Because of the almost magical quality attributed to writing at this time, the very existence of the stela made the law and its contents sacred.

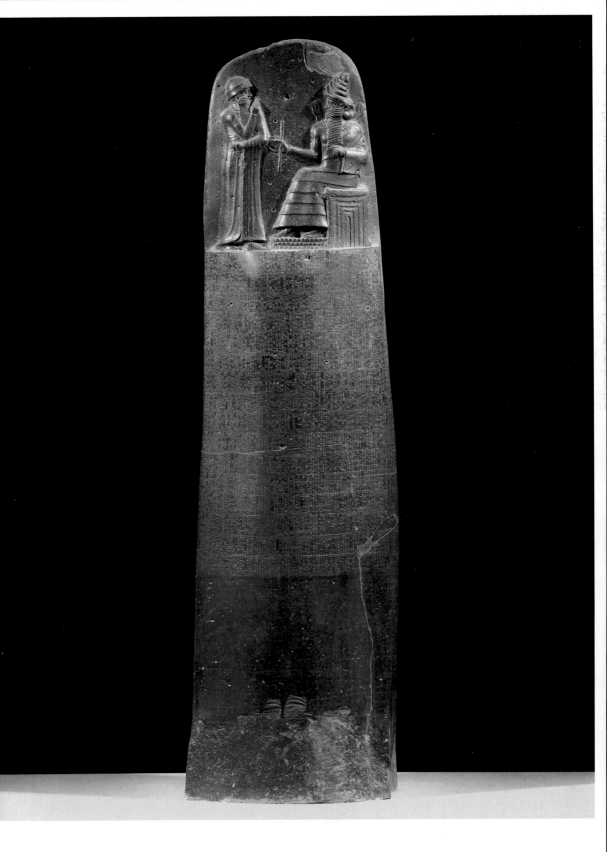

The war between the two empires

Causes
Both Hittites and Egyptians wanted to control the area covered by modern-day Syria, the crossroads of commercial exchange between the Mediterranean and the Middle East.

Main figures
Ramses II, pharaoh of the 19th dynasty, and the Hittite king Muwatallis. Ramses decided to settle matters with the Hittites at the beginning of his reign (1278–1213 BC). Muwatallis mobilized a large army to stop him. Muwatallis's son, Hattusilis III, signed a peace treaty with Ramses.

Consequences
After the Battle of Kadesh, the Hittites remained the masters of the area. The Egyptians regained possession of Palestine.

Note
To control the eastern territories, Ramses founded a new capital on the Nile Delta, Pi-Ramses – all trace of which has been lost.

Reliefs from the Temple of Ramses II
13th century BC. Abu Simbel

A hard-won victory

The two largest and best-organized armies of the time, the Egyptian army and the Hittite army, encountered each other in the vicinity of Kadesh, in present-day Syria. The final outcome of the battle seems uncertain, however, since surviving documents produced by both sides claim victory. What is certain is that the heavy Hittite war chariots initially overwhelmed the Egyptian troops after isolating the army of Pharaoh Ramses II, but the Egyptians were able to repel the Hittite offensive and force their retreat. That neither of the period's two superpowers had won the battle decisively may be surmised from the fact that, in subsequent years, the two sides began to bury their differences to face the Assyrian threat, leading to the oldest known peace treaty. In about 1259 BC, Ramses II and Hattusilis III promised one another mutual assistance and reciprocal recognition of borders, inscribing their agreement on a silver plaque.

Chariot and bow The chariot was the basic weapon of the Egyptian army. Rather light, it held, besides the charioteer, a warrior who was almost always armed with only a bow. Hittite chariots, on the other hand, could carry two combatants who, besides a bow, were armed with a javelin that could be either used in the fray or thrown.

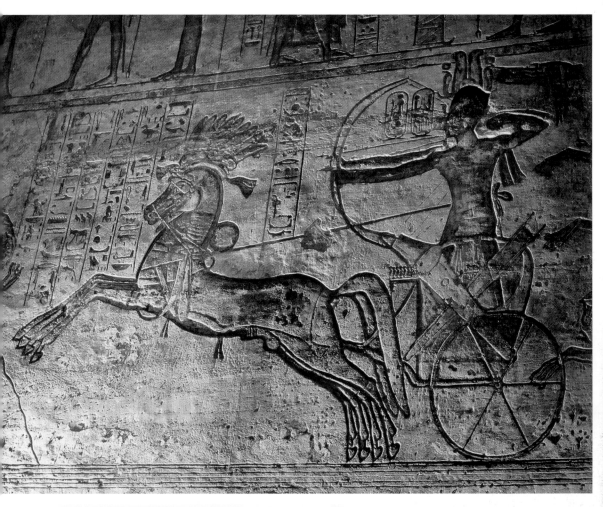

The Battle of Kadesh is depicted frequently in the monumental complexes built by Ramses II, which immortalized in stone the so-called Poem of Pentaur, a work of plainly encomiastic intent extolling the sovereign's valour. Like the reliefs at Karnak, Luxor and the Ramesseum of Thebes, the relief sculptures at Abu Simbel (shown here are those in the large entrance hall) narrate the combat, the deceit of the two traitors who isolated Ramses from the army, his invocation of the god Amon, and the solitary attack of the ruler in his war chariot, which threw the enemy lines into disarray.

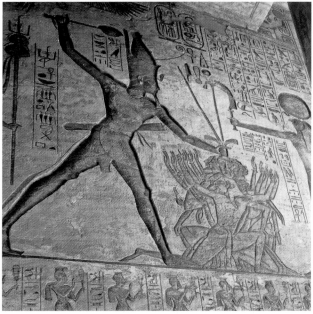

The ritual massacre On the north-east wall of the hall, at the end of the sculptural narrative of the Battle of Kadesh, Ramses kills the prisoners with a white bludgeon as the sun-god Ra looks on.

The Mycenaean Civilization

Origin
The Mycenaeans were probably a warrior people of Indo-European origin who settled in the Peloponnese between the 17th and 16th centuries BC. Their civilization expanded throughout the Aegean but waned in the 12th century BC.

Shepherds and warriors
Organized into autonomous agro-pastoral realms, each city-state was led by a military class. The Mycenaeans soon learned to navigate on the sea and directed their aggressiveness towards the exterior.

Cyclopean masonry and treasures
The acropolises of the Mycenaeans were surrounded by imposing walls, like those at Mycenae itself, where the famous Lion Gate stands. Gold grave goods of inestimable value, a symbol of royalty and the warrior's glory, have been found in tombs. The most famous burial gift is the so-called Mask of Agamemnon that, according to its discoverer, Schliemann, reproduces the Homeric hero's face.

The slaughter This krater, created in around 490 BC, depicts a Greek hoplite ruthlessly attacking the Trojans. The representation derives from the *Iliou Persis*, a lost epic poem on the taking of the city. The *Iliad* does not describe the end of the war and the conquest of the city.

1184 BC THE TROJAN WAR

The Warrior Krater
13th century BC. Athens, National Archaeological Museum

Between myth and history

The Trojan War, the main subject of Homer's *Iliad* and constantly referred to in the *Odyssey*, almost certainly has a historical basis. The city of Troy was rediscovered in 1871 by the German archaeologist Heinrich Schliemann in the area around the hill of Hisarlik, in north-western Asia Minor, disproving the widespread theory that it had not actually existed. Subsequent excavations through the various layers of settlements located one particular level (VII-a) that corresponded to Homer's Troy. The excavated city was indeed destroyed by fire some time around 1184 BC, the year to which the fall of Troy is most commonly dated, as calculated by the later Greek mathematician Eratosthenes. Who fought the Trojan War is another question. The Mycenaeans – the Achaeans of Homeric tradition – had expanded from the Peloponnese towards Crete, Cyprus and Asia Minor, but there is no conclusive evidence that they besieged and conquered Troy. Many scholars maintain that the Homeric war is a literary synthesis of the endemic conflicts among the peoples on both coasts of the Aegean.

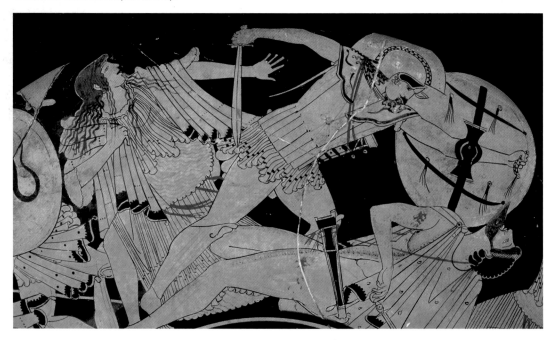

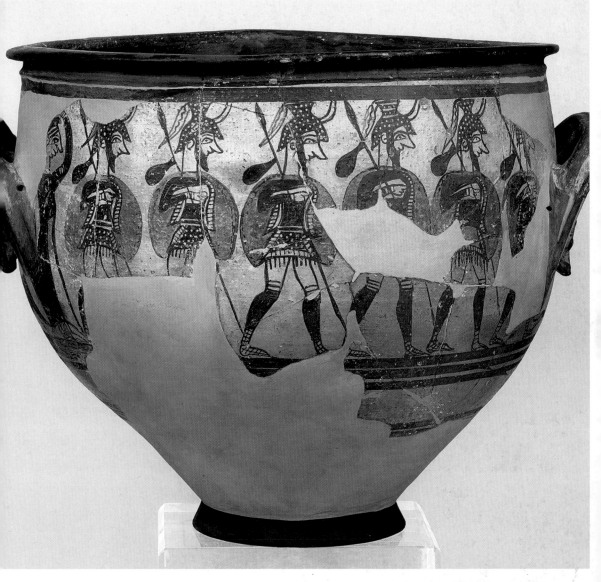

In Homer's epic poems, the Trojan War is described mainly as a clash between individual heroes who face off in memorable duels, like the combat between Achilles and Hector. However, it is more likely that the fighting was done by heavy infantry deployed in open order, attacking with swords and pikes and defending themselves with large shields shaped like a figure eight. In this sense, the equipment of the soldiers on the Warrior Krater, found at Mycenae, differs from the norm. These soldiers are holding a round shield, and the two-horned helmet has an unusual shape that protects the forehead and the back of the neck. These elements suggest eastern mercenaries in the employ of the Mycenaeans.

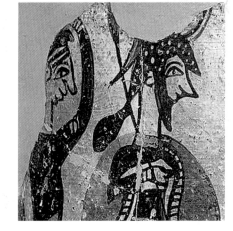

The salute The soldiers march off after taking leave of a woman who salutes them with a hand gesture. The warriors' weapons consist of a pike with a canteen tied to it.

The armoured chariot The Assyrians besieged the city by surrounding it with earthworks on which to advance their war engines, like this chariot with a battering ram for breaking down the walls.

701 BC ASSYRIA AND JUDEA AT WAR

Relief sculptures from the Palace of Sennacherib
700–681 BC. London, British Museum

Two truths

During the 8th century BC, the Assyrian empire regained control over the southern region, frequently coming into conflict with the Babylonians, Israelites and Judeans until they had either completely subjected them or forced them to pay huge tributes. The rebellion in 701 BC of the king of Judea, Hezekiah, against the Assyrian ruler Sennacherib was a turning point in this conflict. Sennacherib sent his army against the kingdom of Judea and placed the capital, Jerusalem, under siege. Historical sources differ as to what happened next. The Bible claims that Assyria was defeated because 'the angel of the Lord went forth and smote in the camp of the Assyrians a hundred and fourscore and five thousand' (Isaiah 37:36). But in his chronicles, Sennacherib declares that he 'forced Hezekiah to enclose himself inside Jerusalem like a caged bird', until Hezekiah paid an enormous tribute so the Assyrians would leave. It is certain that Jerusalem was not conquered, but the ultimate outcome was probably Judea's renewed submission to Sennacherib.

An endless clash

c. 738 BC

The Assyrian king Tiglath-pileser III invades the kingdom of Israel (in the north of Palestine). Ahaz, king of Judea (in the south of Palestine), calls for help from the Assyrian ruler against Syria and Israel in exchange for the payment of tribute. Tiglath-pileser lays waste to Jordan and Samaria (capital of Israel).

c. 725 BC

Hoshea, king of Israel, rebels against the Assyrians and refuses to pay the tribute. Shalmaneser V, son of Tiglath-pileser, besieges and overwhelms the city of Samaria.

c. 720 BC

The new Assyrian king, Sargon II, definitively subjugates Israel. He deports a large portion of the population, replacing them with people originally from Arabia. Sargon also invades the kingdom of Judea and conquers Jerusalem.

701 BC

Hezekiah, son of Ahaz and king of Judea, forms an alliance with Egypt and rebels against the Assyrians – who nevertheless continue to dominate the area throughout the 7th century BC.

Deportation In the inscriptions on the hexagonal 'Taylor Prism' (British Museum), Sennacherib boasts of having taken '200,156 prisoners, old and young, men and women' and sending them far from their land. Such mass deportations were typical of the Assyrian way of conducting war, and the reliefs do indeed depict Judeans setting out on the road to exile with their household furnishings.

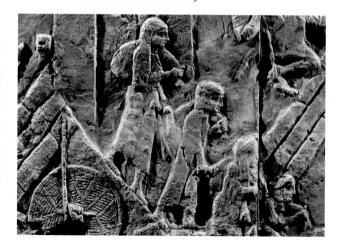

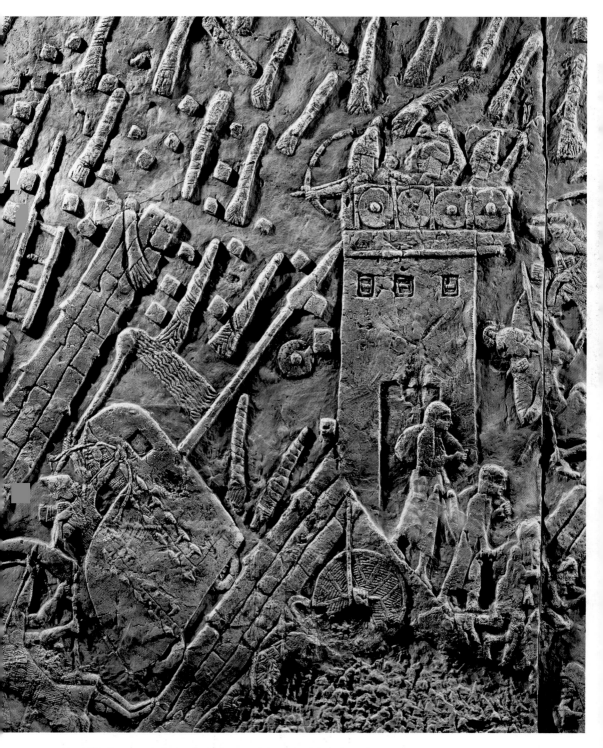

In his palace at Nineveh, Sennacherib decorated the walls of the halls with reliefs that celebrated his greatness and courage. In particular, they illustrate the military campaign that brought the siege and destruction of Lachish, the second largest city in the kingdom of Judea. In the inscriptions on the 'Taylor Prism', Sennacherib declares: 'Because Hezekiah, king of Judea, did not wish to submit to my yoke I…conquered forty-six of his fortified cities.' Here, the besieged on the tower respond to the Assyrians' attack by throwing arrows, rocks and flaming torches.

Cyrus the Great's successors

Cambyses II
Cyrus's son became king in 529 BC. In 525 BC, he defeated Egypt but was forced to return to Persia to counter an attempted usurpation on the part of the priest Gautama. He died in obscure circumstances while travelling, in 522 BC.

Darius I
A relative of Cambyses, Darius killed the usurper Gautama and shattered the subsequent rebellions. He reorganized the vast empire that under him reached its greatest extent. He rebuilt the city of Susa (which served as his capital), and fought against the Greek cities in the early 5th century BC. He died in 485 BC.

Xerxes I
The son of Darius, Xerxes I, is represented in Greek histories as a cruel tyrant. He became involved in fruitless wars against Greece, but also consolidated the empire and beautified its main cities. His death in 465 BC marked the beginning of a long period of decay.

Imperial guard Darius, the first to bear the title 'king of kings', had been an officer in the Immortals, an elite 10,000-strong military corps that was the mainstay of the Persian army. The soldiers depicted in his palace, armed with lances and bows, probably belong to this group. The long, rich tunics they wear add to the splendour of their equipment, which made a great impression on the Greeks.

539 BC THE FOUNDING OF THE PERSIAN EMPIRE

Relief sculptures from the Palace of Darius I
c. 510 BC. Paris, Musée du Louvre

Conquests and diplomacy

Cyrus II (the Great) subjected Babylonia in 539 BC and completed the creation of what would become one of the greatest empires of antiquity, extending from the Indus River in the east to Thrace and Egypt in the west. Having become king in 559 BC, Cyrus rallied the Persian people around the goal of freeing themselves from subjection to the Medes, the people who had put an end to the Assyrian empire in 612 BC. With the aid of the Babylonians, Cyrus rebelled against Astiages, king of the Medes, who was handed over by his own troops in revolt, since the elites of the two peoples were closely related. Cyrus then went for the rich plains of Mesopotamia and the Mediterranean coast, clashing with the Lydian king Croesus, whose capital, Sardis, was overwhelmed in 547 BC. At this point, Cyrus turned his sights on his old ally Babylonia. Taking advantage of the internal turmoil traditionally ascribed to the religious reforms initiated by King Nabonidus, he gained esteem as the restorer of order and occupied the city without any resistance.

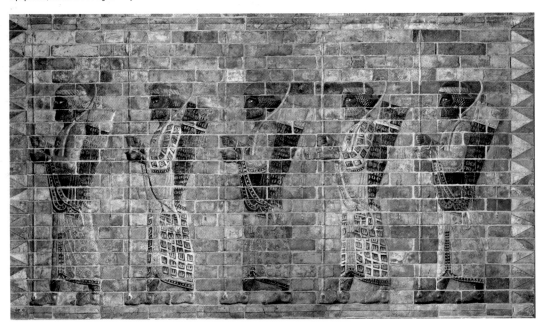

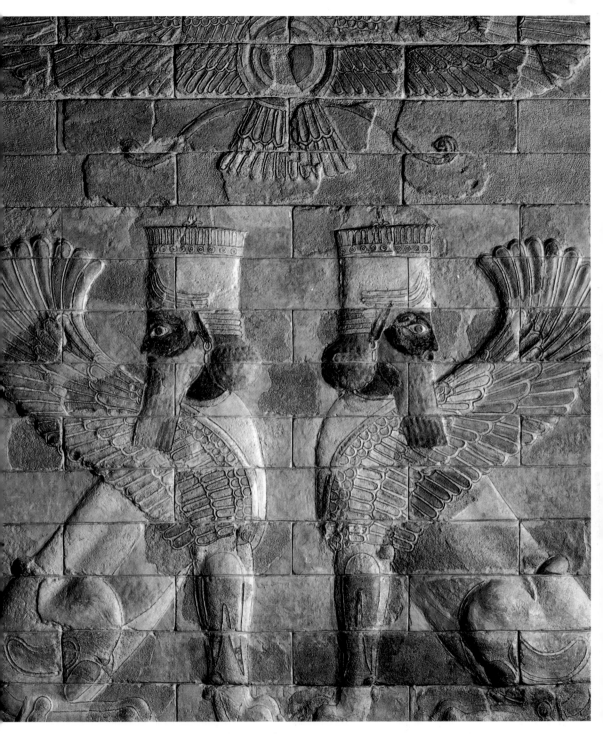

With the Persian empire at its apogee, Darius I revitalized the ancient city of Susa, the Elamite capital destroyed by the Assyrian Ashurbanipal in 640 BC. Here, Darius set up the administrative and political centre of his empire, even though other cities such as Persepolis, Ecbatana and Parsagadae (founded by Cyrus the Great) continued to play important roles. On the acropolis of Susa, Darius built his splendid palace – of this, little remains beyond the polychrome glazed tiles that decorated the walls. Among the decorations were these two winged sphinxes that draw upon Babylonian, Egyptian and Assyrian motifs. The winged solar disc above them is a symbol of royalty and divinity.

539 BC THE FOUNDING OF THE PERSIAN EMPIRE

Master of the Boccaccio Illustrations, **Miniature in Flavius Josephus's *Antiquities of the Jews***

c. 1470. Paris, Bibliothèque nationale de France, *Français 247*

Anachronisms The illuminator, possibly the son of the famous Jean Fouquet, sets the scene in an idealized landscape, where elements derived from Roman antiquity – the column, the triumphal arch – coexist with a Renaissance castle.

A far-sighted sovereign

Entering Babylonia in victory in October 529 BC, Cyrus wanted to present himself to his new subjects as a just and wise king who would put an end to the abuses and godlessness of his predecessor, Nabonidus. To this end, he had inscribed on the so-called Cyrus Cylinder – a clay cylinder written in Akkadian cuneiform characters that was found in Babylonia in 1879 – the misdeeds of Nabonidus, his own restoration of the cult of the god Marduk and the measures he wished to adopt in his reign. Besides eliminating some forms of enforced labour, Cyrus intended to allow all the people deported by the Babylonians to return to their homelands, restore to the temples the statues of the gods taken to Babylonia, and grant freedom of religion to all subjects. The Bible provides information about the Hebrews' return to their country and Cyrus's consequent reputation as a tolerant and magnanimous ruler, which has persisted until today.

The Babylonian captivity

598–597 BC
The kingdom of Judea, confined between Egypt and the Neo-Babylonian empire, revolts against Babylonia, whose ruler, Nebuchadnezzar II, conquers Jerusalem but spares the city and Temple from pillaging. The kingdom's most prominent figures are taken to Babylonia as hostages.

587 BC
Another rebellion breaks out in Judea. This time Nebuchadnezzar defeats Jerusalem and destroys the city and the Temple. King Zedekiah is captured and, according to the Bible, blinded and taken to Babylonia as a prisoner. A large part of the city's population is deported, while the peasants remain at work. The kingdom of Judea is reduced to a province of the Babylonian empire.

586–539 BC
During the period of exile, the Judean elite consider the causes of their defeat in depth and evolve new religious and moral feelings.

538 BC
Cyrus the Great's victory over the Babylonians allows the Judeans to return to their land. The Temple is rebuilt in the following years, but the new state remains a tributary of the Persian empire.

Cyrus The Persian sovereign is considered a model of wisdom and magnanimity for monarchs of all periods.

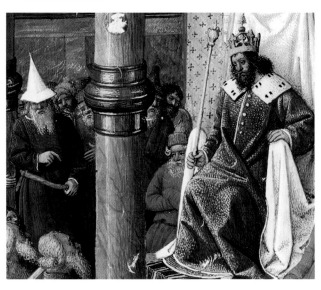

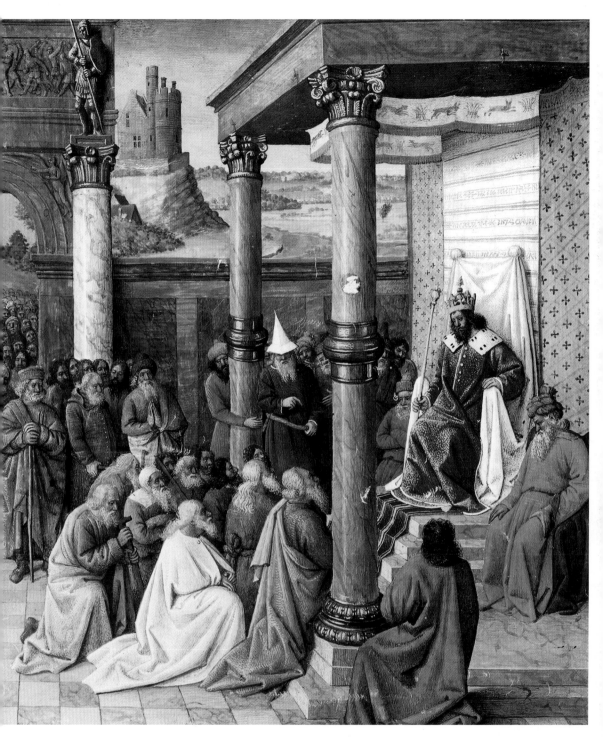

The myth of Cyrus as a good and just sovereign is confirmed in the writings of Flavius Josephus, a Romanized Jewish historian who lived in the 1st century AD. His *Antiquities of the Jews* recounts the story of his people from their beginnings to the Jewish War of 66–70. Flavius Josephus relates how Cyrus, struck by the words of the prophets, decides to send the Judeans back to their territory, restoring to them the treasure removed by Nebuchadnezzar and providing resources for rebuilding the Temple. This miniature for a 15th-century copy of *Antiquities of the Jews* depicts the moment of the Hebrews' entreaty before Cyrus and the king's obvious emotion.

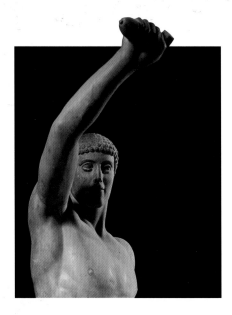

Harmodius The dynamic, idealized body of the young hero thrusts forward towards his target. Both his raised hand and the hand behind his back grasp swords, of which only the hilt of one remains.

514 BC THE KILLING OF THE TYRANT HIPPARCHUS IN ATHENS

The Tyrant-Slayers, Roman copy of a Greek original attributed to Critius and Nesiotes
2nd century AD. Naples, Museo Archeologico Nazionale

A plot that became a symbol

In 514 BC, Athens was governed by Hippias and Hipparchus, sons and heirs of the tyrant Pisistratus. Following in their father's footsteps, they led the city without radically changing the institutions defined by Solon in 594 BC. According to the Greek historian Thucydides, Hipparchus took a liking to Harmodius, the young protégé of Aristogiton, and tried to seduce him, thereby committing a flagrant 'abuse of power'. When Harmodius refused Hipparchus' attentions, Hipparchus retaliated by denying Harmodius' sister the right to participate in the Panathenaic festival, the city's main celebration, thus gravely offending the youth's family. Aristogiton, Harmodius and other members of the family decided to kill the two tyrants. During the Panathenaic festival of 514 BC, Aristogiton and Harmodius attacked the tyrants but succeeded in killing only Hipparchus before they themselves were killed. Their act became a symbol of revolt against tyrannical abuses.

The road to Athenian democracy

594 BC
The statesman Solon reforms the Athenian political system, attributing citizenship (and with it political rights) on the basis of estate income. Four 'tribes' are established that no longer depended on the criterion of birth (which had favoured the aristocracy), but rather on wealth. Public office becomes the prerogative of the richest.

c. 550 BC
After various failed attempts, Pisistratus, an aristocrat with popular support, assumes leadership of Athens. As a tyrant, he maintains Solon's institutions and promoted trade and crafts.

527 BC
Pisistratus is succeeded by his sons Hipparchus and Hippias. After the former's assassination (514 BC), Hippias assumes a despotic attitude and makes overtures to the Persian empire.

508 BC
After the expulsion of Hippias (510 BC), Cleisthenes creates ten new tribes, mixing territories and social classes, thus breaking the old alliances. Each tribe elects an *arkhon* and a *strategos* (general), the main public offices, and participates in the assembly of citizens.

The subject of the two *Tyrannicides* was very successful. In 509 BC, just a year after the expulsion of the tyrant Hippias, Athens commissioned a first group from Antenor, perhaps in bronze, that portrayed the two heroes. After it was removed by the Persians in 480 BC, in 477 the city entrusted the masters Critius and Nesiotes with the commission for another bronze sculpture. The work shown here is a Roman copy in marble of the latter. Both originals are lost.

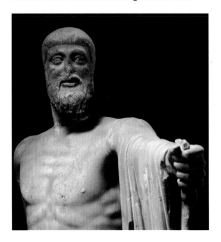

Aristogiton The elder of the two men also brandishes a sword, now reduced to the hilt, while on his back he wears a *chlamys* (cloak). The head of this statue is a replacement modelled on another statue of Harmodius in the Vatican Museums.

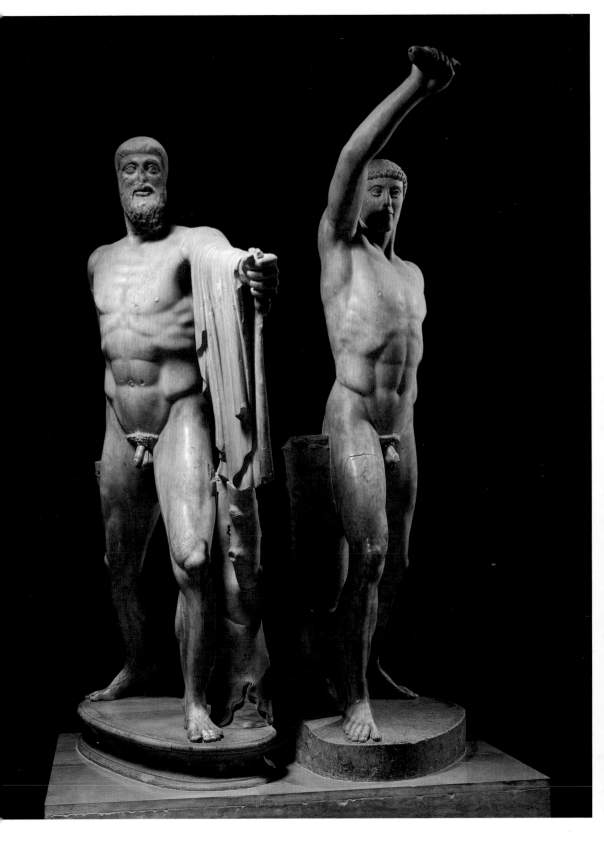

Hoplites The hoplite represented here is nude, but hoplites usually wore a light waistcoat reinforced with thin sheets of bronze, and greaves. Their weapons consisted of a lance two or three metres long, a short sword for hand-to-hand combat and a heavy round shield that covered the left side.

499 BC THE GRAECO-PERSIAN WARS

Combat of a Greek Hoplite and a Persian Soldier
410–400 BC. Wine jug. Paris, Musée du Louvre

A clash of 'civilizations'

'Slaves to no lord', the Athenians are called in Aeschylus's tragedy *The Persians* (472 BC). These words clearly indicate how the Athenians and indeed all the Greeks interpreted the Graeco-Persian Wars: an implacable conflict between differing conceptions of power, on the one side a sun king who ruled by fear, and on the other, a community of citizen-soldiers determined to defend their land and their values. The enduring myth of the clash of civilizations was built upon this vision, which masks the real interests of both the Persian empire and Athens: control of the trade routes that linked the Black Sea with the Aegean.

Twenty years of battles

499 BC
The cities of Ionia in Asia Minor rebel against the Persian king Darius. Athens and Eretria support the revolt. After the rebellion's initial successes, the Persians defeat the Ionian League in 494 BC.

490 BC
Darius decides to punish the cities of Ionia. His fleet subdues the Cyclades and destroys Eretria. The Persian army encamps at Marathon, about 40 kilometres from Athens. The Athenian heavy infantry, the hoplite phalanx, attacks the Persians and drives them back to the sea.

481 BC
In the face of the decision of Xerxes, son of Darius, to invade Greece, the Greek city-states unite to form the Panhellenic League.

August 480 BC
In the pass of Thermopylae, the Spartans of King Leonidas hold out at length against the Persian assaults but are eventually surrounded and defeated.

September 480 BC
Led by the Athenian Themistocles, the Greek fleet routs the more numerous Persian fleet at the naval battle of Salamis.

August 479 BC
Commanded by the Spartan Pausanias, the Greek hoplites attack the Persians at Plataea and win a decisive victory. The Persians withdraw from Greece.

A takabara This warrior belongs to a contingent of the Persian heavy infantry. His equipment resembles that of the Greek hoplite.

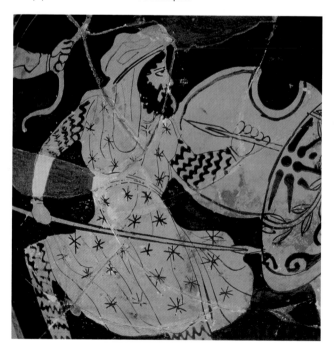

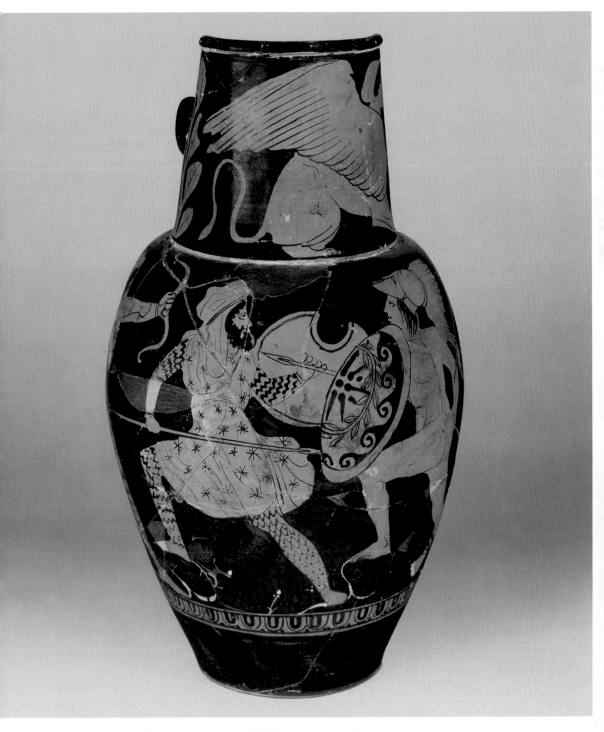

The scene depicted on this *oinochoe* (wine jug) faithfully represents hand-to-hand combat between a Greek hoplite and a Persian soldier – though this was not the most common form of battle. In the Graeco-Persian Wars, battles were fought with a charge at the double by the hoplite army, which advanced the enemy forming a compact wall of shields and lances. The Persian light infantry could not withstand this type of attack or break through the hoplite line of defence, nor were they able to use their archers and cavalry to best advantage. In this way, the Greeks, though fewer in number, achieved great military successes.

399 BC THE DEATH OF SOCRATES

Jacques-Louis David, **The Death of Socrates**
1787. Oil on canvas, 129 x 196 cm. New York, Metropolitan Museum of Art

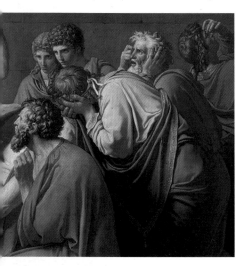

Sorrow and grief Seated at the master's feet is Crito, a pupil who had proposed to Socrates that he flee. The others are overcome with dejection, as described by Plato in the *Phaedo*, which also emphasizes Socrates' surprise at their inconsolable grief.

The end of a wise man

The philosopher Socrates lived in Athens during the transitional period between the age of Pericles and the reforms following the Peloponnesian Wars with Sparta. Just at the end of these wars, in 404 BC, power passed to the hands of an oligarchic regime led by Critias, a pupil of Socrates, who was so disliked by the people that a conservative democratic government headed by Thrasybulus was established the following year. Thrasybulus endeavoured to bring peace to the city and restore the institutions threatened by the previous regime. In the midst of this turmoil, Socrates was accused of having contributed to the dissolution of traditional Athenian values, not least through having educated men such as Critias and Alcibiades, who were considered traitors and dangerous demagogues. Found guilty, the philosopher was condemned to death.

An unfair trial

Eyewitness
The main source for reconstructing the trial is the *Apology of Socrates*, written by another of Socrates' pupils, Plato.

The charges
At the instigation of some politicians, Meletus, a cultivated young man, accused Socrates of corrupting the young and not believing in the city's traditional divinities. Pleading his own defence, Socrates refuted the accusation and argued with the judges.

The sentence
The jury declared Socrates guilty by a vote of 280 to 220. According to Athenian law, the two sides then had to propose to the court the punishment to be inflicted.

The punishment
Meletus proposed death; Socrates, who considered himself innocent, requested that he be given a life pension or pay a trifling fine. Offended, the tribunal condemned Socrates to death by drinking the poison hemlock.

Death
Socrates rejected the idea of exile or flight and drank the hemlock out of respect for the laws of his city.

Plato In the painting, David includes Plato off by himself, wrapped in silent suffering – in the *Phaedo*, however, he is absent at the moment of his teacher's death.

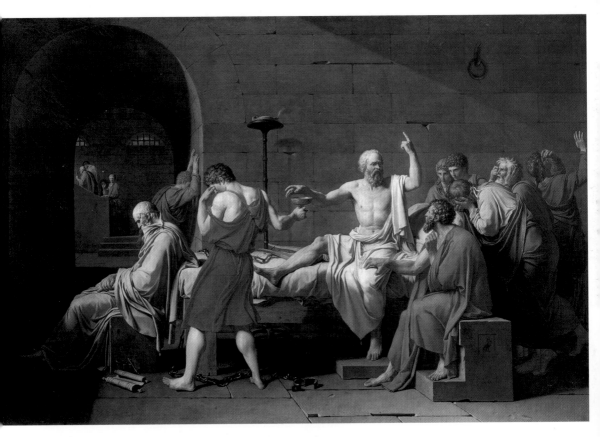

David painted this canvas in 1787, exalting the figure of Socrates as a champion of liberty who chose to die rather than renounce his ideals. This interpretation of the ancient philosopher's sacrifice was born out of the political climate of the period preceding the French Revolution, which viewed Graeco-Roman antiquity as an inspiring model of civic virtue and courage. The composition, based on the contrast between the serenity of Socrates and the despair of his pupils, was inspired by the *Phaedo*.

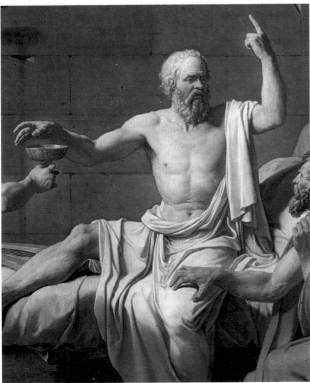

Socrates As his right hand takes the cup of poison, the philosopher points to the sky with his left hand, confirming his faith in the immortality of the soul. Both his physical posture and dignified composure indicate stoic acceptance of his destiny.

333 BC THE CONQUESTS OF ALEXANDER THE GREAT

The Battle of Alexander and Darius
2nd century BC. Mosaic. Naples, Museo Archeologico Nazionale

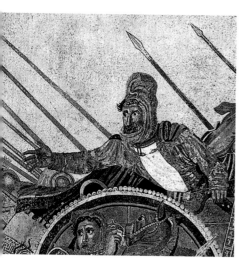

A great but frightened king Fleeing in his war chariot, the Persian king Darius directs a look of terror at his adversary.

Conquering the East

Though he died aged thirty-two, in his brief life Alexander the Great became the conqueror *par excellence*, a model emulated by monarchs and generals throughout antiquity and beyond. In 336 BC, succeeding his father Philip II as king of Macedonia at the age of twenty, he reaffirmed Macedonia's supremacy over the Greek cities, which had been established by Philip and, since 338 BC, sanctioned by the League of Corinth. Immediately after, he initiated a military campaign against the immense Persian empire, propagandizing his war of conquest as a Greek vendetta against the offences and abuses of power inflicted upon the Greeks by the Persians in previous centuries. Conquering the Hellespont (Dardanelles) and penetrating Asia Minor, he immediately achieved military success and forced the Persian king Darius III to flee the Battle of Issus. After this victory, the doors to the entire Middle East were open to him.

From Macedonia to Sogdiana

334 BC
Alexander the Great initiates his campaign against the Persian empire, arriving in Asia Minor with a modest force (estimated at 40,000 men). After the Battle of the Granicus River, he becomes the master of the largest ports on the Aegean coast.

333 BC
The larger part of the Persian army is defeated at the Battle of Issus, near the present-day Turkish city of Iskenderun.

332 BC
Alexander enters Egypt and is greeted by the priests of the sanctuary of Siwa as the 'son of the god Amon'.

331 BC
King Darius is again defeated, at Gaugamela in present-day northern Iraq. Having fled into the eastern territories of his kingdom, he is killed by one of his satraps. Alexander conquers the large centres of the Persian empire, from Babylonia to Persepolis.

330–327 BC
Thanks to an alliance with part of the Persian nobility, Alexander reinforces his army and pushes on across present-day Afghanistan into Marakanda (today Samarkand), subjugating the unstable region of Sogdiana.

The force of youth Alexander is represented without a helmet, his hair loose, a model of the brave young hero – as he was to be depicted so often in the following centuries.

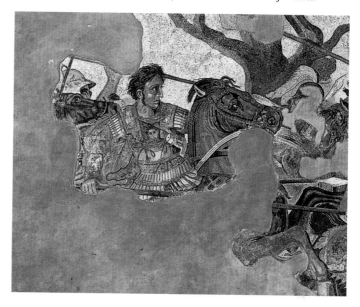

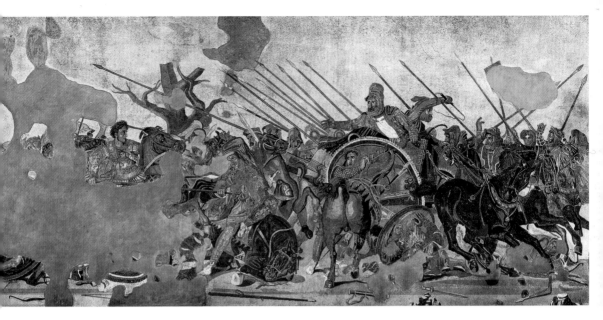

This magnificent mosaic, discovered in Pompeii in 1831 in the perimeter of a luxurious private home, depicts the encounter between the armies of Alexander and Darius III. It is considered by some to be a copy of the painting by Philoxenus of Eretria, executed in about 320–300 BC for Cassander, Alexander's successor as king of Macedonia. If so, it would be close testimony to the events and the main figure. The composition is built around the adversaries, Alexander and the helmeted Darius III, exemplified by the intense exchange of gazes between them.

Shadows and highlights Using limestone tesserae in four colours (white, yellow, red and blue), the mosaicist created shadow and highlighting to give the forms plastic volume – a feature that is particularly noticeable in the horses' bodies.

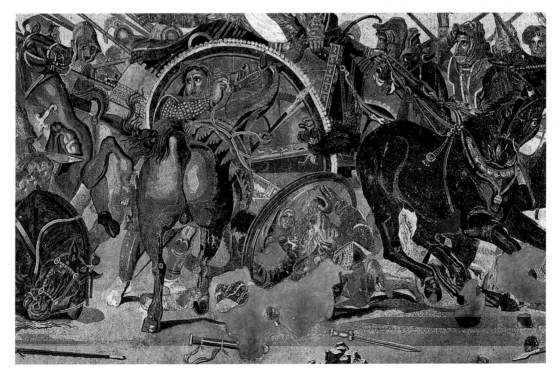

The wolf and the tree The structure of the entire mosaic is a Tree of Life that begins at the church's entrance and extends its branches to the altar. Perhaps a symbol of the path to salvation, the tree is threatened by sin, symbolized by the wolf's bite.

333 BC THE CONQUESTS OF ALEXANDER THE GREAT

PANTALEONE, **The Ascent of Alexander**

1163–66. Mosaic. Otranto, Cathedral

To the farthest reaches of the world

Not content with conquering the immense Persian empire, in 327 BC Alexander set out on a new campaign that took him to India – a country of legend for the Greeks, who knew its contours only vaguely. With his army of Greek and Persian warriors, the Macedonian king fought the troops of the small principalities of the Punjab, in eastern India, eventually managing to subdue them. Alexander wanted to continue the campaign, to explore the territory east of the Punjab and reach the mythical 'Eastern Sea', but in the summer of 326 BC, his soldiers refused to follow him any further and compelled him to begin the long journey back to Persia, where they arrived exhausted in early 324 BC.

A Macedonian–Persian amalgam

'Great king'
Following the conquest of central Iran in 331 BC, Alexander began to use this Persian title and adopted customs and fashions of the Persian court, initiating a new culture that merged Graeco-Macedonian elements with local traditions.

Proskynesis
From 327 BC, Alexander introduced the ritual greeting of *proskynesis* – bowing – to the sovereign. Macedonians and Greeks opposed this, although the upper ranks of society did not have to genuflect or prostrate themselves before the monarch. They were allowed to place the right hand on the lips as if to blow a kiss, simply bowing or not even lowering their head.

Veneration
The Macedonian king asked to be venerated like a god and expected the cities of his empire to offer sacrifices in his name and dedicate altars and sanctuaries to him.

Marriages
Alexander married the Iranian noblewoman Roxana in 327 BC. In 324 BC, he organized a wedding ceremony in which 10,000 Macedonian officials and soldiers married women from Asia. Alexander also married two Persian women.

The sin of pride In his intention to explore and surpass the limits of the world, Alexander committed the sin of pride, and for this reason he is included in the iconography of the floor mosaic, along with the building of the Tower of Babel, another famous act of arrogance in the Christian tradition.

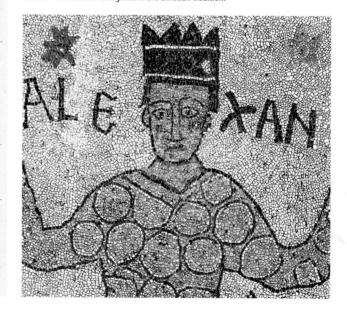

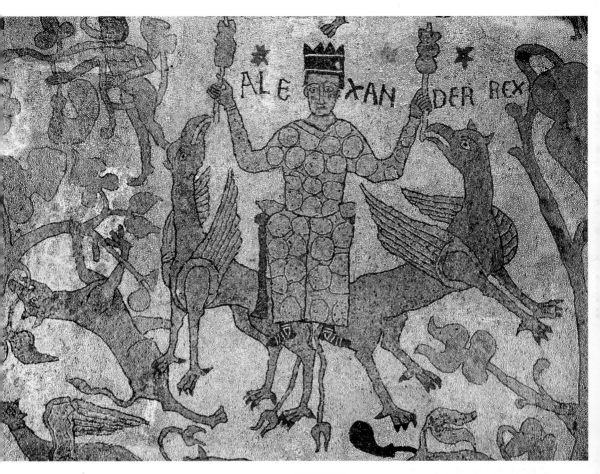

The Alexander the Great of the mosaics in the cathedral at Otranto is part of a complex iconographic programme with various references to the Old Testament and medieval learning. The scene refers to a legend popularized by the *Alexander romance*, an epic that first appeared in the 3rd century BC and has been handed down in various forms. Once Alexander reached the end of the earth in India, he wanted to discover the boundary between heaven and earth. So, he ascended to the celestial sphere in a basket borne aloft by two griffins.

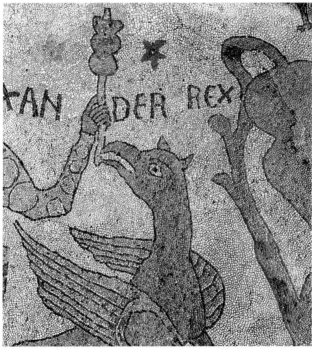

Griffin and spear The romance relates how Alexander fixed the liver of an animal on two spears to induce the griffins to fly heavenwards.

333 BC THE CONQUESTS OF ALEXANDER THE GREAT

Miniature from the *Book of Kings* [*Shah-nameh*] by Ferdowsi

c. 1335. Cambridge, Mass., Harvard University Art Museums

Chinese influence The swirling movement of the flames and clouds is borrowed from Chinese painting, which Persian illuminators had come into contact with via the Mongol empire.

A hero devoured by passion

The ancient sources describe the young Alexander, who in ten exhausting years of relentless military campaigns built a world empire, as a man devoured by strong passions that often drove him to excesses of anger and violence. In 328 BC, under the influence of alcohol at a feast in Marakanda (now Samarkand), in central Asia, he killed his childhood friend Cleitus, one of his bravest generals, because he had offended him. In 324 BC, when his friend and lover Hephaestion died, he crucified the physician accused of neglecting the fatal disease and vented his grief for his lost friend by massacring the Cossaeans. With increasing frequency, Alexander abandoned himself to alcohol at banquets and Dionysian feasts. After one of these in 323 BC, he complained of feeling slightly ill. It developed into a fever, and he died a few days later.

After the death of Alexander

The reign of the Diadochi
Alexander's only heirs were an inept half-brother and a son, Alexander IV, born of his Iranian wife Roxana after his death. His generals, called the Diadochi, divided the empire among themselves. Four independent kingdoms eventually emerged from the long wars of succession: Macedonia, Pergamum, Egypt and the Seleucid kingdom, with its centre between Syria and Mesopotamia.

Economy
Alexander's conquests and the circulation of huge amounts of silver and gold taken from the imperial Persian treasury brought about profound economic upheaval. Large land holdings developed, and cities – particularly the new metropolises founded by Alexander and the Diadochi, such as Alexandria, Pergamum and Antioch – grew with an economy based on crafts and trade.

Cultural life
These were centuries of lively cultural and scientific development in which elements of Greek culture merged with traditions from the ancient Middle Eastern civilizations. The library of Alexandria, the largest in the ancient world, is a symbol of this cultural synthesis. It included Greek texts and Greek translations of Eastern works.

This page showing a battle between Alexander's army and the Indian princes was part of a codex – now dismantled – of the *Book of Kings* by the Persian poet Ferdowsi. Ferdowsi's epic poem, which deals with the history of Persia in a romanticized way, devotes space to Alexander the Great, who is described variously as either a Persian prince with a legitimate claim to the Iranian throne or a violent military commander who was the enemy of the Persian people.

Iron horses Ferdowsi tells that Alexander built horses and riders of iron, mounted on wheels. Filled with oil and spitting fire, these war engines were launched against the Indian troops, who in turn had terrifying elephants at their disposal.

خروشیدن زال سو مندر آمدیش	کجا بند بردیش بدآتش آمدش	درویش جواز نقط کاده شاه	بکردون همی آمد و فروختند	شد و فر و بار آفروختند	بیغ و بمش درون فروختند مادر فرخته

<p style="text-align:right">زدم راسکندر زافوج هندی و صورت اسبان و مردان از آهن</p>

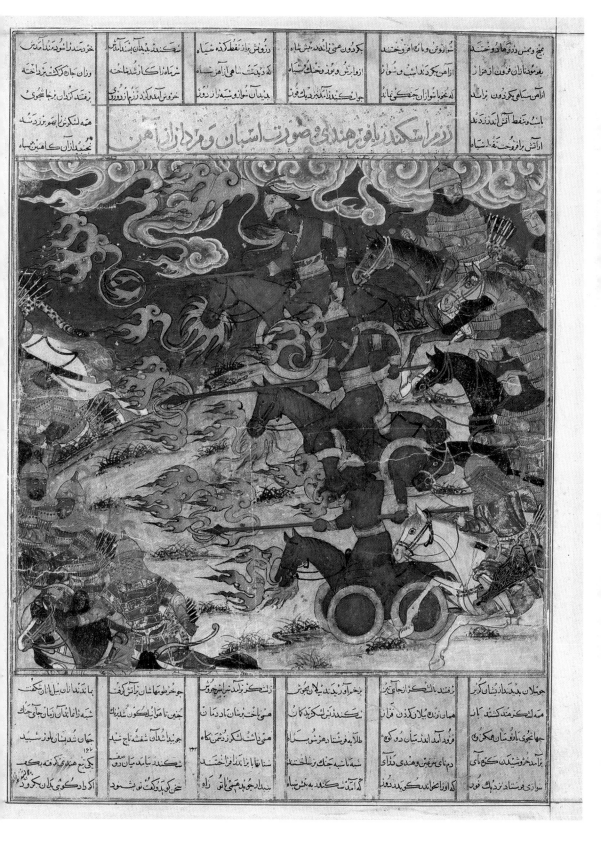

The Dying Gaul. Roman copy of a Greek original attributed to Epigonus, 1st century AD. Rome, Musei Capitolini

Pergamum and the Galatians

In the Hellenistic Asia Minor that developed as a consequence of Alexander the Great's grand adventure, two kingdoms – Pergamum and Galatia – constantly vied for domination. The city of Pergamum in the Troas was the centre of the kingdom ruled by the Attalid dynasty, which, under Attalus I, extended its hegemony over a large portion of western Asia Minor. Attalus refused to pay tribute to the Galatians, a Celtic people who had migrated to Asia around 248 BC, following the Celts' invasion of Macedonia and Thrace under Brennus. The Galatians went to war against Attalus but were defeated at the Battle of the Caicus in about 238 BC. Attalus assumed the name of Soter (Saviour), but the conflict continued, for the Galatians then allied themselves with the Seleucid prince Antiochus Hierax, the 'Vulture'. Again defeated by Attalus, they were definitively pushed back into their territory around present-day Ankara, while Pergamum experienced a period of cultural and economic growth.

Suicide Placed in the centre of the group at Pergamum, the statue of the *Gaul Killing himself and his Wife* represents the moment when a mighty Galatian chief, now certain of defeat, stabs himself in the middle of his collarbone after having killed his consort. It is uncertain whether the original of this more theatrical and less coherent group was executed by Epigonus.

The signs of battle Plainly visible on the nude torso, represented realistically though with restraint, is the bleeding wound that saps the warrior's life. On the ground are an unsheathed sword and a broken musical instrument, indicating that the Gaul was a bugler, whose duty was to direct the army with his signals. The young warrior's body is set on a shield.

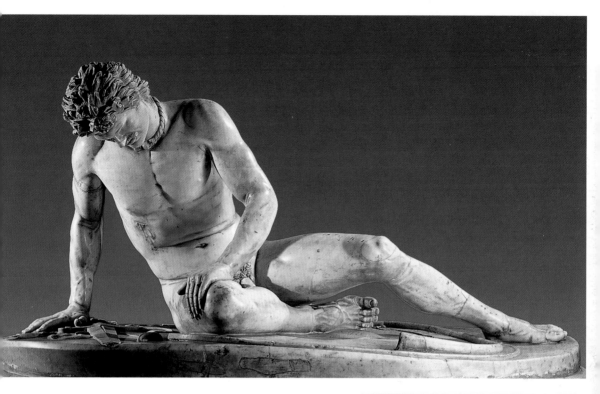

This Roman marble reproduces a bronze original dating from the 3rd century BC attributed to the sculptor Epigonus. The statue must have been part of a group Attalus I placed on the terrace of the Temple of Athena on Pergamum's acropolis. Easily visible from afar, in the centre was the *Gaul Killing himself and his Wife* (another Roman copy) and, around it, various figures of fallen warriors. In the *Dying Gaul*, the sculptor captures the moment when the warrior abandons himself to the exhaustion that precedes death: all the young man's weight is on his right arm, and his energy and strength, though still present, are about to evaporate. The proud, dignified figure conveys respect for the heroism of the adversary, whose bravery only enhanced the glory of Pergamum's victory.

The Attalid Dynasty

282 BC Philetaerus, the treasurer to Alexander the Great's general Lysimachus, takes possession of Pergamum and, profiting from the military difficulties Lysimachus is in, manages the city on his own.

263–241 BC Eumenes I, nephew of Philetaerus, defeats the Seleucid king Antiochus I and frees Pergamum.

241–197 BC Attalus I Soter defeats the Galatians, expands into Asia Minor and sides with Rome against Philip V's Macedonia, which is allied with Carthage.

197–160 BC Under the reign of Eumenes II, son of Attalus, Pergamum experiences its apogee. The city's famous library is founded and the Altar of Zeus erected, the monument that best represents the Hellenistic city. War against Macedonia is renewed, until Macedonia's total defeat at the hands of the Romans.

160–133 BC Attalus II, Eumenes II's brother, governs in peace until 138, when he is succeeded by Attalus III. Little interested in matters of governing and childless, Attalus III bequeaths his kingdom to Rome, which transforms it into the province of Asia.

The face The sculptor has taken care to give the warrior the features proper to his people, with long hair, moustache and the ornament around his neck: a torque. These twisted metal collars, often of gold or bronze, served as talismans. Worn by the Celts even in battle, torques were spoils prized by their enemies.

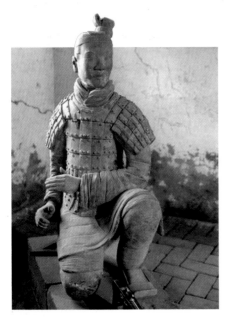

An army on the attack Together, the terracotta figures form an army of the Qin period ready to attack. In the first rows are kneeling archers (as pictured here) and behind them the standing archers, about to release their arrows. Then come the foot soldiers and finally the rearguard. Other pits hold figures of commanders and officers.

221 BC THE FOUNDING OF THE CHINESE EMPIRE

The Terracotta Army for the Mausoleum of Shi Huangdi

240–210 BC. Lingtong, Museum of the Terracotta Warriors and Horses

From the Warring States to the Empire

Between the 5th and 3rd centuries BC, the agricultural civilization of China experienced a period of expansion both geographically – gaining new territories in the south and to the north-west – and culturally, with the flourishing of the Hundred Schools of philosophy, among them Confucianism, Taoism and Legalism. Yet, at the same time, the country was undergoing a prolonged political crisis, and the era of the Warring States was characterized by the splitting up of the territory into competing kingdoms. The unification of the country in 221 BC was accomplished by the Qin dynasty, which had founded its kingdom, called the state of Qin, in present-day central China. This dynasty had adopted a Legalist ideology, which, viewing humankind as fundamentally selfish, considered an authoritarian regime to be indispensable. Thus, a strong centralized bureaucratic state was born with an extensive system of social control over the individual, but also with a remarkable capacity for growth due to the abolition of feudal bonds and the introduction of bonuses for peasants who increased production. These characteristics of the state of Qin were passed on to the new unified Chinese empire.

The rise of the Qin Dynasty

359–350 BC
The reforms of Shang Yang make the state of Qin ancient China's first bureaucracy, weakening the feudal aristocracy. The strengthening of central power makes this state the most powerful of the seven Chinese kingdoms.

278 BC
The kingdom of Qin defeats the southern state of Chu, initiating a period of instability during which the seven Chinese kingdoms fight bitterly. Qin reinforces its domination.

256 BC
The ruler of Qin conquers the ancient capital of Luoyang and celebrates the rite of sacrifice to the 'dominator from above', traditionally reserved for the legitimate lord of all of China.

230–221 BC
The troops of Zheng, ruler of Qin, definitively subjugate the other six Chinese states.

221 BC
Zheng assumes the title of Shi Huangdi, 'First Sovereign Emperor'.

The construction of the immense mausoleum of Zheng, who took the title of 'Shi Huangdi', probably began immediately after his accession to the throne of Qin in 246 BC, before he unified China. The chronicler Sima Qian, who lived about a hundred years after Shi Huangdi's death, recounts that construction required 700,000 workers for thirty-six years. The centre of the mausoleum is the tumulus, which has not yet been excavated. It is presumed to house the emperor's tomb. Around the tomb proper are various pits, the largest of which contain the terracotta army: around 8,000 figures of warriors and more than 10,000 bronze weapons. The figures are life-size or slightly larger, ranging from 183 to 195 centimetres in height.

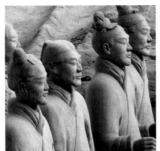

Individual facial features Amazingly, each of the 8,000 figures has its own individual expression. Though line production techniques were probably used to make the thousands of warriors, each face was modelled so that it did not resemble the others too closely. Furthermore, uniforms and hair were differentiated to reflect various ranks in the military hierarchy.

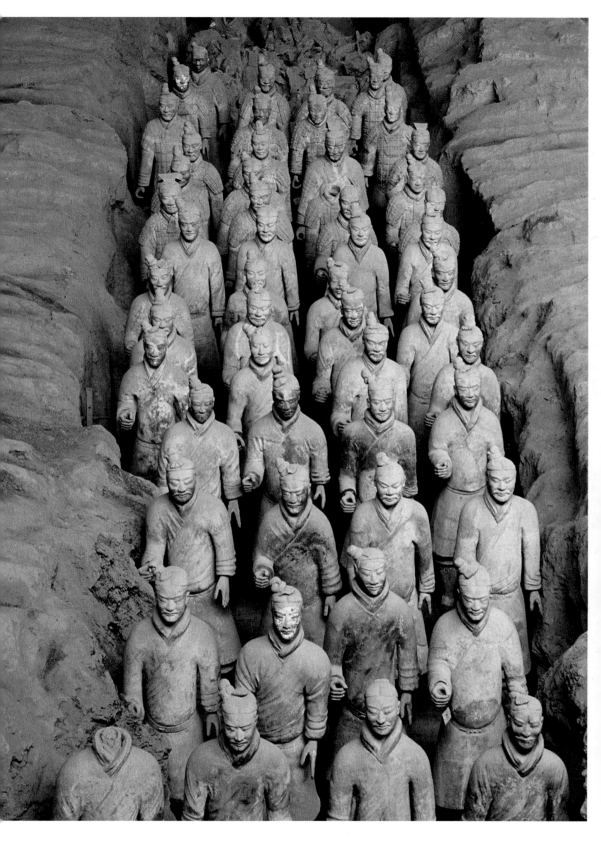

A centralized empire

The main innovations introduced under the government of Zheng Shi Huangdi and passed on to the empire in the following centuries were:

The creation of thirty-six provinces
Each province was governed by three replaceable government officials who had to keep watch on one another to avoid the erosion of centralist control. Furthermore, the figure of the 'grand censor' was introduced, who could check on the actions of all the central and peripheral civil servants.

Standardization of ideograms
Introduction of the 'small seal' script allowed easy communication among the empire's various regions, especially for bureaucratic purposes. However, the pronunciation of the language remained highly diversified.

Weights, measures and currency
These were standardized throughout the empire with the active cooperation of merchants. Even cartwheels had to adhere to an imperial standard gauge.

The first Great Wall
Consisting of ramparts, ditches and simple wooden turrets, the wall provided protection against the incursion of nomadic people along the empire's entire northern border.

221 BC THE FOUNDING OF THE CHINESE EMPIRE

The government of Shi Huangdi

Zheng Shi Huangdi unified an immense empire that stretched across a large part of present-day China, except for the western provinces. Construction of an impressive highway system was undertaken to link the capital, Xianyang, to every corner of the realm and ensure the flow of merchandise and foodstuffs to sustain the imperial court. To govern better, Zheng divided the territory into thirty-six provinces and created a hierarchical bureaucratic system whose officials were subdivided into sixteen classes. At the same time, members of the feudal aristocracy were expelled and deported to the imperial capital. An effort was made to suppress Confucianism – involving an immense book bonfire in 213 BC and the persecution of Confucian scholars – and raise strict Qin Legalism to the state ideology. However, the regime quickly sparked rebellions. The Qin dynasty and its ideology survived only three years after the death of Zheng Shi Huangdi, its first emperor, in 210 BC, though many of the structures created for the empire lasted for centuries.

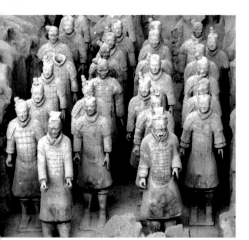

Officials Among the terracotta warriors are many figures of officials, distinct from the troops. Here, they are represented in armour. The officials of Qin's army were chosen not for family background or feudal ties, but for competence and loyalty, in keeping with the ideology of the Legalist state. All of the figures were originally painted, but the colour came off at the time of the archaeological excavation and extraction.

Models of carts Models of two bronze carts were also found in the mausoleum. Though not full scale, they are still of remarkable size. This cast model measures over a metre tall and, from the horses' snouts to the end of the cart, more than three metres long, making it half scale. It represents the sort of cart used as transportation for the imperial family and high officials; the other represents a war chariot. It is said that Shi Huangdi was obsessed with the quest for immortality and so prearranged his mausoleum so that it would mirror the display of ceremony and power he relied on in his earthly existence.

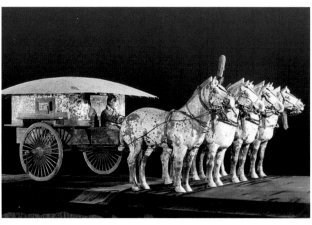

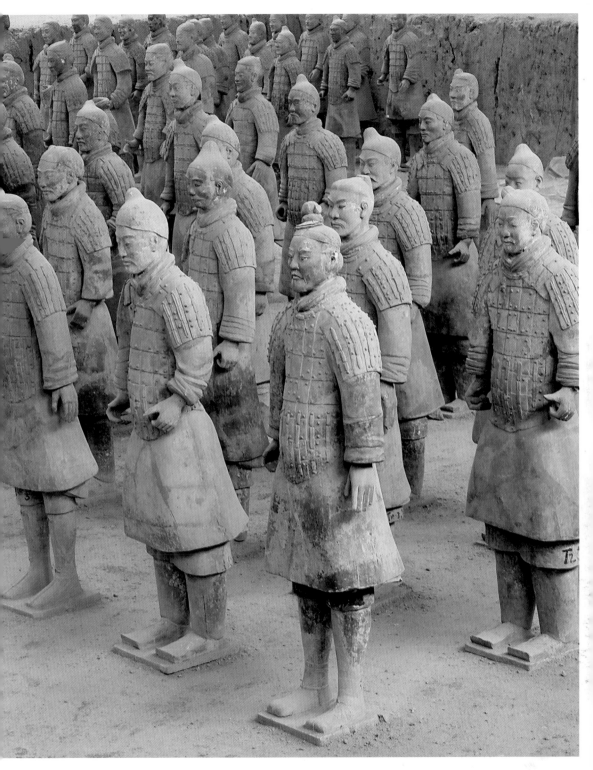

Military force During his reign, Shi Huangdi had at his disposal an immense army that he sent on various adventures, even after the unification of the seven Chinese states. He pressed all the way to the extreme south of China, in the present-day province of Guangdong, where he established military colonies, although he did not succeed in subduing this territory completely.

218 BC HANNIBAL AND THE SECOND PUNIC WAR

Jacopo Ripanda, **Hannibal in Italy**
1508–1509. Fresco. Rome, Musei Capitolini

An unprecedented threat

A decisive moment in the age-old conflict between Rome and the North African city of Carthage came in 218 BC, when the Carthaginian general Hannibal Barca, not yet thirty years old, crossed the Alps into Italy with his army. He went from victory to victory, beating the Romans at the battles of the River Trebia, Lake Trasimene and above all Cannae, until Rome's power seemed threatened. However, after the great victory at Cannae in 216 BC, Hannibal was isolated in southern Italy without supplies or fresh troops, and lacked the resources necessary to lay siege to Rome and deliver the decisive blow. Meanwhile, Rome reorganized itself and defeated the Carthaginians in Spain and Sicily; then Scipio Africanus the Elder carried the offensive to Africa and confronted Hannibal at Zama in 202 BC. Carthage was defeated, never to rise again. Its role in the history of the Mediterranean was over.

An oriental prince Hannibal is wearing a turban and loose-fitting robes, suggesting more the appearance of a 16th-century Turk than that of a Carthaginian of the 3rd century BC.

Fatigue Hannibal's troops were exhausted from crossing the Alps and continually advancing into hostile territory. The Carthaginian army suffered many losses on its move into Italy.

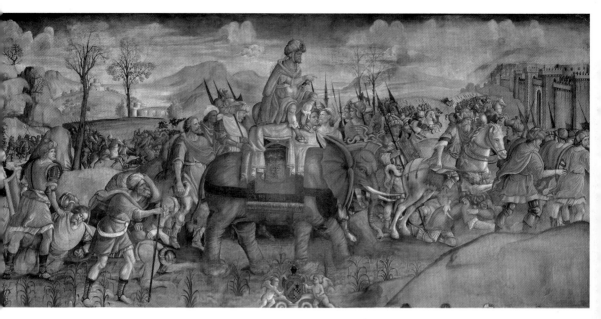

In these frescoes at the Appartamento dei Conservatori in Rome, the 16th-century Bolognese artist Jacopo Ripanda narrates various episodes from the Punic Wars (as the wars between Rome and Carthage were known), glorifying Rome but also underscoring the central role of Hannibal. By emphasizing the 'cruelty' and perfidy of this enemy, while attesting to his bravery and strategic skill, the historians on the Roman side who wrote about the Punic Wars – the Greek Polybius (a member of Scipio's circle) and Livy – made Rome's triumph seem all the greater.

The Punic Wars

264 BC
Rome and Carthage come into conflict over Sicily. The First Punic War begins.

241 BC
After various vicissitudes, Rome raises a fleet and wins the decisive naval battle of the Egadi Islands. Carthage leaves Sicily.

219 BC
Led by Hannibal's father, Hamilcar Barca, the Carthaginians expand into Spain. After Hamilcar's death, Hannibal conquers Saguntum (now Sagunto), a city on Spain's east coast allied with Rome, setting off the Second Punic War.

218 BC
Hannibal accomplishes his legendary crossing of the Alps and sweeps into Italy.

216 BC
On 12 August, the Roman legions are routed at Cannae, in Puglia.

202 BC
On 19 October, at Zama, in present-day Tunisia, the Romans win a decisive victory over Hannibal. Carthage is forced to accept humiliating peace terms.

149–146 BC
When Carthage rebels against the conditions imposed by the Romans, an army is sent to Africa and razes the city to the ground.

The elephant Historical sources agree that Hannibal brought elephants with him when he crossed the Alps, and Ripanda introduces this exotic element as an attribute of the commander.

Rome and Carthage

Founding Both cities were founded between the late 9th century BC and the first half of the 8th. Carthage was a Phoenician colony, while Rome arose from the union of various villages inhabited by the Latini.

Development Rome gradually exerted its influence in central and southern Italy, subjugating the Italic populations, Etruscans and Greek colonies. Carthage rapidly became a seafaring power and dominated the western Mediterranean both militarily and commercially.

Government Both cities were governed by oligarchies that distributed the power among themselves through renewable offices.

Reasons behind the clash Rome and Carthage, with exactly the same areas of territorial and economic expansion, came into conflict in Sicily, a rich and contested island. After the defeat of Carthage, Rome would have complete control of the entire western Mediterranean basin.

218 BC HANNIBAL AND THE SECOND PUNIC WAR

JOSEPH MALLORD WILLIAM TURNER, **Snowstorm: Hannibal and his Army Crossing the Alps**

1812. Oil on canvas, 146 x 237 cm. London, Tate Britain

A feared and hated general

Described in disparaging terms by the Roman historians – the only sources available for reconstructing his personality – Hannibal Barca was a great military strategist. He led his army into enemy territory and won major victories in the field despite inferior numbers. At Cannae in 216 BC, he managed to outflank the 80,000 Roman legionaries and confine them between cavalry and heavy infantry, slaying 50,000 soldiers and taking 11,000 prisoners according to Livy. Little supported in Carthage, where many aristocrats envied him, he was called upon in 202 BC to face Scipio's legions at Zama. Even though he was defeated at Zama, he continued to govern his city, promoting its rebirth, but now disgraced he was eventually obliged to go into exile. The Romans continued to hunt Hannibal down, and he wandered the Near East from court to court, ending up in Bithynia, in Asia Minor. The Romans persuaded the Bithynians to hand him over, and to avoid being taken prisoner, he took his own life in 183 BC.

The ambush 'Craft, treachery and fraud – Salassian force, hung on the fainting rear!', Turner wrote about the scene represented in his painting. The warriors in the foreground, who deal ruthlessly with their victims, are thus of the Salassi tribe, an ancient Alpine people who fought Hannibal's troops. Nearby, an elephant lies collapsed on the ground.

Stormy sky A pale sun pierces through the eddying storm, illuminating a broad Italian valley, Hannibal's goal.

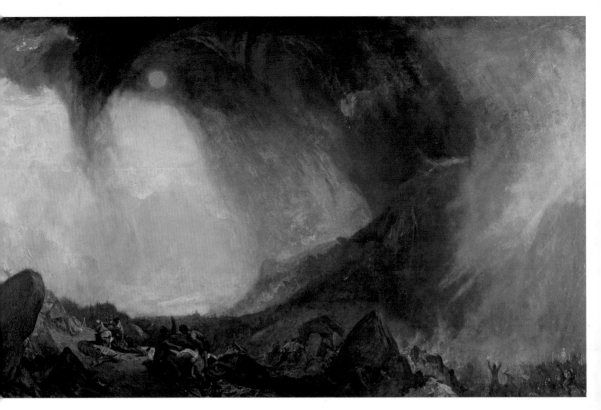

The most famous episode in Hannibal's entire career is the legendary crossing of the Alps with his army and elephants. All the sources are in agreement that Hannibal succeeded in passing through France into Italy, overcoming the natural obstacle of the Alps, though most of the elephants were lost along the way. Turner dwells upon this crossing, romantically highlighting the disproportion between the struggle of the minuscule human figures and the swirling, formidable snowstorm. Human destiny is precarious, he tells us.

The rearguard The rearguard troops' advance through the haze is by no means solemn or martial. One soldier is trying to light the way with a torch, and the standard-bearers – the pride of ancient armies – are relegated to the background.

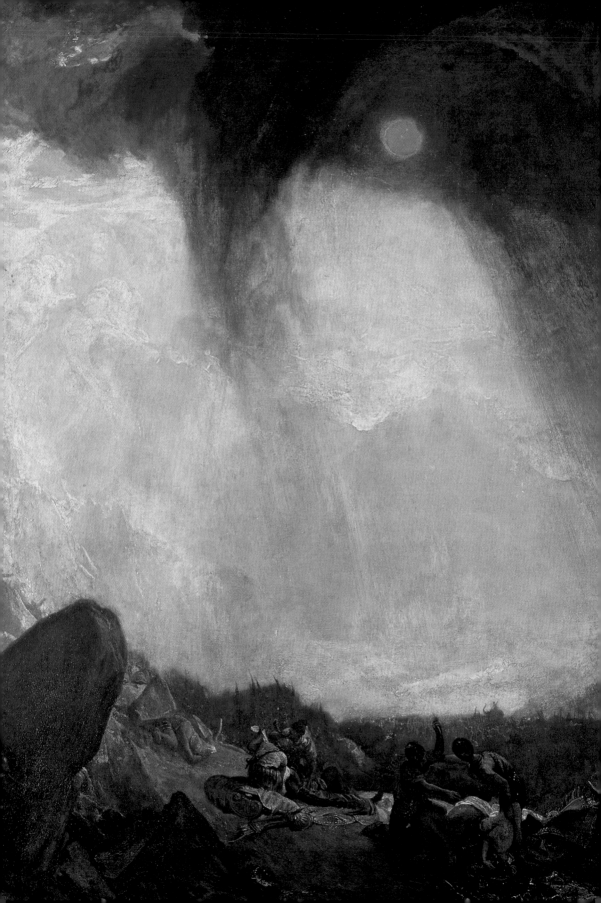

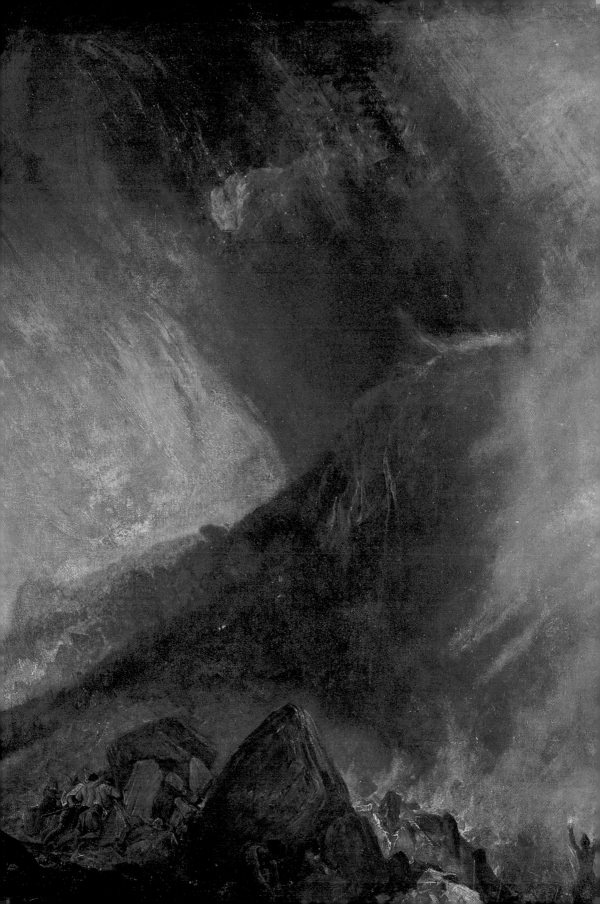

The emperor Liu Bang, the future emperor Gaozu, is represented on horseback passing through one of the city gates with his soldiers. The sources describe Liu Bang as a coarse and ignorant man, but with a peasant's shrewdness. It was not under his government that Confucian scholars became the pillars of the empire and rose to the role of official, but under his successors. Yet he did put an end to the persecution of Confucianists and, in traditional historiography, was the initiator of a long era of prosperity.

The rebellion against the Qin

Main figures
Chen She, a general, was the first leader of the rebellious soldiers but was assassinated; Xiang Yu, a general of noble origin, had great military ability but was no good at governing; Liu Bang, winner of the civil war, became the emperor Gaozu.

Places
Xianyang, the capital of the Qin dynasty, was disputed among the leaders of the rebellion; the new capital, founded by Gaozu not far from the old one, was Chang'an.

Objectives
For the soldiers, to lose the system of harsh punishments introduced by the Qin; for the peasants, to lighten the burden of taxation and forced labour; for the aristocracy, to restore the old feudal states.

Results
The empire remained united, but the rigidities of the Qin Legalist system were overcome. In the following decades, Confucianism was established as the state ideology.

202 BC THE FOUNDING OF THE HAN DYNASTY

Gaozu's Triumphant Entry into the City of Chang'an
12th century. Ink and colour on silk, 29.7 x 312.8 cm. Boston, Museum of Fine Arts

A new dynasty for the empire

In 209 BC, only a year after the death of the Qin dynasty emperor Zheng ('Shi Huangdi'), a revolt against his oppressive regime broke out with the uprising of a division of the army. Unhappy with their tax burden and forced labour, many peasants banded together with the soldiers. At the same time, the old aristocracy, expelled under the Qin dynasty, tried to reclaim the feudal states that had been conquered in the preceding decades and incorporated into the empire. Two leaders emerged in the course of the rebellions: Xiang Yu, a member of the nobility, and Liu Bang, a sub-official of peasant origin. Initially, Xiang Yu had the upper hand over Liu Bang and allotted only a minor fiefdom to the latter. However, the war continued. According to the traditional Chinese historical sources, Xiang Yu lost his allies because of his irascible character, while Liu Bang demonstrated not only great military ability but also an aptitude for managing the affairs of government. In 202 BC, he defeated his rival and became emperor with the name of Gaozu. He reconfirmed the implantation of the centralist empire founded by Zheng but abandoned its Legalist strictness and saw to the renewal of agriculture, which was in difficulty because of the upheaval of the civil war. Gaozu marked the beginning of the Han dynasty, and a long period of growth and prosperity for China.

The vassals At the entrance to the city, a group of vassals in deferential posture greets Liu Bang Gaozu, paying homage to the victor in the civil war.

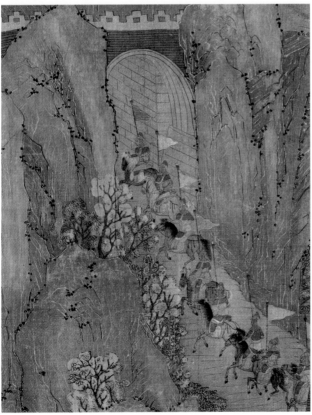

The long silk handscroll, only a detail of which is illustrated here, represents the conquest of the city of Chang'an by Liu Bang Gaozu. It was created during the Southern Song dynasty in the second half of the 12th century, a time of political difficulties: barbarian dynasties occupied all of northern China, and the Song had to sign a humiliating peace treaty with them in 1147. Perhaps because of this crisis, many in the Southern Song period looked back to traditional Confucianism and the virtuous Han dynasty.

The fortifications Chang'an is represented as a fortified city, but this is an obvious anachronism. Liu Bang Gaozu made it his capital after acceding to the throne, and the first fortifications – of rammed earth and not of masonry – were built only after Gaozu's death.

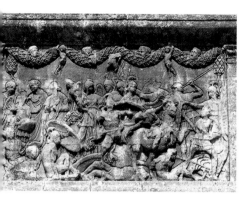

Roman citizenship While three reliefs are devoted to mythological subjects, one narrates actual historical facts, uniting two apparently unconnected scenes. In the centre and at the right we see a violent struggle between cavalry and infantry, perhaps a scene from Caesar's Gallic war. At the left is a group of people in civilian dress, one of whom is reading a document. This is interpreted as representing the granting of Roman citizenship to the Julii family. Their cognomen, Julius, indicates that they were co-opted into the Roman elite within the clientele of Julius Caesar or his grandnephew and successor Augustus.

Constructing the *casus belli*

As proconsul of a Roman province, Caesar was forbidden to wage a war of aggression. Therefore, the entirety of his famous book *De bello gallico*, our main source for these events, is meant to justify his actions and support his fame as a successful commander. Caesar alleges the following motives to legitimize his attack:

The Helvetii, a Gallic tribe settled in present-day Switzerland, intended to migrate and conquer new territory. They were threatening to cross the territory of Gallia Narbonense, under Roman control.

Even if the Helvetii desisted from their intention of crossing Gallia Narbonense, Caesar maintained that their new location in the west of Francia would threaten the Roman province's western borders.

The Aedui, a tribe in free Gaul but allied with the Romans and occupying most of present-day Burgundy, requested Caesar's aid against the Helvetii.

After Caesar's success against the Helvetii, the Gallic chieftains requested his support against the aggression of the German commander Ariovistus.

58 BC THE CONQUEST OF GAUL

The Mausoleum of the Julii

c. 30–20 BC. Saint-Rémy-de-Provence, Glanum archaeological site

Military prestige and political struggle in Rome

Julius Caesar's campaign to conquer Gaul – an immense territory extending from the Atlantic Coast to the Rhine and from the Rhône Valley to the English Channel – was a reflection of Rome's internal political struggle: in 60 BC, Caesar, with Crassus and Pompey, had formed the so-called First Triumvirate, an alliance created to reinforce the three politicians' personal power and to counter the Senate, custodian of the traditional mechanism of collective government of the Roman patricians. Caesar's initial role was secondary, behind Crassus, the richest man in Rome, and Pompey, who had won important military victories in Asia Minor and the Middle East (65–62 BC) and could therefore count on the personal loyalty of the troops involved in those campaigns. To boost his status, therefore, Caesar wanted to accomplish a comparable feat in order to surpass Pompey in prestige and build a personal military clientele to employ in the internal political struggle. In 59 BC, he was entrusted with the administration of three Roman provinces, including Gallia Narbonense (the Mediterranean coast of France). He used this position to attack free Gaul and subject it in a seven-year military campaign laying the groundwork for a sweeping Romanization of these territories.

A valiant combatant The battle scene narrates an act of individual heroism perhaps performed by the person to whom the funerary monument is dedicated. While a horseman, gravely wounded or dead, is collapsed on his horse, a foot soldier protects him with his shield. An engagement in Caesar's army may have underlain the Julii family's move into the Roman elite.

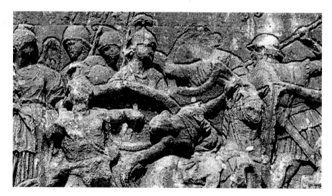

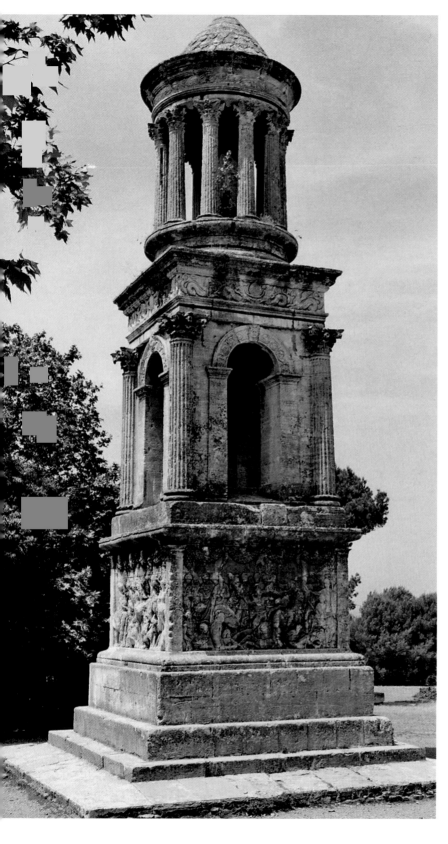

The Mausoleum of the Julii, 17.15 metres tall, stands just outside the ancient Gallo-Roman centre of Glanum, in a highly visible place along the path of the Via Domizia, which connected Italy with the Roman territories in Spain. On the northern architrave, facing the road, is an inscription stating that the funerary monument was built by Sextus, Lucius and Marcus Julius to commemorate their parents. It is probably a local family that had acquired the tastes, horizons and lifestyles of the Roman elite, thus attesting – through the mausoleum, whose reliefs reuse motifs from Graeco-Roman mythology – the rapid process of Romanization in both southern Gaul, under Roman control since 118 BC, and more recently conquered territory.

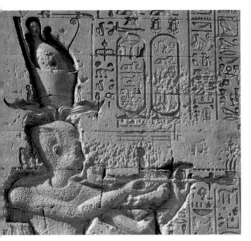

The son Caesarion, who officially took the name Ptolemy to stress dynastic continuity, is portrayed in the garb of a pharaoh.

Cleopatra's Rise and Fall

69 BC
Cleopatra is born, the daughter of Ptolemy XII Auletes of the Graeco-Macedonian dynasty of the Ptolemys. On her mother's side, she is possibly of Egyptian origin.

51 BC
After her father's death, Cleopatra takes the throne of Egypt along with her brother Ptolemy XIII, still a minor.

49–48 BC
Following court intrigues that threaten her power, she turns to Caesar, who becomes her lover.

47 BC
Birth of Caesarion, Cleopatra and Caesar's son. Soon after, Cleopatra follows Caesar to Rome, where she remains until his assassination in 44 BC.

41 BC
Cleopatra aligns herself with Mark Anthony, who, after his victory over Caesar's assassins, is the most powerful man in Rome. With Mark Anthony, she has three children.

37 BC
Mark Anthony provides Cleopatra with wider territory, granting her domains in Palestine, Syria, Asia Minor and on the Phoenician coast.

31 BC
Mark Anthony and Cleopatra are defeated by Octavian's fleet in the naval battle of Actium. The following year, both commit suicide. Caesarion, the son of Cleopatra and Caesar, is killed at the behest of Octavian, who emerged victorious from the Roman civil wars.

51 BC CLEOPATRA ASCENDS TO THE THRONE OF EGYPT

Cleopatra and Caesarion before the Gods Hathor and Ihy

40–30 BC. Relief. Dendera, Temple of Hathor

A queen in defence of independence

Cleopatra VII, the last member of a dynasty that traced its ancestry back to the Macedonian general Ptolemy, companion in arms of Alexander the Great, rose to Egypt's throne in a difficult situation. For thirty years, Rome, the dominant power in the Mediterranean, had expansionist designs on the land of the Nile, which was one of the ancient world's richest areas thanks to its flourishing agriculture. Cleopatra's predecessor, Ptolemy XII, had espoused a pro-Roman policy that the new queen essentially pursued in order to protect her reign from possible aggression and to consolidate her position, undermined by court intrigues. In this context, Cleopatra decided to make political use of her legendary charm and beauty, allying herself with the two most powerful men in Rome at the time, Caesar and Mark Anthony. However, Egypt and its queen would end up being dragged into the civil wars that marked the crisis point in the Roman republic, and in the end, Cleopatra lost everything: her lovers, her kingdom and her life.

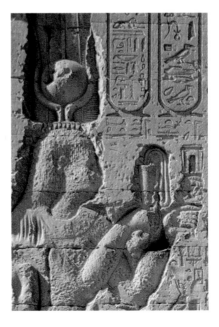

The queen deified
The representation of Cleopatra recalls the attributes of the goddesses Isis and Hathor, to whom she liked to compare herself. Here, she is wearing a headpiece with cow's horns and a solar disc, like the goddess she is facing.

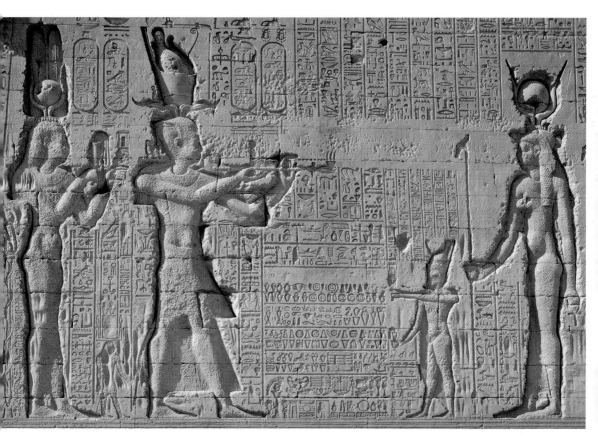

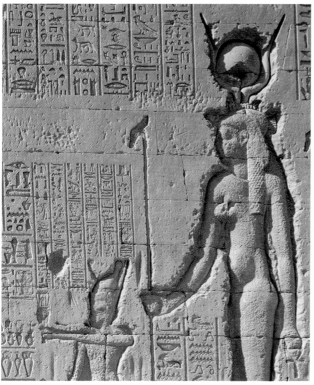

Though the ephemeral empire of Alexander the Great soon fell apart, in Egypt the Hellenistic culture survived in an amalgam of local and the Graeco-Macedonian traditions. The Macedonian dynasty of the Ptolemys used the myths and forms of pharaonic Egypt to give it credibility in the eyes of its subjects as sovereigns legitimized by religion, and to give their rule a sacred aura. This usage continued to the end of the dynasty, as demonstrated by this relief sculpture, which shows Cleopatra and her son Caesarion with two Egyptian divinities.

Hathor Like Cleopatra, Hathor, goddess of maternity, is accompanied by her son, the god Ihy. The mirroring of the two mother–son pairs emphasizes the divine origin of royal power.

27 BC THE ESTABLISHMENT OF THE PRINCIPATE

The Gemma Augustea

AD 9–12. Vienna, Kunsthistorisches Museum

Erosion of institutions

The crisis in the Roman republic that had begun in the late 2nd century BC finally ended in 27 BC with the abandoning of the old oligarchic republican order. Octavian, Julius Caesar's grandnephew, gave the Senate special powers, knowing full well that the senators, representing the Roman patricians, would immediately reinstate him in his functions. They also conferred the title of 'Augustus' upon him, indicating his divine status. Thereafter, Caesar Augustus, who boasted of having 'restored the republic', took more and more republican offices upon himself, thus monopolizing power and emptying the old institutions of their meaning and influence. He eventually acquired absolute power and gave stability to his personal regime by adopting his stepson Tiberius, who succeeded him in AD 14.

All inhabited land The goddess of the inhabited world and the ocean is depicted behind the Emperor Augustus because, as texts of the period proclaim, his empire encompassed the entire inhabited earth to the ocean's edge. At the goddess's feet sits a personification of Italy or fertile land in general, holding in her left hand a horn of plenty, symbol of abundance.

The principate

The principate was the form of government in effect in Rome from 27 BC to the 3rd century AD, characterized by the personal rule of the emperors, who were quite careful not to impinge directly upon the old institutions of republican Rome. The Senate and the magistracy, beginning with the consuls, continued to play their established roles.

The emperors themselves usually held various republican offices. In particular, they appropriated the prerogatives of the plebeian tribunes, who, as defenders of the rights of the common people (*plebs*), had ample opportunity to intervene in the decision-making process of the republican institutions.

Augustus and his successors based their power on supreme military command and direct control of the Roman provinces, from which taxes flowed into the imperial coffers.

Tiberius and Germanicus Near Augustus are the members of his extended family chosen for succession: Tiberius, Augustus's stepson and adopted son, with the laurel wreath (beside the goddess of victory); and the still young Germanicus, nephew and adopted son of Tiberius, already chosen as his successor.

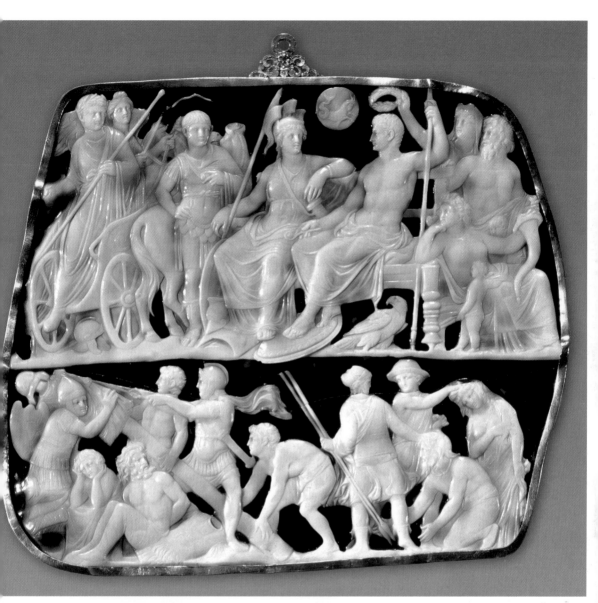

Carved in onyx, the Gemma Augustea (gem of Augustus) is an ancient cameo that glorifies Augustus and his dynasty. It was made about the year AD 10 and clearly represents the principate's guiding ideology. In the upper register, Augustus is portrayed almost in the guise of a god, as the bringer of peace and Rome's well-being, while the lower register narrates his victories against the barbarians. For these reasons, he is being crowned with the civic crown, the *corona civica*.

Defeated barbarians The gemstone's lower register depicts a Roman victory over the barbarians. It might refer to a specific campaign of Tiberius, or perhaps it is a generic reminder of the military successes of the Augustinian empire. This detail shows a woman and a man who have been taken captive.

AD 70 THE DESTRUCTION OF JERUSALEM

The Arch of Titus and its relief sculptures
81–91. Rome, Forum

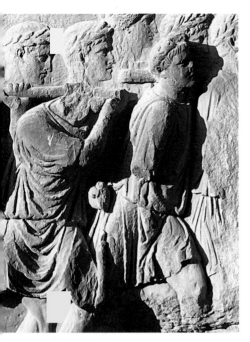

Roman naturalism The Roman sculptors succeeded in giving the relief figures a realistic sense of movement that makes the representation very natural. This artistic skill developed further in the 2nd century.

The outbreak of a long-smouldering conflict

In 66 a conflict that had been brewing for a long time in Roman Palestine exploded into open war. On one side was the Jewish population; on the other, the inhabitants of the Hellenistic cities and the Roman authorities. They had long differed over matters of religion and political power, and several Jewish rebellions had already been suppressed with bloodshed. This time the violence began when the Roman procurator of Judea, Gessius Florus, removed a sum of money from the Temple of Jerusalem. The Temple priests – usually more compliant with Roman requests – headed the protest, while the more radical groups, the so-called Zealots, who had previously armed themselves and among whom protest against Rome was often linked to messianic promises and expectations, took possession of the fortress of Masada, sounding the signal for a popular uprising.

Jewish religious and political groups

Sadducees The elite priests and aristocrats of the Hebrew people. They had a personal interest in maintaining the social hierarchy and so were often on good terms with the Roman ruling classes and the patricians of the Hellenistic cities.

Pharisees Scholars and scriptural experts who advocated religious renewal. Although opposed to the Sadducees and the Romans, at the time of the uprising they were themselves divided between those who assumed a more conciliatory, apolitical attitude and those who supported the rebels.

Zealots A group that shared the Pharisees' religious ideas but engaged in armed struggle against the Romans and their allies in the Hebrew aristocracy. They recruited adherents especially among the poorer classes, who linked the struggle against Rome to hopes of social change.

Essenes A community with strict religious rules and messianic expectations that probably took part in the uprising and that was subsequently destroyed by the Romans.

The triumphal procession Both sides of the arch show scenes of the procession celebrated in honour of Titus in 72, after the Jewish revolt was put down. This relief shows the loot taken from the Temple of Jerusalem being borne in triumph through the streets of Rome. Most conspicuously, there is the menorah, the seven-branched candelabrum that symbolizes Judaism and whose design was prescribed by the Torah.

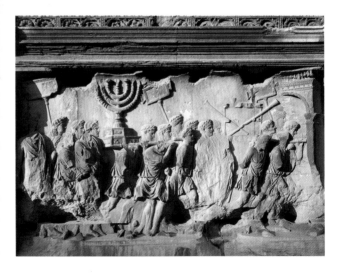

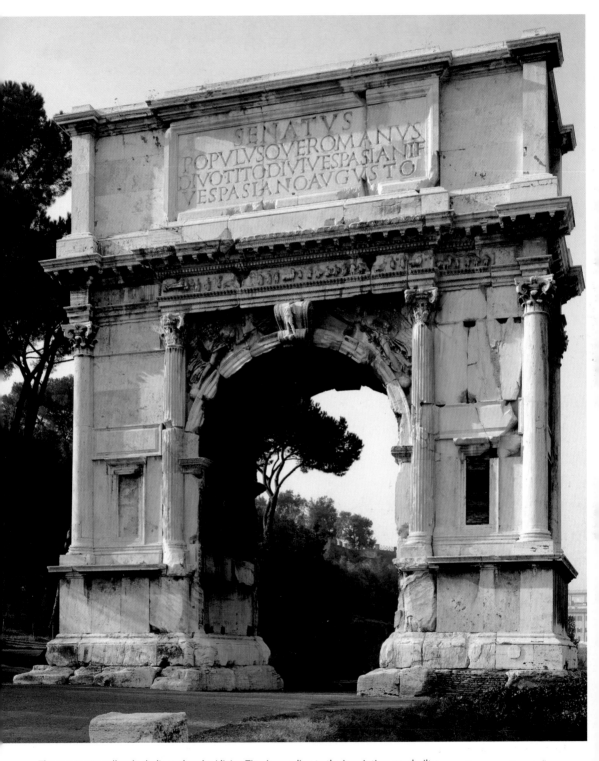

The 14.5-metre-tall arch, dedicated to the 'divine Titus' according to the inscription, was built in the decade after the emperor's death (81), in the reign of his brother Domitian. The sculpture on the arch depicts the triumphal celebration accorded Titus after his suppression of the Jewish revolt. The Flavian dynasty, which had taken power in 69, also based its prestige on the military successes of Titus and his father, Vespasian, against the seditious Jews.

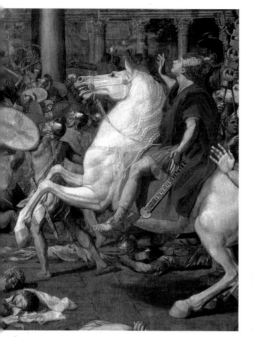

AD 70 THE DESTRUCTION OF JERUSALEM

NICOLAS POUSSIN, **The Destruction of the Temple of Jerusalem**

1638–39. Oil on canvas, 148 x 199 cm. Vienna, Kunsthistorisches Museum

From initial success to defeat

The uprising in the year 66 was initially successful. The Roman troops of Gessius Florus had to leave Jerusalem, and the first reinforcements were obliged to retreat. The political effect of this victory was explosive. A desire for revolution grew among the Jewish elite and the people, giving rise to a government that united the various Jewish politico-religious currents. When other Roman legions under Vespasian advanced against the rebels and occupied Galilee in 67, however, Jewish unity crumbled. Then, the radical factions took the upper hand and managed to hold Jerusalem until 70, thanks also to the period of uncertainty in the Roman empire following Nero's death in 68. Finally, however, Vespasian, who had garnered military prestige through his past successes against the Jewish rebels, became emperor, and his son Titus succeeded in recapturing Jerusalem after an extended siege. The city and its Temple were completely destroyed, and the people were killed or reduced to slavery.

Titus Flavius Josephus, the chronicler of the Hebrew revolt, states that Titus gave orders that no unarmed person should be killed. Josephus was writing under the patronage of Titus and helped forge the myth of Titus as a generous man. Even in this painting, the commander of the Roman troops and future emperor seems to be gesturing that the massacre should end.

The slaughter The Roman soldiers' fury against the defeated Jews, along with the lifeless bodies and decapitated heads in the foreground, leaves no doubt as to the carnage that took place in Jerusalem when it was conquered following the long siege.

This painting from 1638–39 was commissioned by Cardinal Francesco Barberini, nephew and close collaborator of Pope Urban VIII as well as a great patron of the arts in Baroque Rome. It represents the conquest of Jerusalem by Titus in all its drama and violence, and demonstrates Poussin's endeavour to give human events emotional depth.

The sack of the Temple The scene is closed off by the Temple's imposing colonnade, where pillaging is taking place. The legionaries seize sacred objects including the 'table of showbread' (NUMBERS 4:7) for the twelve loaves that were offered every day according to ancient custom.

The great Hebrew rebellion

Main Jewish figures
Eleazar ben Ananias, a member of the more moderate rebel camp; John of Giscala, Shimon bar Giora and Eleazar ben Shimon, leaders of the radical camp who also fought among themselves for control of the revolt; Flavius Josephus, a moderate military leader who in 67 went over to the Roman side and after the war wrote the most important account of this revolt, pro-Roman and highly critical of the radical factions.

Main Roman figures
Vespasian, the general called upon by Nero to suppress the Jewish uprising, who became emperor in 69; Titus, Vespasian's son, who took command of the Roman troops in Judea after his father became emperor.

Outcome
Jerusalem and the Temple, the centre of Jewish religious life, were destroyed. In the collective memory of the Jewish people, this event heralds the beginning of the Diaspora.

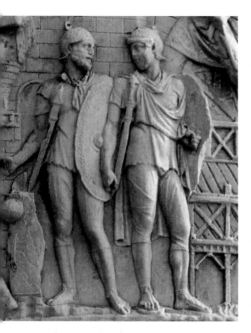

Expressiveness and emotions The relief sculpture of Trajan's Column seeks to express the soldiers' emotions, as can be seen in this pair of legionaries standing guard before a fortified camp under construction.

106 THE ROMAN VICTORY OVER DACIA

Trajan's Column and its relief sculptures
113. Rome, Imperial Forum

The apogee of the Roman empire

Trajan, emperor from 98 to 117, pushed Rome's territories to their greatest extent. A soldier prince loved by his legions and respected by the Senate (the organ of the Roman patricians), he conducted two famous military campaigns with very different outcomes. In 106, he annihilated the Kingdom of Dacia, to the north of the lower Danube, the border of the Roman empire. King Decebalus committed suicide and the capital, Sarmizegethusa, was captured. The spoils of war – Decebalus's famous treasure of gold and silver – were tremendous, and Trajan was granted an unprecedented triumphal celebration. Buoyed up by this victory, Trajan undertook an even more ambitious military campaign. Following in the footsteps of Alexander the Great, he wanted to conquer the empire of Parthia (modern-day Iraq, Iran and Afghanistan) in the east. However, he died during the campaign, after finding that the Parthians were a much more formidable enemy than the Dacians.

Rome under the Antonine Emperors

Emperors From Nerva (r. 96–98) to Marcus Aurelius (r. 161–180), the title of emperor was passed on by adoption. The goal of adoption was to identify a worthy and capable candidate, but the emperor usually chose his successor from within his own extended family. The emperors of the 2nd century not only revealed themselves to be able directors of the empire's fate, but also distinguished themselves as refined patrons and lovers of philosophy and poetry.

Extent In the 2nd century, the Roman empire extended from Britain to Egypt, and from eastern Anatolia to the Iberian Peninsula and Mauretania (the northern part of present-day Morocco). It thus encompassed a large part of Europe and the entire Mediterranean coast.

Culture During the period of the Antonines, Rome experienced a great flourishing of culture, from architecture to philosophy. Roman art reached sublime peaks, developing a masterful naturalistic realism that found expression in the great reliefs narrating historical events, such as those of Trajan's Column.

Building Here, as in other scenes, the anonymous sculptor focuses on physical labour and the everyday life of the legions. Highly esteemed in the 2nd century, Stoic philosophy encouraged attention to the simplest task, since all labour was important in the harmonic construction of human society.

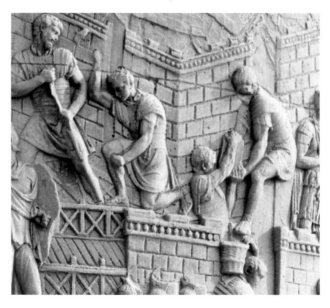

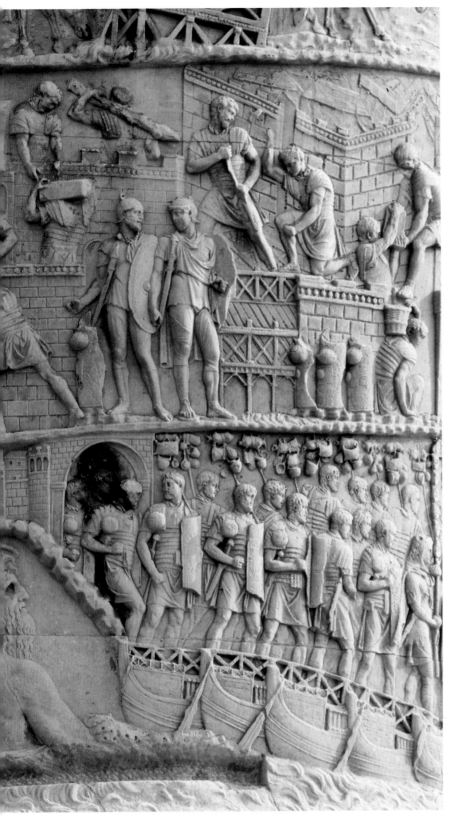

Following the victory over Dacia, Trajan's Column was erected in Rome to exalt the emperor's accomplishments and the strength of the Roman army. Some 29.78 metres high (more than 40 metres counting the base and the statue at the top), its reliefs narrate the progress of the Dacian War in a cycle of 114 individual scenes, arranged in a 200-metre-long band that wraps around the column in a spiral. The detail reproduced here begins the cycle. The Roman troops leave a fort and cross a bridge of boats over the Danube, which is also represented as a river god beside the soldiers (below). The same troops then build an encampment (above).

The Kanishka reliquary casket

c. 127 (Replica). London, The British Museum

Lords of the Silk Road

The Kushan empire reached its zenith under the rule of Kanishka in the 2nd century AD. The dynasty had originated in present-day western China, among the nomadic people called 'Yuezhi' in Chinese sources. From China, they gradually moved south-west and, around AD 135, took over Bactria, in northern Afghanistan, and then Gandhara, between Afghanistan and the mid-course of the Indus River. In those areas, the Kushans came in contact with both Hellenistic culture (which had taken root there after the adventure of Alexander the Great) and Buddhism (widespread in Gandhara thanks to the previous Indian dynasty of the Mauryan empire). For almost three centuries – from the dawn of the Christian era until about 250 – the Kushans dominated that region and thus controlled an important junction between China, India and the Parthian empire – and, by extension, the lucrative long-distance trade between Asia and Europe.

Buddha The top of the reliquary shows the Buddha venerated by two Indian divinities, Brahma and Indra. The stimulus of Greek art in combination with the Buddhist tradition of India produced the first naturalistic representations of the holy figure of Buddha, until then unknown in Indian art.

The Kushan empire

Extent In the 2nd century AD, under Kanishka, the empire extended from the Tarim Basin in western China through Uzbekistan, Tajikistan, Afghanistan and Pakistan to the plain of the Ganges in northern India.

Trade The Roman empire imported silk, spices and other luxury goods from Asia. A large part of this merchandise passed through the territories of the Kushan empire. Craft products, in particular elaborate glass containers and huge quantities of gold, arrived from the Mediterranean world.

Religions Various religious traditions coexisted under the Kushan emperors, from Greek paganism to the Zoroastrian religion of the ancient Persians, from Buddhism to Hinduism. Even though the emperors deferred to all these traditions, Kanishka is remembered as a protector of Buddhism.

Culture The empire was characterized by a mixture of Greek, Persian, Indian and central Asian elements. The Greek alphabet was used alongside Indian scripts, while various languages also coexisted – in particular Indian dialects and Bactrian, an ancient Persian tongue.

Kanishka Identified as Kanishka, the central figure on the base of the reliquary is flanked by the Iranian divinities of the moon (on the left) and sun (right), the latter of which crowns the Kushan king. The garland carried by the putti-like figures that wraps around the vessel shows Hellenistic influence.

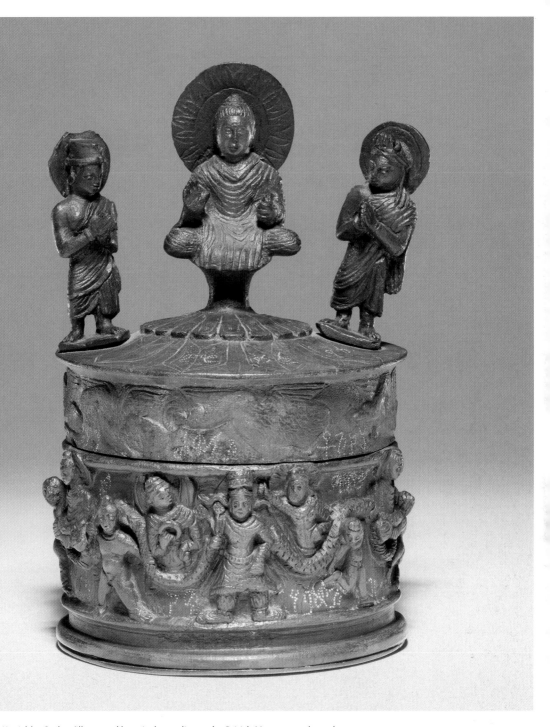

The Kanishka Casket (illustrated here is the replica at the British Museum and not the original, which is kept in Peshawar) was discovered inside Kanishka's *stupa* (a typical Buddhist cult and pilgrimage monument) near Peshawar, Pakistan, in 1908–1909. The casket is a reliquary that originally contained fragments of bone said to be from the Buddha. The object, which was probably executed in the time of Kanishka, shows all the characteristics of the Indo-Hellenistic art typical of Gandhara and the Kushan empire. An inscription on the object informs us that the artist's name was Greek – Agesilas – and that he was also responsible for building the *stupa*.

260 SHAPUR I'S VICTORY OVER THE ROMANS

Shapur Humiliates Rome

c. 260–70. Relief sculpture. Naqsh-e Rostam

Philip the Arab Born in what is today Syria, Philip was proclaimed emperor when his predecessor, Gordian III, died during a campaign against the Sassanians. He negotiated a peace treaty with Shapur, who propagandistically interpreted it as submission on the part of the Roman emperor. In the reliefs, Philip is shown paying homage to his Persian adversary.

Empires in conflict

From the ashes of the Parthian empire, long-time adversaries of Rome, arose a new force capable of causing just as much trouble. Ardashir, a vassal of the Parthians, killed the last Parthian king, Artabanus IV, in 224, and became the first representative of the Sassanian dynasty. The Sassanians reconnected with the splendours of the ancient Achaemenid Persia of Cyrus the Great and Darius I, and strengthened state structures and royal power to the detriment of the great noble families. After the first military successes of Ardashir and especially his son Shapur I, Emperor Valerian assembled an army to defend the eastern limits of the Roman empire but was defeated in 260 near Edessa, in south-east Anatolia. Valerian fell into the hands of the enemy – the only time a Roman emperor was ever captured – and this disgrace was long remembered in Rome.

Shapur I The second sovereign of the Sassanian dynasty used the title 'king of kings of Iran and beyond Iran'. Here, he is portrayed bedecked with jewels, wearing sumptuous silks and a splendid crown.

The 3rd-century Persian Wars

244 Shapur I defeats the Roman emperor Gordian III in Mesopotamia. His successor, Philip the Arab, makes a peace pact with Shapur.

253 or 256 The Sassanian army reaches Antioch, a few kilometres from the Mediterranean coast.

260 Defeat and capture of Emperor Valerian, who dies in a Sassanian prison.

262–63 The Romanized Syrian potentate Septimius Odaenathus defeats the Sassanians on behalf of the Romans and advances as far as Ctesiphon, in the heart of Mesopotamia.

283 Emperor Carus again penetrates Mesopotamia to Ctesiphon.

298 After the reorganization and reinforcement of the Roman empire under Diocletian, a peace treaty favourable to Rome is signed.

The complex at Naqsh-e Rostam, near ancient Persepolis, was originally a burial ground for the Achaemenid kings – the tomb of Darius I is located there. Ardashir had commissioned a sculpture of him being crowned by the Persian divinity Ahura Mazda (or Ormizd) in order to relate his rule to this ancient dynasty, of which the Sassanians possessed only fragmentary knowledge. For his part, Shapur I commissioned this relief of his triumph over Rome, combining two separate events: the supposed homage of Emperor Philip the Arab in 244 and the capture of Emperor Valerian in 260.

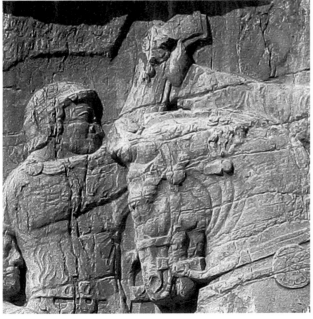

Valerian The figure in the background, his arm grasped by Shapur, is interpreted as Valerian. In a text Shapur had inscribed at the same monumental complex, the Sassanian king boasts of having captured Valerian with his own hands.

The victories of Marcus Aurelius The arch makes ample use of material from other periods. The reliefs on the attic storey date from the reign of Marcus Aurelius (161–80) and celebrate his victories over the Germans. At the left, the emperor is addressing his soldiers before battle, while at the right, he is sacrificing a bull, a pig and a sheep to win the gods' favour. Constantine thus wanted to legitimize his reign as the continuation of the 2nd-century Antonine dynasty – a golden age in the Roman empire – while also acknowledging its pagan foundations.

312 CONSTANTINE'S VICTORY

The Arch of Constantine and its relief sculptures
315. Rome, Imperial Forum

From usurper to uncontested emperor

Constantine, designated 'the Great' by later generations, began his climb to power in the Roman empire as a military usurper. In 306, Constantine had accompanied his father, Emperor Constantius I, on a campaign against the Picts in Britain. When the emperor died, the army commanders and soldiers proclaimed Constantine as successor, outside the framework of the law. Constantine, who could count on the personal loyalty of his father's troops, successfully defended his power in Gaul, Britain and the Iberian Peninsula. In the spring of 312, he invaded Italy, turning against his rival for the emperorship, Maxentius (himself a usurper). The two armies met at the Milvian Bridge, at the northern entrance to Rome. Constantine defeated the forces of Maxentius, who drowned in the Tiber. The city welcomed the triumphant Constantine, who now held the Western Roman Empire firmly in his hand.

The rise of Constantine

293 Constantius I, father of Constantine, is appointed *caesar* (deputy emperor) alongside emperors Diocletian and Maximian.

305 Diocletian and Maximian abdicate. Constantius becomes emperor of Rome's Western empire. He is seconded by Caesar Severus, who was to succeed him.

306 Death of Constantius. Constantine is proclaimed emperor, disregarding Severus's right to succession. Maximian's son Maxentius usurps power in Italy.

307 Maxentius defeats and kills the legitimate emperor, Severus.

308 Constantine is restored as *caesar*, alongside the legitimate emperors Galerius and Licinius; Licinius takes the place of Severus.

311 Death of Galerius.

312 After his victory over Maxentius, Constantine is the uncontested emperor in the West, sharing power only with Licinius.

324 Constantine defeats Licinius, becoming sole emperor of East and West.

Constantine's address This frieze from the time of Constantine depicts him addressing the people of Rome after his triumphal entry into the city. Such orations were part of the celebration of a triumph. The emperor (his head is missing) is in the centre of the image, surrounded by his generals. He stands on the *rostra*, the speakers' platform on the Forum, flanked by statues of two emperors.

Twenty-five metres high, the Arch of Constantine is the most imposing of the ancient Roman triumphal arches. In keeping with tradition, it was commissioned by the Senate to glorify the emperor, in particular his victory over Maxentius. The inscription in the centre of the attic storey tells us that Constantine 'with just arms redeemed the Republic from the tyrant and all his followers'. Constantine thus appears as the restorer of legality to the Roman state, inserting himself into the tradition of the previous emperors.

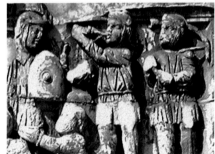

The Battle of the Milvian Bridge The friezes that run above the smaller arches and continue on the sides recount events that occurred in the time of Constantine, among them the decisive Battle of the Milvian Bridge (October 312). At the left are Constantine's soldiers furiously attacking the enemies, who are drowning in the Tiber. Above, trumpeters sound the call to battle. The style of these reliefs eschews naturalism in favour of concentrating on particular expressions and symbols.

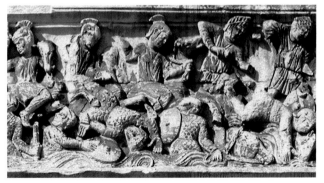

312 CONSTANTINE'S VICTORY

Piero della Francesca, **The Dream of Constantine**

1459–66. Arezzo, Church of San Francesco

The emperor's vision The scene is lit from above by a single beam of light indicating divine revelation. Except for the angel in the upper left-hand corner, Piero della Francesca depicts nothing supernatural, choosing to evoke the vision not through a didactic narrative but by the fresco's complex composition and the skilful play of light. The soldier keeping watch over his master has the expression of absorbed and suspended contemplation that is characteristic of Piero's painting.

A Christian emperor?

Already in Constantine's time, there were reports connecting his victory over Maxentius at the Battle of the Milvian Bridge with his adherence to Christianity. Lactantius, a Christian poet and rhetorician called to the imperial court in 315 to teach the emperor's son Crispus, wrote, 'Constantine was advised in a dream to mark the heavenly sign of God on the shields of his soldiers and then engage in battle. He did as he was commanded and by means of a slanted letter X, with the top of its head bent round, he marked Christ on their shields. Armed with this sign, the army attacked.' It is not known whether Constantine actually chose a new emblem for his troops on the occasion of the campaign against Maxentius or whether this is a propagandistic account invented by a Christian courtier to make Constantine appear to be the 'protector of Christians'. In any case, at that moment began a long tradition celebrating Constantine as the Christian emperor *par excellence*.

The sign on the shields

The Christian historian Lactantius's description of the new emblem chosen by Constantine for his legions is fairly elusive. The sign, which according to Lactantius's account was revealed to Constantine in a dream, has been interpreted as:

the **monogram of Christ**, composed of the Greek letters X (chi) and P (rho), the first letters of the word 'Christ' in Greek.

the **staurogram**, the symbol of the Christian cross that is obtained by superimposing the Greek letters T (tau) and P (rho), which are part of the word *stauros*, meaning 'cross'.

the **ankh** (*crux ansata*, or 'handled cross'), a symbol of Egyptian origin that could be read as a juxtaposition of the cross and the sun, symbolized by a circle.

The angel's finger The descending angel is the source of the light, or the vision. He points to Constantine with his index finger as if this gesture were penetrating the emperor's thoughts.

The Dream of Constantine is part of a fresco cycle depicting 'The Story of the True Cross' executed by Piero della Francesco for the chapel of the Baccis, a rich family of merchants, in the church of San Francesco in Arezzo. The cycle is made up of twelve panels that narrate the medieval legend of the cross on which Christ was crucified. Constantine plays a leading role in the complex account. After his vision and the Battle of the Milvian Bridge, he is said to have urged that the True Cross be sought. *The Dream of Constantine* describes the vision of the cross in accordance with the account handed down from Lactantius: it is the eve of the battle, and the emperor is sleeping in a tent in the encampment, which may be seen in the background against the night sky.

312 CONSTANTINE'S VICTORY

Peter Paul Rubens, The Emblem of Christ Appearing to Constantine

1622. Oil on panel, 46.2 x 56 cm. Philadelphia Museum of Art

The vision Rubens's depiction of the emperor's vision (partially) follows the account by the 4th-century bishop and chronicler Eusebius of Caesarea. In the days before the decisive Battle of the Milvian Bridge, the emperor, at the head of his army, saw the sign of the cross as a luminous vision in the sky. Beside it appeared the words 'In hoc signo vinces' (By this sign, you will conquer). The biographer thus connects Constantine's political and military victory with his growing interest in Christianity.

Constantine and Christianity

311	With the Edict of Nicomedia, Emperor Galerius, who governed the Eastern Roman empire, puts an end to the persecution of Christians, which had begun again in the early years of the 4th century.
313	At a meeting in Milan, emperors Constantine and Licinius confirm Galerius's edict of tolerance, and in the so-called Edict of Milan ensure that buildings and possessions confiscated during the earlier persecution would be restored to the Church.
321	Constantine proposes Sunday, dedicated to both the sun god and the Christian God, as the weekly day of rest.
325	Constantine convenes and presides over the First Council of Nicaea, with the aim of settling the conflict of dogma between the Arians and those who supported the idea of the trinity of the Father, Son and Holy Ghost.
337	Constantine is baptized shortly before his death.

Religion as a means of government

Despite the fact that his biographers Lactantius and Eusebius of Caesarea describe Constantine as a prince devoted to the Christian faith, in fact he maintained an ambiguous relationship with Christianity. As emperor, Constantine viewed the question of faith not so much as a personal choice but as a political decision aimed at strengthening the unity of the empire and legitimizing his power. In an immense and multicultural empire, the ancient Roman rites no longer served to bind the community together. Constantine recognized in the Christian Church a possible pillar of imperial power, but retained the title and office of *pontifex maximus* granted by the Roman religion to the emperor, and observed the cult of the ancient gods throughout his life. However, the Church was torn by conflict over dogma (with the Arianists) and ethics (with the Donatists). The emperor intervened in these disputes even though he had not espoused the faith himself, because only a united church could sustain his imperial power. Constantine was far from conceding Christianity the status of state religion, but he initiated a process that over two generations led to the official adoption of Christianity as the religion of the Roman empire.

The monogram In the sky, Rubens depicts not the apparition of the cross – as told by the late antique author Eusebius – but the monogram of Christ, made up of the Greek letters X and P (chi and rho). This abbreviation of the name of Christ entered the empire's official symbolism in the 320s.

This panel by Peter Paul Rubens is an oil sketch for a tapestry that was to be part of a series commissioned by Louis XIII of France for Cardinal Francesco Barberini and woven in the 1620s. The whole series is devoted to the 'Story of Constantine'. However, the tapestry was never executed. Later, one of a vertical format on the same subject was produced from a drawing by Pietro da Cortona. This panel's composition – with the emperor on a pedestal and soldiers holding standards – reuses ancient reliefs depicting the emperor's address to his soldiers before a battle. Such a representation is included in the Arch of Constantine, built after the Battle of the Milvian Bridge (see pp. 64–65).

The standards In the painting, Rubens includes typically Roman standards (*labara*) and banners (*vexilla*), with eagles and laurel wreaths, whereas according to Eusebius, Constantine had already given the order to change his troops' standard, introducing the cross with the monogram of Christ, by 312. Beyond the testimony of Eusebius, however, there is no historical evidence of such a change in that year. In fact, standards featuring Christian symbolism are only attested to after about 325.

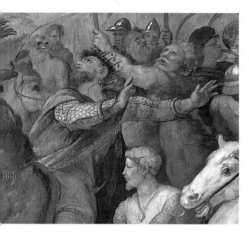

A barbarian prince Attila, king of the Huns and the pope's counterpart in the negotiations, appears not only in a curious pose (indicating he is disturbed by the vision of the Apostles in the sky), but also dressed in a fairly fantastic costume, emphasizing that he is a 'barbarian'. His beard is uneven, his armour is gold, and on his head he wears a pointed crown with precious stones and pearls at the tips. He is also wearing an earring.

The barbarian invasions

The so-called barbarian invasions refer to the period when various peoples, Germanic and otherwise, migrated from eastern Europe to the west and south, where they came into conflict with the Roman empire. However, they often made peace with the Romans and established colonies that provided the empire with military support.

375	The Huns, a nomadic people from central Asia, invade eastern Europe, clashing mainly with the Goths who withdraw beyond the Danube into territory controlled by the Romans. They overcome the army of the Eastern Roman empire at the Battle of Adrianople (378).
406	Vandals, Suebi and Alans invade Roman Gaul.
410	Rome is sacked by the Goths of Alaric, who later becomes an ally of the Romans and founds a Barbaro-Roman kingdom in Gaul.
429	Vandals and Alans invade the Roman provinces of North Africa, important for their rich agriculture.
476	The auxiliary Germanic troops in Italy rebel under Odoacer, who deposes the last emperor of the West and founds a Barbaro-Roman kingdom on Italian soil.

452 THE HUNS IN ITALY

RAPHAEL, **The Meeting of Leo the Great and Attila**

1514. Fresco. Rome, Musei Vaticani

The Sack of Rome forestalled

When Attila, the greatly feared king of the Huns, attacked the Western Roman empire head-on by invading Gaul in 451, Rome had been in a profound crisis for some time. Not only had it been subjected to the invasion of the Goths, Vandals and Alans, but it had also experienced a serious economic and social decline due to the ever-increasing extension of large landed estates and consequent impoverishment of agriculture and decay of the city. However, Attila was defeated at the Battle of Campi Catalaunici, in present-day eastern France, and now turned against Italy, where he sacked Aquileia and Milan. The structures of the Roman state were almost no longer functional, thus increasing the importance of the Church, which together with the old Roman patricians tried to save the old civic and state order. Though there is no concrete evidence for it, it is entirely plausible that it was Pope Leo who led the Roman mission to Attila to dissuade him from proceeding towards the empire's ancient capital. The diplomatic mission was successful because Attila's army had been decimated by epidemics and the Huns were threatened in their territory along the Danube by an attack from the Eastern Roman empire.

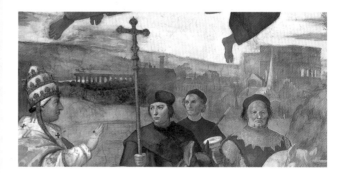

The city Raphael places the meeting between the pope and the king of the Huns in the vicinity of the city of Rome: the fresco includes the Colosseum and an ancient aqueduct. In actual fact, Attila and his army stopped in northern Italy, and the encounter between the Roman delegation and Attila would have occurred much farther north, perhaps near Mantua.

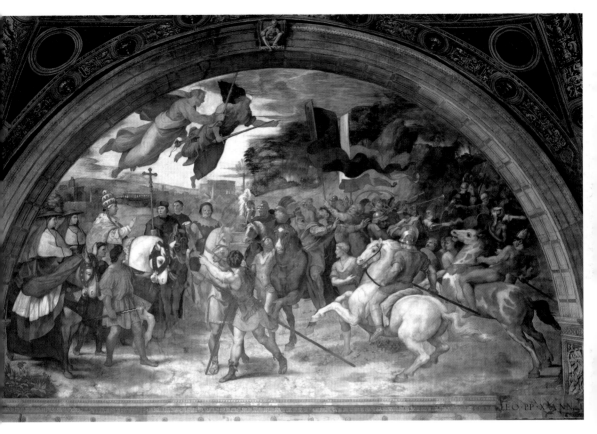

The fresco of the *Meeting of Leo the Great and Attila* fits into the complex iconographic programme Raphael and his assistants executed between 1508 and 1524 in the Vatican *stanze*, the pope's apartments in the Vatican Palace. The entire cycle, distributed through four *stanze*, glorifies the office and history of the papacy – in this case, the role of Leo the Great in averting the destruction of Rome. Attila is clearly put off by the miraculous intervention of the Apostles Peter and Paul, who appear armed with swords above the pope and his companions. Popes Julius II and Leo X, the patrons who commissioned the painting, are credited with being the protectors of Rome, the centre of the Christian world.

The Hun horsemen Raphael has given the figures of this fresco – and these two in particular – a dramatic plasticity that is absent from the previous frescoes of the cycle, executed a few years earlier. The two Hun horsemen, who struggle to control their bolting horses before the mystic vision, represent the image that European historical writings had associated with the Huns since antiquity – savage warriors who were almost one with their horses.

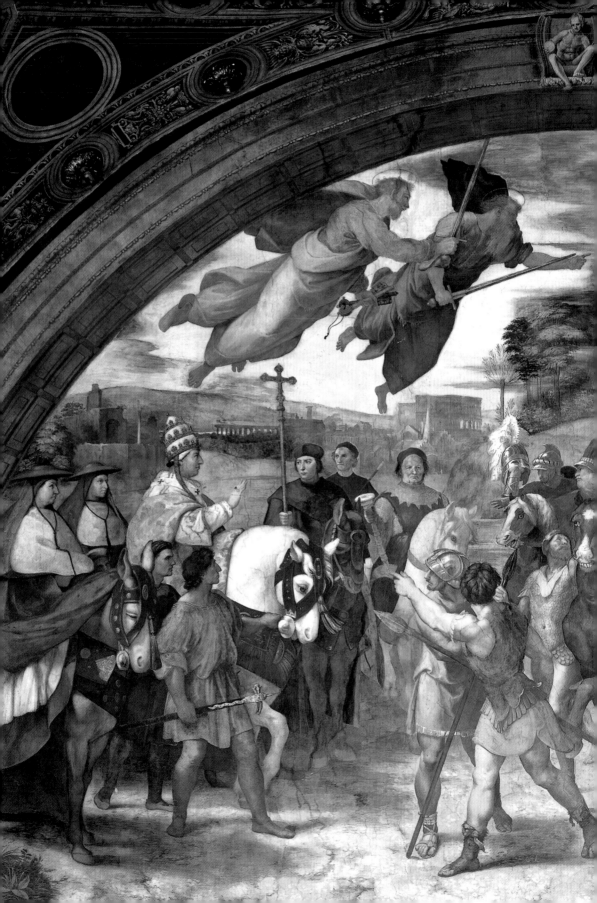

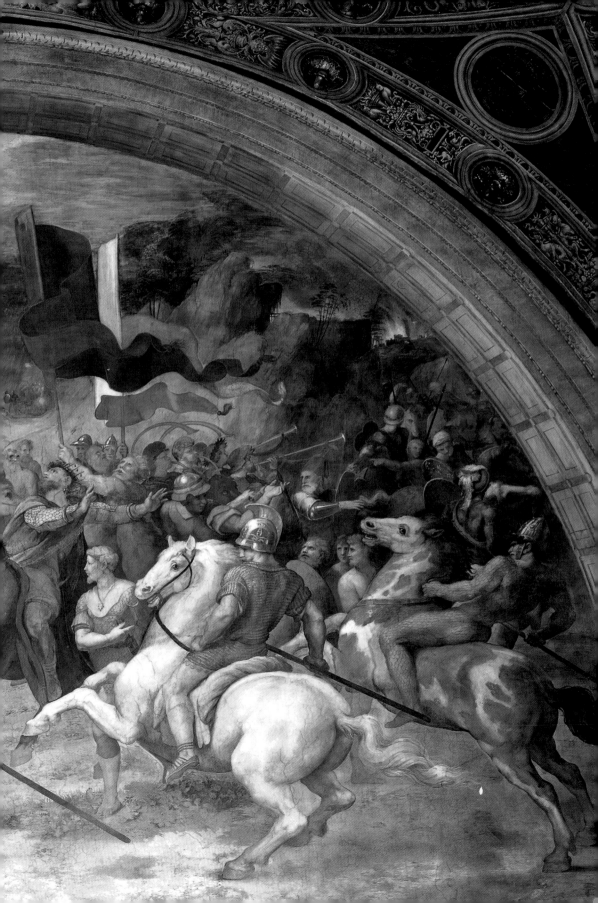

The miracle In the introduction to his *Dialogues*, the early pope Gregory the Great states that he wants to propose models for the virtuous life and that he intends to tell of the miracles performed by the saints in order to demonstrate the power of virtuous conduct. Accounts of miracles therefore occupy much of the biography of Benedict, who here is resuscitating a monk crushed by a wall.

Other founders of Christian monasticism

Anthony Abbot (Anthony of Egypt) According to tradition, Anthony lived from 251 to 356. He abandoned the comforts of a large landowner's life to devote himself to asceticism in the Egyptian desert. He lived as a hermit but was a model and guide for other ascetics who established themselves in the vicinity of his hermitage. It was probably Athanasius of Alexandria, a main figure in theological discussions of the 4th century, who wrote the first *Life* of Anthony.

Pachomius Pachomius, who lived from about 292/98 to 346, founded the first Christian monastery in Upper Egypt in order to overcome the limitations of individual asceticism. In his community, and others that followed, life revolved around prayer and work, subject to a strict discipline.

Basil the Great Basil was born in 329 in Cappadocia and died there in 379. A hermit and bishop, he was among the most important theologians in the history of the Church. He travelled widely to learn about the way of life of Middle Eastern and Egyptian hermits and ascetics. He wrote a rule for monastic life that is still in effect today for monks of the Orthodox churches.

529 THE FOUNDING OF THE ABBEY OF MONTE CASSINO

SODOMA, **Scenes from the Life of Saint Benedict**
1501–10. Fresco. Asciano, Abbey of Monte Oliveto Maggiore

Prayer and work

When Benedict of Nursia founded the monastery of Monte Cassino in 529, Christian monasticism was already well established. News of the first hermits and communities dedicated to the ascetic life had come from Egypt and Palestine around 300, and the first western European monasteries had been founded by the 4th century. However, with his rule – initially only intended for the community of Monte Cassino – Benedict gave monastic life a new form that mitigated its ascetic rigour, exalted the function of the community as a means of mutual support, and placed manual and mental work at the centre of monastic life, along with the prayers to be performed at fixed hours in the course of the day. This model, which combined the contemplative life with work, spread rapidly through western Europe, and Benedictine monasteries became a pillar of feudal society in the centuries to come, contributing greatly both to the development of agriculture and to the preservation of cultural heritage, thanks to scribes who copied and recopied ancient manuscripts.

An accident As prescribed by the rule of Benedict, monks performed manual labour. Here, they are attempting to build a wall at Monte Cassino. However, as in the account of Gregory the Great, the supernatural regularly intervenes. The monk's injuries were no accident: the devil toppled the wall on which the monk had been standing.

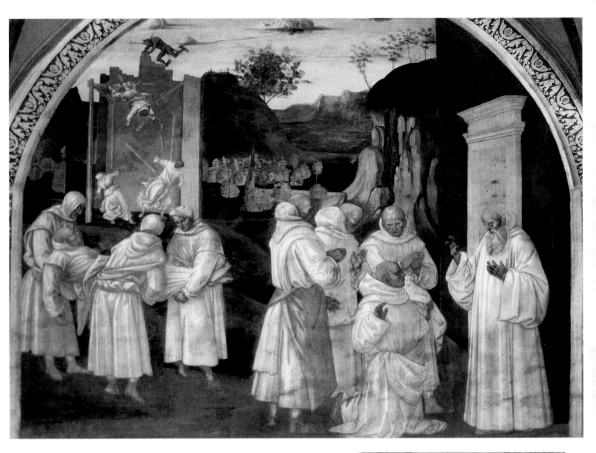

In 1497, Luca Signorelli was commissioned to decorate the large cloister of the Abbey of Monte Oliveto Maggiore in Tuscany. He abandoned the task the following year after painting one side of the cloister. During the following decade, the work was completed on the other three sides by Giovanni Antonio Bazzi (called Il Sodoma because of his homosexuality). The cycle relates the life of Benedict of Nursia according to the account by Gregory the Great. Between 593 and 594, this pope, himself a founder and member of a monastery that followed the rule of Benedict, wrote the first biography of the father of Western monasticism. It is included in his *Dialogues*, which extols saints from Italy.

The community In this fresco, Sodoma depicts in abundant detail an important moment in the daily life of all Benedictine communities: eating together in the refectory at mealtime. There are decanters and glasses for wine and water, loaves of bread and fish on the plates. This scene, too, refers to a miracle reported by Gregory the Great. During a famine, Benedict urged the monks to place their faith in God, so that food would arrive soon. The very next day, the monks found the flour they needed.

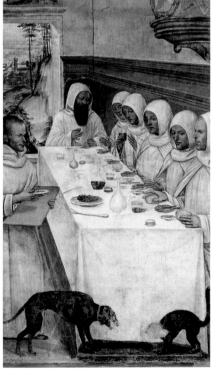

Heresies and religious disputes

During the reign of Justinian, the emperor ensured Christian orthodoxy, which was considered a pillar of imperial power. Justinian took part in defining the religious creed, repressing the trends that were considered heretical. These are some of the most widespread heresies:

Arianism Expounded by the Egyptian theologian Arian, this sustained the different and 'lesser' nature of Christ in relation to God the Father. Condemned at the Council of Nicaea in 325, Arianism was prevalent among the barbarians who had converted to Christianity, becoming a significant identity factor of the Ostrogoths.

Monophysitism This asserted that in Christ the divine nature absorbs human nature. Condemned by the Council of Calcedonia in 451, it had a considerable following in the eastern provinces of Egypt, Syria and Armenia, which aspired to independence from Byzantium. The Empress Theodora herself was probably a Monophysite.

Nestorianism This emphasized the presence of two distinct but equal natures in the person of Christ. To reconcile the Monophysites to Orthodoxy, Justinian declared the Nestorian thesis heretical. The Nestorians consequently fled to Persia, an enemy of Byzantium.

552 THE RESTORATION OF THE ROMAN EMPIRE

Emperor Justinian and Empress Theodora with their Retinue

c. 547. Mosaics. Ravenna, Basilica of San Vitale

From Byzantium to the reconquest of Rome

About eighty years after its dissolution, Justinian, ruler of the Byzantine empire, decided to try to reconstitute the entire Roman empire. Starting from the solid power base of Byzantium and his control over the eastern provinces, in 533 he sent General Belisarius to reconquer Latin Africa. Belisarius first disembarked in Sicily and then continental Italy, where he had to reckon with the Ostrogoths. However, after a conflict that lasted a full eighteen years, Justinian was again emperor of Italy, conquering the old capital Rome and Ravenna, the administrative centre of the Western empire from the 5th century on. At the same time, the Byzantines took part of southern Spain from the Visigoths and controlled all the main islands of the western Mediterranean. Justinian sought to restore imperial authority over all this territory, both by reordering and integrating the old Roman legislation (resulting in the impressive Corpus Juris Civilis) and by imposing a strict political and religious despotism. In reality, a new wave of barbarian invasions soon stifled this dream of restoring the empire.

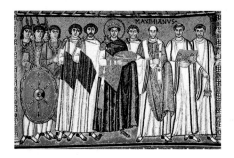

A priestly procession Starting from the left are a group of soldiers, two high dignitaries, the emperor, a noble or courtier, Bishop Maximian and two deacons (one of whom is holding a sacred book and the other a thurible for incense). The figures are rendered two-dimensionally against a gold background, their gazes lost in the distance. These stylistic elements, which became typical of Byzantine mosaics, underscore the hieratic nature of the procession and the sacred nature of the emperor.

The donor and the bishop Some have sought to identify the nobleman immediately to the right of the emperor as Julianus Argentarius, a banker from Ravenna who financed the construction of the basilica. Beside him is Bishop Maximian, who consecrated the basilica. He is the only person clearly identifiable, because of the mosaic inscription. This may indicate that Maximian played the principal role in directing the work of construction and decoration.

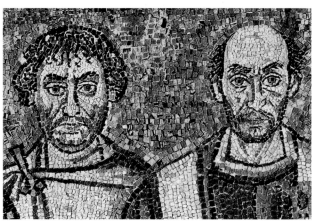

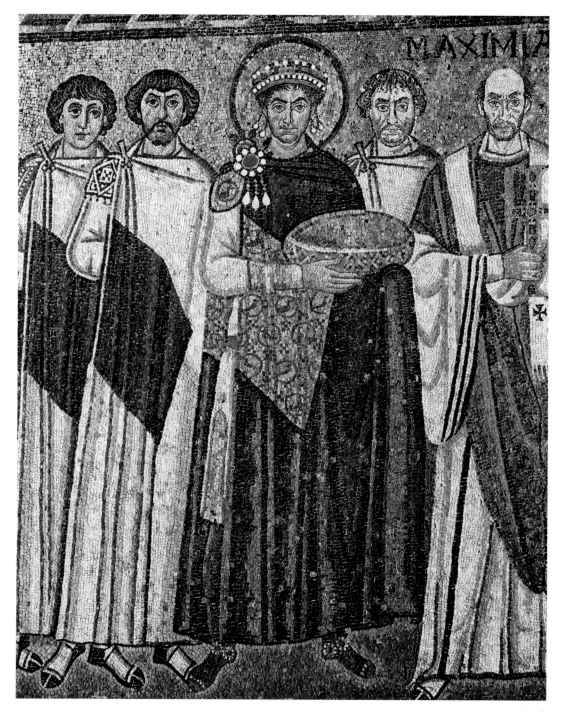

The mosaics devoted to Justinian and Theodora fill the sides of the apse of the basilica of San Vitale in Ravenna, to the left and right of the high altar. Construction of the church, which was originally meant for the Arian community, began in 526 under the Goths. After the Byzantines conquered Ravenna in 540, however, all reference to the Goths and their Arian beliefs was eliminated, and two mosaics devoted to the imperial couple were added. The mosaics' prominent position near the altar emphasizes the central role the emperor wanted to play in ecclesiastical as well as political matters. The church was consecrated in 547.

552 THE RESTORATION OF THE ROMAN EMPIRE

The Gothic War

When, in 535, the Byzantines arrived in Italy to overthrow the Ostrogoths, the resulting war brought about the peninsula's final economic ruin, as well as the destruction of a good part of the remains of ancient Rome. First, Belisarius succeeded in 540 in conquering Ravenna, the capital of the Ostrogoth kingdom and the old Western Roman empire. However, the general's success aroused the jealousy of Justinian, who recalled him to Byzantium, while the Goths' new king, Totila, incited his people and won back much of the lost territory. Totila called on the rural population to rebel against the large landowning class (who had sided with Byzantium), thus enraging the Byzantine historians, who depict him as a bloodthirsty 'scourge of God'. Besieged and sacked four times during these years, Rome was practically reduced to a heap of rubble. In 551, Justinian sent a new army against Totila, commanded by Belisarius's replacement, Narses. The Goths were defeated and Totila killed at the Battle of Tagina (552). Two years later, Justinian reorganized the Italian territory under Byzantine domination and restored to the old property owners the lands that Totila had taken from them.

The Eucharistic gifts The emperor and empress are taking part directly in the most important moment of the Christian liturgy by bringing the bread and wine of the Eucharist to the altar. However, this interpretation has been refuted by some historians, who claim that the imperial couple are instead paying homage to the representation of Christ at the back of the same apse.

Justinian's generals The two dignitaries to the left of the emperor may represent leading figures in the restoration of the empire. The bearded man has been identified as General Belisarius, while behind him would be Narses, a court eunuch who was elevated to commander of the emperor's armies and administrator of the lands reconquered in Italy. The geometric designs each one has on his left shoulder have been interpreted as insignias of military rank.

The empress Like Justinian, Theodora is accompanied by her own retinue of dignitaries and court ladies and, also like him, wears a crown and purple cloak, signs of imperial status. The empress's cloak is further embellished with a hem representing the Three Magi and a collar of gems and pearls. The empress is also represented with a halo. In late antiquity, this symbol, which later became the prerogative of the saints, designated the members of the imperial family.

Sumptuous clothing The clothing of the imperial couple and their retinue is rendered in minute detail, as can be seen in these decorations on the garments of the ladies-in-waiting who accompany Theodora.

Main figures

Justinian Emperor from 527 to 565, Justinian is remembered not only for his politico-military initiatives and legislative action, but also for giving Byzantium new splendour by reconstructing the basilica of Santa Sofia (Hagia Sophia) and adding its lavish dome.

Theodora Historical sources, in particular Procopius of Caesarea, describe Theodora as a woman of humble origin, the daughter of the bear keeper at the Hippodrome, an actress and dissolute courtesan. As Justinian's wife in 527, she became his perceptive adviser, able to moderate his religious intolerance.

Belisarius Justinian's general, Belisarius led all the Byzantine military campaigns. In 540, he fell into disfavour after occupying Ravenna, and the Ostrogoths offered him the emperor's crown, which he refused. Pardoned in 549, he won another great victory against the Slavs, who were threatening Byzantium.

Totila The king of the Goths, in 541 Totila led a revolt against the Byzantines. He was hated and vilified by the Roman patricians and Byzantine historiographers because of his concessions to the peasants. He died in battle in 552.

Ali venerated by the Shi'ites This miniature was painted in Persia under the Safavid dynasty, which had made Shi'ite Islam its state religion. For this reason, Muhammad's son-in-law Ali appears behind him, as co-protagonist of the Islamification of Mecca. Ali was his fourth successor, from 656 to 661, but his election was contested by other influential members of the community. This was the origin of the division between the Sunni and Shi'ite branches of Islam, which soon led to war and Ali's murder. For the Shi'ites, Ali remains Muhammad's most faithful and worthy disciple, founder of the family of the prophet's legitimate successors.

The birth of a new empire

629 A small Arab-Islamic army reaches Palestine but is repelled by the Byzantines.

632 Muhammad dies and Abu Bakr, his first successor (caliph), succeeds in stabilizing the alliance established by Muhammad.

634 The Arab-Islamic armies conquer Damascus. However, they allow the inhabitants to maintain their own faith and customs on payment of a head tax. A similar relationship is established with other subdued peoples.

636–37 In two different battles, both the Byzantines and Sassanians are defeated. The two empires, which dominated the Middle East at the time, were already weakened by the long wars they had fought against each other.

640 The Arab-Islamic troops reach Egypt.

651 The last Sassanian king is killed. All of Persia is in the hands of the Arabs. Their expansion continues towards India and Central Asia.

681–82 The Arabs control northern Africa to the Atlantic Coast.

630 THE CONQUEST OF MECCA

Miniature in Mirkhwand, *Rauzat-us-Safa (The Garden of Purity)*

1585–95. Berlin, Museum für Islamische Kunst

From the exodus to the conquest

 The year 622 saw the transformation of the recently born Islamic community into a political entity. The Prophet Muhammad, a native of Mecca, had met opposition from the aristocratic class in his native city and decided to leave. And so, along with a group of supporters who had embraced Islam (the new faith the prophet proposed following the revelation of the Qur'an), they set off on what is known as the Hijra (exodus), arriving in the nearby city of Yathrib (later named Medina). There, they were well received and Muhammad was given the task of pacifying various quarrelling clans. He succeeded in this, bringing the city's clans to an agreement that ensured peace and stability. Other tribes and clans from the surrounding area soon adhered to the agreement, and the community of Yathrib began to rival the aristocracy of Mecca for control of the area and the caravan routes from western Arabia. Rivalry turned to armed conflict, but in 630 the Meccans surrendered and Muhammad and his community occupied the city peacefully, introducing Islam there. From this alliance between cities and Arab tribes, Muhammad's successors created an empire that in a few decades radically changed the political geography of the Middle East and the world.

The prophet In many Islamic cultures, the prohibition on the representation in art of human and other beings was interpreted strictly, so that there are few depictions of Islam's main figures and episodes. Things were different in Persia, where a strong interest developed in miniatures narrating history and literary subjects. However, Muhammad's face is only very rarely represented. In this miniature, it is hidden by a veil on which 'O, Muhammad' is written in Arabic script. Ali's face is also hidden by a veil. Both are represented with a halo of flames to emphasize their sacred nature.

Living in the 15th century between present-day Uzbekistan and Afghanistan, the scholar Mirkhwand wrote historical works in the Persian language. Among these is *The Garden of Purity*, which tells of the origins of Islam and the history of the Islamic peoples and dynasties. The miniature reproduced here, from a 16th-century copy of the work, was executed by an anonymous artist from what is now Iran. It represents the removal of the pagan idols from the Ka'bah, the structure in Mecca that is today Islam's most venerated shrine. Before 630, it was a temple of the ancient pagan religion of Arabia. This is, therefore, a highly symbolic moment, in which Muhammad confirms the city's adherence to Islam.

The mountain road The artist pays great attention to the pictorial description of the mountain landscape. The province of Sichuan, in the eastern spur of the Tibetan plateau, is characterized by spectacular mountains. In the landscape, the artist introduces a hazardous roadway, with hanging wooden footbridges.

The China of the T'angs

Under the T'ang dynasty (618–907), China achieved its second period of splendour (the first being the Han period, 202 BC–AD 9):

Early in the reign, agriculture was reorganized, with a redistribution of the land to favour small land holdings. Internal and external commerce increased.

China again controlled Central Asia, where it clashed with the expansionism of the Abbasid caliphate. Its political hegemony also extended to part of Korea and Vietnam, and its cultural influence spread to Japan.

A multinational empire was formed including non-Chinese peoples and especially Turkish-speaking nomads, who provided the empire with highly skilled horsemen, soldiers and generals.

Various religions and philosophies coexisted in the empire – Buddhism alongside the traditional Chinese adherence to Confucianism and Taoism – creating an original synthesis of the three currents. The first Muslim and Nestorian Christian communities were established as well. However, periods of tolerance alternated with various persecutions due to the reaction of conservative groups.

755 THE REBELLION OF AN LUSHAN

The Flight of Emperor Xuanzong to Sichuan

8th–11th centuries. Ink and paint on silk, 56 x 81 cm. Taipei, National Palace Museum

An unsuccessful rebellion

The accession to the throne in 712 of the T'ang dynasty's Xuanzong marked the beginning of a period of relative political calm and a great flourishing of culture. However, military commanders, often of foreign origin, acquired ever greater power (to the detriment of the traditional hierarchy of government officials), while the beneficial effects of the agrarian reform carried out during the preceding century faded. The size of large land holdings increased, and the heavy tax burden due to the high military spending was no longer distributed in an egalitarian manner. In addition, there were power struggles between the ruling class's various clans.

In 755, a general of Central Asian origin, An Lushan, a military commander on the north-eastern border, took leadership of the discontented military and government officials and marched on the capital. Emperor Xuanzong fled and eventually abdicated, but his successor renewed the initiative and suppressed the revolt. After the death of An Lushan in 757, the rebel army splintered into gangs that devastated the empire's eastern provinces. The outcome of the revolt and succeeding civil war was disastrous, but the T'ang dynasty managed to re-establish order with the aid of their allies among the nomadic peoples, reorganized the financial system and survived for over a century more.

Ladies and lovers Among the many women in the imperial retinue is Xuanzong's concubine Yang Guifei, who accompanied him when he fled. But she was blamed for the dynasty's ruin and the guards made Xuanzong abandon her. She was decapitated during the flight.

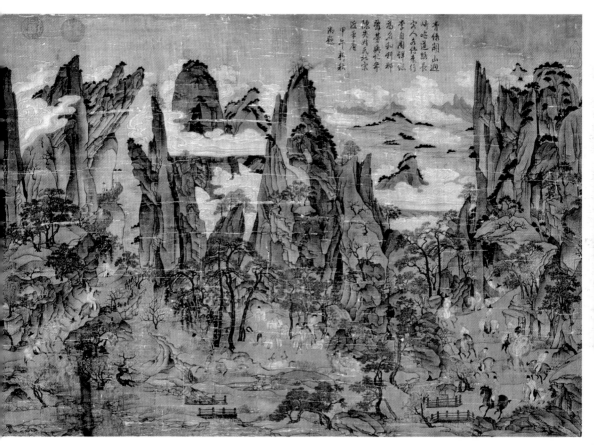

This work is done in the blue and green style typical of T'ang-period landscape painting, but it is probably a later copy of an original executed a few years after the events. In the setting of a mountainous landscape, the anonymous artist describes the flight of Emperor Xuanzong into the region of Sichuan, in south-eastern China, after An Lushan had occupied the ancient capital of Luoyang and threatened Chang'an, the T'angs' residence. Traditional Chinese history makes the emperor's concubine Yang Guifei the scapegoat of the rebellion of 755 and its disastrous consequences: deeply in love with her, the emperor neglected the affairs of state, losing control over the country.

Servants and guards The emperor on horseback is followed by his servants and guards. The second horseman, with the light-coloured clothing, is identifiable as a soldier because of the bow he carries. The caravan also includes a camel. Camels were used as beasts of burden in China at the time.

Charlemagne's wars

772 First campaign against the Saxons. Despite some success and the submission of a part of the aristocracy, Saxony remains unconquered.

774 Charlemagne triumphantly enters Pavia, the Lombard capital, and assumes the title King of the Lombards.

778 Campaign against the Saracens in Spain. It is not until 800, however, that Carolingian presence becomes stable in the north of Spain.

782 At the so-called massacre of Verden, Charlemagne has Saxons who fought against Frankish domination put to death. Contemporary sources of the period report 4,500 victims, a figure much debated by modern historians.

785 The leader of the Saxon rebels, Widukind, surrenders to Charlemagne.

787 Charlemagne attacks the Duchy of Benevento in southern Italy, making it a tributary state.

788 Bavaria is incorporated into the Kingdom of the Franks. The last duke, Tassilo, is tried on false charges and exiled to a monastery.

791 First campaign against the Avars, who had settled in present-day Hungary.

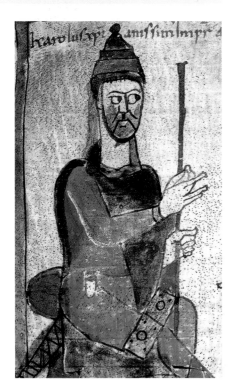

800 THE CORONATION OF CHARLEMAGNE

Miniature in the Capitulary compiled by Lupus Servatus for Everardo of Friuli

c. 900. Modena, Biblioteca Capitolare, O.I.2

Building hegemony in the West

The coronation of Charlemagne as Holy Roman Emperor on Christmas Day in the year 800 was the conclusion of the long process by which the king of the Franks had first established his supremacy in western Europe and then challenged the Byzantine Empress Irene for primacy among Christian monarchs. Having succeeded his father Pepin the Short to the Frankish throne in 768, at the death of his brother Carloman in 771 he acquired control of the whole kingdom, which extended from the Pyrenees to the Rhine and from the Alps to the English Channel. He pursued an energetic policy of expansion directed initially against the Saxons of present-day north-western Germany, where his intervention was so violent that it prompted criticism even from so loyal a courtier as Alcuin, a cultivated monk. At the request of the pope, Charlemagne subsequently attacked the kingdom of the Lombards in northern Italy, took action in Spain and extended the domain of the Carolingians eastward at the expense of the Bavarians, Slavs and Avars. In 787, he challenged Byzantium, which until then had maintained at least an outward primacy over the Germanic kingdoms of western Europe. He broke off the planned marriage between his daughter and the empress of the East's son and then penetrated southern Italy, which was under the sway of Byzantium.

Crown, straw and sword Charlemagne is represented with a crown that underscores his imperial rank and distinguishes him from his son Pepin and all the other German princes depicted in the manuscript. However, he shares two other attributes with them: the sword, a fundamental emblem of the German kings, who based their prestige on their qualities as warriors (though it also served as a symbol of the exercise of justice), and the straw (*festuca*), a reference to the rule of law, as the plant's stalk was exchanged among Germanic peoples in confirmation of a legal agreement.

Pepin of Italy Charlemagne's son is on a throne lower than that of his father to show their difference in rank. Born Carloman, he assumed the name Pepin when he ousted from the line of succession his half-brother Pepin the Hunchback (who was excluded either because he was born of a morganatic marriage (preventing succession) or because – as his nickname implies – he was deformed). As a child, he rose to the rank of king of the Lombards, or Upper Italy, under the guardianship of his father. However, he died before Charlemagne and thus never took full possession of his kingdom.

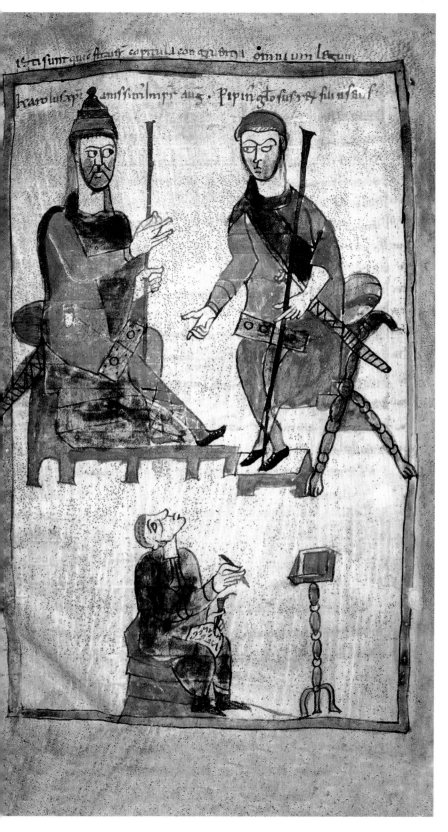

The Capitulary of Lupus Servatus (Lupus of Ferrières) was executed in Fulda, Germany, before 840. The copy in Modena faithfully duplicates the miniatures in the original. The portraits of Charlemagne and his son Pepin are part of the iconographic programme of the codex, which collects the customary laws of each of the peoples that made up the Carolingian empire (the Franks, Alemanni, Lombards and so forth) as well as capitularies: laws no longer customary, but issued in writing by Charlemagne and his sons. Each division is preceded by a representation of the legislators, mythical or historically documented, behind the laws' origin. The portrait of Charlemagne and Pepin, below whom a scribe is taking down the dispositions dictated by the emperor and his son, therefore opens the sections devoted to the capitularies.

The sceptre of Charles V Surmounted by an idealized portrait of Charlemagne, this sceptre was executed in about 1380, not long after the reliquary in Aachen, for the French king Charles V. It shows that Charlemagne was a model not only for the Holy Roman Emperors, but also for the kings of France. In fact, Charlemagne's empire was the basis of both the French monarchy and the empire that included Germany, Italy and other territories of central Europe.

The alliance of the papacy and the Carolingians

751 Pope Zachary legitimizes the *coup d'état* in which the mayor of the palace of Pepin the Short, Charlemagne's father, ousted the reigning monarch and had himself acclaimed King of the Franks.

754 Pope Stephen II, Zachary's successor, solicits the military intervention of Pepin the Short in Italy to avert the conquest of Rome by the Lombards.

783 Pope Adrian I again calls upon the Franks to help stem the Lombards' expansionist aims.

795 Leo III is elected, but his power is immediately threatened: the entourage of the previous pope is hostile to him and criticizes his management of the papacy.

799 Rebellion breaks out against Leo III, who is at first incarcerated but then manages to flee, making his way to Charlemagne's court.

800 Leo III reinstalls himself on papal soil with the aid of Charlemagne, who calls a synod to confirm that the pope cannot be judged, strengthening the pontiff's position in the Church hierarchy. Charlemagne is crowned emperor two days later.

800 THE CORONATION OF CHARLEMAGNE

The Reliquary of Charlemagne
1349. Silver, partially gold-plated. Aachen, Treasury of the Cathedral

A compromise between temporal and spiritual power

The coronation of Charlemagne as Emperor of the Romans arose from an alliance that his family, the Carolingians, had made with the papacy some time before. The kings of the Franks needed further legitimacy to stabilize their rule, while the popes needed a military arm that would stand behind them, since the Byzantine empire was no longer in a position to defend the city of Rome or ensure the pope's independence from other powers. This compromise between spiritual and temporal powers, with continuous competition between the two poles, marked the whole of medieval history and clearly distinguished the western empire from the Byzantine empire, where emperors based their legitimacy on continuity with the ancient Roman empire and had a sacred aura of their own, independent of Church hierarchies. The ritual used in Charlemagne's coronation in 800 reflects the two participants' essential equality. Though Pope Leo III placed the crown on Charlemagne's head, immediately after, he prostrated himself at the emperor's feet, imitating the act of submission that was usual in the Byzantine court.

The Reliquary of Charlemagne, from 1349, is an item of Gothic precious metalwork. Executed at the request of Emperor Charles IV, the reliquary in the form of a bust is an idealized portrait of the first Holy Roman Emperor. In the following centuries, it was carried in processions at the coronation of every German king. The appeal of Charlemagne remained constant throughout the Middle Ages. Otto III (982–1002) had Charlemagne's tomb opened to express his devotion to his illustrious predecessor. In 1165, Frederick Barbarossa obtained the canonization of Charlemagne, to whom he looked in forming his programme for strengthening imperial power, as did his grandson Frederick II. The cult of the 'Holy Emperor Charles' was given a strong thrust under Charles IV, who took the same name to consolidate his own image.

James the Apostle and the emperor According to a widespread legend in the Middle Ages, Charlemagne went to Spain to combat the Moors after Saint James the Apostle appeared to him in a vision. The sceptre of Charles V of France represents the scene of the apparition, and Charlemagne is thus celebrated as a defender of Christianity.

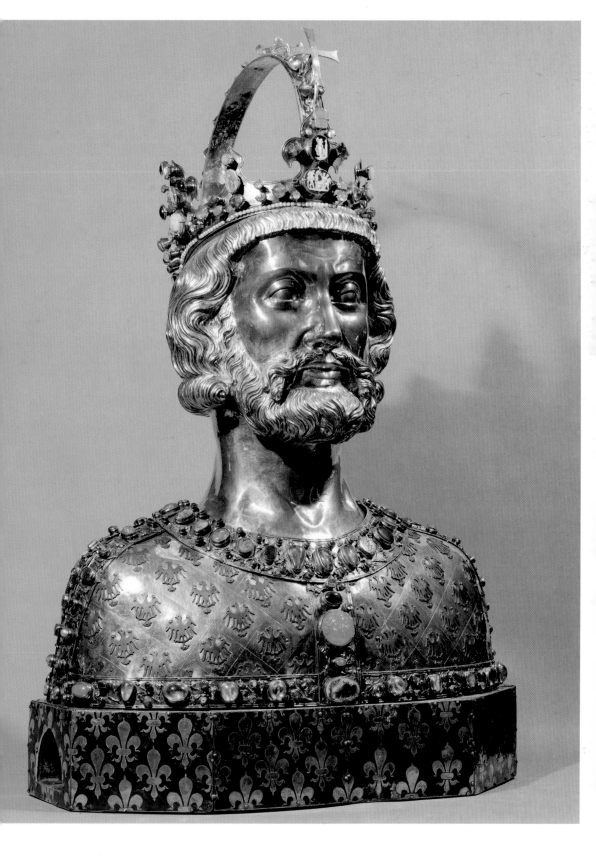

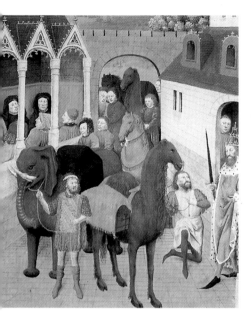

The delegation of Harun ar-Rashid The *Grandes Chroniques de France*, using the annals from the time of Charlemagne as their source, tell that Harun ar-Rashid sent Charlemagne an Indian elephant. The illuminator represents the moment when the exotic animal is brought before the emperor in a procession of dromedaries.

The Carolingian empire compared to the Abbasid caliphate

Politics and administration Charlemagne tried to unify his empire by appointing counts from the Frankish nobility. Monks and clerics, guardians of the written culture, were employed to promote the use of writing. On the other hand, the Abbasid caliphate could avail itself of the collaboration of Persian government officials, now converted to Islam, to strengthen central administration.

Economy The economy of the Carolingian empire was based on the courts of feudal lords, which produced a large portion of the crops and crafts necessary for subsistence on their own. Trade was limited. In the Islamic world at the same time, farming was instead oriented to the big city market. New crops, like rice, and new irrigation techniques increased output.

Culture The 'Carolingian Renaissance' promoted the preservation and dissemination of ancient Latin literature and the writings of the Church Fathers. Under Harun ar-Rashid and his sons, Islamic theology and law were stimulated, while Arabic culture came into contact with the ancient Greek and Persian traditions.

800 THE CORONATION OF CHARLEMAGNE

Simon Marmion, Miniature in *Les Grandes Chroniques de France*

1455–57. St Petersburg, National Russian Library

The encounter of two worlds

Shortly before being crowned emperor, Charlemagne had initiated a diplomatic exchange with the caliph of Baghdad, Harun ar-Rashid. This contact, which continued into the early years of the 9th century, also took place because Charlemagne, representative of the dominant kingdom of western Europe, wanted to deal with figures of dignity equal to his: Harun ar-Rashid, the highest representative of the Islamic world; and the Byzantines, with whom the emperor had come into conflict in 787. Contact between the Frankish kingdom and the Abbasid dynasty (Baghdad) had developed some time earlier, and although there were military clashes with Moorish Spain, trade relations existed between the Orient, the source for imported luxury merchandise, and Carolingian Europe, which was characterized by a rural economy. Furthermore, the caliphate of Baghdad could prove a valuable ally for Charlemagne against Byzantium and the Moors in Spain, where the Islamic Umayyad dynasty that had established itself was hostile to Baghdad. Charlemagne had also been approached regarding the question of the safety of pilgrims bound for Jerusalem. No true diplomatic agreement was reached, however, and if Charlemagne was reassured about the protection of pilgrims and Christians in Palestine, the problem remained that the caliph could not always guarantee safety in his immense empire.

The siege of Venice In this image, the artist synthesizes three unconnected events. Besides the coronation of the emperor and the welcoming of the Eastern embassy, in the background he depicts the siege laid by Charlemagne's son Pepin to Venice in 810. The City on the Lagoon was not conquered but remained under the influence of Byzantium.

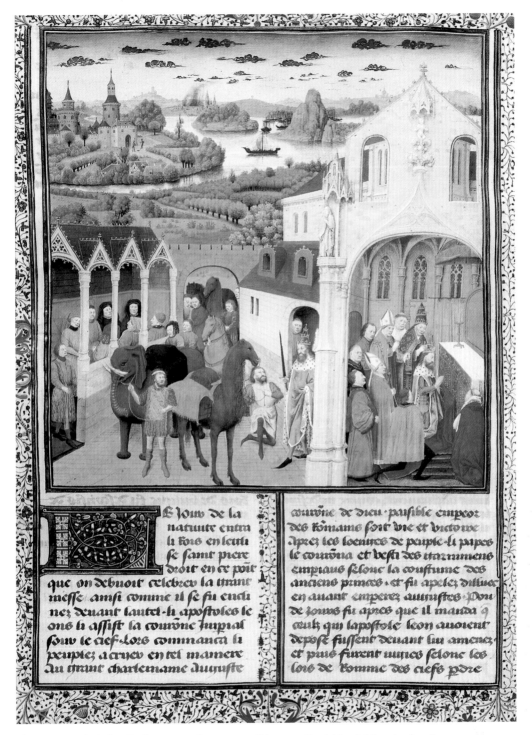

ĉ Jom de la
natuite entra
li kois en leuil
ſe ſamt piere
droit en ce poit
que on deunoit celebrer la trant
meſſe amſi comme il ſe fu enchi
nez denant lautel·li apoſtoles le
ons li aſſiſt la counne impial
ſonr le cief·lors commanca li
peuples a crner en tel mamere
Au trant charlemame duanſte

counne de dieu·pauſible empeor
des komams ſort bie et bictone
apres les loenwes de peuple·li papes
le counna et beſti des tarnimens
empians ſelone la conſtume des
anciens primces·et fu apelez dilluer
en anant emperez auanſtes·pou
de tours fu apres que il manda q
eulz qui lapoſtole leon anoient
depoſe fuſſent denant lui amenez
et puis furent umes ſelone les
lois de komme des ciefs pdre

This miniature, depicting Charlemagne at the moment of his coronation (at the right) and welcoming the delegation of Caliph Harun ar-Rashid (at the left), decorates the St Petersburg copy of *Les Grandes Chroniques de France*. It is a compilation of various medieval chronicles assembled from the 13th century onwards for the purpose of celebrating the French monarchy. The St Petersburg copy was executed for Philip the Good, Duke of Burgundy, in support of his political objectives (which were often in competition with those of the French monarchy). The illustrations in the codex are attributed to Simon Marmion, a northern French painter known only by a few unsigned panel paintings in addition to these miniatures.

The bishops To the left of the emperor are two bishops. The pallium – the white stole decorated with crosses that both wear around their shoulders – identifies them as metropolitan archbishops, second only to the pope in the Church hierarchy. The bishops, who were accorded ample political prerogatives, were a pillar of the Ottonian dynasty's power, and the emperor could appoint them at will. Later a major clash occurred over this question, the so-called 'Investiture Conflict'.

Other main figures

Theophano The Byzantine princess Theophano arrived in Germany in 972 as the wife of the king and emperor Otto II. Widowed in 983, she looked after the interests of her son Otto III, who was threatened by the claims of relatives, with balance and firmness. For some historians, her son's distinctly sacred concept of the role of emperor can be ascribed to her Byzantine background.

Gerbert of Aurillac A monk originally from southwestern France, he was one of the most cultivated men of his time. He was Bishop of Reims and entered the court of Otto in 996. He dedicated a treatise on the use of reason to the emperor, the prologue of which exhorts him to endeavour to restore the Roman empire and not leave the heritage to Byzantium alone. Otto III elected him pope in 999 as Sylvester II.

John Crescentius This powerful representative of the Roman aristocracy was defeated by Otto III in 996 but was soon granted amnesty. He rebelled against Pope Gregory V, chosen by Otto. Otto defeated him again in 998, had him beheaded and displayed his corpse publicly. However, the Roman aristocracy's resistance to Otto's policies was rekindled a few years later.

996 THE CORONATION OF OTTO III

Reichenau School, Miniature in the *Gospels of Otto III* (*Reichenau Gospels*)

c. 1000. Munich, Bayerische Staatsbibliothek, *Clm. 4452*

Emperor and saviour

Otto III was perhaps the medieval emperor who most closely represented the concept of the divine nature of imperial power, signing certificates with such religiously loaded titles as 'servant of the Apostles' and 'according to the will of God the Saviour'. Overstepping the right of confirming the pope's election claimed by his predecessors, he actually appointed two popes. He presided alongside the pope at synods, chose Rome as his residence in 997 and declared false the popes' claim since late antiquity to govern Rome and its territories by virtue of the *Donatio Constantini* (Donation of Constantine), emphasizing instead that he had given these territories to the Church of his own volition. The son of the German king and emperor Otto II, at the death of his father in 983 he acceded to the throne at the age of three; regency was held by his mother, Theophano. In 994–95, the fourteen-year-old Otto assumed the reins of government and in 996 was crowned Holy Roman Emperor. Although he endeavoured to extend the empire to the east to include the Slavic peoples, he showed particular interest in Rome and Italy, where he died of an illness at the age of only twenty-one during a military campaign against his adversaries among the Roman nobility.

The nobility The two lay noblemen represented to the right of the emperor are holding his weapons: the one with a black beard grasps the lance; the older one, with a white beard, is holding the sword. The dukes and princes of the empire, often tied to the Ottonians through marriage, were the second pillar of the dynasty. Like the representations of the two bishops, these are archetypes meant to illustrate the power the emperor exercised over the Church and the nobility.

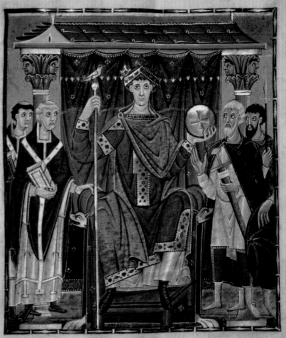

The *Reichenau Gospels* were executed between 998 and 1001 in the workshop of the Abbey of Reichenau, one of the main centres for the production of miniatures during the Ottonian dynasty (10th–11th centuries). This priceless codex includes the four Gospels, commentaries and a list of texts to be read during mass in the course of the liturgical year. In all, it contains more than thirty full-page miniatures. Besides representations of the evangelists and illustrations of stories from the Gospel, there is a two-page miniature depicting the emperor as he accepts the homage of the provinces of the empire.

The homage of the provinces Four women, allegorical figures bearing gifts, approach the emperor's throne. Inscriptions above their heads identify them as the four provinces of the empire: from left to right, Sclavinia, Germania, Gallia and Roma. These were not well-defined geographical entities but rather a general reference to the extent of Otto's power and prestige. It is significant that Sclavinia appears in addition to the territories governed previously by Charlemagne – the land of the Slavs over which Otto III sought to assert imperial authority.

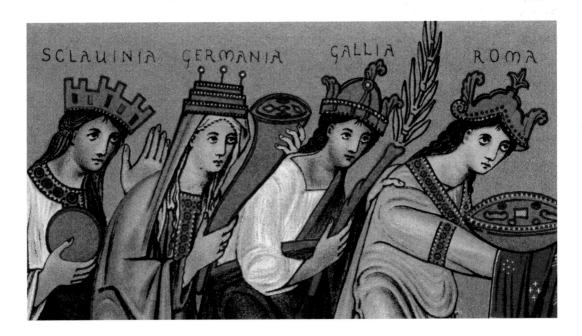

1066 THE NORMAN CONQUEST OF ENGLAND

The Bayeux Tapestry

c. 1070. Embroidery on white linen, 53 x 6800 cm. Bayeux, Musée de la Reine Mathilde

A new king for the Land of the Angles

The kingdom of England was formed in the 10th century, with power alternating between the Anglo-Saxon dynasties and the Danish sovereigns who disputed the territory of what is called the Heptarchy, the seven original domains (among which Wessex was pre-eminent). When Hardecanute, the last Danish sovereign, died without an heir in 1042, he was succeeded by his half-brother on his mother's side, Edward the Confessor, a Saxon who had been exiled in Normandy for twenty-five years. Edward inaugurated a long period of peace and prosperity but had to contend with the rivalry of Godwin, Duke of Wessex, who was opposed to the king's Norman influence. Despite this, Edward designated as his successor William, Duke of Normandy, pushing Anglo-Saxon claims into the background. At Edward's death in 1066, however, Godwin's son Harold proclaimed himself king with the consensus of the local nobility, thereby provoking an armed reaction from William. With the pope's support, William armed a fleet and crossed the Channel, engaging Harold at the Battle of Hastings, where Harold was killed. Thus began the Norman domination of England, which profoundly influenced the history of Great Britain.

Harold swears fealty to William The tapestry illustrates the events leading up to the invasion from the Norman point of view. Shipwrecked in Normandy in 1064 and handed over to William, Harold is represented in the act of swearing loyalty to the duke on the relics of a saint, thus recognizing the duke's right of succession to the throne of England. But Harold breaks his word and William reacts to claim his right. As in a comic strip, Latin inscriptions accompany the episodes to help make their meaning clear. The inscription – 'Harold sacramentum fecit Willelmo duci' – means 'Harold swore an oath to Duke William'.

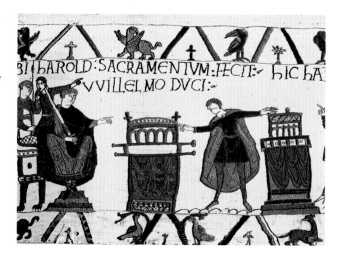

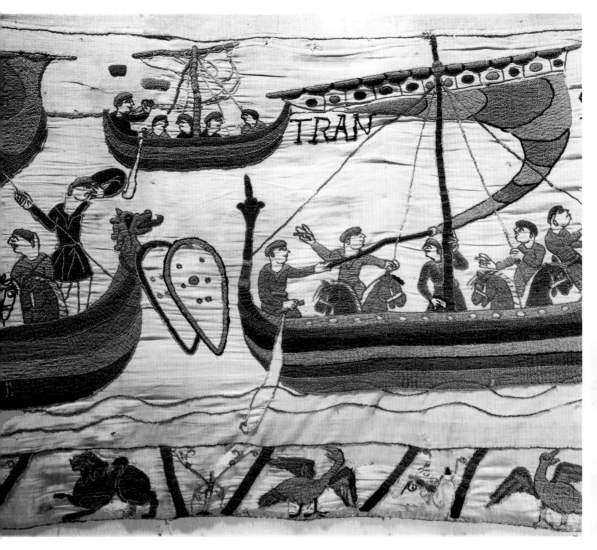

Sixty-eight metres long by 53 centimetres wide, the Bayeux Tapestry
– not actually a tapestry but embroidered on white linen – recounts
the epic of the Norman Conquest of England in fifty-eight scenes.
It has long been attributed to William the Conqueror's wife, Mathilde
of France. However, it was probably commissioned by Odo, half-brother
of William and Bishop of Bayeux in Normandy, and produced in Kent,
England, of which Odo was duke. Brought to Bayeux, the tapestry must
have been displayed in the city's cathedral as testimony of Norman
glory. In the episode illustrated above, the Norman *drakkars* (Viking
ships) plough through the waves of the English Channel to land in
England. Attached to the dragon prow of the first ship are shields with
William's coat of arms.

The face of the traitor Harold's furtive look, angular chin, low forehead and pointed
moustache are all meant to convey the image of an untrustworthy person liable to
treachery. It is an early example of a representation of an individual's face that is not just
a mask linked to a role but also a sign of a personality and a specific psychology.

1066 THE NORMAN CONQUEST OF ENGLAND

The Battle of Hastings

The outcome of the conflict between the Norman William and the Anglo-Saxon Harold II was decided on 14 October 1066 on top of Senlac Hill, a few kilometres from Hastings, in Sussex. Entrenched defensively on this ridge, Harold's heavy infantry was attacked all day by the Norman archers and cavalry. In the morning, the Norman offensive threw itself against the Saxons' solid line to no effect. Later, however, the Saxon lines began to break up, and finally the cavalry managed to penetrate their formation and kill Harold. In the traditional account of the battle, Harold is first struck in the eye with an arrow and then run through with the sword by horsemen, as illustrated in the scene below.

The death of Harold The man on the right, framed by the inscription 'Harold', has been struck by an arrow, and so would depict Harold at the moment of his death. In medieval tradition, being hit in the eye by an arrow was considered justice for anyone tainted by perjury. Having violated his oath to William, Harold could therefore only expect this fate.

The Norman cavalry The strength of the Norman formation was its cavalry of battle-hardened noblemen covered in armour and protected by helmets and shields. Armed with swords and long lances, they were all but invincible when they charged in the open field. Furthermore, the horsemen saddled their steeds with stirrups, which enabled them to strike from the saddle without being thrown by the impact of delivering a lance thrust.

Daily life in the year 1000 Among other things represented in the tapestry's upper and lower registers are scenes of everyday life, such as tilling the fields with the harrow and sowing. The use of the horse, the yoke on the animal's neck and the harrow marking the earth are some of the technological innovations introduced to European farming in the time of William the Conqueror. These tools resulted in a greater yield and hence an increase in population between the 11th century and the first half of the 14th.

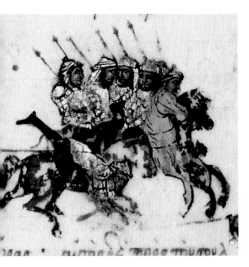

The Byzantine horsemen The Byzantines, in plate armour, are led by Stephen, as is made clear by the original caption above the image. In the encounter, Stephen was taken prisoner, and therefore he is probably the rider who, struck by an enemy lance, falls from his horse.

The birth of the Seljuq empire

c. 960
Seljuq, the leader of a tribe of the Oghuz Turks, accepts Islam. At that time, this nomadic tribe was located in Central Asia, beyond the Syr Darya River.

Early 11th century
The Seljuqs serve the Kharakhanid dynasty but broaden their independent area. They soon govern large cities in present-day Iran and Afghanistan.

1040
The Seljuqs defeat the powerful Ghazanvid dynasty at the Battle of Dandanaqan. In the following years, they broaden their territory to include all of present-day Iran and Transoxiana.

1055
The Seljuqs conquer Baghdad and bring the caliph, the highest authority of Islam, under their control.

1065–92
Under sultans Alp Arslan and Malik Shah, and the vizierate of the cultivated Persian official Nizam al-Mulk, the Seljuq empire experiences a period of great power and cultural splendour.

After 1092
The empire is divided into different independent states that remain important regional powers, including the Seljuq sultanate of Rum, which dominated Anatolia.

1071 THE TURKISH CONQUEST OF ANATOLIA

Miniature in John Skylitzes, *Synopsis Historion*
12th century. Madrid, Biblioteca Nacional, *Vitr. 26–2*

From border skirmishes to the Battle of Manzikert

By the mid-11th century, the Byzantine empire was worn down and weakened. The efforts of the Macedonian dynasty (867–1057), and especially Basil II (976–1025), to reassert Byzantine power in the Balkans and reconquer areas of Anatolia and Syria had depleted the royal treasury, caused high inflation and disrupted the traditional system of border defence. Thus, the Byzantines were unprepared when the Seljuq Turks began to attack Byzantine Anatolia from the east. At first, they plundered and destroyed cities and countryside, carrying off spoils and prisoners. Eventually, they permanently occupied fortresses and cities. In response, Emperor Romanus IV Diogenes, who took the throne in 1068, mounted various military expeditions before organizing a large campaign in 1071 that ended with the rout of Manzikert and the emperor's capture. In the following decades, the Seljuq Turks overran Anatolia and even conquered Nicaea, just a few kilometres from the capital, Constantinople. This military pressure constrained Emperor Alexius I Comnenus to call upon the pope and western Europe for aid, thus setting the stage for the First Crusade.

The 'Persians' The original Greek caption defines the enemy as 'Persians', which is probably more a political than an ethnographic designation, since the Seljuq Turks had taken over Iran and thus appeared to the Byzantines as the continuation of the ancient Persian state, an ancient enemy of Byzantium.

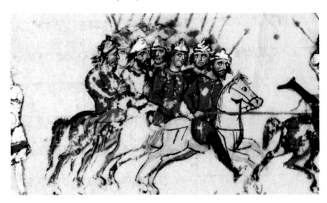

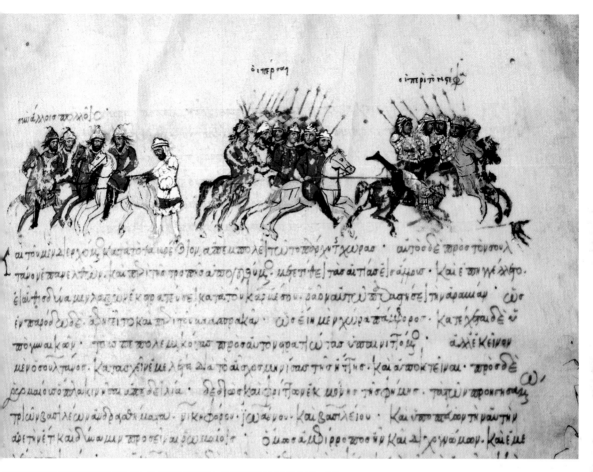

ό ιπερ τ'η

ό ιπ ρ ι τ η φ

ай τοῦ μεν̣ἀ|ερχο᾽η, κατα τοτα ιωσέ|ᾱθ|ον, ἀπε απολε|πειν τὸ πὸ᾽η τ᾽χωρας · ай τοο δε π̣ροσ τοῦ πολου
ταῦ ο γέ παν ελγτην · και ε δια τησ̣ π̣ροσεου δια|ο/η᾽ρν ρᾱν᾽μυ · μπ̀ετ τε|ταο αιτπασελ|ε̑μμοη · Καὶ ε πῃ γε̑ ἐλθο ·
ἐ ῒ πιο δια μεγλα σαε ν εκ κρ απεῖ κατα τουκ ασμε τ·.ραθραῖπν υ᾽π̣Δαγυος̣ε|τὴν αραιμαω · ω᾽ο̑
ἐν παρο δδε̣· ᾱ᾽η ει τοκ ᾱ πι τιλαατλαωραια κατ ῶσ ἐ μερ ‧ χωρα παἶφορο· καπ̣ι χπαιδε̑ υ᾽
π̣ογ μα κωρ · π̣ω τπ̣ πολε μι κοτω προσ αὐτον ὁραῖ τζω τασ ῦπο αλυν̣ι του᾽η · ἀλλ᾽ε κειν̣ου
μεν̣ οσο συλ̣ταν̣ου · ϗα τ᾽ωσ γι γελε θη᾽ δι α το αῗ ο τ ακριρᾱ ρ´ιασ τη ᾱ τ ᾱτησ̣· ϗαι ᾱ πο κτειν̣αι· π̣ροσ δε̑
ρε μαιϣ ϣ̀ π̣λα κι ρνεπ νκκ δειλια · δε δ ωσ και φοῗ π̣αρ ε̑κ κωθεν π̣ι ο φη᾽ κωπ · ταχ̣λην̣ προ κπ̣ηκο᾽μ᾽
τρ α̑ων̣ βασ λε̑ων αῗ ο θρα δι ϣ᾽μ᾽α · νικ νφορον̣· ᾱ´ω̑α μου· Καὶ βασι λειου· Καὶ ῦπο π̣αλορ τιν̣ αῦτ̣ῃν̣
ἀρ̑ετ ν̑έτ και δ῍ω̑α μιν̣ π̣ροσει̣ ἀι δε᾽ο μιο᾽ ι· ὁ ι᾽απαλ ϣ̑ιρρο σ πο ᾱ᾽υκ Καὶ ᾱ̑ ρ̑·ρ γ᾽α μου. Καὶ ε μ̑ε

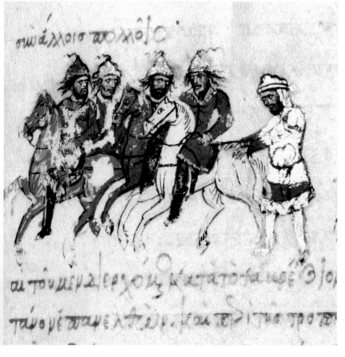

σω άλλοιο πολ᾽μω

ай τοῦ μεν̣ ᾱ|ερχο᾽η, κατα τοτα ιωσέ|᾽θ|ον,

ταῦ ο γέ παν ελ γτην · και ε δια τησ̣ π̣ροσε

This miniature, illustrating a clash between Seljuq and Byzantine cavalrymen, is from the 'Madrid Skylitzes'. The copy of the *Synopsis Historion* in Madrid is the only surviving illustrated manuscript of a chronicle from the Byzantine era. The codex was executed in the second half of the 12th century and reflects all the cultural richness of Norman Sicily's multi-ethnic society: the 572 miniatures, probably painted by seven different artists, show Byzantine, Arabic and European influence. The miniature shown here has been attributed to a master of Byzantine origin. The text tells the history of Byzantium from the point of view of a patrician and high Byzantine official, John Skylitzes, from the death of Emperor Nicephorus I in 881 to the dethroning of Michael VI in 1057.

Stephen taken prisoner The Byzantines' military chief, Stephen, was taken prisoner and here is being led off, tied by a rope to the last Seljuq horseman. However, the text refers to the leader of the 'Persians' as Koutloumus, a Greek transcription of the Turkish Kutalmish, a military commander who was the nephew of the first Seljuq sultan, Toğrül.

1096 THE FIRST CRUSADE

The Departure of the Crusaders

12th century. Fresco. Cressac-Saint-Genis, Commanderie de Cressac

From 'armed pilgrimages' to massacres

The reasons that led Pope Urban II to call the First Crusade in 1095, prompting thousands of European men and women to set off armed or otherwise to conquer Jerusalem, were many and complex. Urban II had accepted a request for help from the Byzantine emperor Alexius I Comnenus. At the same time, by proposing an 'armed pilgrimage' to the knights and nobles of Europe who too often got involved in devastating feudal disputes, he was trying to stabilize the social order – a goal of the Church for some time. The knights who left on the First Crusade the following year had yet other motives. Besides obtaining the plenary indulgence promised by the pope, they were drawn by the spirit of adventure and the possibility of spoils and conquest; meanwhile, thousands of the poor and outcast were driven by fear of the end of the world and the desire to escape their own narrow existence.

However, the crusaders soon abandoned themselves to plundering and massacring the Jewish communities they found along the way. The eventual conquest of Jerusalem, too, was marked by pillaging and the slaughter of the Jewish and Muslim population.

The art of the Fatimids The Fatimid dynasty adhered to the Isma'ili Shi'ite sect of Islam, which was in disagreement with the Sunni caliphate of Baghdad. First, they governed present-day Tunisia, then Egypt and part of the Arabian Peninsula. Under their sway, the arts flourished free of prescriptions and restrictions. Naturalistic depictions of animals were particularly well liked.

The Arabic point of view The situation depicted in this fragment of a 12th-century Egyptian drawing at the British Museum is the precise opposite of the fresco in Cressac. It shows Arab warriors coming out of a fortress to pursue the enemy 'Franks' (as the Arabs called all Europeans without distinction at that time). From 1100 to 1105, the troops of the Fatimid dynasty made various attempts from Egypt to penetrate Palestine, occupied by the crusaders, and retake Jerusalem, which they had lost in 1099. However, the crusaders repelled these attacks.

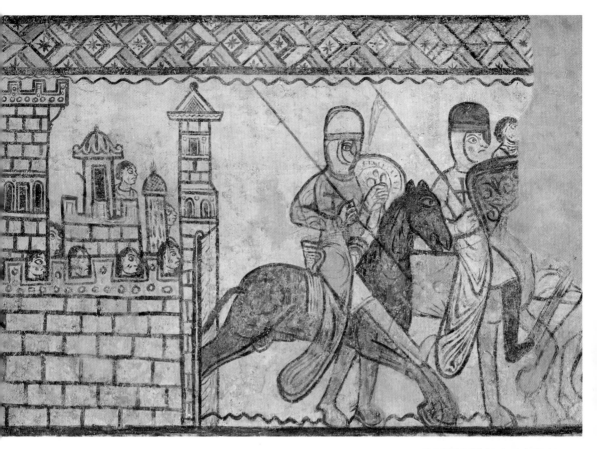

The sadly fragmentary fresco cycle at the Chapel of the Templars in Cressac, in western France, celebrates the deeds of the crusaders, in particular the Knights Templar, who owned this small place of worship. This religious order, which combined traditional monastic vows with chivalric ideals and military action, was founded in Jerusalem in 1120 and immediately took part in the defence of the crusaders' territory. The fresco shows three horsemen arrayed for combat, leaving a fortress to pursue the enemy. Some experts think it depicts a battle in 1163 in which the crusaders saw off Nurredin of Aleppo, the son of Zangi, one of the most tenacious adversaries of the crusader states.

Lance and bow Western horsemen at the time of the Crusades fought with the long lance, attacking the enemy at close range, whereas the Arabs preferred the bow and sought to avoid close combat. Among the Europeans, the helmet with a nose guard was becoming widespread at this time, while Eastern helmets did not protect the face.

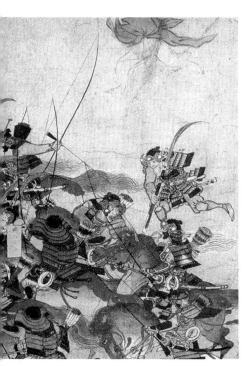

Weapons and armour The scroll depicts warriors with 13th-century armour and weapons – in particular the long bow, which at the time was the samurai's main weapon, and the *naginata*, a short lance with a curved blade.

1159 THE HEIJI REBELLION

Illustrated Scrolls of the Events of the Heiji Era

Second half of 13th century. Ink and paint on paper, 41.3 x 699.7 cm. Boston, Museum of Fine Arts

The origins of Japanese feudalism

The Heiji Rebellion, which set the powerful Taira and Minamoto clans against each other between 1159 and 1160, was one of the events that marked the establishment of Japanese feudalism. In the preceding centuries, a new class of warriors had arisen: the samurai, who allied themselves to the various noble clans, thus reinforcing the nobility in relation to the imperial government. At the same time, many noblemen and the Buddhist monasteries had managed to exempt their domains from imperial control. In this context, Yoshitomo, the Minamoto clan's powerful chief, in league with another feudal power, Fujiwara no Nobuyori, decided to attack the capital, Heian, in 1159, and took the reigning emperor and his father prisoner. Even though the rebellious feudal lords were defeated by empire loyalist Taira no Koyimori, the imperial government's authority was weakened. Taira no Koyimori, himself a powerful feudal lord, became the emperor's counsellor and concentrated power in his own hands. Twenty years later, the Taira clan was expelled, and in 1192 the Minamoto clan proclaimed the shogunate government, definitively excluding the emperor from the exercise of power.

The Rebellion of 1159

Main figures
Minamoto no Yoshitomo and Fujiwara no Nobuyori, leaders of the 1159 rebellion; Taira no Koyimori, feudal lord loyal to the emperor; Emperor Nijo and his father Go-Shirakawa, who had retired but remained influential at court.

Place
Heian, present-day Kyoto, the emperor's capital and residence.

Goals
To establish the influence of the Minamoto and Fujiwara clans against the Taira clan, who wielded great weight in the imperial court at that time.

Results
The Minamoto and Fujiwara clans were at first defeated, but in the following decades they expelled the Taira clan and introduced the shogunate, which reflected the interests of the feudal lords and samurai class.

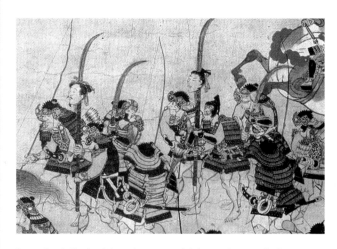

Enemy heads This detail shows the samurai rebels leaving the imperial palace after the attack. Some carry the heads of imperial guards and courtiers impaled on their spears.

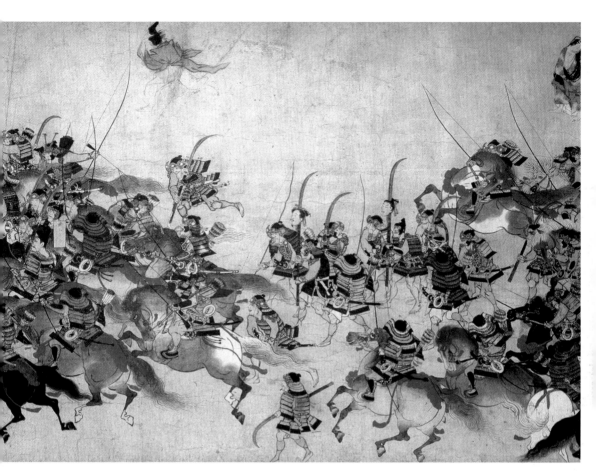

The Heiji scrolls are one of the earliest examples of a form of prose epic very popular in the Japan of the samurai, that were often accompanied by a pictorial narrative. Executed about a hundred years after the Heiji Rebellion, when the shogun government was already firmly established, it celebrates the samurai's deeds in the rebellion and, like other works in the genre, promotes the code of chivalrous behaviour.

The fire In the attack on the imperial palace, the rebels captured both the emperor and his father and carried them off in an ox-drawn cart. Then, as depicted in this scene from the scroll, they set fire to the building.

1189 THE THIRD CRUSADE

Miniature in the *Luttrell Psalter*

c. 1340. London, British Library, *Add. 42130*

The Saracen The representation of the sultan is a caricature, with blue skin and a taut grimace. The Moor decorating his shield has a similar expression. Although Saladin is depicted as a physically repulsive enemy, another image coexists alongside this one in the European tradition: in both *Il Novellino* and Boccaccio's *Decameron*, he is presented as an enlightened prince, tolerant and chivalrous in dealing with enemies and foreigners.

The Crusade of 1189–92

Main figures
Saladin, sultan of Egypt and Syria; Frederick Barbarossa, Holy Roman Emperor; Philip Augustus, king of France; Richard the Lionheart, king of England.

Places
Hittin, the scene of Saladin's victory over the crusaders; Jerusalem, recaptured by the Muslims in 1187; Acre, retaken for the crusaders by Richard the Lionheart and Philip Augustus, and held by the Europeans until 1291.

Objectives
The recapture of Jerusalem; and for the three monarchs who took part, the consolidation of their image as valiant knights and defenders of the Christian faith.

Results
The crusaders succeeded in occupying some territory along the coast of Palestine but failed to reconquer Jerusalem.

Note
Jerusalem returned to Christianity for a few years, from 1229 to 1244, as a result of negotiations between Emperor Frederick II and Sultan al-Kamil.

A meeting of legendary figures

'This Saladin, during his Sultanate, ordered a truce between the Christians and himself, and he said that he would like to see our customs, and if they pleased him, he would become a Christian. The truce was established. Saladin came in person to see the Christian customs.' This is how the crusaders of the Third Crusade's adversary Saladin are presented in *Il Novellino*, an Italian collection of stories compiled in the late 13th century, about a hundred years after the Third Crusade. When Saladin had united Egypt, Syria and part of present-day Iraq under his rule, he attacked the kingdom of Jerusalem, whose vassals had often ignored a previous peace treaty. The crusaders' defeat was crushing, and Jerusalem was lost. The response of the Church and the European nobility was to organize a new crusade. The Third Crusade was led by the Holy Roman Emperor Frederick Barbarossa (who died on the way to the Middle East), the French king Philip Augustus (who soon abandoned the cause to look after his own interests in France), and the king of England, Richard the Lionheart. It was Richard who, after inflicting some defeats of scant significance on Saladin, signed a truce with him and, like the sultan, became a legendary figure.

The rout The Saracen horseman's foot is out of the stirrup, so the violent thrust of his adversary's lance has put him in danger. Perhaps he will fall from his horse to defeat. Yet, the sumptuous decoration of the horses and the armour in the drawing recalls a knightly tournament more than a battlefield.

This miniature, which depicts the combat of a knight and Saracen (often identified as Richard the Lionheart and Saladin), is from the *Luttrell Psalter*, a book of prayers executed for the English nobleman Geoffrey Luttrell and embellished with a wealth of historiated capitals and marginal miniatures. These accompanying images refer not only to the content of the Psalms and prayers contained in the manuscript but also to the social circumstances and daily life of the patron who commissioned it. Thus, we can observe farm work and pastimes cultivated by the nobility of the period, food preparation and, as in the miniature illustrated here, the use of weapons.

Richard the Lionheart The king of England can be identified by his coat of arms, the three superposed lions on a red ground seen on his shield, shoulder guard and the horse's saddle-cloth. Even though his reign only lasted from 1189 to 1199, Richard soon became a legendary figure identified with magnanimity and respect for the ideals of chivalry.

1204 THE CRUSADERS IN CONSTANTINOPLE

The Surrender of Constantinople

1213. Mosaic. Ravenna, Church of San Giovanni Evangelista

A war of conquest

During the Fourth Crusade, proclaimed by Pope Innocent III in 1198, it became obvious that the idea of a war to regain the Holy Land in Palestine had become tied to the thirst for territorial conquest of the European nobility and the commercial interests of the Italian maritime republics, intent upon controlling the maritime trade routes between East and West. It also became evident that there was a conflict between the crusaders and the Byzantines, who for some time had felt that the presence of Western knights and princes in their zone of influence posed as great a threat as the Islamic sultanates of the Middle East. Under pressure from the doge of Venice, Enrico Dandolo, the crusaders who set out from Venice in 1202 directed their energies first against Zara, a competitor of Venice on the Adriatic coast, and then in 1203 against Constantinople, which they eventually occupied and pillaged in 1204.

The surrender These figures, like the others in the mosaic series, are highly expressive despite their stylization. Especially eloquent is the gesture of the extended arm of the Byzantine figure at the left, who turns towards the crusader knight with sword raised. It conveys all the despondency of surrender to the enemy.

The crusaders The soldiers in mail coats and armed with lances have been interpreted as crusaders attacking the city of Constantinople.

The causes of the war against Byzantium

Venetian interests A large colony of Venetian merchants had long been present in Constantinople, but periods of commercial growth alternated with conflict with the Byzantines. Venice, which had backed the crusaders' transport fleet with notable financial force, was interested in strengthening its position in Byzantium and the eastern Mediterranean.

The crusaders' interests To the crusaders, keen to acquire booty and conquer new lands, the Byzantine empire, especially in a time of military and political difficulty, seemed easier prey than the Ayyubid sultanate that controlled Palestine.

The dynastic context in Byzantium The ruling dynasty of Constantinople, the Angelus family, was suffering its own internal conflicts, and Emperor Isaac II had been deposed by his brother in 1195. Isaac's son, Alexius IV, then turned to the crusaders for support against his usurping uncle.

Only fragments remain of the floor mosaic executed in 1213 for Ravenna's church of San Giovanni Evangelista. They recount miscellaneous aspects of 13th-century life and culture. Among the allegorical representations of the months, hunting scenes and imaginary animals are scenes depicting events of the Fourth Crusade, including the surrender of Constantinople illustrated here. The highly stylized mosaics are executed in polychrome marble, glass paste and bits of reused stone.

1204 THE CRUSADERS IN CONSTANTINOPLE

JACOPO PALMA IL GIOVANE, **The Crusaders Assault Constantinople**

c. 1587. Oil on canvas, 575 x 625 cm. Venice, Palazzo Ducale

The costumes The artist transposed the scene into his time, and the costumes and armour recall 16th-century customs more than medieval.

The origin of Venice's power

The ultimate result of the Fourth Crusade was the division of a large part of the Byzantine empire among the crusaders and the Venetians. The Venetians directly controlled the Peloponnese, the islands of Euboea and Crete, and some lesser territories, while the rest of the empire was organized into a feudal kingdom of which Baldwin of Flanders, one of the leaders of the Crusade, was elected emperor. The other eminent participants each received their own imperial fief. This short-lived 'Latin Empire of the East' was defeated in 1261 by an alliance between the Paleologus dynasty of Byzantium and the Genoese, who together reconquered Constantinople. However, Venice held on to much of the territory it had acquired and strengthened its network of trading bases along the routes to the Orient, even if the defeat in 1261 excluded it from the major crossroads of Constantinople for some years.

From the arrival in Constantinople to the 'Latin Empire of the East'

24 June 1203
The crusaders arrive in Constantinople and lay siege to the city.

17 July 1203
The crusaders conquer the city and restore Emperor Isaac II to the throne. Isaac confirms the princely recompense and support promised to the crusaders and Venetians.

January 1204
The crusaders prolong their stay as they await their reward. Uneasiness towards them grows among the Byzantines. Isaac II is again deposed during a revolt headed by Alexius Mourtzouphlos, who is crowned emperor as Alexius V. He refuses any payment whatsoever to the crusaders and orders them to leave the city.

12–13 April 1204
The crusaders and Venetians again take the city and sack the old metropolis.

May 1204
Baldwin of Flanders is elected emperor of the 'Latin Empire of the East'.

Treason 'More than forty people told him they saw the standard of St Mark of Venice above the towers, but no one knew who had put it there.... Now those within the city are fleeing and abandoning the walls.' Thus Geoffrey of Villehardouin, a participant and chronicler of the Fourth Crusade, describes the crucial moment of the siege, when the Venetians and crusaders gained the upper hand over the Byzantines, probably through an act of betrayal in the ranks of the besieged.

This large canvas, part of the lavish decoration of the Ducal Palace of Venice, hangs in the hall that housed the Maggior Consiglio (Great Council), the central organ of the Venetian oligarchy. The hall's iconographic scheme, developed after a fire in 1577 had destroyed everything, focuses on glorifying the history of Venice. Canvases devoted to episodes from the Fourth Crusade, like this one, which depicts the crusaders' first attack on Constantinople in 1203, occupy an entire wall, since the event paved the way for Venetian domination over the eastern Mediterranean.

The doge's ship In the centre of the composition is doge Enrico Dandolo's galley, flying the flag of the Republic of Venice with the lion of St Mark and the red and white arms of the Dandolo family.

1208 THE FOUNDING OF THE MENDICANT ORDERS

GIOTTO, **The Story of Saint Francis**

c. 1295–1300. Fresco. Assisi, Basilica of San Francesco

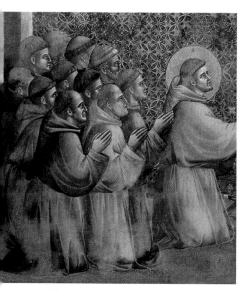

The first companions Wearing simple tunics, twelve monks including Francis present themselves to the sumptuously attired pope and his court. According to legend, the number of friars corresponded to the number of Apostles. In fact, the hagiographers' accounts of the life of Francis include numerous parallels with the Gospels.

Mendicant orders and new communities

Franciscans The community founded by Francis lived solely from alms offered by the faithful and devoted itself to itinerant preaching of the Gospel. Pope Innocent III recognized the order in 1210–11. In time, it was joined by a female religious order and a lay movement.

Dominicans In 1215, during the Crusade against the Cathars, Domingo de Guzmán founded the Order of Preachers to spread the Gospel and combat heresy not only with words but also with a radical witness of poverty. Initially hindered by the official Church, the order was later employed in the fight against heretics.

Humiliati This lay and clerical movement arose spontaneously in southern Italy in the quest for a life as close as possible to the early Christian community's model of poverty and simplicity. Contemporary to the movement of Peter Waldo, which was considered heretical, it was absorbed by the official Church with a rule granted in 1201. The Humiliati were not a mendicant order in the strict sense because their adherents lived from the proceeds of communal labour and they admitted married laypeople.

New ways of life, between heresy and monasticism

'But one day when in this church was read the passage of the Gospel relating how the Apostles were charged with preaching, the saint, who had only intuited its general meaning, asked the priest to explain it to him after mass. The priest commented on it to him point by point, and Francis, hearing that Christ's disciples were not to own gold, silver or money, not to carry a knapsack or bread, or a walking stick, not to have shoes or two tunics, but only to preach the Kingdom of God and penitence, suddenly, exulting in the Holy Spirit, exclaimed, "This I want, this I ask, this I long to do with all my heart!"'

This is how Thomas of Celano, the first biographer of Francis of Assisi, describes the moment in 1208 when Francis decided to imitate the Apostles completely and reject ownership of all goods. Francis's choice, which resulted in the foundation of a new religious order, fell within the overall religious and social restlessness permeating Europe in those years. If the quest for a way of life fully in harmony with the Gospel led some, like Cathars and Waldensians, down the path to heresy, the same tensions gave rise to the mendicant (meaning 'begging') orders which, in the ensuing years, worked to suppress those heresies.

The piazza in Assisi Almost all the frescoes include architectural elements, which are used to give depth to the image and locate the figures of the story within a real, recognizable space. This was one of Giotto's great innovations, replacing the former empty, often gold, backgrounds found in earlier paintings. The architecture in the other scenes of the cycle is imaginary, but this episode features an actual view of the central square (Piazza del Comune) in Assisi, with the characteristic colonnade of an ancient temple – which can still be seen today.

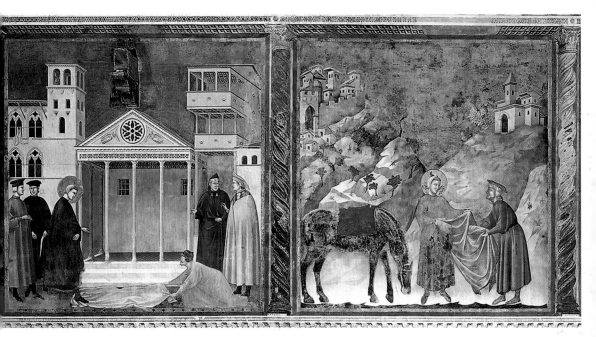

The famous cycle of the *Story of Saint Francis* by
Giotto and his pupils occupies the lower register
of the sides of the upper church of San Francesco
in Assisi, built from 1228 onwards to honour the
saint's memory. The cycle consists of twenty-
eight scenes that recount the life of the order's
founder, from his youth to his death, including
the miracles wrought by the saint after his death.
The first two episodes are illustrated here: at the
left, the homage of a simple man who recognizes
the saintliness of the young Francis; at the right,
St Francis giving his cloak – an act of generosity
performed before he committed himself to a life
of poverty.

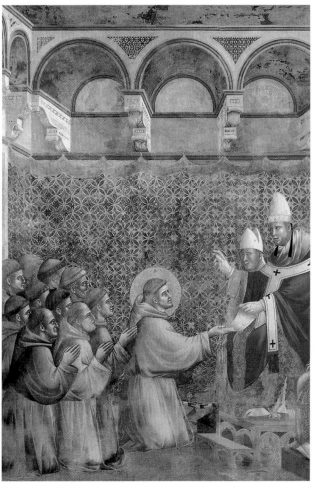

Recognition of the rule The seventh fresco in the cycle
shows Pope Innocent III handing the rule of the new order
over to Francis. Francis had sought the approval of the
ecclesiastical authorities from the outset and never doubted
the particular role the Church assigned to the priesthood.
His radical criticism of society and the Church, with their
craving for material wealth, remained in line with the
official teachings of the Church.

1208 THE FOUNDING OF THE MENDICANT ORDERS

A hard-won inheritance

Francis of Assisi's message and choice of radical poverty was enormously successful during his lifetime. The number of adherents to the order grew rapidly, and communities were founded in many European countries. Only two years after his death, in 1228, Francis was proclaimed a saint by Gregory IX. Yet, a serious conflict loomed in his order. How could Francis's radical choice be pursued in an organization that had grown large and complex? Part of the order, the so-called Conventuals, wanted to reduce the ideal of poverty to a general ban on private ownership for the friars, while the order itself could possess material goods, if only through a third party. The Spirituals, on the other hand, wanted to perpetuate Francis's total renunciation of all property, thus denouncing the riches of the rest of the clergy and the Church as an institution. And later on, the very memory of the saint ended up in dispute when the General Chapter of 1266 declared Bonaventure of Bagnoregio's *Legenda maior* to be the only authentic biography of the founder of the order, dismissing eyewitness accounts like that of Thomas of Celano, which appeared in the years immediately following the death of Francis.

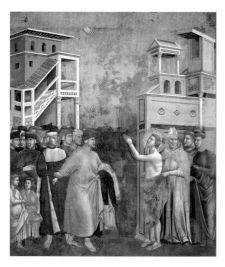

Renunciation of all property The scene that best synthesizes Francis's radical choice of poverty is the fifth in the cycle, in which he returns all his earthly possessions to his father, Pietro Bernardone, stripping himself before the Bishop of Assisi and the town's illustrious citizens, who observe the proceedings standing behind the father.

A father's anger Francis was the son of a family of rich merchants, and his father disapproved of his son's choosing a way of life so far removed from the values of the mercantile middle class. Giotto depicts Pietro Bernardone as furious and barely restrained by another middle-class citizen as he carries the clothing that Francis has just returned to him on his arm.

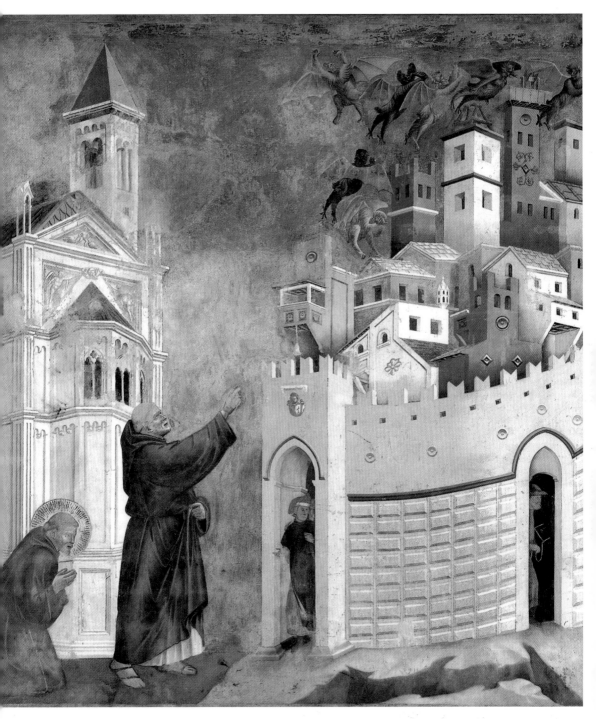

The demons of Arezzo In the tenth scene of the cycle, Francis and one of his friars are driving demons from the city of Arezzo. It is an episode told in both Bonaventure's *Legenda maior*, which is the primary source for Giotto's paintings, and the biography of the saint by Thomas of Celano. The scene symbolizes Francis's efforts to keep the peace by striving to dissipate the fratricidal conflicts of his time and proposing a humble attitude and behaviour. In this context, the demons are nothing other than the spirit of war and factional strife that was tearing Arezzo apart – and that was a distinctive feature in the life of towns at that period.

1209 THE ALBIGENSIAN CRUSADE

The struggle for control of southern France

1209 Pope Innocent III proclaims the crusade against the Cathars. The army of crusaders assembles in Lyons. Many participants are motivated by the wish to secure fiefs and possessions. In June, Raymond VI of Toulouse, the greatest feudal lord in southern France, publicly submits to the Church in order to save the greater part of his land from being confiscated.

1211 After the conquest of other territory in Languedoc, Simon de Montfort, a nobleman from northern France who took leadership of the crusaders, attacks the county of Toulouse, the domain of Raymond VI, who, despite his alliance with King Peter II of Aragon, is defeated.

1215 The Fourth Lateran Council recognizes the conquests of Simon de Montfort.

1216 Raymond VI and his son Raymond VII head a rebellion of the Provençal and Languedoc aristocracy against the crusaders and retake their land.

1226 King Louis VIII of France again takes up the crusade. After his death, the conquest of southern France is completed under the regency of his widow, Blanche of Castile, in 1229.

Pedro Berruguete, **Saint Dominic and the Albigensians**

c. 1495. Tempera and oil on panel, 122 x 83 cm. Madrid, Museo Nacional del Prado

A crusade in the heart of Europe

Churchmen had been reporting [*segnalavano*] communities of heretics since the 12th century, first in the cities of the Rhineland and then in Flanders and northern France. The heretics criticized the clergy for their worldly way of life and display of wealth and power. Some carried this dislike of material things to the extreme, considering all of life on earth as an expression of evil, and thus arriving at a radical dualism between the immaterial blessings of faith (to be embraced) and earthly things (to be rejected). In this context, a community arose that outsiders called 'Cathars', from the Greek word for purity, though they called themselves simply 'good people'. The movement eventually took root in southern France, where it was given a proper institutional structure with bishops and clergy, thus entering into direct competition with the official Church. The latter combated the Cathars with sermons, excommunications and death sentences. The situation came to a head in 1208, when the papal legate Peter of Castelnau was murdered, perhaps on orders from Raymond VI of Toulouse, a feudal lord who tolerated the Cathars. At this point, Innocent III declared a 'crusade' against these heretics, which soon took the form of a ruthless war of territorial conquest in southern France.

Trial by fire The subject of this painting is an 'ordeal', or trial by fire. Domingo de Guzmán (1170–1221) carried out the work of conversion for the official Church in Cathar territory, and in the process founded a new religious order, the Dominicans, or Friars Preachers (see p. 108). When burning writings by the Albigensians – as the Cathars were also called, because one of their centres was the city of Albi – he had orthodox books thrown into the flames as well. According to legend, these rose miraculously from the fire untouched by the flames.

The heretics The Cathars who observe the scene, discussing its meaning among themselves, are dressed in 15th-century Spanish clothing. Berruguete, whose painting combines the realism of the Netherlandish and Italian Renaissance masters with elements of Gothic painting like the gold ground, transposes the scene to his time, though it occurred almost three centuries earlier.

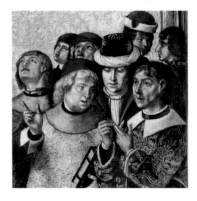

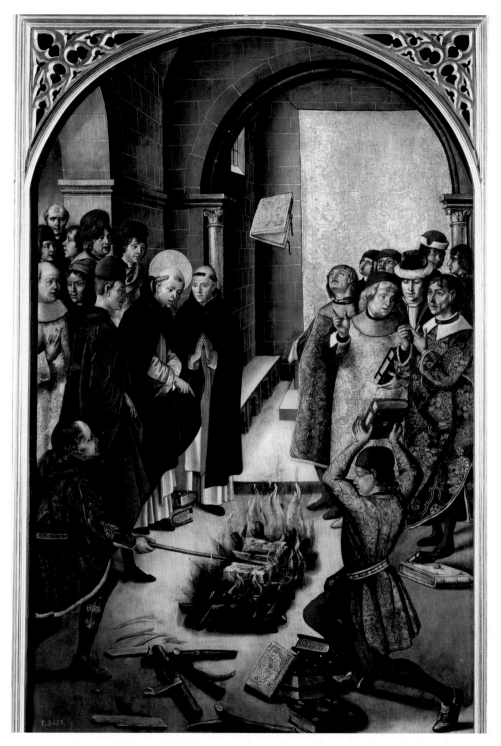

In the late 15th century, Pedro Berruguete painted a series of panels on the struggle of Dominic and the Dominicans against the heretics. The panels were intended for the monastery of Santo Tomás in Ávila, Spain, among whose founders was Tomás de Torquemada. He was employed in the late 15th century by the Catholic monarchs of Spain, Ferdinand and Isabel, to organize the Spanish Inquisition, which took the systematic persecution of every form of difference to the extreme. Berruguete's panels glorify the Inquisition's work and seek to place Torquemada's brutal repression within a tradition considered ennobling.

1211 THE ELECTION OF FREDERICK II AS KING OF GERMANY

Relief sculptures of the ambo

1229. Bitonto, cathedral

The fruits of knowledge With their right hand, Frederick II and his son Conrad are picking a fruit: the arcade framing the four figures represents the Tree of Knowledge, with leaves growing upward and fruit hanging downward. That Frederick and Conrad are picking the fruit of knowledge could be an allusion to Millennialism, implying that under their government, a messianic reign of peace would be achieved.

King Frederick II

Legal reform In 1231, Frederick II promulgated the Constitutions of Melfi, which strengthened the king's power in Sicily and southern Italy, and introduced standards that applied to all subjects, regardless of ethnic origin. In Germany, where his power was weaker, he attempted to control his relationship with the lay and ecclesiastical vassals.

Cultural life At the time, Sicily was a lively crossroads of Arabic, Hebrew, Greek and western European culture. Frederick surrounded himself with scholars who instructed him in natural philosophy, which made great strides in the 13th century.

Clash with the papacy The aspirations to primacy of the pope and the emperor came into conflict. While the papal chancery depicted Frederick II as the 'Antichrist', the authors of his court celebrated him as the true 'protector of Christianity' and an 'emperor messiah'.

From election to war with the papacy

In 1211, at the suggestion of Pope Innocent III, a group of powerful German feudal lords offered Frederick II of Hohenstaufen the title of King of Germany. In fact, at that time the title was already held, by Otto IV of Brunswick, but the legitimacy of Otto's authority was contested by the pope and those same lords. Frederick was the heir of two of the most powerful dynasties at the time, the House of Hauteville (rulers of Sicily and southern Italy), and the Hohenstaufen (who had already given the empire two emperors and two kings). So, the seventeen-year-old Prince Frederick set out for Germany from the rich city of Genoa with a handful of loyal followers and money lent by the pope. With the pope's support, he prevailed over the much more powerful and experienced Otto, and German cities and territories readily submitted to the young king. In 1220, Frederick was crowned Holy Roman Emperor in Rome, sealing his authority from the North Sea to the Mediterranean. However, he soon came into conflict with the papacy, which feared his growing power, and while Frederick undertook ambitious legal reforms and made his court a centre of science and culture, the pope and the powerful cities of northern Italy drew him into a war that dragged on after his death in 1250.

The predecessors To Frederick II's left are Frederick Barbarossa (seated on a throne) and Henry VI – his grandfather and father, respectively. Barbarossa is handing a sceptre over to Henry, thus demonstrating the line of succession. The sequence of members of the House of Hohenstaufen is represented in an ascending line from Barbarossa to Conrad IV, Frederick's son.

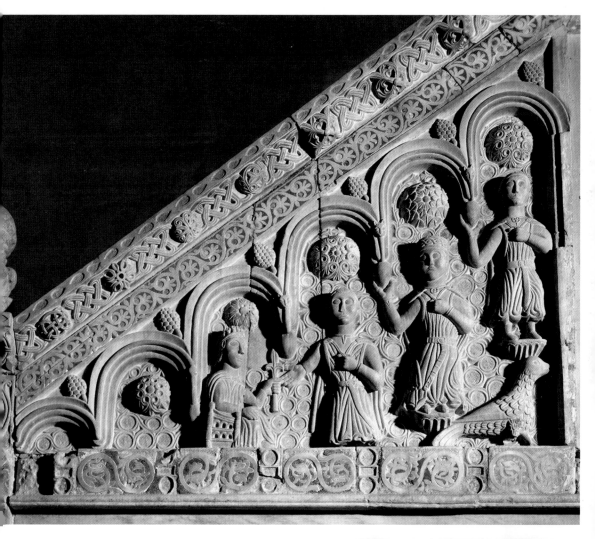

The ambo in the cathedral of Bitonto, Puglia, was made by a certain priest Nicola in 1229, according to an inscription on the work. The ambo was therefore executed the year Frederick returned from his Crusade, after 'conquering' Jerusalem through diplomatic negotiations. When he returned to Puglia, he was confronted with an invasion by papal troops, whom he quickly defeated. Thus, the ambo was executed in a political context where Frederick was affirming himself symbolically as the conqueror of Christendom's holiest city and had just won a victory over the pope's forces. The figures in the reliefs decorating the parapet of the stairs leading to the ambo are usually identified as Frederick II, his ancestors and his son Conrad, although this interpretation has been challenged.

The 'Lord's Chosen' Frederick II is represented crowned and wearing a cross around his neck. Some historians have interpreted this sculpture as an iconographic transposition of a famous panegyric written in honour of Frederick, in which the sovereign and his dynasty are identified as belonging to the lineage of Jesse, father of the Old Testament King David and an ancestor of Jesus Christ. Emperor Frederick could thus be associated with the 'stem of Jesse' (Isaiah 11:1–2), a term the Bible reserves for Christ, the Messiah.

1258 THE FALL OF BAGHDAD

SAYF AL-VAHEDI, **Miniature for the *Jami al-Tawarikh* (Compendium of Chronicles) of Rashid ad-Din**

1430–34. Paris, Bibliothèque nationale de France, *Suppl. Persan 1113*

The caliph Coming out of the city gate to meet Hulagu, al-Musta'sim asks clemency for the city but does not want to accept subjugation to the powerful Mongol empire. Many legends grew up around the last caliph. Some say he was badly advised by his vizier, who was in league with the Mongols. Others portray him as heedless of the danger, watching his favourite concubine dance as the Mongols tightened their siege.

The Abbasid caliphate

c. 800 The pinnacle of power of the Abbasids, who have been based in Baghdad since the mid-8th century. The caliph's rule extends (at least nominally) from Algeria to Central Asia.

Second half of the 9th century The Abbasids begin to lose control over large sections of their empire, including Iran, Egypt and Maghreb.

945 The Buyid dynasty, of Persian origin, defeats the army of the Abbasid caliph, who is forced to accept their dominance. Consequently, the Buyids control all the political decisions of the caliphate.

1055 The Buyids replace the Seljuqs, of Turkish origin, as the political and military power in the Abbasid caliphate.

1152 Caliph al-Muqtafi and his successors manage to reassert their own political autonomy in the face of the military dynasty but barely control the territory of present-day Iraq.

1258 After a brief siege, Baghdad falls to the Mongol army of Hulagu, who pillages the city and executes the last Abbasid caliph, al-Musta'sim.

The end of a metropolis

When the Mongol Hulagu Khan, brother of the Great Khan Möngke and nephew of Genghis Khan, besieged Baghdad in late 1257, the city was a metropolis that, along with Cairo, was the most populous urban settlement in all the Middle East. With no fewer than 250,000 inhabitants – according to the most conservative estimates – it far surpassed any European city of the period. Baghdad was still the seat of the caliph, the supreme political and religious authority of Islam, but had lost a measure of its splendour some time before. The caliph al-Musta'sim refused to subject himself to the domination of Hulagu, who had recently conquered Iran and was now overrunning the Middle East with his troops, but did not have the means or strength to organize an effective defence. And so, the Mongols conquered the seat of the caliphate on 10 February 1258. It was traumatic for the Islamic world, and in Arabic tradition, Hulagu and the Mongols became synonymous with death and destruction. According to the accounts, there were many victims during the sack of the city, and important testimony of the age-old Islamic culture – including Baghdad's famous library – was lost.

The beauty of Baghdad The blue band running along the city wall is inscribed with a poem in the Persian language. With these verses, the miniature by Sayf al-Vahedi celebrates the beauty and wealth of Baghdad, the centre of Islamic learning as well as the starting point of the most important caravan routes to Central Asia and generously supplied with fruit and other foodstuffs from the well-watered farmland of the Tigris and Euphrates valleys.

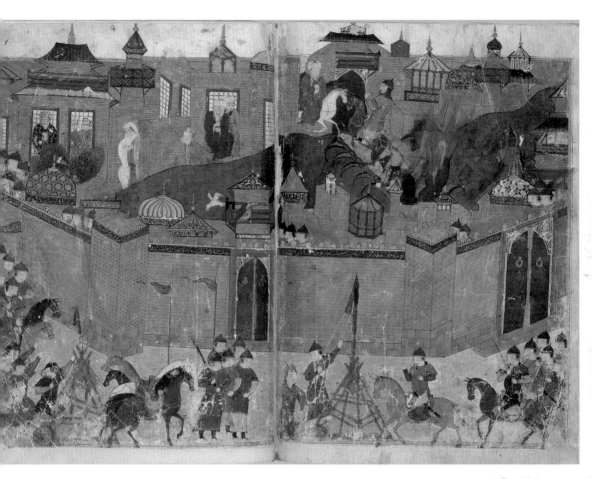

This image, which portrays Baghdad at the time of the Mongol siege as a city with many large buildings and the Tigris flowing through it, appears in a copy of the *Jami al-Tawarikh* made in Herat (in present-day Afghanistan) during the Timurid empire. The author of the text is Rashid ad-Din, a Persian dignitary and scholar who served at the court of the Ilkhans, the Mongols who ruled Persia. At the behest of his master Ghazan (a descendant of Hulagu), in the early 14th century he wrote a history of the administration of Ghazan and his predecessors. However, the work grew to become a universal history of the peoples and dynasties of Asia and Europe.

Trebuchets The Mongol soldiers are installing siege engines before the city walls. They appear to be using trebuchets, large machines that could hurl rocks or even boulders into the city under siege.

1266 THE BATTLE OF BENEVENTO

Combat of a Swabian Knight and an Angevin Vassal

13th century. Fresco. Pernes-les-Fontaines, Tour Ferrande

The Swabian knight The eagle on the horseman's shield, the heraldic emblem of the Hohenstaufen, clearly indicates that the warrior is fighting on behalf of Manfred. Some even consider the anonymous knight to be Manfred himself, who died in the battle.

The end of the House of Hohenstaufen

Frederick Barbarossa and Frederick II were the last emperors who credibly represented the Holy Roman Empire's universalist aspirations and, in the tradition of Charlemagne, considered themselves equal in dignity to the pope. The question of the supremacy of spiritual or temporal power – along with the disagreement over the kingdom of Sicily, which the pope did not want to belong to the same imperial dynasty – led to heated conflict between the pope and Frederick II, which lasted after the latter's death in 1250. But his son, Conrad IV, did not have the opportunity to defend his father's heritage, as he died of malaria in 1254. It was then up to an illegitimate son, Manfred, to try and preserve at least the Italian part of the Hohenstaufen territories. The pope offered the kingdom of Sicily to various European princes and at last convinced Charles of Anjou, younger brother of the king of France, to lead the papal war against Manfred, who was defeated and killed at the Battle of Benevento in 1266. Once the empire's universalism was destroyed, however, the pope became entangled in the dispute among the dynastic powers of Europe, and soon his own universalist ambitions were thwarted.

War between the Hohenstaufen and the pope

1235–36 Outbreak of the conflict between Frederick II and the pope over control of the powerful cities of southern Italy.

1245 Pope Innocent IV declares Frederick II dethroned as emperor.

1250 Death of Frederick II.

1252 Conrad IV takes over the war with the pope but dies in 1254.

1254 Manfred, acting in the name of the infant Conradin, son of Conrad IV, defeats the papal troops.

1263 Charles of Anjou agrees to lead the 'crusade' against Manfred.

1266 After being crowned King of Sicily by Pope Clement IV, Charles sets out to conquer the kingdom. Manfred is killed in the Battle of Benevento.

1267 The fifteen-year-old Conradin, at the head of a few loyal followers, attacks the kingdom conquered by Charles. He is defeated and taken prisoner. Charles has him beheaded like a common criminal in the market square of Naples.

The colours of Provence The horse of the warrior who is killed is caparisoned in red and yellow, the colours of the arms of Provence. This was actually a heraldic symbol of the House of Barcelona, which governed Provence until 1245, at which time it was acquired by Charles of Anjou through his marriage to the heir of that county.

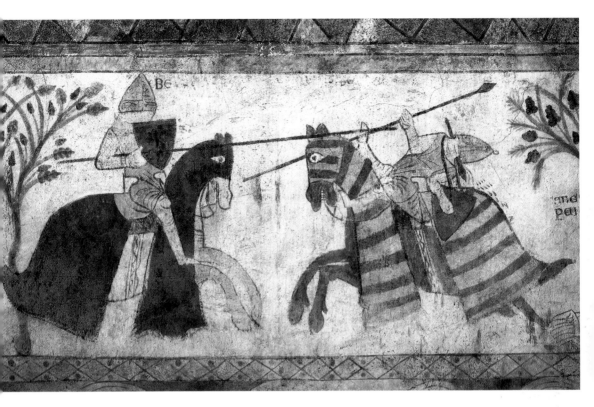

The fresco, which decorates the interior of a noble residence in the Provençal town of Pernes-les-Fontaines, is part of a cycle of four scenes from the war Charles of Anjou waged against the Hohenstaufen at the pope's behest. The cycle opens with Pope Clement IV's investiture of Charles as King of Sicily and ends with the capture and execution of Conradin. It is presumed to have been commissioned by a vassal of Charles who had taken part in the campaign in southern Italy. Although Charles acquired Provence in 1245, Pernes was under the control of his brother, Alphonse of Poitiers. Depicting a clash during the Battle of Benevento, the fresco curiously shows the defeat of an Angevin vassal – whereas the battle was actually a decisive victory for Charles and his entourage.

Death The Angevin horseman meets his death in the encounter, and the anonymous artist represents the event in all its crudeness. The enemy lance has pierced through his body, entering his mouth and exiting on the opposite side of his head or neck. The blow is so violent that the lance breaks, and the rider cannot control his arms and legs in his fall.

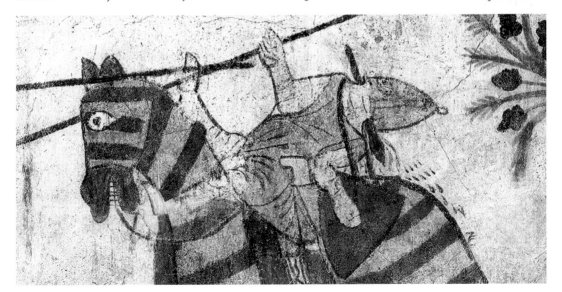

Precious stones Besides pearls, Marco Polo mentions the quarrying of turquoise, a detail that the anonymous miniaturist, known as the Egerton Master, depicts faithfully.

Europe and the Mongols

c. 1220 Led by Genghis Khan, the Mongols control a great proportion of Asian trade by way of the Silk Route, which under their protection resumes its role as a commercial artery between Asia and Europe.

1241 The Mongols invade eastern Europe.

1245–47 The Franciscan Giovanni da Pian del Carpine, accompanied by a Polish fellow friar, goes on a diplomatic mission for the pope to the court of the Mongol Khan Güyük, a successor of Genghis Khan.

1253–55 The Franciscans William of Rubruck and Bartolomeo da Cremona leave on another papal mission to the court of the Great Khan Möngke, Güyük's successor.

1265–66 The brothers Niccolò and Matteo Polo, Venetian merchants, visit the court of Kublai Khan, the Mongol ruler of China and east Asia.

1271 The Polo brothers leave on another business trip, accompanied by Niccolò's son, Marco, the author of the famous travel account. Their voyage lasts until 1295.

1287–88 A Mongol monk of the Nestorian Christian faith visits some European courts on behalf of the Mongol ruler of Persia.

1368 Mongol domination of China ends. The Silk Route begins to lose its role as a link between East and West.

1271 THE VOYAGE OF MARCO POLO

The MAZARINE MASTER and the EGERTON MASTER, Miniature for *Le devisement du monde* (The Description of the World) in *Le livre des merveilles* (The Book of Wonders)

1410–13. Paris, Bibliothèque nationale de France, *Français 2810*

An expedition for business and politics

In 1271, following a first expedition in the previous decade, the brothers Niccolò and Matteo Polo, Venetian merchants, set out again on a long voyage to the court of Kublai Khan in present-day Beijing. The two merchants, accompanied by Niccolò's seventeen-year-old son Marco, were motivated mainly by the possibility of the profits that could result from direct trade with the Far East, avoiding the commercial intermediaries of the Silk Route. They were also on a diplomatic mission from the pope to the Great Khan. Since the mid-13th century, the papacy and western European monarchies had hoped that Mongol pressure on the Islamic powers of the Middle East might favour the crusaders in Palestine. Father, son and uncle Polo were detained in Asia for more than twenty years, participating in the life of Kublai's court, travelling far and wide in the empire of the Great Khan and accepting responsibilities of an administrative and diplomatic nature on behalf of the Mongol government.

Presenting pearls and stones to the Great Khan Marco Polo believed Kublai to be the richest man in the world. The traveller attributed this prosperity in part to the use of paper money, a system of payment that fascinated the Venetian merchant and that is described extensively in *The Travels of Marco Polo*. Marco tells how the Khan's bank received gold, silver, pearls and gemstones and simply issued paper money in exchange.

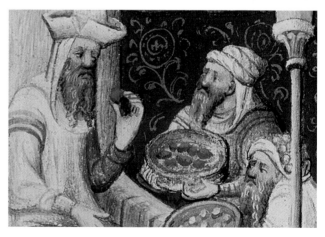

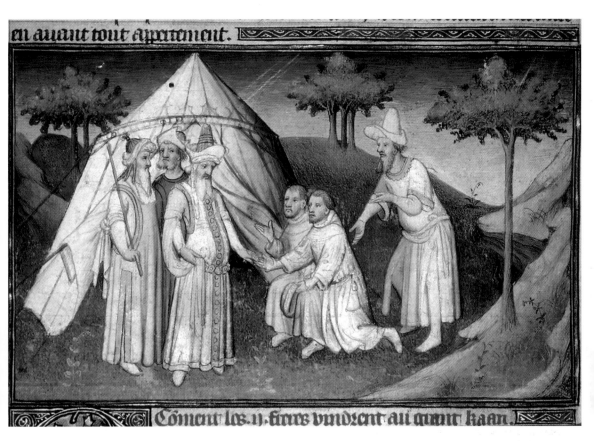

Cômeut les. ij. freres vindrent au guaut kaan.

The French manuscript *Le livre des merveilles* (The Book of Wonders) of 1410–12 includes the account of Marco Polo's travels along with other medieval texts on the marvels of the Orient. This miniature illustrates the meeting of the brothers Niccolò and Matteo Polo with Kublai Khan in 1265, during their first voyage (and so without Marco). The anonymous illuminator has set the event in an imaginary landscape before a nomad's tent, even though Marco Polo's account describes Kublai's residence as an 'extremely large and rich city' and, moreover, the successors of Genghis Khan had long abandoned the nomadic way of life. The miniaturist of this codex often ignores Marco Polo's sometimes detailed descriptions and limits his illustrations to a stereotype image of Asia and its people.

The riches of the Orient Marco Polo looked at the countries he visited with the eye of a merchant. He was interested in the raw materials extracted and the products brought to market. He often observes how the East contains a wealth unimaginable to his compatriots – for example, in describing the extraction of pearls, which, according to the Venetian merchant, were found in such great quantity in some parts of China that the Khan restricted their extraction. The miniature represents the harvesting of pearls and the presentation of the resulting treasures to the Great Khan.

121

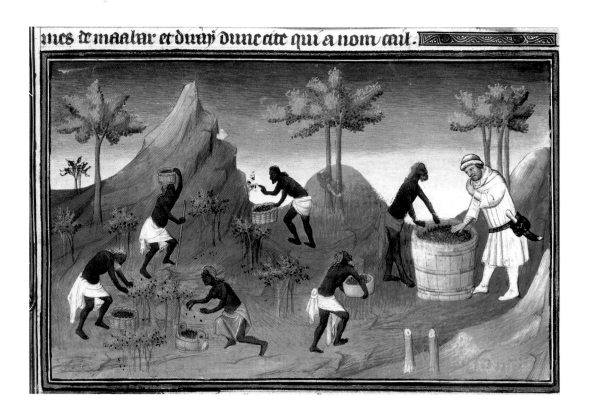

1271 THE VOYAGE OF MARCO POLO

Fantastic worlds

In 1295, Marco Polo returned to Venice by sea, by way of Indonesia, the Strait of Malacca, the coast of India and the Arabian Sea, Iran and Turkey. Later, during a period of imprisonment in Genoa due to hostilities between his native city and the Genoan republic, he dictated his celebrated account to the writer Rustichello, of Pisa. The French translation was called *Le devisement du monde* (The Description of the World), and the Italian translation is known as *Il milione*. As with the provinces of the empire of Kublai Khan, in treating the places visited along the coast of the Sea of China and the Indian Ocean, Marco Polo intermingles precise descriptions of geography, the peoples' ways, customs and commercial practices, with legends and fantasies acquired by word of mouth. Thus, he tells that some islands in those parts were inhabited by dog-headed men, while others were home to men with tails 'longer than a span'.

Harvesting pepper In India, Marco Polo observed the cultivation of pepper and noted a local tree whose fruit was said to have medicinal properties: 'Here, ginger and pepper grow in great abundance, so that all the fields and woods are full of them. They are gathered in May, June and July. The trees that produce pepper are not wild but cultivated – they are planted and watered.' The miniaturist known as the Mazarine Master obviously had no direct knowledge of Asia and its environment. Thus, he drew an entirely arbitrary plant. Pepper is not, in fact, a small shrub but a climbing plant of considerable height.

mes de maalar et duiuj dunc ace qui a nom caul.

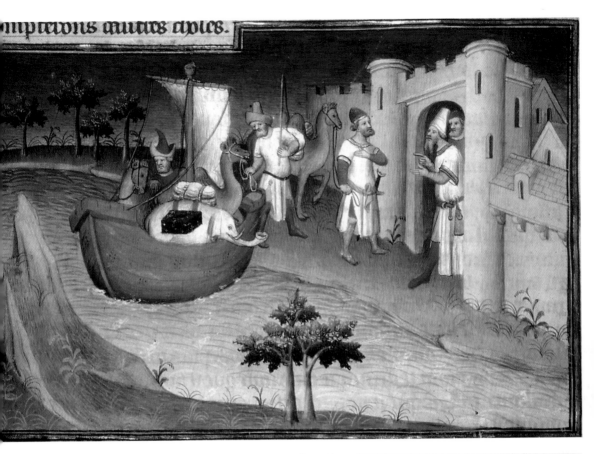

In the port of Hormuz After a long journey across the sea routes between China and the Middle East, Marco Polo arrived at Hormuz, a small island between the Arabian Sea and the Persian Gulf, off the coast of present-day Iran. The illuminator suggests the location of Hormuz on the strait, but otherwise the city looks European. From there, the Polos returned to the mainland in Iran, then governed by the Ilkhans, of Mongol origin.

Sea trade Marco Polo describes how goods from Asia were unloaded on the shores of the Red Sea and then carried to the Mediterranean coast by camel. This transfer was definitely not carried out on the island of Hormuz, and even less by transporting camels and elephants by boat. The miniaturist veers far from the Venetian traveller's exact description, indulging in a picturesque rendition of the more exotic aspects of the Orient.

Trade between East and West

In the Middle Ages, most of the goods exchanged via the caravan routes that crossed the deserts of Central Asia and via the sea routes between the Indian Ocean and the China Sea were considered luxury items. Among these were:

Silk The precious cloth that gave the caravan route of Central Asia its name remained one of the commodities most commonly imported from China, even after the silkworm had been disseminated in Europe.

Porcelain and glass Chinese craftsmen had perfected the technique of producing porcelain and glass.

Spices Spices imported from East Asia were used not only for food but also as medicine. Among the substances sold on the market were camphor, aloe, cinnamon and musk.

Metal, swords and slaves These were exported from Europe and the Islamic world to China. Furs from northern Europe were sold as well.

The last decades of the crusader states

1244 Turkish mercenaries serving the Ayyubids recapture Jerusalem. The crusaders are confined to the coastal regions of Palestine and Syria.

1250 The Mamluks, slave soldiers in the service of the Ayyubid dynasty, take power in Egypt. The crusaders, who under the leadership of Louis IX of France had invaded Egypt two years earlier, are defeated by the Mamluks.

1260 At the Battle of Ain Jalut, the Mamluks defeat the Mongols, with whom some crusaders had hoped to form an alliance.

1262–71 The Mamluk sultan Baybars fights the crusaders, capturing various territories and cities.

1279 Sultan Qala'un comes to power. He again defeats the Mongols and then turns against the remaining crusader states.

1291 Sultan Khalil, son of Qala'un, conquers Acre and Tortosa. In the following years, with the fall of the last outposts, the history of the crusader states comes to a close.

Bad advice As described in this *cantiga*, the miniature illustrates Baybars receiving an agent of his at court who advises him to attack Tortosa, which would be scarcely defended or garrisoned. But as it happened, the intervention of the Virgin Mary overcame the forces in the field.

The sultan and his army Baybars's army arrived at the gates of Tortosa to discover that the crusader city was well defended by thousands of men, sent from heaven – says the song – on Mary's instructions. The sultan then decided not to fight, because Mary is venerated by Muslims as well.

1291 THE END OF THE CRUSADER STATES

Miniature in the *Cantigas de Santa María*

13th century. Madrid, Monasterio de San Lorenzo de El Escorial, Real Biblioteca, *T.I.1*

Military outposts and trading centres

The crusader states (also called the Latin states) that controlled the Middle Eastern coast were the result of the First Crusade (1096–99). Their relations with the bordering Islamic emirates were generally marked by hostility, but in some situations, politico-military alliances that straddled religious boundaries could be forged. In the crusader states, a small class of feudal lords of European origin governed a population mostly made up of Muslims, Jews and Christians of the various Eastern churches. While these precarious states survived thanks to the constant influx of knights from Europe, their real value was as a commercial link between Europe and the East. In the 12th century, the Italian seafaring republics, particularly Genoa and Venice, obtained trade privileges in the crusader cities in exchange for providing logistical support. This flourishing trade also involved the Islamic states. In the second half of the 13th century, however, when the military contribution of the European princes and aristocracy was interrupted, a new Islamic power arose – the Mamluks of Egypt, who relentlessly attacked the remains of these states. The last crusader cities in Palestine fell between 1291 and 1298.

The compilation of 420 songs in the *Cantigas de Santa María* is traditionally attributed to the Castilian king Alfonso X (the Wise), who lived in the second half of the 13th century. It is devoted to the miracles worked by Mary, the mother of Jesus. In these six miniatures, which illustrate the text of the 165th song, we witness an intervention of the Virgin: the 'sultano Bondoudar', who may be identified as Baybars of Egypt (r. 1260–77), is seeking to surround and besiege the crusader city of Tortosa (Tartus, on the coast of present-day Syria). It is historically documented that the Mamluk sultan Baybars conducted several campaigns against the crusader states, conquering large territories. However, confronted with Mary (who is named and venerated in the Qur'an as well), Baybars – a noble adversary, in the words of the song – refuses to fight and abandons his siege of Tortosa.

Three emblematic cases

Milan The city grew under the cloud of the intense religious conflicts that weakened the bishop's authority in the 11th century. The creation of 'consuls' was the result of compromise among three classes: the major vassals of the bishop, the knights (or minor vassals) and the merchant class. These three groups shared in governing the city, consolidating it as an autonomous political entity.

Cologne After the citizens' revolt in 1074 (which remained an isolated episode), the *Schöffen* (aldermen) established their authority in the following century. At first accountable to the bishop, they gradually acquired an independent political role, often allying themselves with the merchant class. According to circumstances, they might act as allies or opponents of the bishop, who kept a role in city government until the late 18th century.

Lübeck In north-east Germany and central eastern Europe, the desire of the great feudal lords and princes to foster trade was often a decisive factor – this was the case with Lübeck, which was founded in the 12th century as a port on the Baltic Sea and, in 1160, was granted autonomy in writing.

Ambrogio Lorenzetti, **Allegory of the Effects of Good and Bad Government**

1338–40. Fresco, Siena, Palazzo Pubblico

From the Rhineland to Italy

Beginning in the 11th century, cities and their inhabitants became a dominant feature in European history. North of the Alps, Rhenish and Flemish cities were the first to be established as communities independent of the temporal or spiritual lords of the surrounding territory. In 1074, the citizens of Cologne rebelled against Archbishop Anno, the ruler of that city, but were defeated, and the archbishop regained control. The same year, Emperor Henry IV conceded important privileges to the city of Worms, also on the Rhine. Ghent and Bruges, in Flanders, received privileges of self-government in the early 12th century.

In Italy, a hub of municipal development, the city of Asti was the first in which 'consuls' appeared, called upon to rule a city independently of the bishop as early as 1095. Since the earliest times, cities have been socially complex organisms whose government included various diverse groups and classes: feudal lords living in the city, lesser nobility, notaries and other men with training in law, administration (in the service of princes and feudal lords), trade and crafts.

The school Lorenzetti has included a school among the shops, perhaps an allusion to the desire of the governing 'Council of Nine' to provide Siena with a university. In fact, the government of Siena tried to attract teachers and students from other prestigious centres.

The countryside Lorenzetti's city is set in the countryside, and its peacefulness and flourishing commerce shine upon the surrounding rural area. The medieval city was not a closed microcosm: the city's nobles and merchants owned land and feuds in the countryside. Interaction between the two worlds was intense, especially in Italy, where the cities imposed their dominion over the surrounding territory.

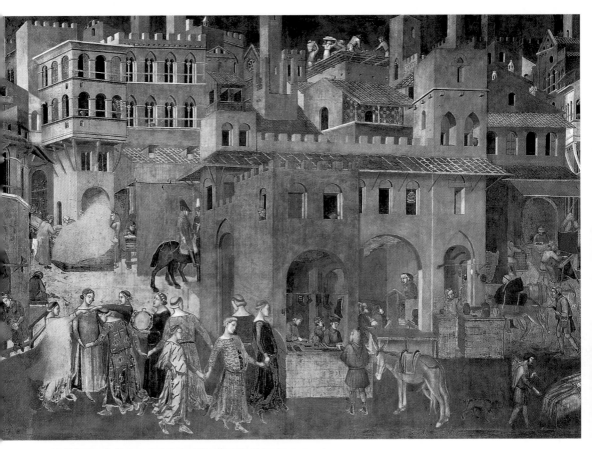

The celebrated frescoes of Ambrogio Lorenzetti on the good and bad governance of the city occupy three sides of Siena's Palazzo Pubblico, the meeting chamber of the governing 'Council of Nine', which had constituted the city's government since 1287 and which had commissioned these frescoes. The painter's task was to glorify the regime of the Nine as a model of 'good government'. The work conveys a vivid – even idealized – representation of daily life in the Italian municipalities at the height of their economic and social development. Lorenzetti emphasizes the flourishing of trade and industry. The frescoes depict shops, beasts of burden loaded with merchandise, and masons at work on a rooftop.

The falconer As a group of noblemen leaves the city to go hunting, one of them carries a falcon on his gloved hand. Falconry – hunting with trained raptors – was a favourite pastime of princes and patricians in the Middle Ages.

1300 THE EMERGENCE OF CITIES

Factional strife and social conflicts

Medieval communities were pervaded with conflict. The great noble families, the apex of the social pyramid, were divided into factions that disputed power by force of arms. At the same time, the minor feudal lords, merchants, bankers and craftspeople, who all profited from the process of urban growth, were no longer inclined to accept the monopoly of power of the nobility (which at times incorporated families who had grown rich through commerce). So, to check the power of these patrician merchant-nobles, the emerging classes organized themselves into confraternities and guilds that asked for effective participation in communal power. Thus, the *capitano del popolo* arose in many Italian communities, a figure who worked alongside the old magistracy, upheld by the patricians. Furthermore, collective councils were created by the guilds in other cities. Nonetheless, many city-dwellers remained excluded from all political participation: servants, employees in craft workshops and the incipient wool industry and, naturally, the poor and beggars of every sort. Their frustration, too, was vented in periodic revolts, such as that of the 'Ciompi' (wool carders) in Florence in 1378.

Strict government Lorenzetti's iconographic programme provides many indications that the regime of the 'Council of Nine' deemed strictness and discipline to be necessary in order to ensure peace and harmony in the community. Here, close by the allegorical figure of the monarch and beneath the personification of Justice, we see soldiers of the republic leading off a group of prisoners.

The government of the Nine

In 1287, a new regime was set up in Siena, centred on the 'Council of Nine'. Here are the main features of the system, which ruled the city until 1355:

The government was headed by merchants and bankers. Members of the old nobility were officially excluded from public office but continued participating indirectly in the management of the public cause.

The period of the government of the Nine coincided with a phase of exceptional growth in trade, the basis of Siena's wealth. The city also experienced a notable increase in population, which doubled between 1260 and 1330. This happy cycle was broken with the epidemic of the Black Death, in which Siena lost at least half of its inhabitants.

The government of the Nine intervened in every aspect of urban life, from by-laws that prescribed the architectural form and style of buildings to the drafting of the 'Table of Possessions' to distribute the tax burden equitably. They also managed the introduction of a community police force and the promulgation of laws against extravagant consumption and unbridled luxury.

Tyranny On the wall facing the *Effects of Good Government*, Lorenzetti placed the *Allegory of the Effects of Bad Government*. In the centre, the allegory of Tyranny dominates. While the ruler of the good government is advised by the Theological Virtues, Tyranny is surrounded by Vices. Around the allegory unfurls a desolate landscape where work has stopped, in counterpoint to the flourishing city in the *Effects of Good Government*.

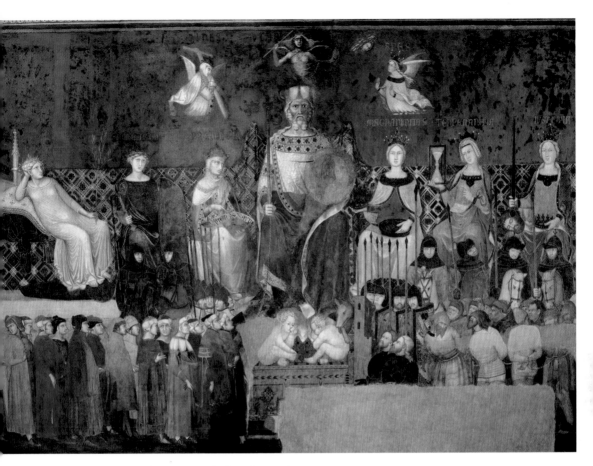

At one end of the chamber of the Nine, not far from the murals representing the *Effects of Good Government on Town and Country*, is an *Allegory of Good Government*, personified by a monarch on his throne with a magnanimous expression, surrounded above by three angels representing the Theological Virtues (Faith, Charity and Hope). Furthermore, at his side are six female figures that symbolize (from left to right) Peace, Constancy, Prudence, Generosity, Temperance and Justice. This is an iconographic transposition of the programmatic vision of the 'Council of Nine': inspired by the Christian faith, the government must combine constancy and peace, justice and generosity to govern the community successfully.

The administrators A group of eminent citizens moves in a procession towards the ruler, who represents republican government. These figures, all with individualized features and therefore probably meant to be portraits, could depict members of the merchant oligarchy that ruled the city through the 'Council of Nine'.

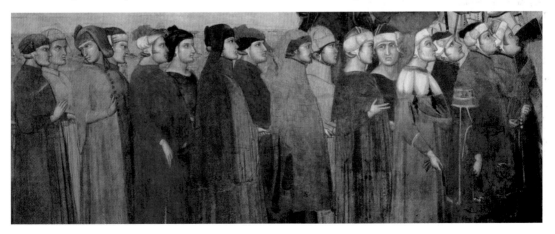

1302 THE BATTLE OF THE GOLDEN SPURS

Front panel of the so-called Courtrai Chest

c. 1302–1305. Oxford, New College

From feudal contest to civic rebellion

On the night of 11 July 1302, on a battlefield near Courtrai (Kortrijk) in present-day Belgium, the men of the citizens' militias of Bruges, Ghent and Ypres allegedly gathered hundreds of golden spurs from the lifeless bodies of the thousands of French horsemen who had died in battle that day. The golden spurs were proof of a victory no one had expected. The infantry of the Flemish cities had beaten the French king's heavy cavalry in the climax of a long political struggle that had actually intertwined two different conflicts: the attempts of the French monarchy to gain direct control over the rich province of Flanders, and the attempts of the Count of Flanders, Guy of Dampierre, to assert his own autonomy. War had broken out in May of the same year, when the militias of the guilds of Bruges had massacred the city's French garrison, and ended in 1305 with a treaty that sanctioned the annexation of part of Flanders by France but confirmed the autonomy of the remaining cities.

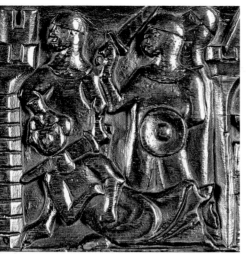

The 'Matins of Bruges' The citizens' militias of Bruges attacked the French garrison and their local allies, the members of the city's oligarchy, in the night of 17–18 May 1302. The massacre is said to have begun at Matins, the first prayers of the day for clerics. The chest depicts armed assailants ruthlessly attacking a man, perhaps killed in his bed.

The struggle between France and Flanders

Main figures

Philip IV (the Fair), King of France; Guy of Dampierre, Count of Flanders; Pieter de Coninck and Jan Breydel, leaders of the Bruges craft guilds; William of Jülich, Guy's grandson and commander of the armies.

Goals

For the king of France, to acquire direct control over the Flemish cities which, along with the Italian municipalities, were the richest, most flourishing centres in Europe at the time. For the count of Flanders, to maintain his autonomy. For the guilds, to broaden their political and economic power in the cities.

Results

The Flemish cities kept their independence; part of Flanders was ceded to the French monarchy.

Note

The struggle over Flanders was one of the causes of the Hundred Years War between France and England, which at that point had close commercial ties with the Flemish cities and was keenly interested in control of the area.

The guild armies As they set off, the troops of the city of Bruges receive the blessing of a monk or clergyman. To the right of the blessing, the lines of departing soldiers raise the standards of the various craft guilds. Some of the soldiers carry a mace, a rudimentary but effective weapon consisting of a club studded with sharp metal points.

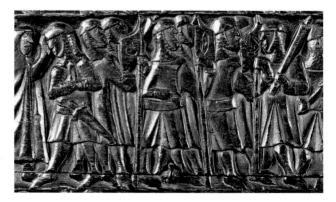

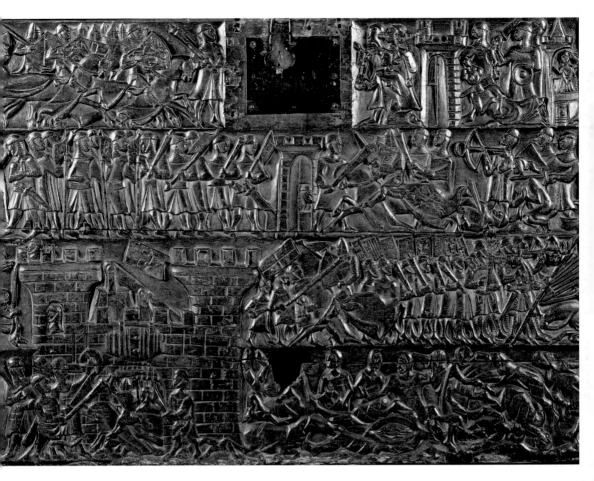

The wooden panel depicts the entire episode of the conflict between the Flemish guilds and the king of France, from the massacre of the French garrison of Bruges in May 1302 to the victorious Battle of the Golden Spurs on 11 July. The panel was presumably carved soon after the events by a person or group of people directly involved in the conflict – perhaps by the cabinetmakers' guild of Bruges. The panel's provenance remains obscure, however. At the time it was discovered on an English farm in 1905, it was incorporated into a 17th-century chest that was being used to store grain. Dendrochronological analysis has confirmed that the panel dates to the early 14th century.

Handing over the keys The handing over of the keys of Bruges is depicted near the massacre scene. After the expulsion of the French, the city submitted to the delegates of the counts of Flanders, William of Jülich and Guy of Namur, portrayed with their faces uncovered and their shields decorated with the lion of Flanders.

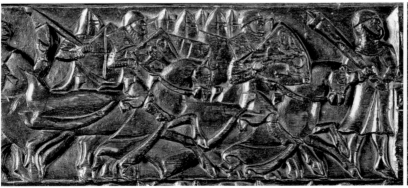

The stake Philip, with his crown and sceptre, watches the Templars, dressed in black, being led to the stake. Meanwhile, two servants stoke the flames. The soldiers who drive the condemned men towards their execution carry blue shields with a gold fleur-de-lis, the heraldic emblem of the French monarchy. The scene takes place before a large city identifiable as Paris, which is where the Grand Master Jacques de Molay was burned at the stake.

History of the Templars

1119 or 1120 The order is founded in Jerusalem to help defend the crusader states. It takes up residence on the Temple Mount, the site of Solomon's Temple, hence its name.

1128 The Council of Troyes approves the order's rule, which provides for various roles: warrior knights; sergeants, who serve the knights; and chaplains, the priests included in the order.

c. 1135 The Templars begin to develop banking activity. During the Second Crusade (1147), they also lend a considerable sum to Louis VII of France.

1291 Like the other knightly orders and the crusaders, the Templars lose their last possessions on the mainland of the Middle East and set up their headquarters on Cyprus. However, their activity is now mainly based in France, where a large portion of the order's possessions is concentrated.

1307 Philip the Fair brings the Templars before the tribunals of the Inquisition and confiscates their property.

1312 The pope suppresses the Templars under pressure from France by a papal order issued independently of the Council of Vienne convened the year before.

1307 THE END OF THE TEMPLARS

Miniature from a Treatise on the Vices (*Tractatus de septem vitiis*)

c. 1330–1340. London, British Library, Add. 27695

Undercover operations and false accusations

On 13 October 1307, secret instructions from King Philip the Fair that had been circulated the week before were carried out throughout France. All members of the order of the Templars were arrested, initiating an operation of repression that covered the entire kingdom. Many knights and priests who belonged to the order were imprisoned, and castles, palaces and other property were confiscated. The order had become highly prosperous, above all through large donations from the European nobility, who were fascinated by its mixture of religious strictness and knightly fervour. The accumulated wealth, combined with the vast network of properties at their disposal, enabled the Templars to offer banking services that soon made them a creditor of even the most important European monarchs. This, along with the broad privileges that exempted the Templars from monarchs' control, was the primary cause of the proceedings Philip the Fair launched against them, which included accusations of activities ranging from sodomy to heresy and the celebration of satanic rites. The order was abolished by the pope, and Jacques de Molay, the last Grand Master, was burned at the stake in 1314 as a heretic.

The accident The lower part of the sheet depicts Philip the Fair falling from his horse during a hunting party. The illuminator set the scene in a walled reserve filled with animals. After his fall, the king was taken to the Château de Fontainebleau, where he died a few weeks later.

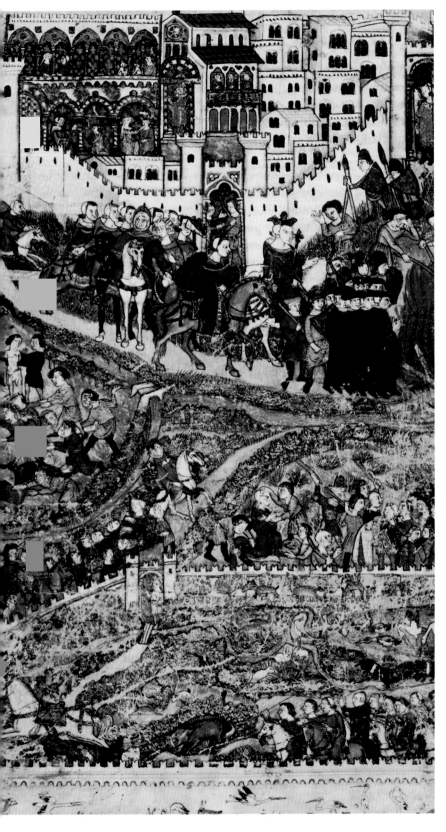

This miniature is from a *Treatise on the Vices* compiled in the 14th century in the Italian city of Genoa and surviving only in fragments. The text had didactic intentions. For stylistic reasons – the attempt at a naturalistic representation of men and animals is remarkable – as well as from the dating and geographical provenance of the manuscript, the miniatures have been attributed to a certain Cybo, monk of Hyères, a Genoese illuminator. The page reproduced here combines two seemingly unconnected events that occurred in 1314: the death at the stake of the Templars' Grand Master Jacques de Molay and the fatal accident of Philip the Fair, king of France, who had pressed for bringing the order to trial before the Inquisition. However, another chronicler of the period tells that at the stake, Jacques de Molay had predicted his persecutor's imminent death.

A crossbowman The French engaged Genoese mercenaries with crossbows. The crossbow was a powerful weapon, but it was heavy, and loading it was a somewhat long and elaborate process – making it ill suited to battle in the open field, as at Crécy.

1346 THE BATTLE OF CRÉCY

Loyset Liédet, **Miniature in the** *Chronicles* **of Jean Froissart**
c. 1450–75. Paris, Bibliothèque nationale de France, *Français 2643*

The start of the Hundred Years War

In the early 14th century, after almost three centuries of population and economic growth, many signs of a deep economic and social crisis could be detected throughout Europe. It was in this context of decline that, in 1337, a disagreement between the English and French monarchies erupted into a war that would go on (with interruptions) until 1453: the so-called Hundred Years War. The original matters of contention were the control of the duchy of Guyenne, a fief in south-west France that had been inherited by England; French support for the Scottish king who was fighting the king of England; and the English attempt to control the county of Flanders through an agreement with the powerful Flemish merchants and craft guilds. After some years of war in which Edward III of England and Philip VI of France fought each other's respective enemies (the Scots, the Flemish, various claimants to the duchy of Brittany) without direct confrontation, in 1346 Edward landed in France and plundered his way inland. His small army defeated Philip VI's cavalry near Crécy, in Picardy. This was the first in a long series of English victories that put the French monarchy in serious difficulty.

The early stages of the conflict

1328 King Charles IV of France dies without leaving a direct male heir, so Philip VI of Valois accedes to the throne – in the process blocking any possible claim of Edward III of England, who was also closely related to the late king.

1329 Edward III agrees to take a vow of fealty to Philip VI, recognizing him as the king of France and his feudal lord for the duchy of Guyenne.

1337 Philip confiscates Guyenne from Edward, whom he considers guilty of supporting the Flemish rebellions. Edward claims the throne of France for himself.

1346 First English victory, at Crécy. Calais falls to the English and becomes Edward's main outpost in France.

1356 Battle of Poitiers, won by the English. King John the Good of France, who succeeded his father Philip in 1350, is taken prisoner.

1360 In the Treaty of Brétigny, France cedes one-third of its territory to Edward III, while John the Good is freed from prison upon payment of a considerable ransom.

Flight The French crossbowmen could not hold their position against the English archers and, after undergoing considerable losses, abandoned the field. This is the moment represented in the miniature. By force of arms, the French cavalry try to compel the mercenaries to renew the battle, but they turn their backs to the battlefield.

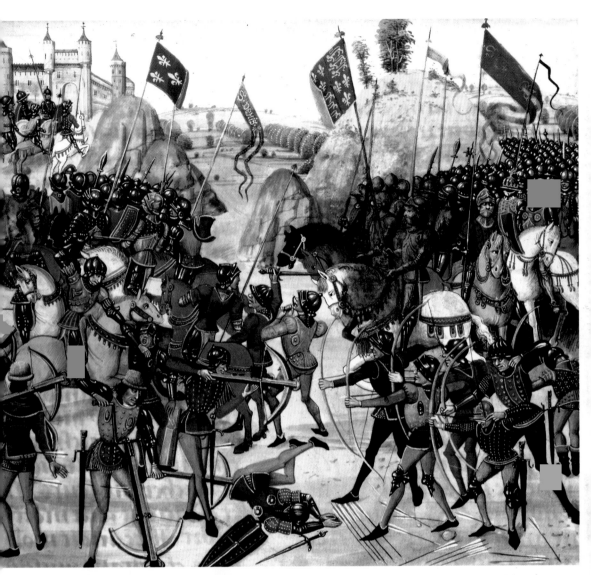

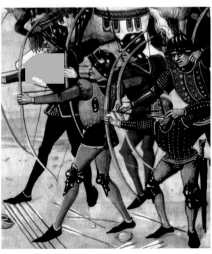

The *Chronicles* of Jean Froissart, from which this miniature representing the Battle of Crécy is taken, is one of the most important sources for the history of the Hundred Years War. Although this image was executed by Loyset Liédet more than a hundred years after the events, Froissart wrote his text only a few years after the Battle of Crécy. His sources included not only earlier written documents, but also information from eyewitnesses and leading participants in the events. The author, a clerk whose chronicle glorifies the ideals of chivalry, knew the views of both sides in the war, having served at both the English court and that of Wenceslas of Luxembourg, a close ally of the French king.

The English archers The English used the longbow, which, though less powerful than the crossbow, was lighter and more easily handled. The archers' continuous action kept the French cavalry from coming near the English lines and engaging in close combat, which was the cavalry's aim. The arrows took a heavy toll on the French cavalry. The most famous of the fallen were John of Luxembourg, an important French ally, and the king's brother, Charles of Alençon. For the chronicler Jean Froissart, this was the end of the chivalric ideal, to which he continually pays homage in his *Chronicles*.

Crisis in the 14th century

Demography Fourteenth-century Europe was characterized by a radical decrease in population as a result of famine, epidemics and war. Not until the 18th and 19th centuries did Europe's population regain the levels it had reached in 1300.

Society The population decrease had a number of repercussions on society and the economy. If at first it was the poor urban masses who bore the brunt of famine and disease, the scarcity of manpower subsequently created new opportunities for the humblest classes.

War and violence The traumatic events of the period also led to public violence, especially against the Jews. They also led to often protracted wars that aggravated the demographic crisis.

1347 THE GREAT PLAGUE

Buonamico Buffalmacco, **The Triumph of Death**
c. 1340. Fresco. Pisa, Camposanto monumentale

The age of fear

From about 1000 to the early 14th century, Europe saw improvements in most areas: greater agricultural production, population growth, increase in cultivated land and development of the cities. But the limits of development had now been reached. The yield from the land recently put under cultivation was poor, while the cities accumulated masses of unemployed and beggars who barely lived from day to day. The first obvious signs of crisis were the famines that afflicted various areas of western Europe from the very first years of the 14th century. So the plague, which first arrived in western Europe at Messina in October 1347, struck down an already weakened population. It is estimated that one-third of Europe's population fell victim to the epidemic, which spread from the Mediterranean to Scandinavia and, in 1350, reached Russia. The Black Death and famine, and the consequent decline of whole cities and regions, led to what might be called an 'age of fear'.

Death the equalizer Bishops, monks, noble ladies, friars and wealthy patricians are equal in the face of death, and their souls (represented as children issuing from the mouths of the dead) can end up in the devil's clutches. This equality of all human beings before death is a frequent theme in art of this period, as the traditional social hierarchy crumbled under the effects of the plague.

136

This monumental fresco decorates the cloister enclosing the
Camposanto (cemetery) of the cathedral of Pisa. Even if the work
was painted some years before the plague ravaged Europe, it clearly
renders the climate of precariousness and transience that had
developed in 14th-century Europe. New to European iconography,
the theme of the Triumph of Death arose in response to the dramatic
developments of those years. This fresco is divided into two large areas:
the left is devoted to the encounter between living and dead, and
the right to the combat of the angels and demons over the souls
of the dead.

Encounter with Death An aristocratic company setting
out on a hunting party (note the dog and falcon at the
right) suddenly comes upon death in the form of three
corpses in open coffins. The young people assume different
attitudes in the face of death: one lady reflects thoughtfully,
while others hold their noses because of the smell of
putrefaction.

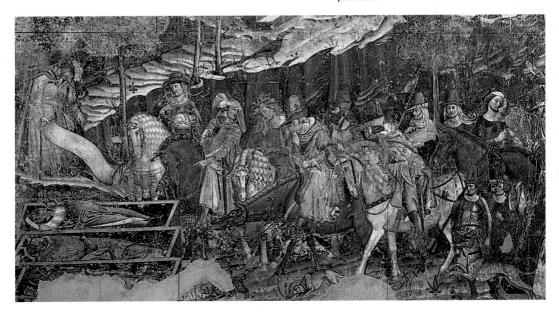

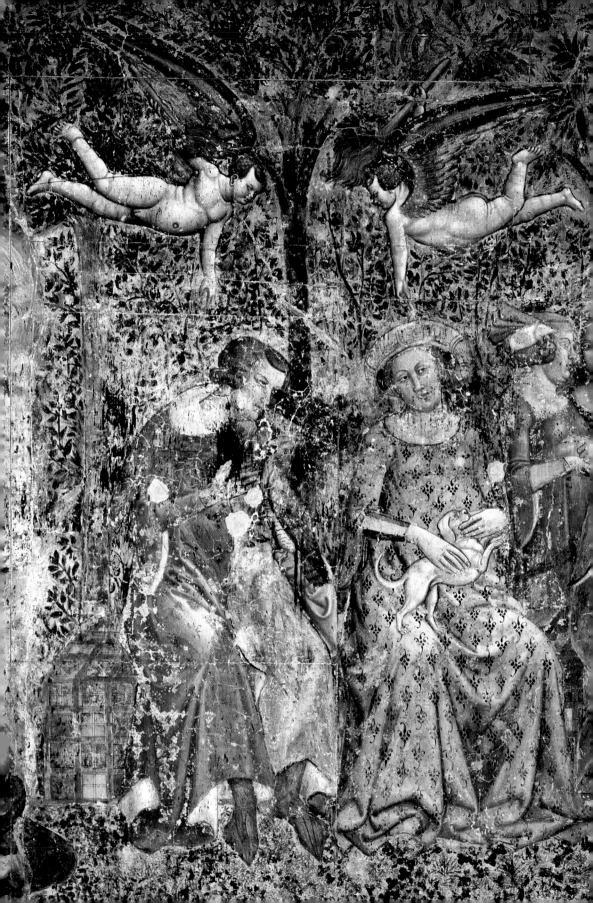

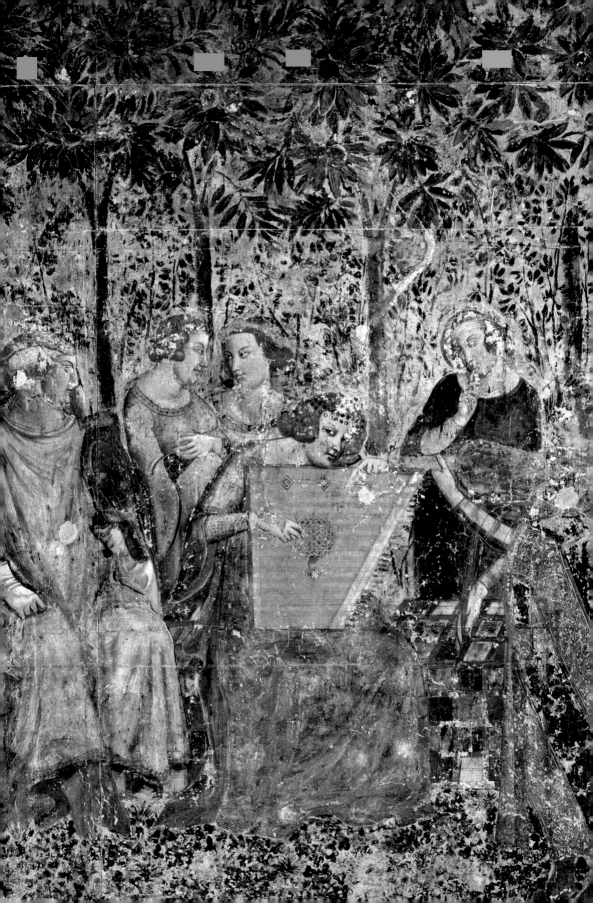

1370 THE RISE OF TAMERLANE

Miniature for the *Book of Tamerlane* by Abdullah Hatifi

1538. London, British Library, *Or. 2838*

Timur the Lame Tamerlane, a contraction of the name Timur and the nickname Lenk (meaning 'lame'), was feared for the brutal force with which his troops assailed and subjected cities and territories. Yet he was no ignorant barbarian. The biography of the famous Arab scholar Ibn Khaldun tells of meeting the commander, who showed interest in all branches of learning.

A new empire in Central Asia

In just a few years, Tamerlane managed to extend his dominion to cover vast reaches of Central and South-western Asia, along the way blending Mongol, Turkish and Persian traditions. Tamerlane was born in about 1328 in Transoxania, in present-day Uzbekistan. That period saw the break-up of the Mongol khanate of Chagatai, which had controlled the region, and the creation of a power vacuum. Tamerlane, a member of the Barlas, a hitherto marginal Turkish clan, exploited this vacuum with unquestionable military ability and unscrupulous alliances. After freeing himself from the chief of the Barlas, he allied himself with Husayn, the powerful Emir of Balkh (in present-day Afghanistan), and even married his sister. However, in 1369 Tamerlane turned against Husayn, and the following year was paid homage to by Husayn's vassals in Balkh. Thereafter, Tamerlane was continuously involved in wars to broaden his empire. However, he did not succeed in providing it with stability, and so, amid fratricidal wars, the Timurid empire survived only a few decades after its founder's death.

The conquests of Tamerlane

1370 Tamerlane is paid homage to in Balkh by the vassals of the chief of the southern Chagatai.

1379–93 Tamerlane gradually subjects the lands covered by the present-day Iran and Afghanistan and pushes on to Baghdad.

1392–99 Tamerlane's grandson, Pir Muhammad, governor of Kandahar, conducts various military campaigns for the control of India, which culminate in 1398 with the conquest and pillaging of Delhi (in which Tamerlane also takes part).

1401 Conquest and sack of Damascus. In the same year, the population of Baghdad is massacred, after the city separates from Tamerlane's empire.

1402 Tamerlane invades Anatolia, and defeats and captures the Ottoman sultan Bayazid I.

1405 During the campaign against the Mongols in present-day Kazakhstan – a campaign intended as a prelude to the invasion of China – Tamerlane dies suddenly of a fever.

This miniature depicts Tamerlane at Balkh, a city just conquered from his brother-in-law and adversary Husayn, as he receives the homage of the southern Chagatai vassals and clan leaders. Tamerlane is thus confirmed as the khanate's new sovereign. The image, executed by an anonymous artist from what is now Iran, illustrates a celebratory poem by Abdullah Hatifi written around a hundred years after Tamerlane's death. Tamerlane's military successes, brutality towards his enemies and disloyal subjects, generosity towards allies and loyal followers, and patronage in his new capital of Samarkand have always aroused fascination and admiration.

Persians, Turks, Mongols Various ethnicities may be recognized among the leading Chagatai citizens – some seated around the commander inside the palace, others outside in a garden – who pay homage to their new sovereign. Alongside the men wearing turbans in accordance with the Islamic custom are dignitaries with fur-trimmed hats, the typical headgear of the Mongols.

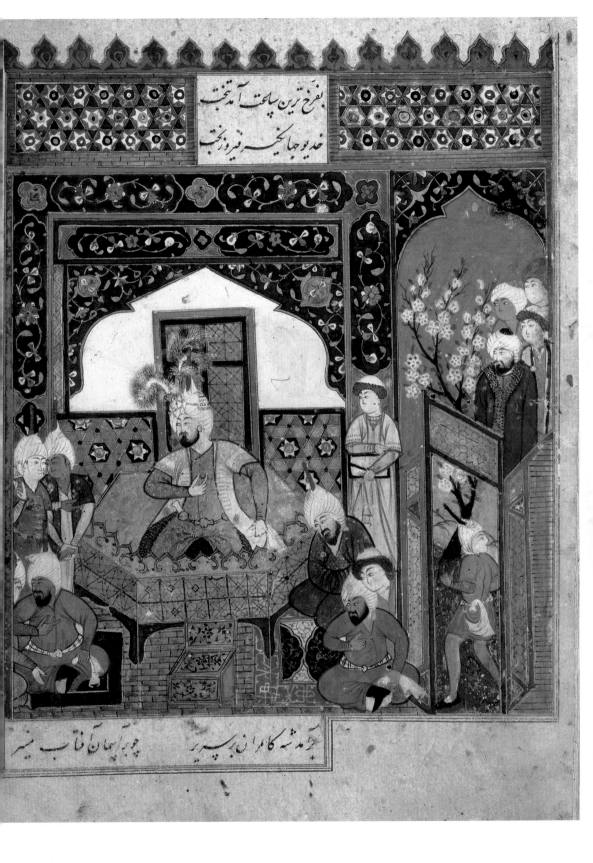

The English fort The English built temporary fortifications around the besieged city of Orléans, and the decisive encounter occurred on 7 May 1429 near the fort of Tourelles. This miniature shows a French attack on one of these wooden bastions. An English soldier with hands clasped addresses his last prayer to God before certain death.

The French monarchy, from crisis to rebirth

1392 Mental illness prevents the French king Charles VI from performing his duties. A heated power struggle breaks out around him, between the Duke of Burgundy, his uncle John, and brother Louis d'Orléans.

1415 The English rout the French at the Battle of Agincourt.

1418 The Duke of Burgundy's faction, allied with the English, takes Paris.

1420 King Charles VI is forced to yield the right of succession to the English king Henry V and his dynasty.

1422 After the death of Charles VI and Henry V, Henry VI is proclaimed king of France while Charles VI's son Charles VII remains in Bourges.

1429 Orléans is liberated from the English siege.

1436 Paris submits to Charles VII.

1453 At the Battle of Castillon, the English are defeated and forced to abandon all their territory in France.

1429 JOAN OF ARC AND THE LIBERATION OF ORLÉANS

Miniature for the *Vigiles de Charles VII* of Martial d'Auvergne

c. 1484. Paris, Bibliothèque nationale de France, *Français 5054*

A country devastated by war

By the early 15th century, France had been devastated by the Hundred Years War with England, which had begun in 1337. Besides the effects of the war, there was the Great Plague and grave economic and social crises, with continual peasant rebellions and struggles between aristocratic factions. After a partial restoration of royal authority under Charles V (r. 1364–80), the power of the French monarchy was again eroded in 1422 when Henry VI of England had himself proclaimed king of France in Paris (which was controlled by the English and their ally, the Duke of Burgundy), while the legitimate claimant, Charles VII, remained in Bourges. After some initial defeats for Charles, fighting became concentrated around the city of Orléans, on the border between the areas controlled by Charles and Henry. The liberation of this city from the English siege – accomplished with the intervention of Joan of Arc, who acted in accordance with her mystic visions – became the turning point in the war. Charles could then rebuild the power of the French monarchy and forge new alliances with feudal powers, among them the English's former ally, Philip the Good, Duke of Burgundy.

The oriflamme The small, red three-pointed standard was the symbol of the royal French troops. In the miniature, it can be seen within the walls of the city now freed from the siege of the English, and in the hands of the soldiers of Charles VII.

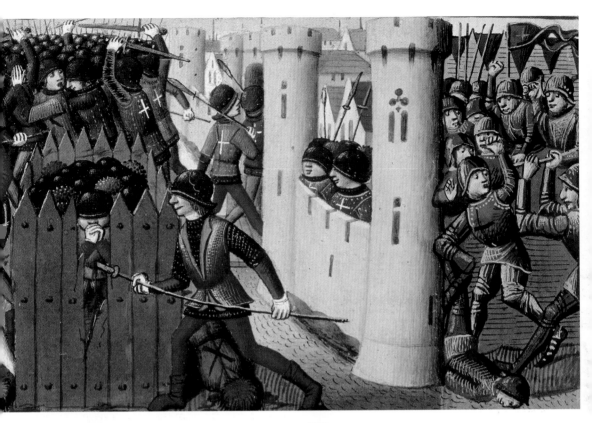

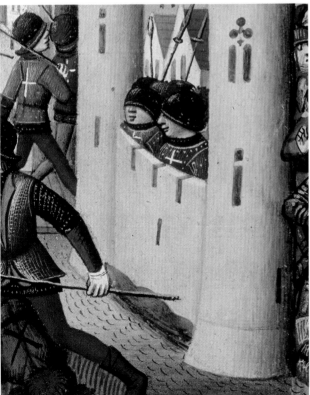

This miniature represents the moment when the French troops of Charles VII enter the city of Orléans on 8 May 1429, freeing it from the siege laid by the English forces and their Burgundian allies months before. It illustrates the *Vigiles de Charles VII* by Martial d'Auvergne, a historical work with characteristics of a chronicle that aimed at celebrating Charles VII as an exemplary monarch. Written a few years after Charles's death, it questions the management of his son and successor, Louis XI. The work also celebrates the deeds of Joan of Arc – as part of the long path towards rebuilding the monarch's power undertaken by Charles – despite the divisions and squabbles that arose between Charles and Joan after the victory at Orléans.

The river and the bridge Orléans was strategically situated on the Loire river, which roughly marked the boundary between the English-Burgundian forces one one side, and the French forces loyal to Charles VII on the other. One of the few bridges over the river was in Orléans itself.

Saint and Lay Heroine Ingres was the first to paint Joan of Arc with a saint's halo – even though, in 1854, the beatification of 1909 and the adoption of Joan by French Catholics were still a long way off. Here, he adds to the religious atmosphere by placing Joan between her chaplain, who is absorbed in prayer, and the altar.

From the stake to the altar

September 1429
After the victory at Orléans and Charles VII's coronation, Joan proposes to attack Paris, which is still held by the English and the Duke of Burgundy. The attack fails and Joan loses the support of Charles's court.

May 1430
On her own initiative, she joins some French troops who are trying to lift a siege at Compiègne, but is captured by the English.

December 1430
The English demand a heresy and witchcraft trial against Joan before the French Inquisition.

30 May 1431
Joan is burned at the stake in Rouen.

10 November 1449
Charles VII frees Rouen, confiscates the documents relating to the trial against Joan and orders the case to be re-examined.

1455–56
The Inquisition officially annuls its judgment against Joan.

1909
Pressure from French Catholics leads to Joan's beatification. In 1920, she is declared a saint.

1429 JOAN OF ARC AND THE LIBERATION OF ORLÉANS

Jean Auguste Dominique Ingres, **Joan of Arc at the Coronation of Charles VII in the Cathedral of Reims**
1854. Oil on canvas, 240 x 178 cm. Paris, Musée du Louvre

The scandal of a woman on horseback

When, on 17 July 1429, Joan of Arc took part in the coronation of Charles VII in Reims Cathedral (the traditional place for the crowning of the kings of France), it marked both her highpoint, and the beginning of her fall. Inspired by mystical visions, this daughter of a well-off farmer from Lorraine set out in support of Charles's struggle against the English troops in 1428, fighting with the French army from the Loire valley to Reims in a campaign that eventually got rid of the English and their allies. The young woman dressed in man's clothes and a knight's armour captivated her war-weary countrymen, whether noblemen or peasants. People revered her and flocked to touch her standard and garments, believing that they had healing properties. But after the coronation, the first disagreements arose. Joan wanted to continue the war, while Charles wanted to initiate diplomatic negotiations. Joan tried to renew the conflict on her own with her own troops but fell into enemy hands. The English immediately exploited the scandal of a woman knight and the rumours of her supernatural powers to bring her before the Inquisition – and eventually condemned to the stake.

When Ingres presented his canvas of Joan of Arc at the Paris World's Fair in 1855, a re-evaluation of the medieval heroine was already under way. Though for centuries scholars had neglected and derided this figure so dear to popular tradition, in the mid-19th century Joan was widely celebrated for her struggle on behalf of the 'liberty of the nation' (despite Charles VII's timid wait-and-see attitude and the court's hostility towards her). Ingres depicts Joan as the true artificer of the restoration of the monarchy, based on the coronation of 1429. In her right hand, she holds her standard, which depicts God and an angel, while her left hand rests on the altar, by the crown carefully laid on a cushion decorated with fleur-de-lis, the emblem of the French monarchy.

The armour Ingres emphasizes the realistic representation of certain period details such as Joan's helmet. Some contemporary critics claimed that such historical pedantry damaged the overall composition and harmony of the colours, which are dominated by the metallic finish of Joan's armour.

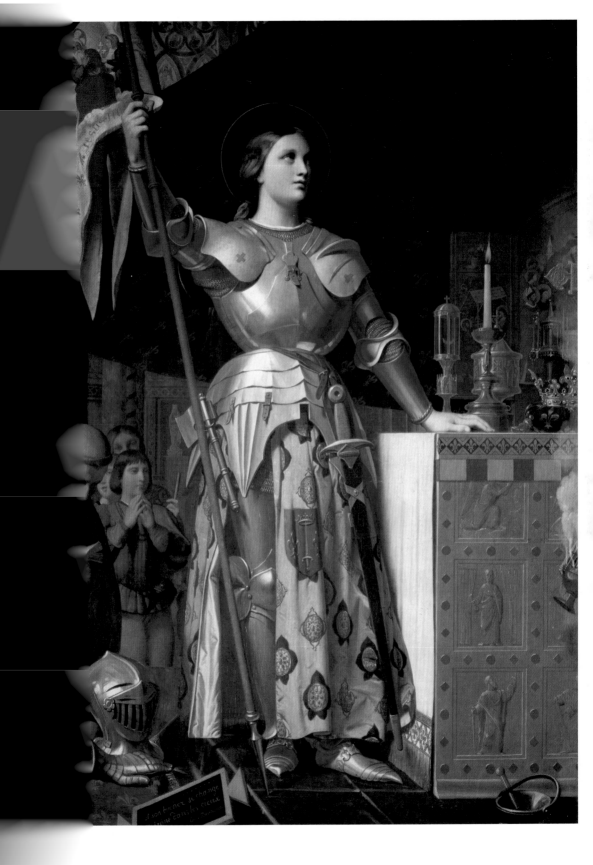

Geometry and fantasy A master of perspective, Paolo Uccello combines a geometrical foundation – perhaps most obvious in the horses – with an almost fantastical use of colour, as seen in this unlikely blue stallion.

The war to dominate Italy

1415 Filippo Maria Visconti takes power in Milan, aiming to subjugate northern Italy.

1426 Venice leads an anti-Visconti coalition that includes Florence.

1427 The Venetians soundly defeat the Milanese at the Battle of Maclodio. The Serenissima's troops were commanded by the Count of Carmagnola, a mercenary captain previously in the service of the Visconti. The Florentines were led by Niccolò da Tolentino, and the Milanese by Francesco Sforza.

1432 After the defeat at Soncino, the Venetians are convinced that Carmagnola betrayed them to Milan. The count is tried and beheaded.

1434 Cosimo de' Medici establishes his authority in Florence.

1435 Queen Joan II dies in Naples, and René of Anjou and King Alfonso of Aragon vie for the kingdom. Milan, Venice and Florence support the Anjous, but in a remarkable about-face, Filippo Maria Visconti allies himself with Alfonso.

1436 Florence, Genoa and Venice renew the war against Milan. This time, the anti-Visconti troops are headed by Francesco Sforza.

1441 Sforza marries Bianca Maria, the daughter of Filippo Maria Visconti, thereby inheriting the duchy of Milan. Alfonso of Aragon now rules Naples.

1454 The Peace of Lodi recognizes the sovereignty of the Sforzas over Milan and the Aragons in Naples. Bergamo and Brescia are restored to Venice. Florence consolidates its control over Tuscany.

1432 THE BATTLE OF SAN ROMANO

Paolo Uccello, The Battle of San Romano, Bernardino della Ciarda Thrown from His Horse
c. 1435–40. Tempera on panel, 182 x 323 cm. Florence, Galleria degli Uffizi

Italy at war

The Battle of San Romano, a clash between Florence and Siena, the two most powerful towns in Tuscany, was fought on 1 June 1432 near the town of Montopoli in Val d'Arno, north of Florence. It resulted in the victory of the Florentines, commanded by the mercenary captain Niccolò da Tolentino. The battle was just one of a series of conflicts between various Italian city-states in the 15th century, as the various entities vied for primacy. Florence manoeuvred skilfully amid the continually shifting alliances, in particular supporting the stronger Venice against Milan, which hoped to subjugate the whole of northern Italy. On the other hand, Florence was keen to control the whole of Tuscany, causing nearby towns to ally themselves with its enemies, as did Siena. Furthermore, most of the fighting was done by professional soldiers – mercenaries – who had no qualms about changing sides for better pay. After half a century of fighting without a clear winner, in 1454 a treaty was signed in Lodi, bringing Italy fifty years of peace.

An unreal atmosphere
The mass of lances, the excited atmosphere of the battle and the hand-to-hand combat seem suspended, like a freeze-frame in a movie. This sublimates the encounter and idealizes it into an exemplary representation.

The task of commemorating the victory at San Romano was given to Paolo Uccello, not by Cosimo de' Medici (as was long believed), but almost certainly by the Florentine patrician Leonardo Bartolini Salimbeni. The artist painted three works illustrating outstanding moments in the battle: *Niccolò da Tolentino leads the Florentine Troops* (London, National Gallery); *Michelotto da Cotignola engages in Battle* (Paris, Musée du Louvre); and *Bernardino della Ciarda Thrown from His Horse* (Florence, Galleria degli Uffizi). The Medici family acquired all three panels in 1484 and kept them in the Palazzo Medici-Riccardi. They were separated and sold during the 19th century.

Commanders in the fray In the panel depicting Niccolò da Tolentino leading the Florentines (below), Uccello uses the shattered lances on the ground to indicate the depth of the space, from the commander and two duels between horsemen in the foreground to the hills in the background. However, many of the details — the splendid armour and headgear, the placement of the horses' volumes, the colourful banners and gilt harnesses — are signs of an artist still strongly influenced by the International Gothic style.

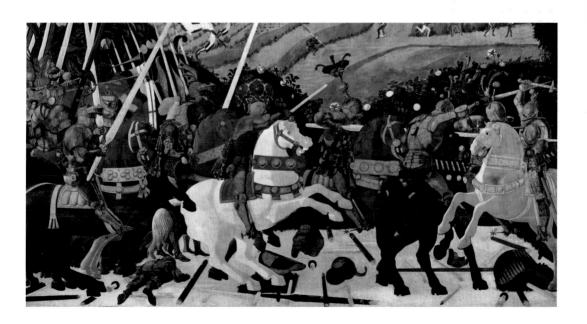

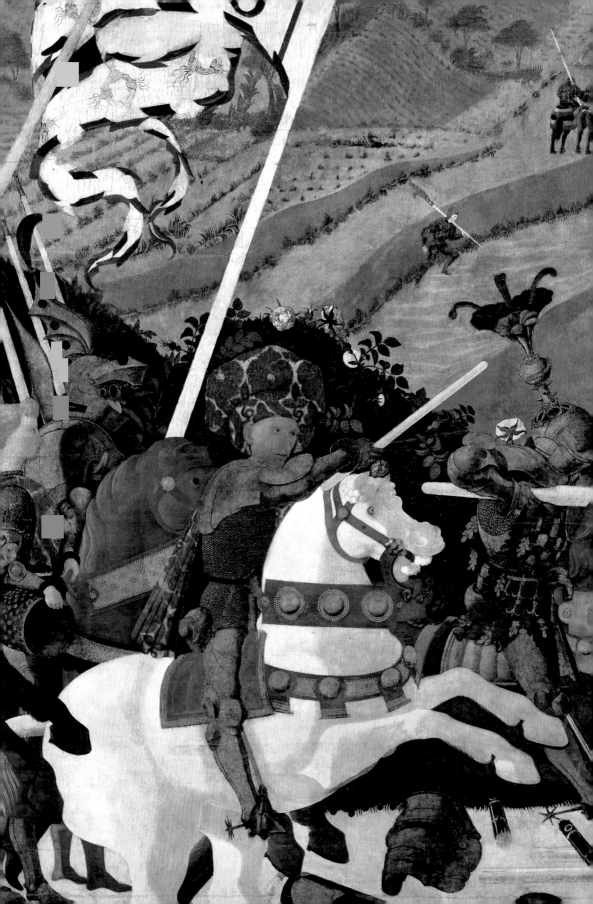

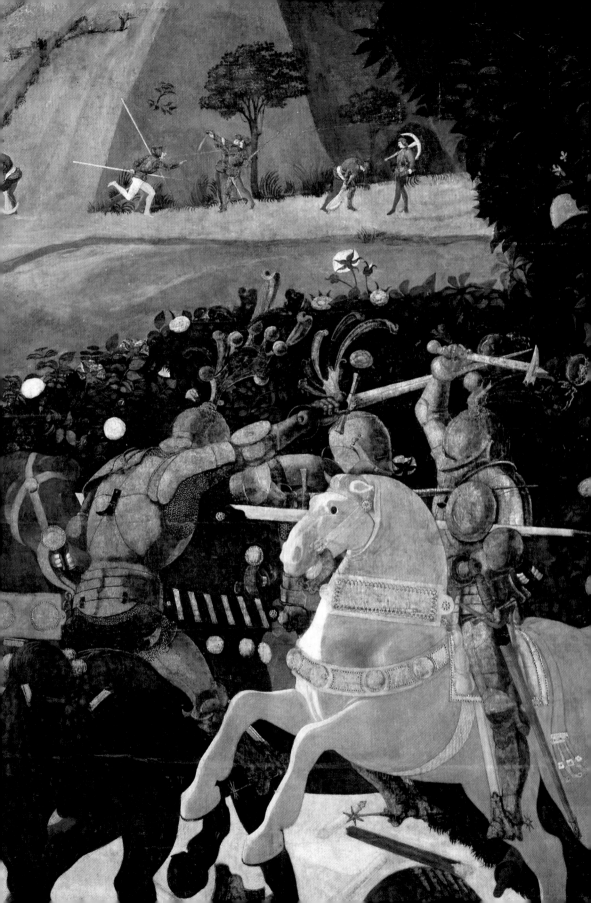

Lorenzo de' Medici Benozzo has turned the splendid procession of the Magi into a celebration of the Medici family. The idealized figure of Lorenzo stands out against a pleasingly luxuriant landscape. The young prince – he was just ten years old when these frescoes were painted – advances with regal bearing.

Florence: From republic to *signoria*

1378 The Ciompi revolt results in a new form of government that features strong participation from the Florentine lower classes.

1382 The Florentine nobility begin gradually to exclude the popular classes from city government, setting up an oligarchy. At the head of the oligarchic party is the Albizi family.

1384 With the subjugation of Arezzo, the Republic of Florence begins an ambitious programme of territorial expansion that within thirty years brings it control over almost all of Tuscany.

1413 The Medici bank acquires the exclusive right to collect tithes on behalf of the pope. The family begins to grow rich.

1427 Giovanni di Bicci de' Medici, Cosimo's father, is among the promoters of a fiscal reform aimed at lightening the tax burden on the less well-off, which had increased due to the wars of Florence's territorial expansion. It is one of the measures that earn the Medici family popular support.

1434 After returning from exile, Cosimo de' Medici effectively turns Florence into his *signoria*.

1434 FLORENCE UNDER THE MEDICI

Benozzo Gozzoli, **The Procession of the Magi**

1459–61. Florence, Palazzo Medici-Riccardi

The return of Cosimo

In 1434, Cosimo de' Medici returned to Florence from the exile to which he had been condemned the previous year by Palla Strozzi and Rinaldo degli Albizi, leaders of the oligarchic anti-Medici party. Received enthusiastically by his supporters, Cosimo then succeeded in managing the smooth transition of Florence from a republic to a *signoria* – even though he never formally assumed the office of *signore* (lord) of the city. Born in 1389, Medici had over time consolidated the family's banking activity and gradually introduced men connected to him by personal and economic ties into the key posts of municipal government. Generous towards the people, between 1434 and 1464 he exercised *de facto* lordship over Florence, in the process bringing stability to Italy's volatile political situation. At his death, he was succeeded by his son Piero the Gouty, who led Florence until 1469, when Piero's twenty-year-old son Lorenzo (later called 'the Magnificent') assumed command over the city. Lorenzo inaugurated a period of extraordinary cultural flourishing and political prestige, which ended with his premature death in 1492.

Cosimo and Piero de' Medici In the cycle's central scene, the procession that unwinds behind the young Lorenzo the Magnificent (dressed in gold) is led by Piero (to the right) and Cosimo (to the left). Though Piero commissioned the cycle, it was his father, Cosimo, who was the true founder of the dynasty.

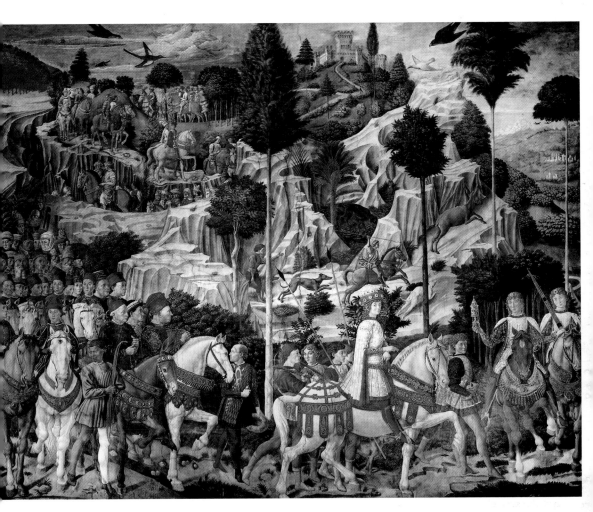

The fresco cycle of *The Procession of the Magi*, commissioned by Piero, occupies all the walls of the first-floor chapel in the family's Florence palazzo, and was painted by Benozzo Gozzoli between 1459 and 1461. The subject was particularly dear to the Medici family. Since 1434, Cosimo had been the prior of the Confraternity of the Magi. Every three years, on 6 January (the feast of the Epiphany), the confraternity organized a lavish costumed procession through the streets of Florence to recall the journey of the Magi. It was an occasion for the great families to display their wealth, and the Medici became its promoters, indirectly asserting their signorial rule.

Hunting scene Benozzo Gozzoli sets the procession of the Magi in a densely decorated landscape. In it we can see castles, animals, hunting scenes and fantastic plants — many of which make symbolic reference to the prestige of the Medici.

Pope Pius II The old king on the west side has sometimes been identified as Pius II, pope at the time the frescoes were painted, though not at the time of the Council. Others maintain that he is the Holy Roman Emperor Sigismund (1411–37), who was already dead at the time of the Council in Florence.

1434 FLORENCE UNDER THE MEDICI

The Ecumenical Council of 1439

One episode in particular indicates the power Cosimo wielded not only within Florence but also when dealing with other states. In 1439, he convinced Pope Eugenius IV to move an important meeting of the Catholic and Orthodox Churches from Ferrara to Florence. Convened in Basil in 1431 and first moved to Ferrara, the Ecumenical Council was attended by the pope and the council fathers, as well as John VIII Paleologus, emperor of the East. Paleologus was anxiously seeking aid against the irresistible advance of the Ottomans (who would eventually succeed in conquering Constantinople in 1453) and was therefore disposed to make broad concessions. Cosimo favoured the reconciliation of the two Churches, which was sanctioned by a joint declaration of the pope and Paleologus. In the event, reunification was not achieved owing to the resistance of the Orthodox community, which rejected submission to Rome, but the Council did bring great international prestige to Florence and the Medici.

The Council of Ferrara and Florence

Main figures
John VIII Paleologus, emperor of Constantinople; Pope Eugenius IV; Cosimo the Elder, *de facto* ruler of Florence.

Location
Ferrara from 1438 until the outbreak of the plague; Florence, summer 1439.

Goals
To unite the Catholic and Orthodox Churches; for the emperor of the East to obtain military aid against the Ottomans, who were advancing towards Constantinople.

Results
The prestige of hosting the Council consolidated Cosimo de' Medici's position of power in Florence. Despite the formal meeting between the Churches, however, Catholics and Orthodox remained separate. Constantinople fell in 1453.

Impetus to learning
In the retinue of John VIII Paleologus were prelates and philosophers versed in Greek and Neoplatonic culture, the basis of Florentine humanism.

Giuliano de' Medici The old king is preceded by another member of the Medici family: Giuliano, Lorenzo's older brother. The leopard at his side is another example of the exotic detail Benozzo uses throughout the cycle.

A multicoloured caravan Aside from the procession of Lorenzo de' Medici, two other processions unfurl on the chapel's remaining walls. One is led by a noble figure often identified as the Byzantine emperor John VIII Paleologus, who took part in the Council. The other, illustrated here, focuses on the old king at the left edge of the fresco. The caravan that accompanies him can be seen moving off in the background. The camels and mules are piled high with merchandise, and the figures in multicoloured costumes clearly come from every corner of the world — a distant echo of the exotic guests who thronged Florence at the time of the Council.

The birth of the Ottoman empire

1300–26 Osman founds the domain of the Ottoman Turks in north-west Anatolia.

1326–59 Orhan I transforms the federation of Turkish tribes into a state, following the Byzantine administrative model.

1389 At the Battle of Kosovo, the Ottomans defeat an alliance made up of Serbia and other Balkan principalities, asserting their authority in south-eastern Europe.

1402 The sultan Bayezid I is defeated by Tamerlane, lord of Central Asia. In the following years, the Ottoman state endures a grave crisis marked by internal wars.

1422 Murad II renews the expansionist policy and attacks Constantinople but does not succeed in conquering the city.

1453 Mehmed II occupies Constantinople.

The sultan's camp Dressed in 15th-century European fashion, the sultan receives a messenger in front of his tent. The Turkish camp is located to the west of the city, as it was during the actual siege. This was the only access to Constantinople by land, and the Ottoman troops intended to launch their attack from this direction.

Bridge and cannons The miniature depicts some of the technological innovations Mehmed used to break the resistance of the Byzantines: a pontoon bridge to cross the estuary of the Golden Horn and some specially built cannons of unsurpassed firepower.

1453 THE FALL OF CONSTANTINOPLE

Miniature for *Le Voyage d'outremer* by Bertrandon de la Broquière

c. 1457. Paris, Bibliothèque nationale de France, *Français 9087*

From decline to fresh splendour

When the Ottoman sultan Mehmed II besieged Constantinople in the spring of 1453, the ancient capital of the eastern Roman empire was but a shadow of its former, glorious self. The population had shrunk considerably, to the extent that its walls now contained fields and pastures. Forced to pay tribute to the Ottoman sultan for some time, it had lost all political importance and survived only because it remained an important crossroads for the Italian trading cities of Venice and Genoa. In fact, Venetian and Genoese ships hastened to defend the city in 1453, but Mehmed II was determined to conquer this port, strategically located between Europe and Asia Minor. He would make the city his capital, rebuilding it and reviving its imperial splendour for the coming centuries.

This depiction of Mehmed II's troops besieging Constantinople illustrates the account of the travels of Bertrandon de la Broquière, who, between 1432 and 1433, undertook a voyage to the East on behalf of Philip the Good, Duke of Burgundy. When he visited Constantinople it was already in decline, but still in the hands of the Byzantines. By the time he began writing about his trip, after 1455, it had been conquered by the Ottomans. The miniature faithfully re-creates the geographic position of the city on a narrow stretch of land, even if the architecture and landscape are the fruit of the miniaturist's imagination.

1492 THE DISCOVERY OF AMERICA

THEODOR DE BRY AND WORKSHOP, **Hand-coloured Engraving for *Historia americae*, Part IV**
1594. Frankfurt

The beginning of the modern era

When Christopher Columbus set foot on an island in the Bahamas on 12 October 1492, he was unaware of what he had discovered. With only three ships and about a hundred men, Columbus had set out from Spain two months earlier in search of a westward route to Asia – and indeed, right up to his death in 1506, he was convinced that he had visited Asia, even though he made three more voyages to America between 1493 and 1504. However, two letters attributed to the navigator Amerigo Vespucci, which were published in the early years of the 16th century, translated into many languages and endlessly reprinted, promoted the idea in Europe that the land discovered beyond the Atlantic Ocean constituted a 'new world', distinct from Asia. The consequences of this discovery were so decisive – not only for Europeans, but also for the people of America, who would soon be decimated and subjugated – that Europeans have conventionally adopted this event as marking the beginning of the modern era.

Forced Christianization As soon as they arrived, Columbus's companions erected a cross as a sign of the Christianization of the continent. However, the idea of forced conversion had not yet arisen at the time of Columbus's first voyage, the goal of which was to find a new route for trade with India.

In search of routes to India

From 1420 Portugal's Prince Henry the Navigator encourages the exploration of the coast of Africa and the Atlantic Ocean.

1487 Searching for a route to India, the Portuguese explorer Bartolomeu Dias sails around the Cape of Good Hope, at the southern tip of Africa.

1492 Christopher Columbus, heading west to reach India, discovers the Bahamas and continues on to the Caribbean.

1493–96 Columbus undertakes a second voyage, with the goal of founding the first Spanish colony on the island of Hispaniola.

1497–99 The Portuguese Vasco da Gama sails around Africa and reaches India by sea.

1499–1502 Two expeditions in which Amerigo Vespucci participates explore the coast of South America. The idea that this land is distinct from Asia takes hold.

The *Santa María* Columbus's flagship, the *Santa María*, is depicted as a caravel, a type of high-sided ship ideal for ocean sailing.

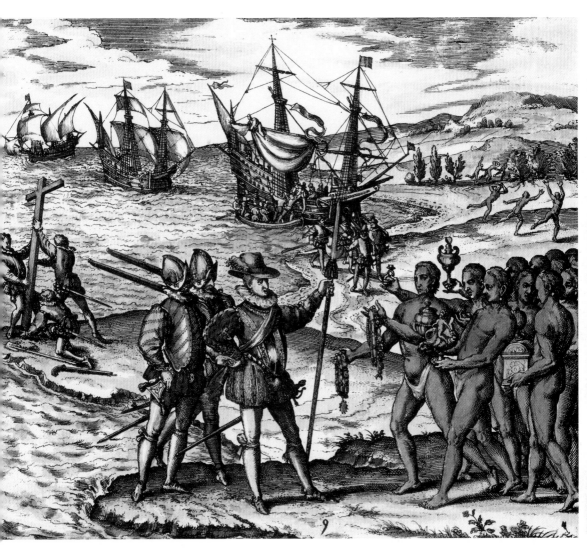

In the last decade of the 16th century, the publisher and engraver Theodor De Bry, originally from Liège and active in Germany, started work on a collection of travel logs and accounts of discoveries. This monumental collection contributed notably to disseminating news about the 'new world' in Europe. Illustrated with many engravings – among them this one, representing Columbus's arrival in 1492 – the work was not completed until the first decades of the 17th century by the publisher's sons.

Myths and wealth This representation of naked (or nearly naked) indigenous people provides one of the first traces of the myth of the 'noble savage', which enjoyed great popularity, especially in the 18th century. The lavish gifts of gold refer to the abundance of precious metals found later among the Aztecs and the Incas, though not on Columbus's first voyages.

1517 THE PROTESTANT REFORMATION

PIETER BRUEGEL THE ELDER, **The Sermon of St John the Baptist**

1566. Oil on panel, 95 x 160.5 cm. Budapest, Szépmüvészeti Múzeum

John the Baptist and Jesus John the Baptist gestures towards Jesus (dressed in blue), the Messiah, but they are not the painting's main figures. Instead, it is the colourful crowd that is the true object of the artist's interest.

Reform and reformers

1517 Martin Luther issues the Ninety-five Theses condemning the sale of indulgences.

1518 In a public debate in which he had to defend himself against the accusation of heresy, Luther denies papal authority, claiming instead that the Bible should be the sole basis of faith.

1521 Luther is excommunicated by Pope Leo X and banished by Emperor Charles V. However, he is supported by his sovereign, Frederick the Wise of Saxony.

1522 In Zürich, Ulrich Zwingli leads a programme of church reform in close connection with the municipal authorities.

1525 Luther reorganizes the Church in Saxony, which is placed under the authority of the regional prince. At about the same time, the Anabaptist movement is formed among Zwingli's followers, combining social demands with radical theological criticism.

1541 In Geneva, John Calvin introduces his strict version of theology and reform process.

A new concept of the Christian religion

In 1517, the German monk Martin Luther was the first publicly to voice a widespread uneasiness about the Roman Catholic Church and to promote a new, individualistic conception of faith that, in the spirit of the humanism of the period, sought to free itself from imposed interpretations and rely instead on a direct reading of the Bible. Two factors aided the spread of his ideas. First, Luther received the protection of the elector of Saxony, Frederick the Wise, the sovereign ruler of the area where he lived. (Frederick hoped to use the reform movement to increase his own independence from the Church and the empire.) Second, Luther was able to take advantage of the new technology of the printing press, which had made it possible to distribute handbills, pamphlets and tracts by the hundreds and thousands. Inspired by Luther and others, more radical movements would soon arise that, besides questioning the authority of the ecclesiastical hierarchy, demanded radical changes to the social order.

The gypsy and the burgher The crowd includes members of all social classes. Here, a gypsy is reading the palm of a middle-class man. The idea of the equality of men before the word of God refers to the spread of the more radical reform movements that found in the Bible inspiration for a forthright criticism of society.

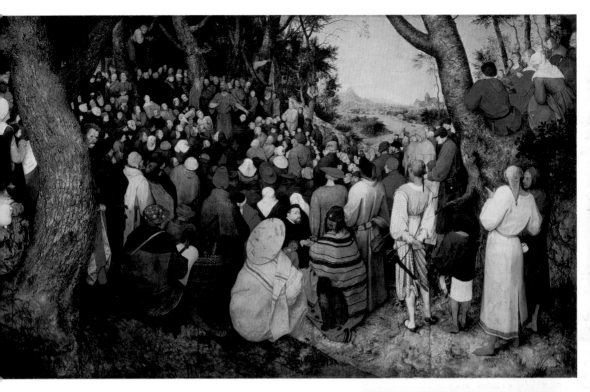

In this panel, Pieter Bruegel seems to show St John the Baptist, the precursor of Jesus, preaching. Yet, the scene is set in Bruegel's world, the Low Countries of the 16th century; what we actually see is a sermon by an exponent of reform. The reformers gathered their followers outside the city walls to avoid surveillance by the Spanish authorities who controlled the Low Countries at this time and persecuted the reform movement.

Men from afar In the crowd are various representatives of non-European peoples. The detail at the left shows an Asian warrior; above is a Turkish dignitary. They emphasize the universality of the Gospel's message.

The first encounter After Cortés landed, the Aztec emperor Montezuma immediately sent ambassadors to try to persuade the Spanish not to enter the interior. This picture shows the ambassadors offering the Spanish commander gifts and food; the Europeans, on the other hand, would have tried to impress the Aztecs by demonstrating the power of their firearms and displaying their horses.

Stages of the conquest

20 April 1519
Cortés and his fleet reach the coast of Mexico.

18 September 1519
Cortés arrives at the Mexican city of Tlaxcala and enters an alliance against the Aztecs.

October 1519
Cortés and his local allies massacre the population of the large city of Cholula.

8 November 1519
Cortés enters Tenochtitlán, the Aztec capital.

April 1520
The governor of Cuba sends an army against Cortés, deemed guilty of insubordination.

30 June 1520
The population of Tenochtitlán drives the Spanish out of the city.

Autumn 1520
Smallpox breaks out among the Aztecs, due to contact with the Spaniards.

December 1520
After reorganizing his troops and those of his indigenous allies, Cortés renews his war against Tenochtitlán.

15 August 1521
Cortés again enters Tenochtitlán and captures Cuauhtémoc, the last Aztec emperor.

1521 THE SPANISH CONQUEST OF MEXICO

Miguel and Juan Gonzáles, The Meeting of Cortés and the Ambassadors of Montezuma
1698. Oil and mother of pearl on panel, 97 x 53 cm. Madrid, Museo de América

The adventurer who conquered an empire

When Hernán Cortés landed on the coast of Mexico near present-day Veracruz in April 1519, he was an adventurer of meagre resources but great dreams of power and wealth. The Spanish governor of Cuba had sent him to conquer Mexico, but they soon fell out because of Cortés's desire to direct his own military campaign and ensure that the honours and fruits of conquest fell to him alone. Cortés had few men at his command, but his equipment – firearms, horses and combat dogs, all unknown to the inhabitants of Mexico – together with his ability to take advantage of the conflicts between various cities and tribes, allowed him to be the first European to penetrate the interior of the American continent. There, he conquered the tremendously wealthy Aztec empire and its capital, Tenochtitlán, which, with as many as 300,000 inhabitants, was a large city even by European standards. With this conquest, Cortés laid the foundation for the Spanish empire in the 'new world'.

No way back After arriving on the coast of Mexico, Cortés sank his ships, removing all means of return and binding his men to him and to the success of the undertaking.

This panel is part of a cycle of twenty-four paintings depicting the various stages of the conquest of Mexico. They were produced in the late 17th century for the local Mexican ruling class, who identified with the tradition of the Precolumbian culture and yet also considered themselves heirs to the Spanish conquistadors. By this time, a new elite had been formed, co-opted from the old Mexican nobility by the Spanish. They devised a conciliatory image of the events of the previous century.

1526 THE BATTLE OF PANIPAT

DEO GUJARATI, Miniature for the *Book of Babur*

c. 1590. London, British Library, *Or. 3714*

The heat of battle The artist depicts the details of the struggle – here we see the death of an Indian warrior – in a lifelike and realistic way.

Babur's successes and failures

1483 Babur is born into a noble family that traces its roots back to Tamerlane and, on his mother's side, Genghis Khan.

1494 At the death of his father, Babur becomes the prince of the Fergana Valley, in present-day Uzbekistan.

1497 He fails to conquer Samarkand.

1504 After being defeated in his own territory by the Turkish tribe of the Uzbeks, Babur occupies Kabul.

1511 In league with the Safavids, who govern Iran, Babur briefly occupies Samarkand. However, he is once more defeated by the Uzbeks. In the following years, he stabilizes his rule over present-day Afghanistan.

1519–24 Babur conducts various military campaigns in India, pillaging and plundering this rich territory.

1526 After the Battle of Panipat, he is proclaimed sultan of Delhi.

1530 Babur dies in Agra, India.

A poet-adventurer with his sights set on India

When, in November 1525, Babur gathered his Turkish, Mongol and Iranian troops at Jalalabad, in present-day Afghanistan, a great many adventures already lay behind him. Though he controlled the mountainous zones of Afghanistan, however, these were largely poor and he knew that in order to maintain the loyalty of his unstable following of tribes, he must give them new opportunities for conquest and spoils. So, with forces considerably inferior to those of the sultan of Delhi, he attacked rich and densely populated India. He was victorious over the large army of his adversary, Ibrahim Lodi, at the Battle of Panipat in April 1526 because Ibrahim could not count on the full loyalty of his subjects and because Babur had at his disposal firearms (artillery and arquebuses) unknown to the Indian forces. Babur conquered Delhi and founded the Mughal dynasty, which governed the Indian subcontinent for more than two centuries.

Though he spent a large part of his life in military camps, Babur nonetheless cultivated cultural interests. He turned his hand to calligraphy (a highly esteemed art in the Islamic countries), wrote poetry and kept a diary.

Persian influence The Mughal miniature, like the contemporary Ottoman miniature, was heavily inspired by Persian art, thanks to the influx of Persian masters under Babur's successors. The Mughal miniature differed from others, however, in paying particular attention to the naturalistic depiction of the landscapes, plants and flowers.

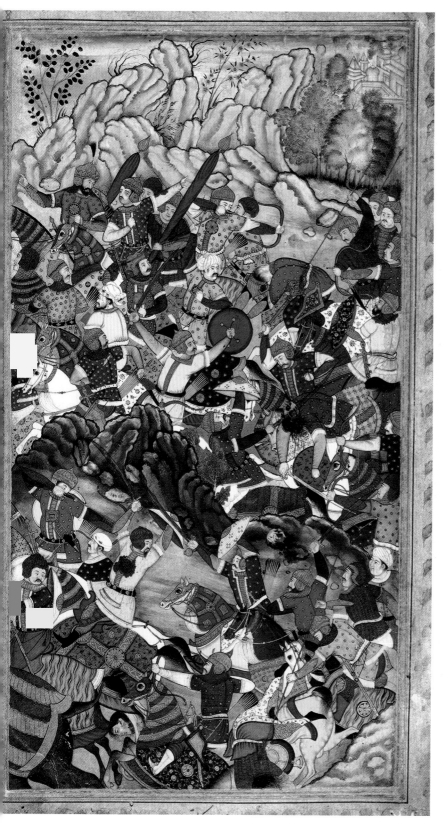

The *Book of Babur*, from which the present miniature is taken, contains the memoirs Babur wrote in his own hand (using the Chagatai language of the Turks and Mongols of Central Asia). It provides a fairly detailed account of the military and political events of his reign, as well as a full commentary on and description of the Battle of Panipat. The diary was translated into Persian in the late 16th century, during the rule of Babur's grandson Akbar, and the best miniaturists of the Mughal court illustrated it. However, the miniatures are mainly decorative, and stray far from the diary's detailed descriptions.

The Ottoman troops In the battles depicted in the *Hünername*, the Ottoman troops are arrayed in orderly ranks of foot soldiers and horsemen to emphasize their superiority over the enemy.

1526 THE BATTLE OF MOHÁCS

[NAKKAS] OSMAN, **Miniature for the** *Hünername* **by [Seyyid] Lokman**

1587. Istanbul, Topkapi Palace

Hungary falls to the Ottomans

In 1520, Suleiman I (later known as 'the Magnificent') ascended to the throne of the Ottoman empire after his father, Selim I, had conquered large parts of the Middle East and reformed and strengthened the army. Suleiman continued his father's expansionist policy and attacked the kingdom of Hungary (from which he had already wrested the stronghold of Belgrade, then located on the border between the two territories). Hungary at this time was riven by strong social tensions, and the young Hungarian king, Louis, of the Polish–Lithuanian Jagiellon dynasty, faced opposition from a large part of the Hungarian nobility. It was thus easy for the Ottomans to overcome the disunited Hungarian forces at the Battle of Mohács on 29 August 1526. The twenty-year-old Louis was killed, and John Zápolya, the leader of the Hungarian faction opposed to the monarch, took possession of the crown, under the protection of the Ottoman sultan. Suleiman's empire had reached its apogee.

The highpoint of the Ottoman empire

Expansion Selim I (r. 1512–20) had doubled the extent of the empire, conquering eastern Anatolia, Azerbaijan, Egypt and other parts of the Middle East. Suleiman I (r. 1520–66) turned westward to conquer Hungary and, in 1529, lay siege to Vienna.

Internal structure The sultan's power was based above all on boys forcefully recruited from subjected peoples. Employed as soldiers (janissaries) and administrators, they were absolutely loyal to the monarch. Suleiman solidified and reformed the administration through the codification of traditional law.

The arts Suleiman's favourite architect, Sinan, brought the Ottoman architectural style, a synthesis of Byzantine and Islamic traditions, to its pinnacle. Meanwhile, the court saw the institution of the office of official historian and a workshop of miniaturists – these were to celebrate the deeds of the Ottoman sultans in writings and images, and to produce copies of the most important Persian literary texts.

The enemy in retreat In contrast to the well-ordered Ottoman ranks, the Hungarian troops flee in disarray, pursued by a Turkish light cavalry division. The action is concentrated in this corner of the page.

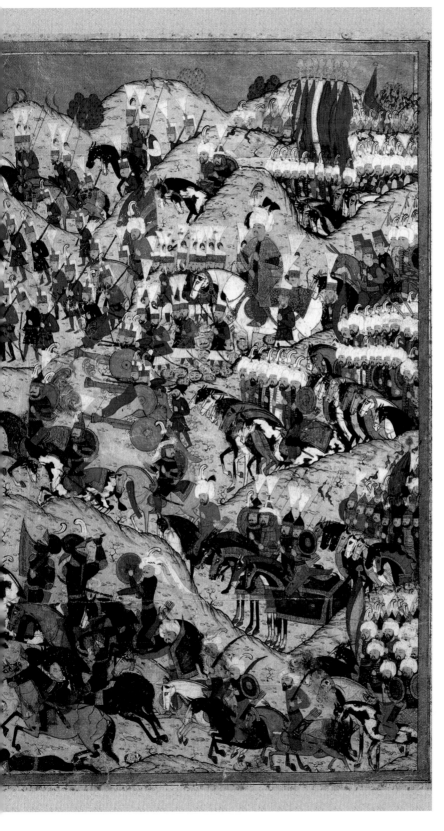

This miniature depicting the Battle of Mohács is from the *Hünername*, a history written and illustrated in the court of Murad III, Suleiman I's grandson. The art of the Ottoman miniature had reached superlative levels, and the imperial workshop in Istanbul employed artists from Persia, Herat and Egypt. They could draw inspiration from the immense collection of miniatures that included both the finest productions of Islamic countries and European volumes that had come from Hungary among the spoils of war. At the centre of this miniature is Suleiman. Wearing a cloak woven with gold, he is represented in a larger scale than the other figures.

1543 EUROPE AND JAPAN MEET

The Arrival of the Portuguese in Japan

c. 1600. Screen: colour and gilt on paper, 170 x 380 cm. Paris, Musée Guimet

A brief period of exchange

It was probably in 1543 that the first Europeans – a group of Portuguese traders and adventurers aboard a Chinese junk – landed on the Japanese island of Tanegashima. The Portuguese consequently established a flourishing three-way trade, taking on goods (especially silk) in China, selling them to the Japanese, and then returning to Europe with rich profits in silver and gold. The Europeans of the period developed great admiration for these distant lands of refined culture, while the technological innovations brought from Europe (weapons, armour and ships) aroused the interest of the Japanese. Immediately successful, arquebuses were copied by local craftsmen, in the process heavily influencing the course of the civil war in Japan. The other great innovation introduced by the Portuguese was Christianity, which quickly won converts. However, the cumulative effect of stirring up the civil war and the missionary activity (which threatened the country's cultural unity) upset many in Japan, and after re-establishing its power over the individual feudal lords between 1600 and 1615, the shogunate decided to close their doors to the Europeans.

The carrack The Portuguese ship is depicted in precise detail. The European carracks and caravels aroused the professional curiosity and interest of the Japanese, who went on to build boats of their own modelled on them.

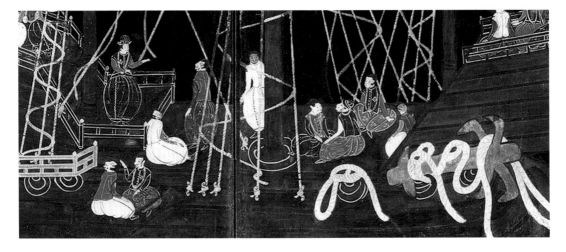

166

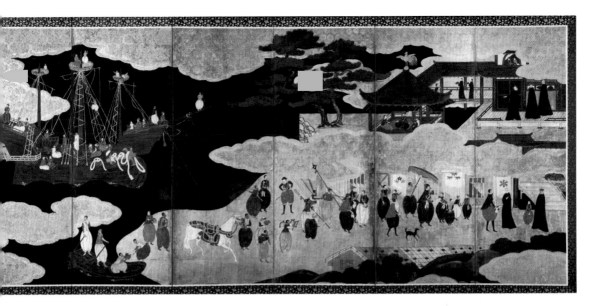

The curiosity aroused in the Japanese by the Europeans, with their different physical features, costumes and customs, spawned a new genre of art in the country. *Namban* is the name given to images and objects inspired by Western models, or that, like this screen, represented the European visitors realistically – even though the Japanese artists sometimes exaggerated certain features of the Westerners.

Men from different countries Japanese artists had a keen eye for observing the foreigners who arrived on their shores. Here, obvious distinctions have been made between the Europeans and people with darker skin – Indians or Africans – that the Portuguese had brought with them from their outposts in India, Indonesia and Africa.

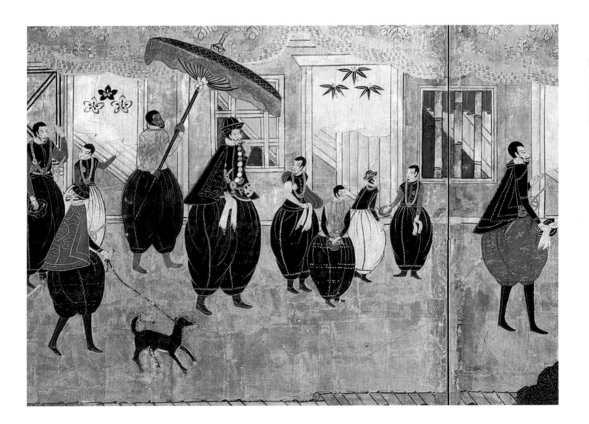

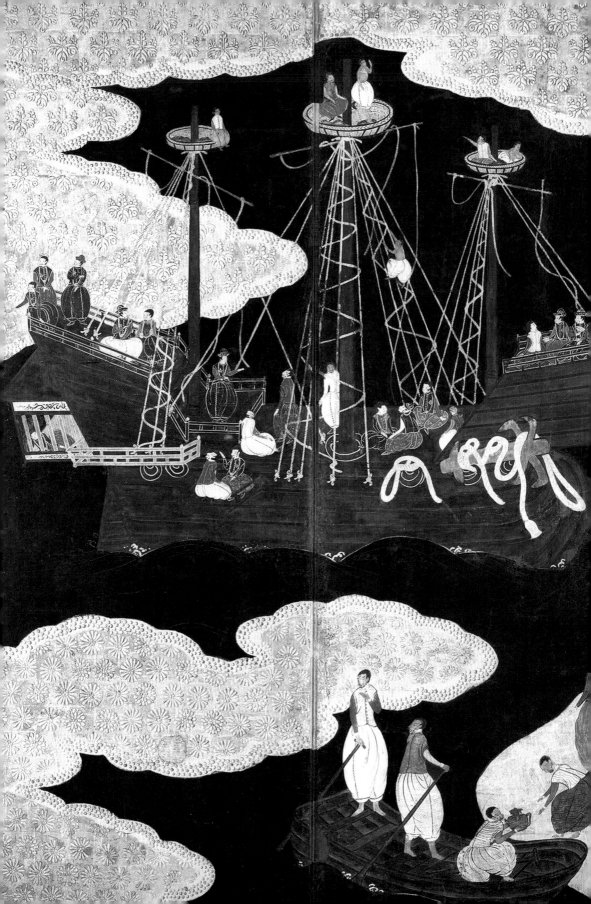

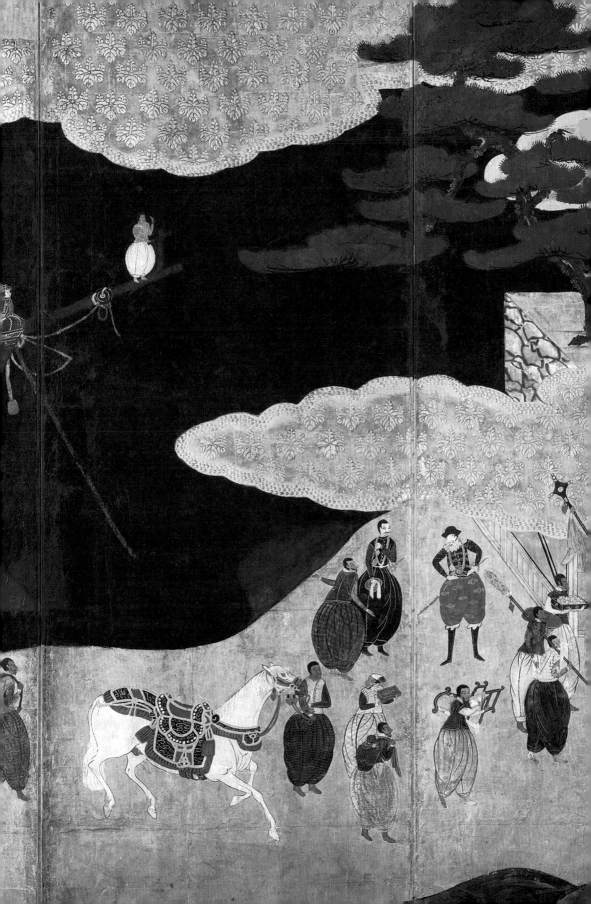

1568 THE EIGHTY YEARS' WAR

Adriaen Pietersz. van de Venne, Fishing for Souls

1614. Oil on panel, 98 x 189 cm. Amsterdam, Rijksmuseum

From rebellion to independence

The conflict between the Spanish crown and the nobility and patricians of the Low Countries that erupted in 1566–68 had been coming for some time due to three issues: the high taxes paid to Spain; Spain's attempts to limit the power of the nobles and city dwellers; and the lack of religious tolerance towards the Protestants, who were widespread in the Low Countries. Moreover, both Catholic and Protestant nobles and cities defended these principles – Count Egmont, a devout Catholic, was condemned to death in 1568 for leading the rebellion. Only about 1600 did the division crystallize into a Catholic south loyal to the Spanish crown and a predominantly Protestant rebel north. At this point, worn down by repeated defeats and wars on other fronts, Spain had to accept the loss of the northern provinces of the Low Countries, at least temporarily, in the truce of 1609. Rekindled in 1621, the conflict did not fully end until 1648.

The Catholic procession The procession on the right bank includes the pope under a gilded canopy. The artist contrasts the lavish Catholic rites with the sober attire of the Dutch Calvinists.

Thriving and dying trees The contrast between flourishing and dried-up trees alludes to Psalm 1, which describes the believer as 'a tree ... [whose] leaf shall not wither'. The trees on the Protestant shore flourish, but those on the Catholic side are dying.

Adriaen van de Venne painted his famous allegory of the conflict between the Dutch and the Spanish after the signing of the truce of 1609, which marked the first step towards the recognition of the independence of the northern Low Countries. Over time, the war had become a religious conflict, which is how Van de Venne represents it: stationed on opposite riverbanks, Protestants and Catholics busily compete to net as many souls as possible.

The revolts leading to the truce of 1609

1569–71 After initial victories, the rebel forces under William of Orange are defeated in 1568. The harsh repressive measures taken by the Spanish king's envoy, the Duke of Alba, strengthen the resolve of the opposition.

1572–79 The rebels take the small port of Brielle, causing another confrontation that is won by the Dutch.

1579–88 Some predominantly Catholic provinces distance themselves from the rebel alliance and form the Union of Arras. The Spaniards reconquer the southern and eastern Low Countries but do not manage to enter the north-west, the rebels' stronghold.

1588–1609 Under the leadership of William of Orange's son Maurice, the rebels again extend their territory to the boundaries of today's Netherlands.

The Protestants and their allies Among the Protestants on the left bank are Maurice of Orange, the stadtholder of the Low Countries rebels; his brother Frederick Henry; and the kings of England and France, who were the most eminent supporters of Dutch independence.

171

The flight of Uluj Ali Pasha As is evident from the inscription *Ociali re d'Alger fug*[ge] *la bat*[taglia] (Ociali, king of Algeria, flees the battle) set in the space between the ships, the anonymous artist has depicted an actual episode from the naval encounter. The Ottoman admiral and ruler of Algiers, Uluj Ali Pasha, whose name was often mispronounced as Ociali in the West, managed to outflank the Genoan array, commanded by Giovanni Andrea Doria. Rather than a flight, it was a counterattack in which Uluj seriously damaged the Christian alliance's navy and then left, undisturbed, to make his way to Istanbul.

Ottoman expansion in the Mediterranean

1515 The brothers 'Aruj and Khayr ad-Din, privateers working on behalf of the Turkish nobles, independently occupy Algiers and its coast but later submit to the Ottoman sultan.

1517 Egypt becomes an Ottoman province.

1522 Rhodes falls into Turkish hands.

1534 Tunisia is conquered by Khayr ad-Din and becomes an Ottoman province.

1535 The Spanish conquer Tunisia in turn.

1538 The Christian powers are heavily defeated near Prevesa, off the coast of Greece.

1540 The Venetians lose their last possessions in the Peloponnese.

1560 The island of Gerba off the coast of Tunisia is occupied by the Turks.

1565 The Turks fail in their assault on Malta, the seat of the order of the Hospitallers (now known as the Knights of Malta).

1566 The Genoese colony at Chios is occupied by the Ottomans.

1571 Famagusta, the last Venetian stronghold on Cyprus, falls to the Turks.

1571 THE BATTLE OF LEPANTO

The Battle of Lepanto
16th century. Oil on canvas, 152 x 202 cm. Venice, Museo Correr

A battle for control of the Mediterranean

Since the first half of the 16th century, Spain and the Ottoman empire had been fighting for control of the Mediterranean, while the seafaring republics of Venice and Genoa – which not only exercised political and military control over vast coastal and island territories but also dominated trade – both suffered at the hands of the Turks. The fight was often not particularly clean, with both sides using corsairs to hinder their enemy's shipping and trade. In 1569, pirates working on behalf of the Knights of Malta captured a ship in the waters of Cyprus that was transporting a huge haul of treasure from Egypt to Istanbul. This incident provoked the Turkish empire to expel the Venetians from Cyprus, which it did in June 1570. Enraged, the Republic of Venice, the Papal States, Spain and some minor Italian states agreed to act in concert against the Turkish sultan's fleet. The agreement was signed on 15 May 1571, but the fleet was not ready to sail until after the definitive loss of Cyprus in August 1571. The ships then headed for the west coast of Greece, where they engaged and soundly defeated the bulk of the Turkish naval force near Lepanto on 7 October 1571.

The Madonna of victory or of the rosary Pope Pius V, who had been instrumental in forging the alliance against the Turks, seems to have been the first to attribute the victory at Lepanto to the miraculous intervention of the Virgin Mary. As a result, he declared 7 October the Feast of the Madonna of Victory or of the Rosary. Thereafter, the apparition of Mary was frequently included in artistic representations of the battle.

The production of paintings of the Battle of Lepanto was especially widespread in Venice. Veterans, families of the fallen and the many confraternities of the rosary that were founded to keep the memory of the battle alive formed a natural market for such works. These paintings often followed the stylistic conventions of *ex voto* images, representing the direct intervention of God and his saints in the battle. The Venetian canvas shown here clearly has a votive intent, but it also attempts to provide a precise depiction of the battle, showing particular interest in the details of the ships, arrangement of the fleet, the costumes and weapons, and the geography. The narrow entrance to the Gulf of Corinth, where the battle took place, is clearly recognizable at the upper right.

Galleys and galleasses Besides classical galleys, the Venetians also had some galleasses (at the left), boats of relatively large tonnage that could mount a greater number of cannons and thus provide increased firepower. These also had cannons mounted broadside, while the traditional galley (above) had cannons on the prow only. The galleasses gave the Venetians a considerable tactical advantage over the Turks.

1571 THE BATTLE OF LEPANTO

Paolo Veronese, **Allegory of the Battle of Lepanto**

1572. Oil on canvas, 169 x 137 cm. Venice, Galleria dell'Accademia

'Clouds of arrows and a great mass of flames'

One of the best-known accounts of the Battle of Lepanto is the memoir of the Venetian Gerolamo Diedo, written for private use but published in 1588: 'Terrible was the sound of the trumpets, kettledrums and drums, but far greater was the roar of the muskets and the thunder of the artillery; and so great were the shouts and clamour of the multitudes that a horrendous din went up and all felt an appalling numbness. Thick clouds of arrows and a great mass of flames flew through the air, which was almost completely black from the smoke'. Anguish and confusion reigned, and even though the Christian powers were victorious, their losses were enormous. However, the Turks had sustained even greater losses: only about forty of the 280 ships involved in the battle returned to Istanbul.

Angelic combatant In this image, the victory of the Christian alliance is attributed to divine intervention. On the instructions of the Madonna, an angel throws flaming arrows at the Ottoman ships, so deciding the battle's outcome.

The battle unfolds…

Around sunrise on 7 October 1571, the Christian ships enter the stretch of sea where the Battle of Lepanto was to take place. The commander-in-chief of the Ottoman fleet, Ali Pasha (also known as Müezzinzade), decides to attack.

The six Venetian galleasses open barrage fire with their remarkable firepower as the Turkish ships approach.

Having avoided the galleasses, Ali Pasha deploys the greater part of his fleet in attacking head-on the centre of the Christian formation, where the flagship of the commander-in-chief, John of Austria, is located.

The Christians barely escape the Turks' attempt to surround them to the north and south. Nevertheless, the Ottoman forces cause considerable damage to the Christian fleet, especially on the southern flank.

In the centre of the deployment, the Christian allies finally board the Turkish flagship, beginning the hand-to-hand combat on the ships. Ali Pasha is killed and the Turkish forces retreat.

This canvas by Paolo Veronese has the traditional composition of an *ex voto* image, and would have been exhibited in a church or sanctuary. The lower part depicts the happy outcome of the Battle of Lepanto; the upper part depicts the miraculous intervention of the saints that assured this outcome. The painting was probably commissioned by Piero Giustiniani, who commanded the contingent of the Knights of Malta at Lepanto and, though wounded several times, survived the battle. The lower part demonstrates the skilful interplay of light and shadow that characterizes the painting of Veronese.

Madonna and saints Veronese depicts a group of saints who intercede with the Madonna on behalf of the combatants. From left to right, they are: St Peter, St Roch, St Justina (holding the sword or dagger of her martyrdom) and St Mark (with his symbol, the lion, next to him). The white figure between Mark and Justina has been read as a personification of Faith.

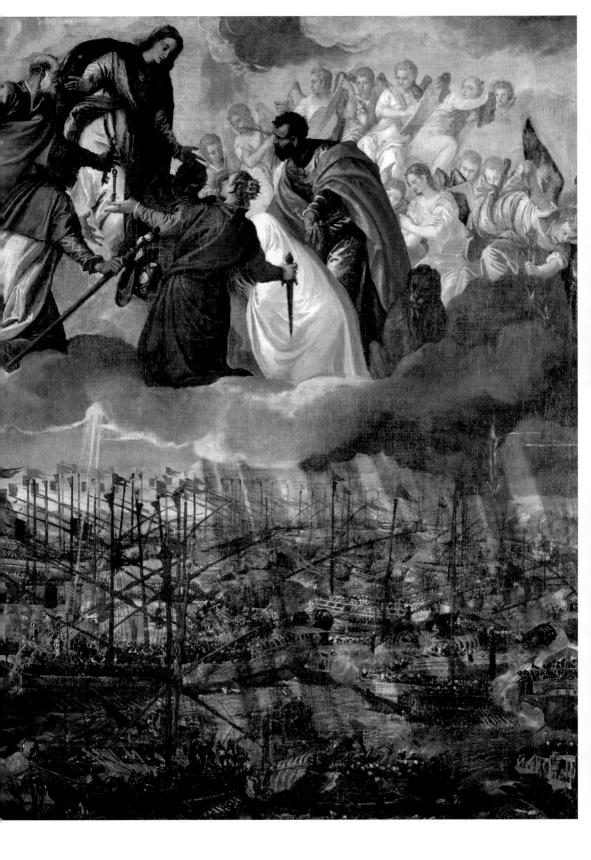

John of Austria In addition to the representatives of the Christian allies, there is a young man holding a sword who also looks up into the sky. This idealized portrait has been identified as John of Austria. The painting could have been commissioned on the occasion of his death (1577) or the translation of his remains to the royal monastery of the Escorial (1578).

John of Austria, hero of Lepanto

1547 John of Austria is born, the illegitimate son of Emperor Charles V and a daughter of artisans from Ratisbon.

1559 The king of Spain, Philip II, his half-brother, receives him at court and has him given the same education as the royal princes.

1568 He is appointed commander-in-chief of Spain's Mediterranean fleet.

1569–70 He takes part in acts of repression and the expulsion of the last Moors from the south of Spain.

1571 At the age of only twenty-four, he heads the fleet of the Christian alliance that wins the Battle of Lepanto. He is celebrated as a hero throughout Europe.

1576 After obtaining various other naval commands, he is sent by his half-brother Philip II to put down the rebellion in the Low Countries.

1577 John dies from an illness in a military camp in the environs of Namur while on campaign against the rebel Dutchmen.

1571 THE BATTLE OF LEPANTO

EL GRECO, **The Adoration of the Name of Jesus**
1578–79. Oil on canvas, 140 x 110 cm. Madrid, Monasterio de San Lorenzo de El Escorial

A victory above all psychological

Although in Venice, Rome and Spain the battle was celebrated enthusiastically and with constant reference to divine intervention, the geopolitical and military balance in the Mediterranean was barely altered. The Ottoman empire succeeded in rebuilding its naval strength in a few months and equipped itself with galleasses, the type of boat that had given the Venetians such an advantage at Lepanto. Furthermore, the Republic of Venice was forced to offer the Turks a separate peace in order to resume trade relations, while it had to accept the loss of Cyprus, which had been the initial motive for the war. The Turks embarked upon an expansionist policy in the Mediterranean. In 1574, they took Tunisia from the Hafsids, a Muslim dynasty allied with the Spanish. After 1571, however, all the former Mediterranean powers began to lose influence and importance. The new centres of the European economy were now London and Amsterdam, linked to the ocean trade routes.

In this painting by El Greco, the focus is clearly the luminous vision of the monogram of Christ. In the lower part is a group of men who represent the victorious alliance of Lepanto: Philip II of Spain in a black cape and trousers; Pope Pius V, wearing liturgical vestments; and from the back, in a cloak of golden tones, the doge of Venice, Alvise Mocenigo. Far from being a direct account of the historical events, the main military and political figures of the victory of Lepanto are included here in a programme that seems to foreshadow the Last Judgment: the Christian princes lead the faithful to heaven, while the infidels, the damned and heretics are devoured by hell, represented as a monster's gaping maw.

The monogram of Christ The monogram IHS (a contraction of the Greek spelling of the name of Jesus) evokes an important past event. Before the Battle of the Milvian Bridge in 312 (see p. 66), a similar monogram appeared to Constantine with the inscription *In hoc signo vinces* (By this sign you will conquer), which can also be abbreviated to the letters IHS. Philip II, who commissioned the painting, wished to include himself in the tradition of the great defenders of Christianity.

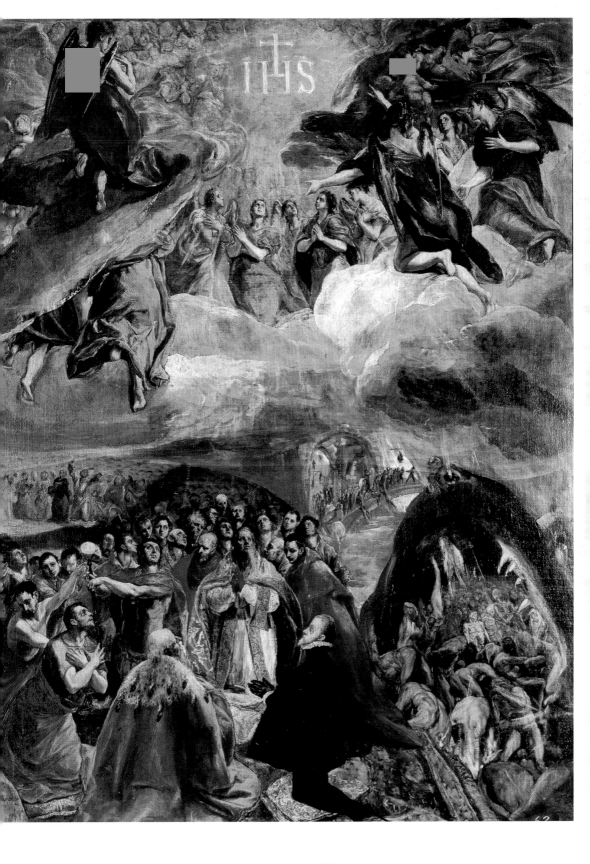

The Wars of Religion in France

Duration

Tension between Catholics and Protestants reached a critical level in 1560 after the failed Conspiracy of Amboise, in which some Protestant aristocrats had plotted to overthrow King Francis II. This was followed by harsh repression of Protestants by Catholic extremists. The wars only ended in 1598.

Causes

The Protestants' struggle for recognition of their faith; the weakness of King Francis II (r. 1559–60) and Charles IX (r. 1560–74), both of whom ascended to the throne as children; the resistance of a part of the nobility to royal centralism; interference from foreign powers.

Consequences

The country was devastated, and the French monarchy's centralized power was curbed. After the war, however, it became clear that a strong state was needed to avoid divisive conflict.

1585 THE LAST PHASE OF THE WARS OF RELIGION

François Bunel the Younger (or circle), The Procession of the League, 5 June 1590

1590–99. Oil on panel, 44 x 57 cm. Valenciennes, Musée des Beaux-Arts

From war to reconciliation

When, in 1584, Henry III, king of France, recognized the Protestant prince Henry of Navarre (the future Henry IV) as the legitimate successor to the throne, the conflict between Protestants and Catholics suddenly flared up again. A group of Catholics unwilling to compromise had already formed the 'Catholic League' and allied themselves with Philip II of Spain to oppose the succession of a Protestant prince. The League's troops took Paris in 1588 and maintained their control of the city after Henry III was killed by a Catholic assassin – despite various attempts by his successor, Henry IV. The new king did not manage to enter the city until 1594, after embracing the Catholic faith. The programme of reconciliation Henry IV initiated between the two faiths culminated in the Edict of Nantes of 1598, which granted some religious freedom to the Protestants in the context of a predominantly Catholic France. He also endeavoured to rebuild the authority of the monarchy, which had been violently shaken by the long Wars of Religion.

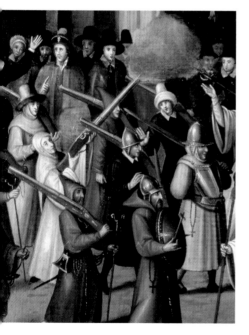

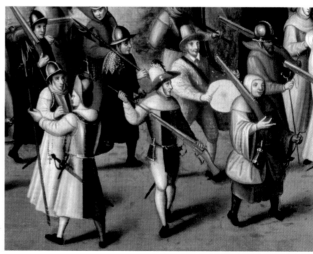

Brothers in arms The procession's participants are mainly laymen and members of the orders, who wear breastplates and helmets over their ecclesiastical garments. Some are firing their arquebuses.

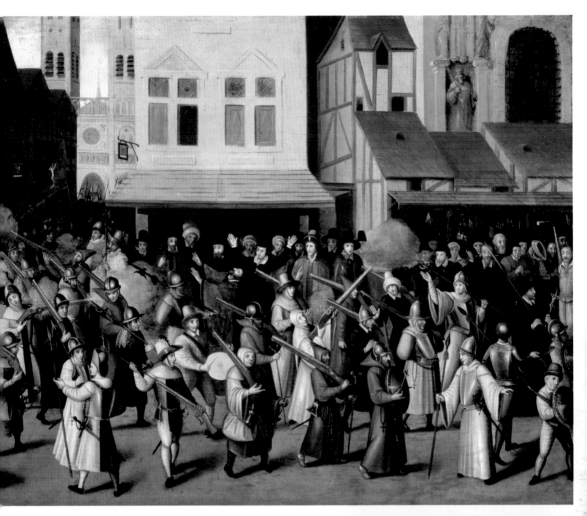

François Bunel the Younger, in whose circle this panel was painted, was employed by Henry IV. Thus, this procession of staunch Catholics is treated in a disparaging, almost satirical, way. The events that it represents took place in 1590, when Henry IV was besieging Paris. In the city reduced to starvation, an armed procession was organized to demonstrate the will to resist the assault of the prince, who at that point was still a Protestant.

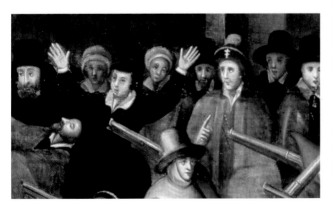

The Parisians The citizens of Paris standing in front of shops along the procession's route do not seem to express particular enthusiasm. The men of the Catholic League had in fact inaugurated a reign of terror in Paris. Not only were Protestants persecuted, but also any Catholics inclined to compromise with the enemy.

Main figures

King Philip II of Spain; Queen Elizabeth I of England; Francis Drake (who fought as an English corsair and vice-admiral).

Goals

For Spain, to reintroduce the Catholic religion into England, avenge the execution of the Catholic Mary Stuart, deprive the Dutch rebels and French Protestants of English support and make the seas safe for its own ships; for England, to defend the Protestant Reformation and deprive the Catholic opposition of Spain's support.

Results

Only later was the defeat of the Invincible Armada considered the beginning of the end of Spanish domination of the seas. At that time, Spain's control of the seas remained firm, and an English attempt to attack Spanish ports the following year failed.

1588 THE DEFEAT OF THE INVINCIBLE ARMADA

George Gower, **Elizabeth I and the Armada**

c. 1590. Oil on panel, 106 x 134 cm. Woburn, Woburn Abbey

A blistering defeat for the Spanish empire

When Philip II of Spain organized an imposing fleet – the Invincible Armada – to invade England, Spain was Europe's, if not the world's, dominant power. Setting out in May 1588, the planned invasion soon turned to disaster, however. Despite the superior number and firepower of Spain's ships, the English fleet inflicted a considerable defeat on them off the coast of the Spanish Netherlands, where the Armada was waiting to take on reinforcements for the invasion. Although Spain managed to reassemble its fleet, the English navy prevented the Spanish ships from either turning back to the Flemish coast or crossing the Channel homeward in retreat. At this point, the Spanish chose the highly risky path of sailing around England, Scotland and Ireland to reach the shores of Iberia. But bad weather, storms and the lack of provisions for so long a voyage cost more lives than the military encounter with the English, and only a small proportion of the Spanish ships returned – months later – to Spain.

The globe Elizabeth rests her hand on a globe. Her palm covers America, one of the areas contested with Spain, even though the English had founded their first colonies there only twenty years after the Spaniards.

The light of fortune To the left of the queen are English ships in full sunlight; Elizabeth's face is also bathed in light. In the other window, however, the Spanish ships are shown under a dark, stormy sky.

Although the features of Elizabeth can be considered relatively true to life, this portrait, executed by the court painter George Gower, is not really about realism. Rather, the artist aimed to create a statement of power. Elizabeth's body disappears under her sumptuous, voluminous costume, and she is transformed into an emblem of sovereignty.

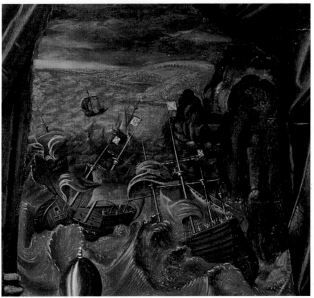

The Spanish Armada To the right of the queen, the ships of the Invincible Armada smash against the rocks, as happened on their return voyage along the Irish coast.

Akbar, the father Jahangir is represented holding a portrait of his father, Akbar, thus underscoring the legitimacy of his succession. Jahangir's ascension to the throne had been opposed by some in the court because of his revolt in 1600–1602 and his tendency to consume alcohol and opium.

1600 THE REBELLION OF JAHANGIR

ABU'L HASAN AND HASHIM, **Jahangir with a Portrait of His Father, Akbar**

c. 1615. Watercolour, gouache and gold highlights on paper, 12 x 8.3 cm. Paris, Musée Guimet

Father–son conflict

In July 1600, a serious conflict broke out in the Mughal empire, which had expanded hugely under Akbar. Akbar's son and heir designate, Salim (later called 'Jahangir', or 'world conqueror'), took advantage of his father's absence to rebel but did not manage to take possession of the capital, Agra, and was forced to flee when his father's troops returned to quell the revolt. Salim refused Akbar's attempts at mediation and in 1602 had his trusted counsellor Abu-l Fadl – who had attempted to settle the dispute – assassinated. Salim and Akbar were eventually reconciled, and the son was reinstated as heir. In 1605, he ascended to the throne, and the Mughal empire continued to flourish through his reign, although the government gradually slipped from his control due to his indulgence in alcohol and opium. The government then passed to his favourite wife, Nur Jahan, and her family, who divided between themselves the various public duties of the empire.

Mughal India

Extent Akbar (r. 1556–1605) governed present-day Afghanistan, Pakistan and the whole of northern India as far as the central zone of the Deccan; after the death of his son Jahangir in 1628, Shah Jahan (r. 1628–58) and Aurangzeb (r. 1658–1707) also managed to control vast areas of southern India.

A multinational empire Founded by Babur and his followers, the Mughal dynasty initially consisted of a restricted elite of foreign warriors in heavily populated India. Akbar incorporated part of the Hindu aristocracy into the empire's ruling class, forming shrewd alliances through marriage.

The arts Architecture (for example the famous Taj Mahal, built by Shah Jahan), landscape gardening (the creation of sumptuous parks) and the decorative arts achieved remarkable new heights. The Mughal sovereigns were personally interested in, and great patrons of, the arts, philosophy and science.

Hindu motifs The miniature also includes forms from the Hindu tradition. Both Jahangir and his father, Akbar, promoted a synthesis between the Mughals' Turko-Persian culture and that of the local Hindu population.

In this small portrait of the Mughal emperor Jahangir, we can clearly see the evolution of the art of the Indian miniaturists as they synthesized the Persian tradition with new European influences. In fact, Akbar's counsellor and chronicler, Abu-l Fadl, records that European works were held in high esteem because 'through the use of particular forms, the artists of Europe express the moods of the soul'. In this miniature the Indian artist seems to want to capture the relationship between the son and his deceased father.

1600 EUROPEAN EXPANSION

HENDRIK VAN SCHUYLENBURGH, **The Dutch East India Company's Trading Post at Hougly, Bengal**

1665. Oil on canvas, 203 x 316 cm. Amsterdam, Rijksmuseum

Europe's economic domination

The English East India Company was founded in London on 31 December 1600. Recognized by royal decree but financed privately, the company monopolized trade between England and Asia. A similar institution, the Dutch East India Company, was founded in Amsterdam two years later. England and Holland thus joined Portugal and Spain in a process of European expansion to other parts of the world that had begun in the 15th century. However, in the 17th century this process mainly took the form of trade and economic domination. First the Portuguese, then the Dutch and English, and later other European nations, built an extensive network of trading posts and military bases, without ever penetrating the interior. Only the Spanish founded a colonial empire that encompassed vast inland regions.

The Trading Post The Dutch East India Company trading post dominates the foreground. Indian labourers toil in the courtyards, lugging merchandise while Dutch merchants conduct business. The entrance pavilion is guarded by warriors in Oriental dress.

Global trade in the 17th century

In the 17th century, Europe controlled flourishing intercontinental trade.

Asia While the English East India Company imported cotton, silk, indigo dye, saltpetre and tea from Asia, the Dutch concentrated on the spice trade, supplanting the Portuguese.

Africa The Portuguese, who had established a series of trading centres along the coast of Africa, were involved in trading slaves between Africa and the plantations of America. They also exported ivory, precious woods and gold from the continent.

The Americas Besides exploiting the New World's gold and silver deposits, the Spanish and Portuguese developed intensive agriculture, producing in particular sugar and cacao.

The Camp In the camp's main tent, a seated dignitary stands out amid the courtiers; in the tent at the right, food is being prepared. The artist has injected scenes of daily life all around the camp, from musicians to a peasant's ox-drawn cart.

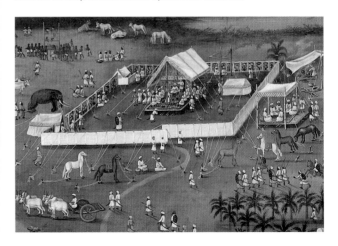

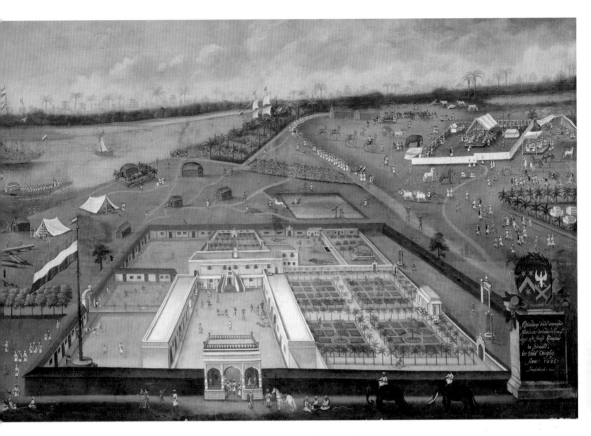

This unusual painting of an Asian landscape – more specifically the Ganges delta – seen through the eyes of a Dutch painter was commissioned by Pieter Sterthemius, the first director of the Dutch East India Company in Bengal. Presumably, Hendrik van Schuylenburgh was not relying on his imagination but knew these places first hand: it seems likely that from 1661 to 1668 he was travelling in Asia, where he would have taken on the task of recording on canvas the trading centre at Hougly, the main seat of the Dutch East India Company in Bengal (the area around the border between present-day India and Bangladesh).

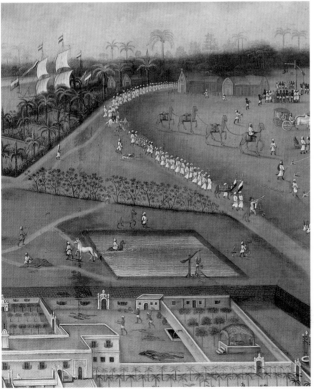

The Procession A procession winds along the road in the background. At the head is a trumpeter in Western attire, followed by servants carrying the Dutch flag. Conveyed on a litter, a Company official nears the camp on the right, where an Indian dignitary awaits him. Throughout this scene, the painter lingers over anecdotal descriptions of local life, including, among other things, a small caravan of camels also headed toward the camp.

185

1600 EUROPEAN EXPANSION

Juan Bautista Maíno, The Recovery of Bahia de Todos os Santos in 1625

1634–35. Oil on canvas, 309 x 381 cm. Madrid, Museo Nacional del Prado

New maritime and trade powers

When England and Holland became commercial powers in the early 17th century, both nations were already in conflict with Spain – which, from 1580 to 1640, was also united with Portugal. In particular, the Dutch, who were fighting the Eighty Years' War against Spain, decided to target outposts from the Portuguese and Spanish. In 1624, they temporarily occupied Portugal's Bahia de Todos os Santos, in Brazil, and later the province of Pernambuco. Some African outposts were conquered as well. More incisive and longer lasting, however, was the intervention in Asia, where the Dutch fought for control of the Moluccas, the source of the most highly prized spices. There, they wrested from the Portuguese the important Strait of Malacca, through which all maritime traffic from China and South-east Asia passed.

The soldier's wife This figure bends forward expressing intense anxiety and expectation. The soldier's jacket she carries under her arm suggests that she is the wife of the wounded man, at whom she is gazing.

Charity The foreground scene centres on a wounded, bare-chested soldier and two people who are aiding him. The woman with the white headscarf has been interpreted as a personification of Christian Charity.

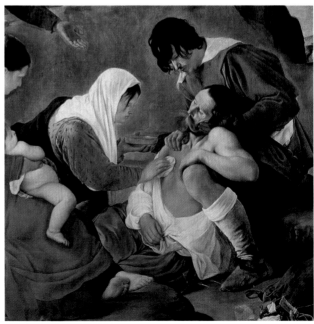

The subject of Maíno's canvas is an episode in the conflict between the Low Countries and Spain for control of sea routes and colonies. On 1 May 1625, a Spanish and Portuguese expedition retook the Brazilian colony of Bahia, which had fallen into the hands of the Dutch. Like Velázquez's famous painting of the surrender of Breda, this work was meant for Philip IV's throne room as part of a series of celebratory paintings on the Spanish armies.

The painting in the painting To celebrate Spain's triumph in retaking Bahia, the commander Fadrique de Toledo shows the defeated Dutch a tapestry representing Philip IV being crowned with a laurel wreath by Minerva, the Roman goddess of war, and the Count-Duke of Olivares, the king's favourite. At the feet of Philip and Olivares are allegorical figures representing Heresy, Wrath and Deceit — characteristics of Spain's enemies.

The stages of the war

Bohemian–Palatinate period, 1618–23

The Protestant noblemen rebelling against the Catholic monarch, Ferdinand II of Habsburg, elect Frederick V of the Palatinate as their new king in 1619. However, Frederick and the Protestants are quickly defeated.

Danish period, 1625–29

After the Protestants are defeated, King Christian IV of Denmark enters the war. The Catholic and Habsburg troops overwhelm him and force him to sign a peace treaty in 1629.

Swedish period, 1630–35

The Protestants are then supported by the Swedish king, Gustav II Adolf. He sets out to conquer the Habsburg capital of Vienna but dies in the Battle of Lützen in November 1632. The war again turns in favour of the Catholics and the Habsburgs.

Franco-Swedish period, 1635–48

Wary of the Habsburg emperor's growing strength, France signs an alliance with Sweden and enters the war. After a string of alternating victories and defeats of the Franco-Swedish alliance, peace negotiations are undertaken in 1645.

Ifrael ex. Cum Priuil. Reg.

A la fin ces Voleurs infames et perdus ,
Comme fruits malheureux a cet arbre pendus

1618 THE THIRTY YEARS WAR

JACQUES CALLOT, **The Miseries and Misfortunes of War**
1633. 18 etchings. Vienna, private collection

From religious wars to a pan-European war

On 23 May 1618, some Protestant Bohemian noblemen threw two Catholic regents of the Habsburg government and their secretary out of a window of Prague Castle. This act, sparked by protest against the Counter-Reformation policies of Emperor Ferdinand II of Habsburg, set off a chain of events that eventually resulted in a war lasting thirty years. The conflict between the Protestant nobility and the Habsburg government in Bohemia quickly spread throughout the empire, causing Protestant and Catholic princes to confront each other. It eventually dragged in all the European powers, becoming a war for hegemony. The war almost completely devastated the territory of the Holy Roman Empire, from northern Italy to the Baltic.

The consolation of religion The hanging mercenaries are attended to by friars and priests who exhort them to repent.

'en que le crime (horrible et noire engeance)
e instrument de honte et de vengeance,

Et que ceft le Deftin des hommes vicieux
Defprouuer toft ou tard la iuftice des Cieux. 2]

Jacques Callot, an artist from Lorraine, executed a series of eighteen etchings on the miseries of war after his region was invaded by France in 1632–33. His prints tell the story of a battalion of mercenaries of the time, from their enlistment to combat and pillaging. The series' overall meaning is obvious, though some are particularly graphic: for example, in the ninth etching the mercenaries, who had committed some misdeed, are captured by other soldiers and condemned to hideous punishments – such as the mass hanging depicted in the eleventh print.

Order re-established The hanged men in the tree are contrasted with the soldiers' disciplined formation. This terrifying scene is not just another of the mercenaries' abuses of power, but a sort of 'divine justice' for their earlier criminal acts, as emphasized by the verse that accompanies the image.

Christian of Brunswick (also called Christian the Younger) Organizer of a mercenary militia on behalf of the Protestant prince Frederick V of the Palatinate. His Catholic enemies nicknamed him the 'madman of Halberstadt' because of his impetuous temperament and the ruthlessness with which he conducted the war. He was one of the first commanders systematically to sack territory to maintain his army. He died of an illness in 1626, at the age of twenty-six.

Albrecht von Wallenstein A Bohemian nobleman who became wealthy through an advantageous marriage and from 1617 founded mercenary militias on behalf of the Habsburgs. After 1620, he took part in the repression of the Bohemian rebellion, and in 1625 he was placed at the head of the imperial troops. The war made him even richer, and he became the duke of Mecklenburg. Fearing the commander's growing power, the Emperor Ferdinand II had him assassinated in 1634.

Johan 't Serclaes, Graf von Tilly Commander-in-chief of the Catholic League until his death in battle in 1631. He was sixty years old when the war broke out. His siege of Magdeburg was infamous: the Catholic troops sacked and completely destroyed the city.

Voyla les beaux exploits de ces cœurs inhumains Ils rauagent par tout rien nechappe h. leur mains

1618 THE THIRTY YEARS WAR

Torture 'One invents torments for gain of gold, the other urges his accomplices in ways a thousandfold', as the rhymed caption of the fifth etching states.

A war without quarter

'The towers are in flames, the churches toppled, the town hall is left to destruction … the maidens are raped', wrote the German poet Andreas Gryphius in 1636, describing Germany's forlorn situation after almost twenty years of war. The effects of the military campaigns on the population and the land were horrendous. The armies employed by the princes were usually private militias and often sold themselves to the highest bidder. Since the warring parties had trouble paying wages on time, the militias took anything that might be of use to them from the cities they occupied and the territory they passed through during displacements. Crops and livestock were requisitioned, houses and villages sacked. This, in turn, caused shortages and epidemics, which spread throughout the devastated land. It is estimated that in some areas, more than half the people were victims of the war and its consequences.

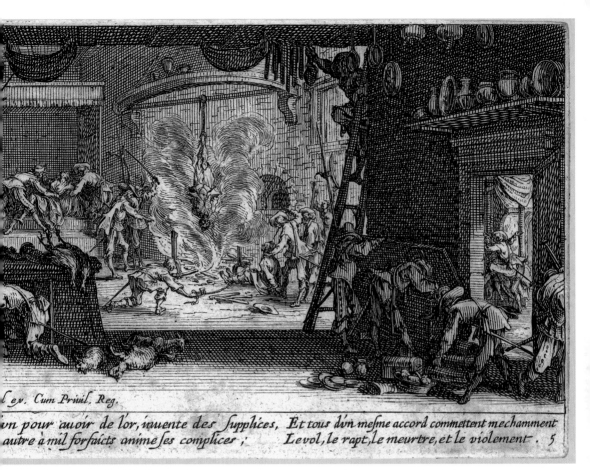

ex. Cum Priuil. Reg.

vn pour auoir de l'or, inuente des supplices, Et tous d'vn mesme accord commettent mechamment
autre à mil forfaicts anime ses complices ; Le vol, le rapt, le meurtre, et le violement . 5

Might is right With the precision and clarity of a photo-reportage, the fifth print in Callot's series records the everyday reality of the civilian population during the Thirty Years War. A division of soldiers has taken over a large and presumably well-to-do house. The mercenaries arbitrarily rape, torture and murder as they pillage food, furniture and objects of value.

Revenge The seventeenth etching shows some farmers who had been subject to the soldiers' abuse set an ambush for their tormentors, whom they massacre in turn. More than outrage at war, the artist reminds us of the need to re-establish discipline, even through brutal justice, in order to curtail man's savage instincts.

Apres plusieurs degast par les soldats commis Les guettent à l'escart et par vne surprise Et se vengent ainsi contre ces Malheureux
A la fin les Paisans, qu'ils ont pour ennemis Les ayant mis à mort les mettent en chemise, Des pertes de leurs biens, qui ne viennent que d'eux . 17

The final phases of the Eighty Years' War

Main figures
Frederick Henry of Orange, stadtholder of the northern provinces; Ernst Casimir of Nassau, stadtholder of the provinces of Friesland, Groningen and Drenthe; Ambrogio Spinola, commander of the Spanish troops; Cardinal Infante Ferdinand, governor of the Spanish Netherlands.

Locations
Bergen-op-Zoom, Breda, 's-Hertogenbosch and Maastricht are some of the cities attacked during the war. Naval battles near the Downs on the English Channel, in the Bay of Matanzas, Cuba, and in the Bay of Manila, Philippines, were also significant.

Goals
For the Spanish, to reaffirm at least nominal sovereignty over the northern Netherlands, and weaken Dutch maritime power; for the Dutch, to confirm full independence and strengthen their position in world trade, to Spain's detriment.

1625 THE SURRENDER OF BREDA

Diego Velázquez, The Surrender of Breda (The Lances)

c. 1635. Oil on canvas, 307 x 367 cm. Madrid, Museo Nacional del Prado

The fight for independence and European alliances

The Spanish siege of the Dutch stronghold of Breda, from August of 1624 until the city surrendered on 2 June 1625, occurred in the eighty-year war waged by the northern provinces of the Netherlands for independence from Spain. The earlier armistice of 1609 (see pp. 170–71) ended in 1621, at which point the conflict was renewed. However, the war did not reach the intensity of the earlier decades, nor did it have the devastating effects of the contemporary Thirty Years War in Germany, since by this point the Spanish had abandoned the idea of reconquering the northern provinces, which were allowed their independence. However, limited military operations were conducted for the purpose of strengthening the respective positions during peace negotiations.

The lances The upper right of the painting is filled with the Spanish troops' tightly arranged lances – which stand in contrast to the chaotic Dutch troops at the left.

The adversaries The centre of the painting portrays Justin of Nassau, the Dutch governor of Breda, and Ambrogio Spinola, the commander of the Spanish troops. Spinola places his hand on the defeated general's shoulder in a gesture of welcome as Justin, bent slightly forward, hands over the key to the city.

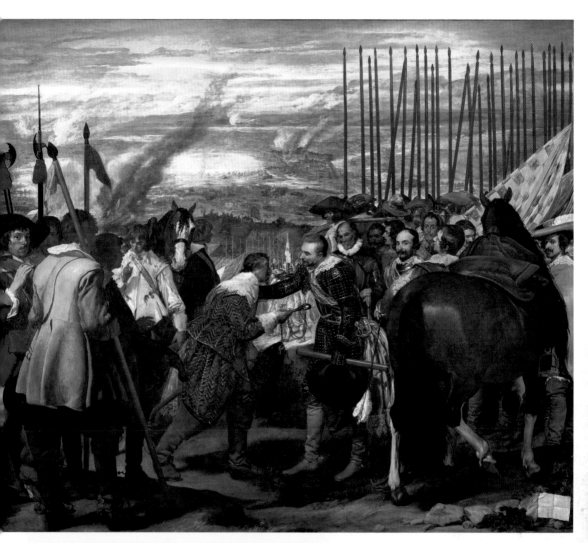

Commissioned for the throne room of King Philip IV of Spain, this famous painting depicts the surrender of Breda as a gentlemanly encounter between mutually respectful adversaries, even if it was the final act in a nine-month siege that had reduced the garrison and townsfolk to starvation. Velázquez obviously intends to emphasize the Spaniards' magnanimity – the quality of an army and an empire sure in its victory. When the artist painted the canvas, the war was still in progress, and the final result – with Spain forced to recognize the Netherlands' full independence – ran counter to Spanish expectations.

The discouragement of defeat Among the surrendering soldiers, a young man stands out who is visibly affected by defeat. One of his companions lays a consoling hand on his shoulder.

1630 THE PLAGUE

Nicolas Poussin, **The Plague at Ashdod**

1630–31. Oil on canvas, 148 x 198 cm. Paris, Musée du Louvre

A vicious circle of war, shortages and disease

After the Great Plague of the 14th century, the terrible disease became more or less native to Europe. From the 15th to the 18th centuries, Europe witnessed many new outbreaks, often with disastrous, but local, effects. Contagion increased in the 17th century, and the epidemic again struck with great force throughout Europe. As in the 14th century, the spread of the disease was preceded by dreadful shortages that weakened the populace. This new string of catastrophes occurred during the so-called Little Ice Age, a slight lowering of the average temperature that caused cold, rainy summers with disastrous effects on crops. It was also closely related to the ongoing wars, which were fuelled by the social insecurity this crisis caused and, in turn, aggravated shortages by destroying crops and farms. Furthermore, the continuous displacement of large masses of people on military campaigns helped spread the epidemic.

The colour of death In this work Poussin focuses on the individual fate of each person swept away by the epidemic, depicting gestures and facial expressions with great drama. However, his grey-green palette also conveys the hideousness of their death, even if it is more expressionistic than naturalistic.

Poussin drew inspiration from an Old Testament story to speak of his own time. The book of Samuel tells that the Philistines had stolen the Ark of the Covenant, the most sacred object of Judaism, and God punished them for this sacrilege by smiting them with a plague. However, the painting's stricken bodies, disturbed faces and desperate gestures tell of the disasters of 17th-century Europe and the disturbing news that reached Rome (where the artist was living in 1630) from Milan and central-northern Italy.

Rats and gravediggers Though drawing on all the conventions of contemporary Baroque art (such as the antique-style architecture that serves as a stage set), Poussin realistically relates the irruption of plague in the life of a city. The rats foraging among the victims' corpses are a particularly daring touch.

The confrontation between Charles and Parliament

1629 Charles I dissolves Parliament and abrogates all prerogatives of government to himself.

April 1640 Pressured by a rebellion in Scotland, the king reconvenes Parliament, which is little inclined to accede to his request to finance an army against the Scottish rebels. The so-called Short Parliament is dissolved after only three weeks.

November 1640 After suffering a clear defeat from the rebels, the king again convenes Parliament (known as the Long Parliament, as it sat until late 1653).

1642 In a show of force, Charles tries to arrest the members who are hostile to him. This open violation of parliamentary immunity sparks revolt, and the king is forced to flee London.

1642–45 The royalist troops are defeated by the parliamentary army at the Battle of Naseby, in central England.

1647 The king falls into the hands of his parliamentary opponents. He is tried and executed in 1649.

1642 ENGLAND'S CIVIL WAR

ANTHONY VAN DYCK, **Portrait of Charles I Hunting**

c. 1635. Oil on canvas, 266 x 207 cm. Paris, Musée du Louvre

Towards a popular sovereignty

Sometimes called the 'English Revolution', the period of confrontation between the English Parliament (intent on defending its traditional prerogatives) and the House of Stuart (determined to impose an absolutist government on its English, Scottish and Irish subjects) climaxed with the beheading of King Charles I in London on 30 January 1649. Though it was not the first time a king had met his death at the hands of political opponents, it certainly was unprecedented for a king to be tried in the 'name of the people', as happened with Charles. The sentence of the high court appointed by Parliament overturned the principle of absolutism (which placed the monarch above the law) and established instead that the sovereign was bound to use his authority 'for the good and benefit of the people and for the preservation of their rights and liberties'. Even though the motives of the protagonists on both sides were entangled in the traditional divisions of English society, and even though the republic instituted after Charles's death was short-lived (his son Charles II returned to the throne in 1660), it is unquestionable that the 'revolution' had introduced new concepts such as 'popular sovereignty' and equality before the law that would play a large role in the coming centuries.

The death of Charles I This depiction of the execution in front of the royal residence, Whitehall Palace in London, shows an interest in describing the details of the event. The executioner, with a bloodied axe, is masked, and the face of the assistant who displays Charles's severed head to the crowd as a sign that the execution has taken place is also hidden.

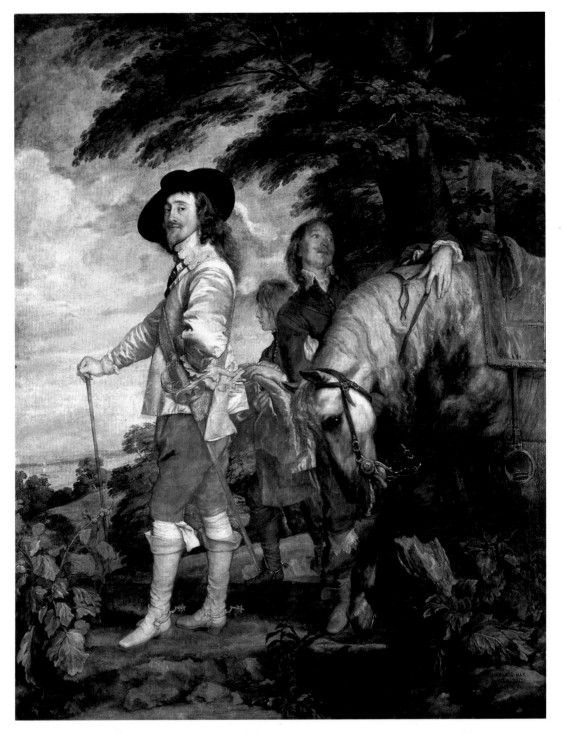

Precisely because the king is portrayed in an informal situation, during the hunt, without ornament or emblem that might refer to his regal station, this 1635 portrait by Anthony van Dyck, first painter to the court of Charles, became a manifesto of the absolutist conception of royal power: Charles – at the time of this portrait about thirty-five years old – appears as a 'naturally' different and aristocratic figure, in both his bearing and elegant costume. The impression of royal superiority the painting seeks to communicate is underscored by the contrast of the two squires, whose pose is determined by their practical duties (holding the horse, carrying clothes), while the figure of Charles stands out freely against the horizon, with its distant river landscape and sailing ship.

1648 THE PEACE OF WESTPHALIA

Bartholomeus van der Helst, **The Celebration of the Peace of Münster, 18 June 1648, in the Headquarters of the Crossbowmen's Civic Guard (St George Guard), Amsterdam**
c. 1649. Oil on canvas, 232 x 547 cm. Amsterdam, Rijksmuseum

Wine and food The burghers of Amsterdam liked to celebrate with choice food and plentiful wine. Some show their cultivation by using a knife and fork, implements that were spreading throughout Europe in the 17th century.

Assertion of the modern concept of sovereignty

The Thirty Years War that had devastated Germany and its neighbours finally came to an end with the Peace of Westphalia, concluded in the cities of Münster and Osnabrück between May and October 1648. The terms of peace between the emperor and Sweden were discussed in Osnabrück, with the participation of the individual territories and princes of the Holy Roman Empire. The delegates of the emperor and his allies, Spain in particular, met with France's ambassadors in Münster. It was there that Spain and the empire had to recognize the northern Low Countries' independence, putting an end to the Eighty Years War between the Dutch and the Spanish. The Peace of Westphalia, the first great gathering of European nations and princes, was also an important step in the affirmation of the system of modern states. Each state was recognized as a sovereign entity with its own clearly defined territory.

The terms of peace

Catholics and Protestants reaffirmed the existing Peace of Augsburg (1555), which had introduced the rule that the prince could determine his subjects' religion. The Calvinist faith was recognized as legitimate in the empire. The status quo could not be altered by force.

Sweden conceded large territories in northern Germany and obtained votes in the Imperial Diet of Regensburg. Its role as a great power in the Baltic was confirmed.

France obtained Lorraine and Alsace, and began its rise as a great power.

All the princes and territories of the empire obtained full sovereignty, effectively ending the power of the emperor.

Chilled wine The painting contains various interesting details of the daily life of Dutch patricians of the period, including the large metal receptacle that kept the wine cool. Decorated with vine leaves, it contains a metal flask.

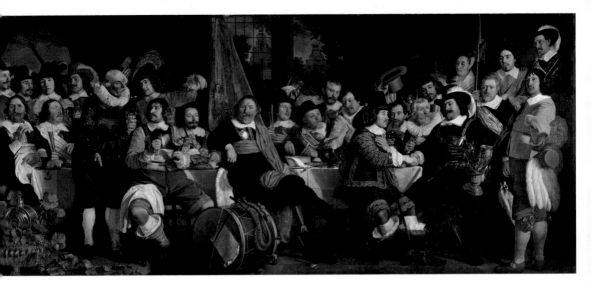

This painting by Van der Helst captures a convivial moment among the men of Amsterdam's civic guard of crossbowmen. They are celebrating the recognition of the Low Countries' independence and the end of the war with Spain. Even though autonomy had been secured some time before and the country was experiencing a growing prosperity, the Peace of Westphalia still represented the achievement of a long-hoped-for goal. It is unlikely, however, that these men had seen much military action. By the 17th century, Dutch civic guards were no longer called on to defend cities – rather, they had become associations of well-to-do middle-class men, who loved to have their picture painted by the most famous artists of the day. This gave rise to a painting genre in its own right, the most famous example of which is Rembrandt's *Night Watch* of 1642.

Captain and Burgomeister Each of the twenty-five portraits was executed individually and then brought together in a single canvas. The man holding the magnificent beer horn is Cornelis Jansz. Witsen, a member of Amsterdam's leading class, who besides being captain of the crossbowmen's guard also became Burgomeister.

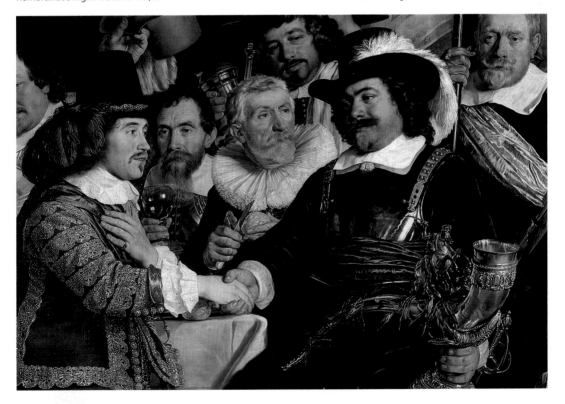

1661 THE GOVERNMENT OF LOUIS XIV

HENRI TESTELIN, **The Institution of the Academy of Sciences and the Founding of the Observatory**

c. 1670. Oil on canvas, 348 x 590 cm. Versailles, Musée national des châteaux

The geometry of power

Louis XIV's government in France was considered the most thorough expression of the absolutism that characterized European dynasties in the 17th and 18th centuries. The bloody wars of religion that had riven Europe between 1550 and 1650 prepared the way for the absolute rule of the sovereign, conceived by intellectuals such as the Frenchman Jean Bodin and the Englishman Thomas Hobbes as a precondition for society's peaceful development. The turmoil of war and conflicts among the nobility, religious groups and intermediary bodies of the state contrasted with the new rationality of absolute government, which found a parallel in, among other things, the growing interest in the exact sciences. If on one hand the sciences offered an effective metaphor for the monarchical order of the state with their plan of a geometrically ordered world, on the other they provided practical knowledge for the development of modern administration and the growth of trade and the economy.

Promoter of the Academy Louis XIV's minister of finance, Colbert, initiated the work of the Academy in 1666, imitating the Royal Society that had been founded in London just four years earlier.

Armillary sphere, celestial globe, skeletons The armillary sphere, like the celestial globe and quadrant, refers to astronomy, a discipline held in high esteem both for its practical applications in navigation and because the movements of the heavenly bodies around the sun were considered a metaphor for the relationship between society and monarch. The skeletons allude to efforts at classifying nature, another highly regarded subject in the 17th and 18th centuries.

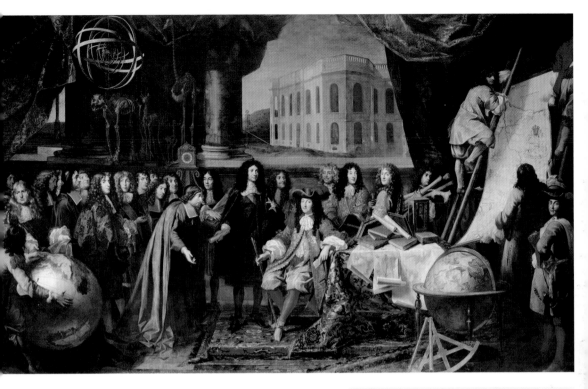

This immense canvas – almost six metres wide – by Henri Testelin depicts the highly symbolic moment in the government of Louis XIV when the king received the Royal Academy of Sciences in 1667. Seated alone wearing a black and red hat, the monarch is portrayed among the scholars of the Academy, surrounded by objects that recall the progress of science in the 17th century.

Characteristics of absolutism

Administration At the apex of the state is the king or prince, who is considered above all laws. The absolutist state favoured the growth of a bureaucratic apparatus to apply the will of the monarch and his cabinet uniformly throughout the territory.

Court The court, the centre of the state, is where the social life of the ruling classes was concentrated. Sumptuous, strictly disciplined rituals were developed that celebrated the monarch as the cornerstone of society.

Army and war The absolutist state established professional standing armies, superseding the old mercenary system. Frequent wars aimed to increase the power and prestige of the individual monarchies.

Economy The absolute monarchs needed a huge income to finance the professional armies, court and growing administration. For this reason they favoured growth in the manufacturing and trade sector.

Maps An important focus of research in the academies was geometry, useful for measuring and representing territory. Making geographical charts more exact was necessary for military purposes and for efficient administration of the territory.

1676 THE FIRST RUSSO-TURKISH WAR

Ilja Repin, **The Reply of the Zaporozhian Cossacks to Sultan Mehmed IV**

1880–91. Oil on canvas, 203 x 358 cm. St Petersburg, Russian Museum

The Ukraine contested

In 1667, Russia gained control over the Ukraine to the east of the Dnieper river. And while the Cossacks of the Dnieper definitively entered the orbit of Russian power, the country now found itself sharing a boundary with the Crimean khanate, a vassal state of the Ottoman empire. These two factors led to the first Russo-Turkish War in 1676. The Cossack hetman Petro Doroshenko, who controlled the west bank of the Dnieper, wanted to unify the Cossacks under his command and therefore allied himself with the Ottomans. Russians and Cossacks loyal to the Czar conquered Doroshenko's headquarters at Chyhyryn in 1676 and took him prisoner. At this point, the Turkish army intervened, twice besieging and finally conquering Chyhyryn, forcing the Russians to the east bank of the Dnieper. The war ended in 1681 with no one gaining territorial advantage.

The myth of equality In this idealized 19th-century representation, the Cossacks were a confraternity where total equality reigned. Nonetheless, there were social distinctions among the Cossacks, as Repin also seems to suggest with differing costumes and poses.

Merriment The Cossacks' rebelliousness is also manifested in the unrestrained hilarity with which they are dictating their letter of mockery to the sultan.

The Cossacks of the Ukraine

In the 15th century, the Cossacks settled as peasants and soldiers in present-day Ukraine along the Dnieper river, where they established a rudimentary political organization around the figure of the hetman, a commander elected by the assembly.

During the 16th century, the Polish crown and nobility attempted to subjugate the Cossacks. In 1648, these attempts led to a revolt under Bohdan Khmelnytsky that resulted in the recognition of Cossack autonomy.

In 1667, the Ukraine was divided into a zone of Russian influence and a zone of Polish influence. Soon after, the Ottomans too advanced into Ukrainian territory.

Under hetman Ivan Mazepa (1697–1709), the Cossacks experienced their last period of independence. In the 18th century, their territory was incorporated into the administrative structure of czarist Russia.

The painting shows the Cossacks amusing themselves by writing a mocking letter to the Ottoman sultan, who had expected obedience from them in the war of 1676. Repin dealt with the subject during the last Russo-Turkish War, in 1877–78 – two hundred years after the first conflict between the two empires. Still, it is not merely a patriotic painting, since Repin celebrates the Cossacks as an example of a free people, not subordinate to any authority – thus implicitly contrasting their way of life to the Russia of Repin's day, which was a rigid czarist autocracy.

Accuracy and exoticism Repin has lingered over the Cossacks' costumes, weapons and tools. Although he has reconstructed individual elements with regard for historical accuracy, there is nevertheless an obvious quest for exoticism in representing these people as generous, independent and bold, as well as fond of dancing and music – as suggested by the presence of a musical instrument.

Civilizations The painting sets the Quakers' 'civilization' – exemplified by stone buildings, among other things – against the Indians' 'primitive' nature.

1682 THE FOUNDING OF PENNSYLVANIA

Benjamin West, **William Penn's Treaty with the Indians**

1771–72. Oil on canvas, 192 x 273 cm.
Philadelphia, Pennsylvania Academy of the Fine Arts

To 'live in love and peace'

'I intend to order all things in such a manner, that we may all live in love and peace one with another.' These are the words with which William Penn, founder of Pennsylvania in North America, addressed the Native Americans. In 1681, he received territory from King Charles II in payment of a Crown debt to his father. The descendant of a rich, noble English family, Penn's approach to colonization was very different to that of others, where the native populations were not considered worthy or equal partners. An adherent to the Quaker faith, which rejected all violence, Penn sought to apply his convictions in his dealings. Even if the account of a meeting with the Lenape chiefs and the signing of a treaty under an elm tree is probably fictitious, Penn did succeed in instituting a relationship of respect and trust with the Native Americans – a relationship that began to deteriorate only after his death in 1718.

The growth of the English colonies

1608 The London Virginia Company founds the Jamestown Settlement. After an initial failure, agriculture begins to flourish, especially tobacco farming.

1620 The voyage of the *Mayflower* leads to the founding of the Plymouth Colony in Massachusetts by the radical Puritan group of Pilgrim Fathers.

1629 Mainly for religious reasons, another group of Puritans founds the Massachusetts Bay Colony.

1664 The English take control of New Amsterdam (present-day New York) from the Dutch. Ten years later, all Dutch colonies in North America pass to the English.

1670 A group of English noblemen found the Charleston colony in present-day South Carolina, where they promote plantation farming.

The transaction In the centre of the composition, one of the colonists is handing a bolt of cloth over to the Indians. According to the legendary account, William Penn purchased land from the Indians with cloth and other goods.

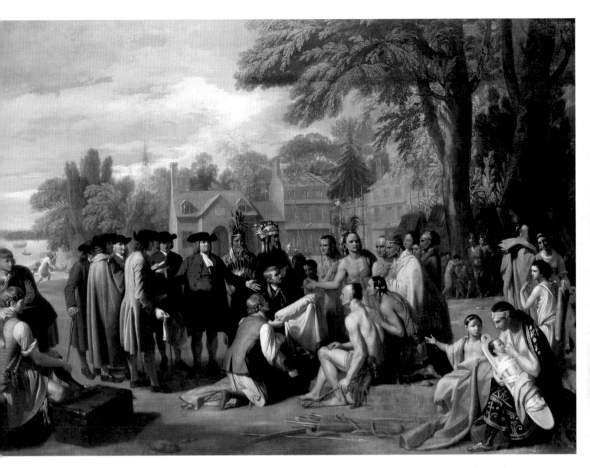

This famous painting of *Penn's Treaty with the Indians* is a veritable icon of American history. Executed in 1771–72 on commission from Thomas Penn (William Penn's son, who, along with his brothers, had inherited the Pennsylvania territory), the canvas was meant to restore and reinforce the Penn family's image in the colony. Under the young Penn's leadership, however, Pennsylvania drifted away from his father's ideals of coexistence. Thomas, who left the Quaker community and joined the Anglican Church, was interested mainly in his own economic well-being. As a result, relations with the Indians had become more difficult.

William Penn The artist had only a posthumous portrait of William Penn to go by in determining the founder's features. Furthermore, all the Quakers are portrayed in the costume of the artist's time and not that of the 17th century.

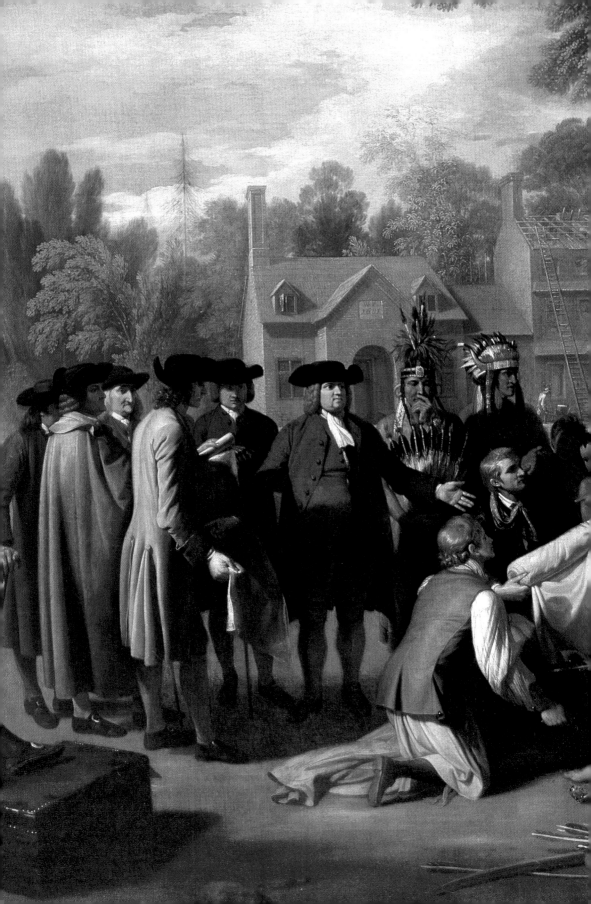

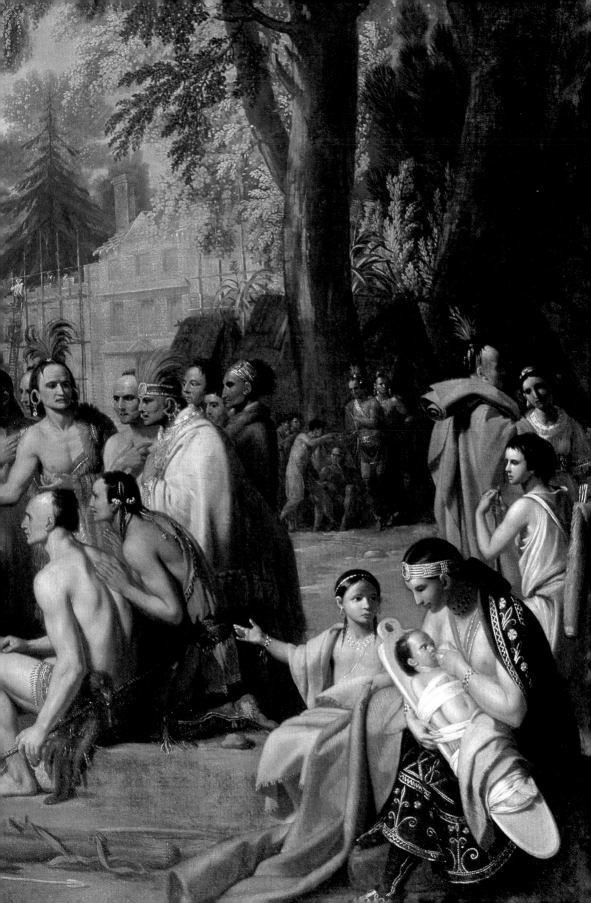

1683 THE TURKISH SIEGE OF VIENNA

Francesco and Giovanni Marchetti, The Victory of Leopold I

c. 1685. Fresco. Prague, Trója Castle

From the Ottoman threat to the reconquest of Austria

In the spring of 1683, an immense Ottoman army commanded by Sultan Mehmed IV and his vizier Kara Mustafa Pasha set off with the goal of inflicting a significant defeat on the Habsburg empire, which had already been weakened by a revolt of the Hungarian nobility in the territory of present-day Slovakia. The army headed for Vienna, laying siege to the imperial residence as Emperor Leopold I and his court fled to Linz. Under siege for more than two months, the city was reduced to starvation. However, with the decisive support of the Polish king John III Sobieski, the field marshal of the imperial troops, Charles V Leopold, Duke of Lorraine, succeeded in massing an army near Vienna and defeating the Turkish attackers. The success of John Sobieski and Charles of Lorraine at the gates of Vienna was the beginning of a victorious counter-offensive demonstrating that the Ottoman empire was in decline.

John III Sobieski The son of a noble Polish family, John Sobieski travelled throughout Europe and in Turkey, developing broad cultural interests. Having pursued a career as a commander in the Polish army, he was elected king of Poland in 1674, when his country was at war against the Ottoman empire. In this painting from 1686, his court painter Jerzy Eleuter Siemiginowski portrays him in sumptuous, exotic armour, reflecting the taste of the Polish nobility of the time.

The battle This detail from the equestrian portrait of John Sobieski depicts a battle between Turkish and Western soldiers, a reference to the fighting that freed Vienna from siege.

Between 1679 and 1685, Count Václav Vojtěch Šternberk, a Bohemian nobleman and an important official in the Habsburg government, built a summer residence just outside Prague. Italian and Flemish artists were called upon to decorate the interior, including the grand hall, whose frescoes present an apotheosis of the Habsburg dynasty. The triumphant Emperor Leopold I is carried by Turkish prisoners. The banner proclaims that the fresco was painted to recall the liberation of Hungary from 'Ottoman tyranny' during the military campaigns following the Siege of Vienna.

1688 THE GLORIOUS REVOLUTION

JOSEPH MALLORD WILLIAM TURNER, **The Prince of Orange, William III, Embarked from Holland, and Landed at Torbay, November 4th, 1688, after a Stormy Passage**

1832. Oil on canvas, 91 x 120 cm. London, Tate Britain

The end of the conflict between king and Parliament

The Glorious Revolution of 1688 put an end to the long series of conflicts that had rocked England in the 17th century, pitting Catholic against Protestant and the House of Stuart against Parliament. The conflict had broken out again in 1685 when, at the death of Charles II, his brother James II took the throne. Having espoused Catholicism, James enacted a policy of tolerance and protection towards the Catholic minority, which his Protestant subjects disliked. At the same time, he sought to establish a professional army to provide support against dissidents and rebels. The opposition then turned to William III of Orange, stadtholder of the United Provinces of the Netherlands and the husband of James's daughter, Mary. And so William organized a successful invasion of Great Britain, and with his wife accepted the throne. He broadened the power of Parliament, approving the Declaration of Right.

A joyous event In the canvas by Turner, the rejoicing is underscored by the attitude of the sailors and soldiers depicted in miniature on the boat. They wave their arms and raise their hats to celebrate the landing.

The Declaration of Right

In 1689, William III and Mary II accepted the Declaration of Right, which as the Bill of Rights passed by Parliament in December of that year became the basic law of England. Among its provisions:

The king was not above the law and could not bend standards or apply them arbitrarily.

The monarch could not introduce taxes or tributes without Parliament's consent.

The king could not recruit and arm an army without Parliament's permission.

Parliamentary elections had to be free and without interference from royal power. Parliament and its members must be able to perform their duties in total freedom.

The people had the right to resist with arms any tyrannical behaviour on the part of the monarch.

A buoy amid the waves In the lower right is a wave-tossed buoy, which illustrates the force of the sea. Faced with the first autumn storms, William's landing fleet was at first forced to return to Holland. The second attempt to disembark was successful.

The artist took up the theme of the Glorious Revolution, a fundamental moment in the shaping of modern Great Britain, in 1832. As always in Turner's painting, the interest in nature seems to dominate over the narration of historical facts. However, the band of light that illuminates the small landing craft, contrasting with the dark, stormy zone at the left, takes on the symbolic value of a good omen, and thus the landing of William III is hailed as portending a splendid future for Britain.

The coat of arms of the House of Orange The landing boat of William's troops is decorated with the armorial bearings of the House of Orange: a lion on a blue field, surmounted by a crown. In the 16th century, the Oranges, originally from Germany, established themselves as rulers of the Low Countries.

1754 ELECTIONS IN OXFORDSHIRE

WILLIAM HOGARTH, **An Election: Canvassing for Votes**
1754. Oil on canvas, 102 x 131 cm. London, Sir John Soane's Museum

Winning votes with banquets and bribes

In 1754, general parliamentary elections were held in Great Britain. Competition for votes was particularly heated in the well-to-do county of Oxfordshire: although it had been the exclusive precinct of the conservative Tory party for forty years, the Tories' political opponents, the Whigs, had decided to challenge them in their stronghold. In Oxfordshire as in the rest of the country, the electoral campaign was waged with lavish offers to the voters. Candidates held feasts and banquets, and were not loath to buy votes with cash. In the end, the Tories won by a hair's breadth, but the Whigs did not recognize their victory, and so Parliament had to decide to whom the county's two seats would be assigned. With a comfortable majority in Parliament, the Whigs awarded victory to their own candidates.

Assault on the state coffers On a poster in the top centre of the scene, Hogarth relates how money was taken from the public coffers to distribute among voters.

The British political system in the 18th century

Parliamentary government After the Glorious Revolution of 1688, Parliament further increased its power. The government was no longer dependent on the king's confidence but on a majority in Parliament.

Electorate Each English county corresponded to an electoral 'riding' that sent two or four members to Parliament. In the counties, all the male citizens who owned property of a certain value (40 shillings) could vote. In addition, some ridings were restricted to cities. Wales, Scotland and Ireland elected their own deputies.

Electoral corruption The number of voters was limited, so it was easy for candidates to ensure their entrance into Parliament with promises and cash payments.

Money under the table In the central scene, the two candidates (Tory and Whig) crowd around a peasant to persuade him to vote for them as they discreetly place coins in his hand to buy his favour. The peasant accepts both candidates' offers.

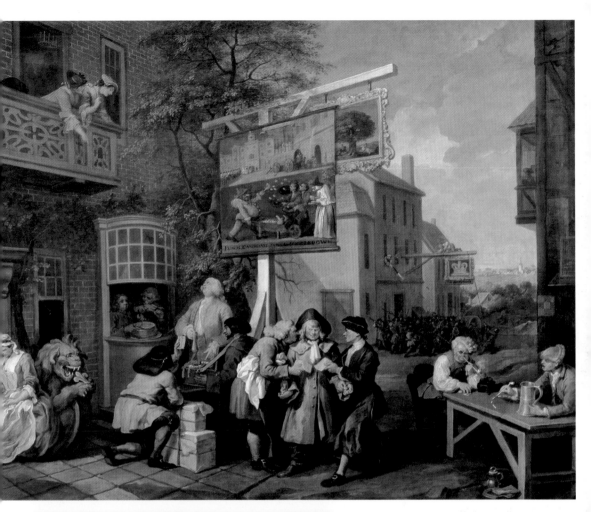

In 1754, the year of general elections, English newspapers were filled with news of misappropriation and corruption in the campaign. Hogarth, who had already turned his hand to the satirical and moralistic representation of contemporary society, decided to devote four paintings to forms of corruption connected with the elections. With these works, also distributed as prints, the artist gave voice to a discontent that was spreading throughout Great Britain at the time and that a few years later would strengthen the monarchy to the detriment of Parliament, which had become discredited in the eyes of the public.

Past glories Among the many secondary anecdotal scenes the artist has inserted into the painting are the two old men sitting around a table at an inn. Using a diagram, one of them describes a naval battle, but his audience is blind and cannot follow him. As the brief inscription on the tankard explains, it is the Battle of Porto Bello, a great victory of the English fleet over the Spanish in 1739.

1755 THE CHINESE CONQUEST OF XINJIANG

Syntheses of tradition While the naturalistic representation of the horses derives from Europe, the landscape elements are painted according to Chinese models.

GIUSEPPE CASTIGLIONE, **Kazaks Offering Horses in Tribute to the Emperor Qianlong**

1757. Ink and oil on paper, 45 x 269 cm. Paris, Musée Guimet

China dominates Central Asia

In the 17th and 18th centuries, the present-day region of Xinjiang (in western China) was controlled by the Mongol tribe of Dzungars, whose dominion extended from western Mongolia in the north to Tibet in the south, thus bringing them into conflict with the Chinese empire for control of Central Asia. In 1755, a tantalizing opportunity to stem Dzungar power presented itself to Emperor Qianlong. Amursana, a claimant to the title of khan of the Dzungars, fled to the Chinese court and asked for help in defeating a rival. Qianlong organized a first military campaign against the Dzungars to set Amursana up as khan and a vassal of China. However, Amursana broke the bonds of fealty to which the relationship of vassalage obliged him. Qianlong then organized a second campaign that not only destroyed the Dzungar state but also exterminated a large part of the population. Xinjiang entered China's orbit through this brutal war of annihilation.

The Jesuit painter Giuseppe Castiglione was born in Milan in 1688 and studied in Europe before arriving in China as a missionary in 1715. Working at the court of Qianlong, he strived to temper the European character of his art in order to satisfy his patrons' taste. Here, for example, he combines a traditional Chinese format with a European composition in which the entire width is occupied by a single scene, rather than a succession of various moments as was usual in pictorial-narrative scrolls. Although Castiglione uses the European technique of shading to model the faces of the men and the bodies of the horses in particular, he forgoes the representation of shadows on the ground, in keeping with Chinese tradition.

The reign of Qianlong

The reign of Emperor Qianlong (1736–96) is considered the Chinese empire's final phase of flourishing before the long decline of the 19th century.

Territorial possessions and conquests In addition to subjugating Xinjiang, western Mongolia and Tibet, the emperor broadened his domain to the south-west, in the mountains of Yunnan and Guizhou. He made Nepal and Burma tributaries, adding them to the traditional vassals Korea and Vietnam.

Cultural policies Like the other emperors of the Qing dynasty, Qianlong favoured Confucianism. He founded a large library in Peking to preserve the intellectual heritage of the Chinese tradition. Despite severe limitations on missionary activity, the European Jesuits were well received at court, because they brought new technical and scientific knowledge.

The beginning of the crisis The first signs of economic and social decline appeared in the final years of Qianlong's reign. In 1780, the emperor entrusted ministerial powers to his favourite, Heshen, who fostered widespread corruption.

Court dignitaries Emperor Qianlong, who is receiving horses in tribute from the Kazak subjects of Xinjiang, is surrounded by court dignitaries, two of whom bear the imperial arms: the sword and the bow.

1756 THE SEVEN YEARS' WAR

Bernardo Bellotto, The Ruins of the Kreuzkirche in Dresden after the Prussian Invasion

1765. Oil on canvas, 80 x 110 cm. Dresden, Gemäldegalerie Alte Meister

The first world war?

Some historians have called the Seven Years' War 'the first world war', because military operations took place on a continent-wide scale, and the war even dragged in some powers from outside Europe, such as the Native Americans in North America and the Bengal sovereign in India. Two conflicts were intertwined: the Austria of the Habsburgs was anxious to halt the rise of Prussia; and Great Britain wanted to strengthen its position in the colonies at the expense of France and Spain. Thus, two opposing alliances were created: between Austria, France, Spain, Russia and Sweden on one hand; and between Prussia and Great Britain on the other. Great Britain emerged victorious, which strengthened its position in North America and India, as did the still young state of Prussia, which demonstrated that it was now a power to be reckoned with among the great European states.

Reconstruction Some of the workmen employed on the ruins of the Kreuzkirche are climbing a rung ladder on the remains of the tower. When Bellotto painted this view in 1765, reconstruction was already under way.

Seven years of war

1756 After two years of fighting between the French and English in North America, hostility between the two powers explodes in Europe. Prussia occupies the Electoral Principate of Saxony, which is allied with Austria.

1757 Late in the year, Prussia replies to the initial successes of Austria and France, again taking the military initiative. The French and their ally the Nawab (governor) of Bengal are defeated in India.

1758–61 Thanks to the Russians' intervention, Austria and France place the Prussians in serious difficulty. England makes advances in France's American, African and Indian territories.

1762 After the death of Czarina Elizabeth, Russia withdraws from the anti-Prussian coalition. England achieves further successes against France and Spain in the Caribbean and Philippines. Armistices are reached on all fronts at the close of the year and confirmed by a peace treaty in 1763.

Houses destroyed A series of damaged houses appears behind the ruins of the church. It is estimated that one-third of the buildings of the capital of Saxony were destroyed in the war.

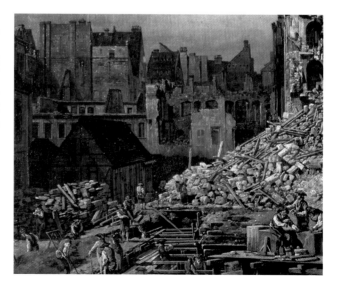

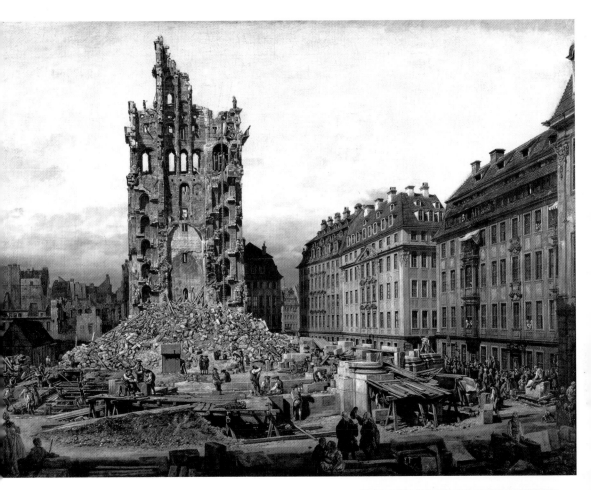

At the outbreak of the war, Bernardo Bellotto, a Venetian painter in the service of Augustus Frederick, Elector of Saxony and King of Poland, was in Dresden, a city that had been involved in the military operations since 1756. The Prussian occupation forced the artist to seek his fortune elsewhere, and he returned to Dresden only after the conclusion of the hostilities. Using the typical expressive means of the *veduta* (panoramic view), of which he was a great master, in this canvas he produced a detailed and shocking record of the destruction the war caused in the city.

Curious onlookers Except for the couple in the foreground, all the spectators are looking up to watch the work. During reconstruction, the tower partly collapsed and was then knocked down completely. Perhaps this is the event the bystanders are commenting on.

1776 THE UNITED STATES' WAR OF INDEPENDENCE

JOHN TRUMBULL, **The Declaration of Independence**

1817–19. Oil on canvas, 366 x 549 cm. Washington, United States Capitol

A first affirmation of the rights of man

'We hold these truths to be self-evident, that all men are created equal, that they are endowed by their Creator with certain unalienable Rights, that among these are Life, Liberty and the pursuit of Happiness … That whenever any Form of Government becomes destructive of these ends, it is the Right of the People to alter or to abolish it, and to institute new Government, laying its foundation on such principles.' Although the Declaration of Independence, approved by the representatives of the English colonies in North America on 4 July 1776, did not create the United States of America, it was a fundamental document in the development of the modern concept of universal rights that has informed political debate to this day.

President and secretary of the assembly The draft is being delivered to John Hancock (seated), president of the assembly, and Charles Thomson, secretary to Congress.

Causes underlying the independence movement

Politics of trade Great Britain favoured direct exchange between the homeland and the colonies and wanted severely to limit the colonies' trade relations with other nations. However, this policy was detrimental to the colonies' economic interests.

Taxation To defray the cost of defending the colonies, the British governor sought to impose taxes. The newspaper tax introduced in 1765 was especially despised. The slogan 'no taxation without representation' protested the injustices suffered by the North American colonies, which were taxed without being represented in the British Parliament.

Control of the colonies After the considerable territorial increases following victory in the Seven Years' War (1763), King George III's government intended to control the American territories strictly. Ten thousand soldiers were permanently stationed there.

A group portrait While the painting seems rather pedestrian overall, Trumbull devotes great attention to the portraits of the various representatives. He made many individual portraits from life before inserting them into the main composition.

This well-known painting represents the moment when the draft of the Declaration of Independence is presented to the representatives of the American Congress. The artist, John Trumbull, was a member of the colonial elite who organized the rebellion against the British government. Back in 1787, he had executed an initial version of the painting in smaller dimensions. Thirty years later, when the United States was becoming a reality, Congress gave him the task of painting the same subject in a monumental format, with the figures portrayed at life-size. This version was destined for Capitol Hill in Washington, the centre of US federal power, where there are also three other canvases by the artist dealing with military episodes from the War of Independence.

The Founding Fathers In the centre of the painting, five figures present the draft of the Declaration of Independence. From left to right they are John Adams, Roger Sherman, Robert R. Livingstone, Thomas Jefferson and Benjamin Franklin – the select committee formed in 1776 to prepare the draft.

1776 THE UNITED STATES' WAR OF INDEPENDENCE

EMANUEL LEUTZE, **Washington Crossing the Delaware**

1851. Oil on canvas, 378 x 647 cm. New York, Metropolitan Museum of Art

From resistance to civil war

The policies of the British king and Parliament regarding taxation and politics in the 1760s aroused indignant protest among the North American colonies. In 1767, a boycott of British merchandise was organized, and in 1773, in protest against Britain's trade policies, a group of American colonists caused a terrific uproar by throwing overboard the cargo of tea from an East India Company ship moored in Boston harbour. When the British government responded with repressive measures, the colonists called the First Continental Congress, which twelve of the thirteen colonies attended in September 1774. When the Congress convened, Georgia was not represented. The assembly did not go so far as to declare independence, but it did address a petition to the king of England with their demands. It also decided to organize an armed militia as defence against any possible reaction.

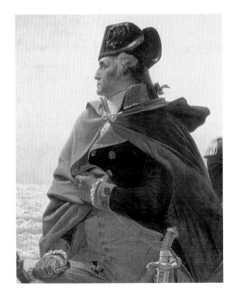

Heroic poses The two central figures, in an emphatically heroic pose, are George Washington, commander-in-chief of the rebel colonists, and, holding the flag, James Monroe – another future president of the United States.

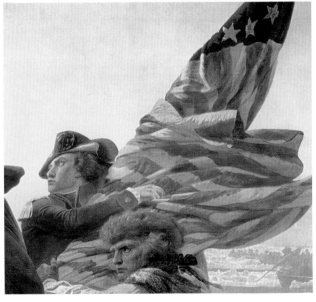

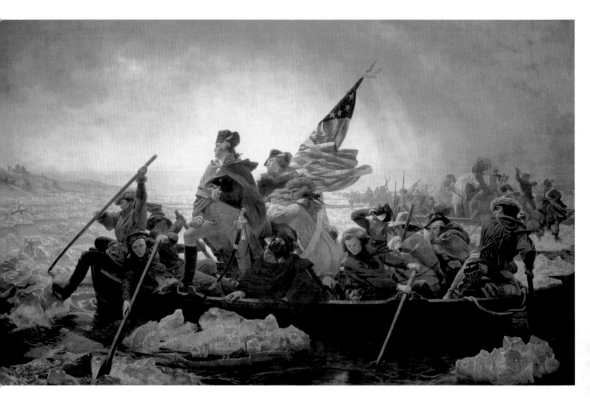

The German-American artist Emanuel Leutze painted two versions of this image, in 1849 and 1851, while in Germany. The canvas actually connects the historical fact of the War of Independence to the politics of Leutze's own time. Leutze wanted to give a sign of encouragement to the German liberals who, in 1848, had just emerged from a failed revolution that the artist had supported. The example of George Washington shows that one must be able to cope with temporary defeat. The crossing of the Delaware came at a time of great difficulty for the American insurgents, but through this undertaking, Washington turned the course of the war in his favour.

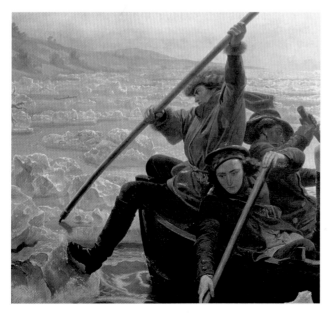

Comrades in adventure The rhetorical heroism of the main figures is contrasted with the lack of heroism in the secondary figures. Next to a pioneer in a fur hat, Leutze has included an Afro-American sailor as well as a figure that some have seen as a woman dressed in a man's clothing.

1789 THE OATH OF THE TENNIS COURT

JACQUES-LOUIS DAVID, **The Oath of the Tennis Court: The Representatives of the Third Estate Swear to Give France a Constitution, 20 June 1789**
1790–91. Oil on canvas, 65 x 88.7 cm. Paris, Musée Carnavalet

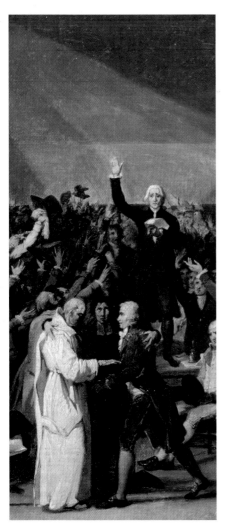

The beginning of the Revolution

The event that confirmed the definitive rupture between Louis XVI, king of France, and his subjects was not so much the famous storming of the Bastille on 14 July 1789 – though this has taken its place as a symbol of the Revolution and today is the French national holiday – as the decision of the representatives of the Third Estate to claim the right to pass laws independently of the sovereign. This took place on 17 June 1789, and three days later, on 20 June, the king tried to prevent the deputies from meeting again. Finding the hall where the meetings of the Estates General were usually held blocked by the king's soldiers, the representatives of the Third Estate and many of the clergy instead met in the Hall of the Tennis Court at Versailles and swore 'never again to disband, and to meet as required by circumstances until the Constitution of the kingdom is established and set on a firm foundation'. On 23 June, Louis tried to dissolve the rule of the new assembly but yielded in the face of the deputies' obstinate refusal to abandon their work. It was the beginning of the French Revolution.

Jean Sylvain Bailly The whole scene converges on the central figure standing on the table. It is Deputy Bailly, reading aloud the text of the oath written by Pierre Bevière and calling for all to swear with him. Meanwhile, two clerics from different branches of Christianity in the foreground are fraternizing to indicate the dawn of an era of religious tolerance. One is the Cistercian monk Dom Gerle (who was not actually present at the meeting of 20 June), and the other is the Protestant pastor Rabaut-Saint-Etienne. Another priest seals the reconciliation. A cone of light spilling through the hall's large windows focuses on Bailly as the curtains blow in the wind — a wind that seems to bear the shouts of the crowd and usher in a new age of liberty.

Joseph Martin-Dauch There was only one dissenting voice amid the enthusiastic consensus: Deputy Martin-Dauch, who refused to commit to the document proposed by Bailly. David portrays him seated on a chair at the far right, with his arms folded across his chest, his gaze downcast as if crushed with shame. In reality, however, Martin-Dauch energetically defended his position in the assembly and was not intimidated by the threats made during the debate.

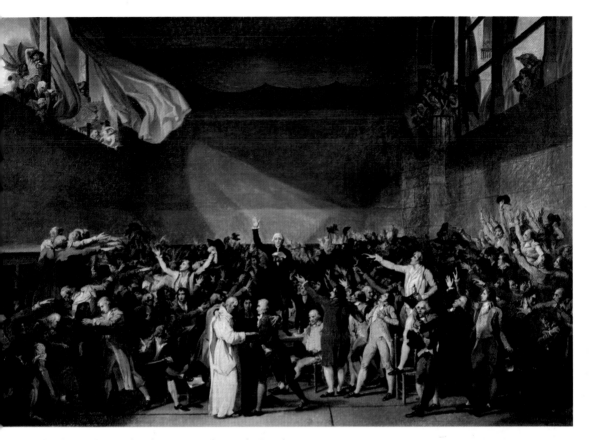

Rarely in history has art played so active a role as in the French Revolution, and Jacques-Louis David was one of its main interpreters. A revolutionary from the outset, in 1790 David was asked by the Society of the Friends of the Constitutions (the original name of the Jacobin Club) to produce a work to commemorate this momentous event. The plan was to execute a large canvas (some seven by ten metres) with all 630 deputies, but the ambitious project was never completed because of both a lack of funds and the altered political climate, which came to see many of the participants in the oath as moderates and counter-revolutionaries. All that remains is some preparatory drawings, which were favourably received at the Salon of 1791, and a small-format canvas version.

The people at the window To emphasize the popular participation in the event, David depicts ordinary men, women and children watching their representatives' oath from above.

The institutions of absolutism

In the French absolutist regime, society was organized around old customs and traditional institutions. Some of these continued to play an important role in the Revolution:

Estates General A body consulted by the king, consisting of representatives of the three 'classes' of subjects, namely the clergy, the nobility and the Third Estate (the commoners). Founded by Philip the Fair in 1302, it had last been convened in 1615. In 1789, Louis XVI decided to call the Estates General together to deal with the kingdom's great financial difficulties.

Third Estate All those who were neither clergy nor nobility belonged to this 'class' – in practice, this accounted for 98 per cent of the population (on the eve of the Revolution, about twenty million people). There were great differences within the Third Estate, which grouped together the upper and middle bourgeoisie (more or less three million people) with the great masses of peasants and disinherited urban dwellers.

Cahiers de doléances 'Complaint registers' containing the people's proposals and requests for presentation to the Estates General. Drawn up in every part of France, they represented a cross-section of the country's problems, expectations and hopes on the eve of the Revolution.

1789 THE OATH OF THE TENNIS COURT

Alexandre Fragonard, **Mirabeau and Dreux-Brézé**
1st half of 19th century. Oil on canvas, 71 x 104 cm. Paris, Musée du Louvre

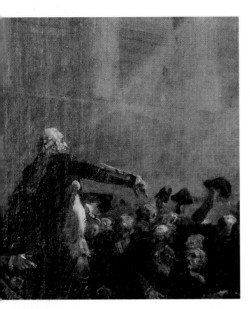

Mirabeau Lit by a band of light, the Comte de Mirabeau's gestures indicate the deputies' will to remain assembled. Elected to the Third Estate, this nobleman, libertine and orator played a prominent role in the formation of the National Assembly.

Economists in the king's service

Besides the sovereign, a number of economists were engaged in the attempt to reform the kingdom's finances. Among the main figures were:

Louis XVI Acceding to the throne in 1774, he immediately had to face the enormous public debt. But in 1778, he worsened it by dragging the country into the war of the Americans, who had risen up against Great Britain. Once revolution broke out in France, he vacillated at length between repression and compromise, until his disastrous attempt to flee France in June 1791. Louis XVI was guillotined in January 1793.

Anne-Robert-Jacques Turgot Called by Louis XVI to supervise the kingdom's finances in 1774, he instituted radical reforms, liberalizing trade and production, and planned a fairer distribution of taxes. He was dismissed in 1779, and all his measures were revoked.

Jacques Necker A Calvinist banker of Swiss origin, he was Louis XVI's minister of finance at various times and sought to pursue his predecessor Jacques Turgot's reforms, albeit with a milder tone. In 1781, he denounced the court's wastefulness, thus losing favour with the nobility but winning a great popular following.

The ancien régime *in crisis*

Organized into rigid classes, the French absolutist system was dragged into a crisis by serious financial problems with no obvious solution. Both the clergy and the nobility (altogether about a million people) enjoyed the ancient privilege of not paying taxes, though they were by far the richest classes, collectively owning more than 35 per cent of the nation's land. Consequently, the tax burden lay exclusively with the Third Estate, which in addition was still saddled with the weight of feudal obligations. This slowed economic development and kept the greater part of the rural population in chronic poverty. However, when Louis XVI convened the Estates General to support his minister Jacques Necker's ideas for tax reform, the situation completely escaped his control. The assembly became an opportunity for the representatives of the Third Estate – the enterprising and politically astute middle classes – to denounce the contradictions of the French social structure and initiate a process of radical political and economic change that would eventually sweep away the institution of the monarchy, the king and his family.

Dreux-Brézé Accompanied by soldiers, Louis XVI's grand master of ceremonies addresses the Third Estate but is forced to listen to the Comte de Mirabeau's rebuttal. The scene is represented with a certain exaggeration, particularly in the poses and attitudes of the deputies. The record states that Dreux-Brézé went to the king to report Mirabeau's answer, to which the king exclaimed, 'What does it matter? Let them stay!' – thereby yielding to the assembly's demands.

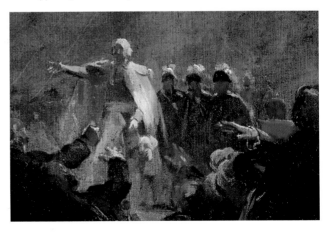

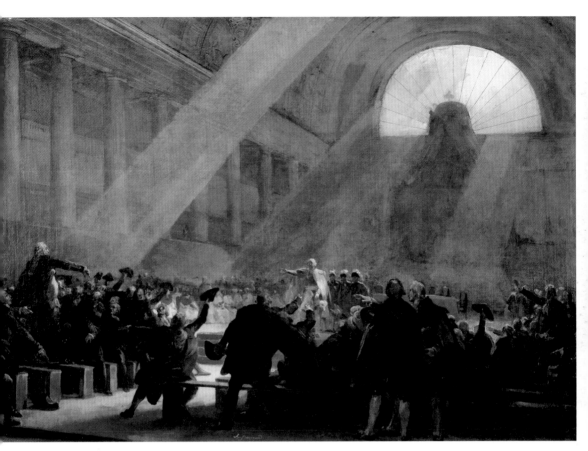

The son of the famous painter Jean-Honoré Fragonard, Alexandre specialized in historical subjects, painting episodes from French history – especially the Revolution – in a Romantic vein. In this painting, he has represented a famous debate that took place on 23 June 1789, three days after the Oath of the Tennis Court. After speaking and promising reform, Louis XVI asked all the participants of the Estates General to leave the session, but the deputies of the Third Estate did not move. When an hour had passed, Henri-Evrard de Dreux-Brézé, the king's grand master of ceremonies, returned to the hall to reiterate the king's order. At this point, the Comte de Mirabeau replied: 'We are here by the will of the people, and we will leave only at bayonet point.'

The architecture The scene is set in the Hôtel des Menus Plaisirs at Versailles, where the sessions of the Estates General actually took place. Finding the hall closed three days earlier, the delegates of the Third Estate went to the Tennis Court, where they swore their famous oath. Fragonard treats the architecture of the room effectively, recalling the neoclassical projects of architects like Etienne-Louis Boullée and Claude-Nicolas Ledoux.

1792 THE TAKING OF THE TUILERIES

JACQUES BERTAUX, The Taking of the Palace of the Tuileries, 10 August 1792

Late 18th century. Oil on canvas, 124 x 192 cm. Versailles, Musée national des châteaux

Loyalty and patriotism The dead lie on the ground amid pools of blood and abandoned axes, swords and rifles. Also fighting against the strenuous resistance of the king's corps of Swiss guards was a contingent of volunteers from Marseilles, who first sang the famous revolutionary hymn *The Marseillaise*. The hymn was actually written by Rouget de Lisle in April 1792 in Strasbourg, not Marseilles.

The end of absolute monarchy

20–21 June 1791
Louis XVI, his wife Marie Antoinette and two sons secretly leave Paris to join loyalist troops on the Prussian border. They are recognized and held in the small town of Varennes, then returned to Paris, where the crowd greets them with cold hostility.

13 September 1791
The Constitution drawn up by the National Assembly takes effect. Louis XVI signs it reluctantly, making France a constitutional monarchy.

20 April 1792
War is declared against Austria and Prussia. Promoted by the revolutionaries, initially it has disastrous results for the French. In the meantime, Louis XVI refuses to enact laws to mobilize the country's resources in the conflict.

20 June 1792
The people attack the Tuileries for the first time.

25 July 1792
The Duke of Brunswick, the commander of the Prussian army, drafts a proclamation in which he threatens the people of Paris with severe reprisals if Louis XVI's safety is again placed at risk.

10 August 1792
The people seize possession of the Tuileries and arrest the king.

2–6 September 1792
A country-wide wave of massacres breaks out against citizens considered anti-revolutionary.

21 September 1792
The Republic is proclaimed.

Besieging the monarchy

The tenth of August 1792 was a decisive day in the radicalization of the demands of the leaders of the French Revolution. Led by Danton, the people of Paris besieged the Palace of the Tuileries, where King Louis XVI had been living under house arrest since attempting to flee from France in June 1791. The Swiss guard that defended Louis fought relentlessly, but in the end the sovereign and his family were captured and imprisoned. As France proclaimed the Republic, so began the trial before the Convention that would eventually send Louis to the guillotine in January 1793. The main motivation for this attack on the remaining part of the French monarchy was the belief that an Austro-Prussian victory in the war with France that had just broken out (on 20 April) could see the king reinstalled. Furthermore, the removal of the king served to silence the Feuillant faction (who wanted a constitutional monarchy). The moderate Girondins were eliminated soon afterwards, leaving the field free for the more uncompromising Cordeliers and Jacobins.

The Cap of Liberty The revolutionaries have placed a Phrygian cap and two long tricolour cockades atop a spike on the palace's entrance wall. In ancient Rome, the red headgear was given to freed slaves by their former master and thus took on the meaning of liberty.

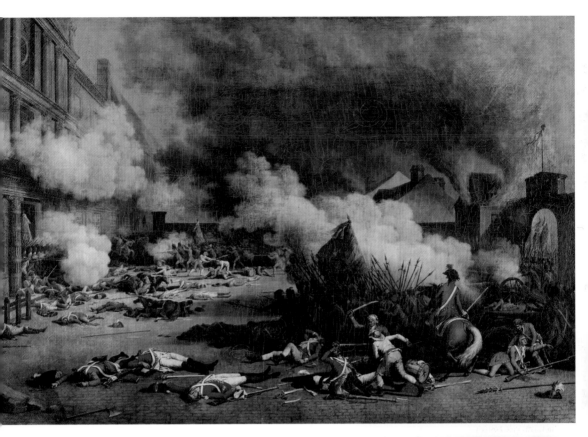

The academic painter Jacques Bertaux (c. 1745–1818) painted many episodes from the French Revolution. Here, in didactic mode (but with a sufficient dose of realism), the artist depicts the storming of the Palace of the Tuileries on 10 August 1792. The revolutionary troops and forces have penetrated the Courtyard of the Carousel, where they run up against the pennons of the Swiss guard. As a fire spreads, the insurgents' cannons open fire on the palace. The battle degenerated into hand-to-hand combat, with many casualties on both sides.

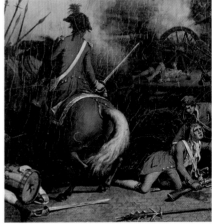

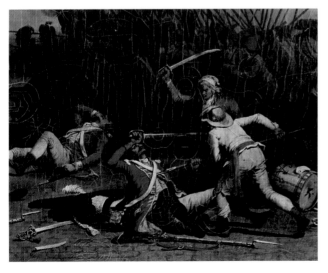

The National Guard Leading a group of revolutionaries is a mounted officer of the National Guard, a citizens' militia formed in 1789 for the purpose of maintaining order in the city. Their uniform was blue, and officers were elected directly by the soldiers.

The Sansculottes A cluster of Sansculottes armed with pikes is attacking the palace. A radical popular militia, the Sansculottes wore long trousers and were thus literally *sans culottes* — without the knee breeches worn by the nobility. On their heads, they wore another symbol of the revolution, the Phrygian cap.

The letter In his left hand, Marat still holds the letter that Charlotte Corday sent him promising to expose a plot. David does not transcribe the exact text but summarizes its conclusion: 'My unhappiness alone entitles me to your goodwill', Corday writes, convincing Marat that they should meet. The sheet of paper is smeared with blood. In the other letter, resting on the crate, the tribune expresses his wish to give an *assignat* (a form of paper currency under the Revolution) to a mother of five: Marat is thus represented as a generous and altruistic man.

The revolutionary factions

Political participation during the French Revolution was very intense, and the revolutionaries were organized into various 'parties' that opposed each other bitterly. These are the main alliances:

Girondins A political group made up of representatives of the provinces (in particular the Gironde region), they held a more moderate position. Republican but federalist, they strongly emphasized individual and economic freedom. They confronted the Jacobins and lost out.

Jacobins So called because they met at the Paris convent of the Jacobins (the Dominican friars), they were led by Maximilien Robespierre. Republican but centralist, they professed democratic and egalitarian ideals. In fact, they pursued a dictatorial regime under the Terror.

Sansculottes ('without knee breeches') These belonged to the lowest classes in Paris, who did not own the *culottes*, or knee breeches, of the rich. The front line of attack during the Revolution, they demanded radical social and economic reforms. They too were persecuted as extremists by the Jacobins.

1793 THE MURDER OF MARAT

JACQUES-LOUIS DAVID, **The Death of Marat**

1793. Oil on canvas, 165 x 128 cm. Brussels, Musées royaux des Beaux-Arts de Belgique

A martyr to the revolution

On 13 July 1793, Jean-Paul Marat was killed in his house while taking one of his frequent baths to combat a skin disease. The crime was committed by Charlotte Corday, a twenty-five-year-old woman who had come from Caen, in Normandy, with the intention of murdering Marat. In her eyes, he was guilty of persecuting the Girondins, the political faction with which her sympathies lay. The murder was part of the bitter struggle between the political currents within the National Convention (the assembly, elected in September 1792, that had proclaimed the Republic and dethroned King Louis XVI). It was before the Convention that Louis XVI was tried for treason and condemned to death. Marat played an important role in seeking the condemnation of Louis, and it was he who led a harsh campaign against the Girondins, whom he thought guilty of moderatism and collusion with the monarchy. After Marat's death, men such as Robespierre, Danton and Saint-Just continued on the same path, becoming more and more radical and concentrating power in their own hands.

The Convention asked the Jacobin Jacques-Louis David to execute this painting immediately after the event. A personal friend of Marat, the artist was also put in charge of organizing the funeral, which he managed to transform into a solemn lay rite consecrating Marat as a hero of the Revolution. The canvas was presented to the Convention on 14 November 1793 and remained on display there until February 1795, when it was returned to the artist. In the painting, David does not resort to rhetorical artifice but tersely presents the event in its essential drama: the victim's lifeless body and the austere furnishings emerge in light against a dark, empty background that takes up more than half the canvas. Everything accentuates the tribune's virtue, contrasted with the villainous betrayal and murder.

The pen Marat's inert hand still holds a quill pen, his 'weapon': as a well-known journalist and polemicist, Marat denounced the corruption and shilly-shallying of countless lukewarm revolutionaries in the columns of his newspaper, *L'Ami du peuple*, founded in 1790.

The dedication The artist's dedication is inscribed at the base of the rough crate used by the tribune as a table: *À Marat / David / L'an deux*. 'Year two' is 1793 according to the new Revolutionary calendar.

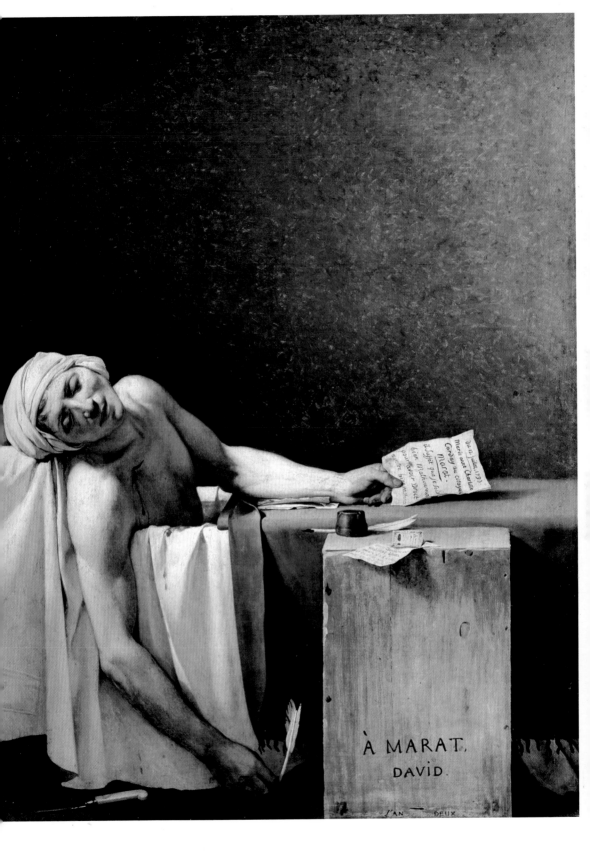

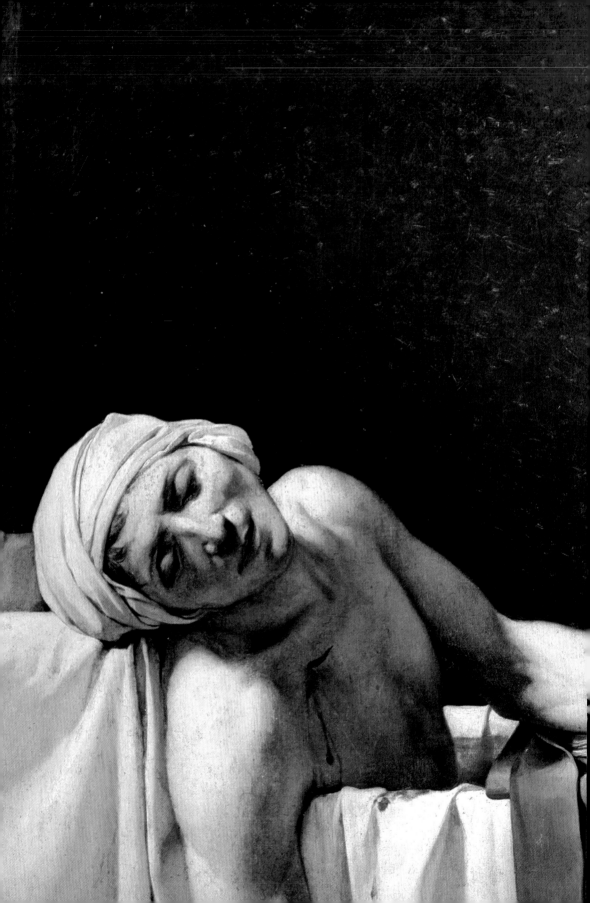

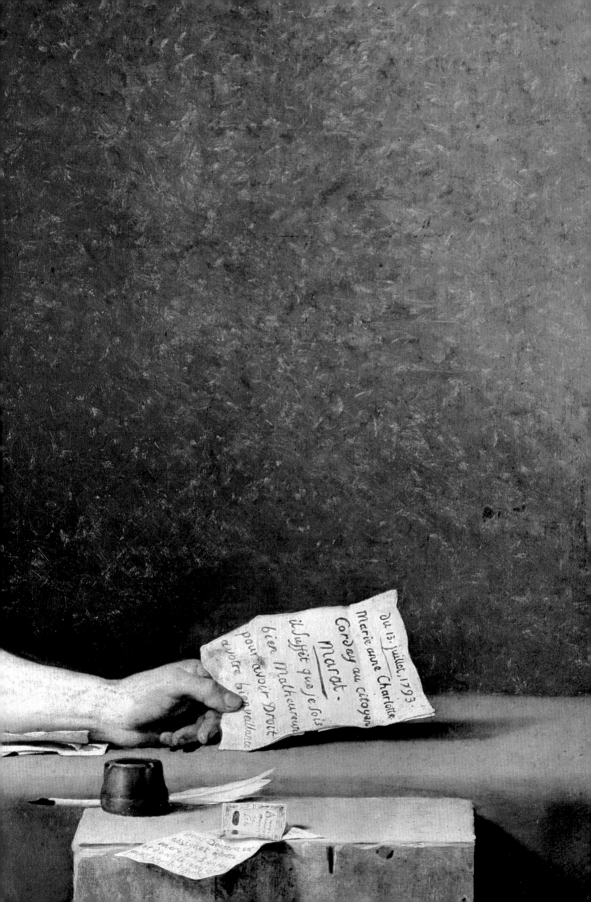

The assassin The central figure in images depicting Marat's murder had always been the revolutionary himself, while the murderess, Charlotte Corday, never appeared. This painting by Munch, however, places the woman's face and nude body in the foreground. With her fixed gaze, blank expression and pallid flesh marked with splotches of blood, the young woman is the lone living figure amid the landscape of death conveyed by the painting's strong colour contrasts.

From the Convention to the Terror

20 September 1792
First session of the National Convention, elected by universal male suffrage. The same day, French troops win a victory against the Prussians at Valmy.

17 January 1793
By a vote of 361 in favour and 288 against, the Convention sentences Louis XVI to death.

11 March
The Vendée rebellion begins after the extraordinary conscription of 300,000 men.

6 April
The Convention sets up the Committee of Public Safety and the Committee of General Security, which act as police and court for the Revolution. The painter David is a member.

2 June
The Girondins are expelled from the Convention following the revolt led by the sansculottes in Paris.

13 July
Jean-Paul Marat is stabbed to death by Charlotte Corday.

10 August
The republican constitution voted by the Convention in June is suspended. Power is placed into the hands of the Committee of Public Safety. The Reign of Terror begins.

17 September
The Law of Suspects is enacted.

1793 THE MURDER OF MARAT

Edvard Munch, **The Death of Marat**
1907. Oil on canvas, 150 x 200 cm. Oslo, Munch Museet

The Terror

The groundwork for the harshest and most intolerant phase of the French Revolution was laid in the first months of 1793. With the field cleared of the monarchy and the more moderate Girondins, the Convention entrusted all power to the Committee of Public Safety, controlled by the strong personality of Maximilien Robespierre. Thus was initiated the Reign of Terror that lasted until July 1794, when Robespierre was imprisoned and guillotined. Justified by the need to defend France from its internal and external enemies, the Terror succeeded in maintaining the revolutionary regime – initiating forms of economic control that prefigured socialism – but at the high price of total suspension of individual rights and the sentencing to death of anyone who was even remotely suspected of harbouring counter-revolutionary sentiments. In this context, the murder of Marat, celebrated and consecrated as a hero and martyr, provided the pretext to consolidate the rule of the Committee of Public Safety. In September 1793, the Convention approved the so-called Law of Suspects that gave the revolutionary tribunals unlimited power. It is estimated that from that time, there were about 17,000 victims of the guillotine.

The mangled body The corpse is stretched out on the bed, the wound-covered arms spread like a cross. Far removed from the historical reality (as recorded by David), this painting underscores the incident's allegorical dimension. In the 20th century, the figure of Marat and his death stimulated the imagination of various creators, among them the German playwright Peter Weiss, who wrote *Marat/Sade* in 1964. In the play, the revolutionary's utopian force collides with the sceptical mistrust personified by the 'divine' Marquis de Sade.

Edvard Munch painted this subject several times in 1906 and 1907.
Two versions of *The Death of Marat* from 1907 are known, and *The Murderess*,
from the year before, depicts the same scene. For Munch, the killing takes
on a symbolic value. Denying the scene any historical connotation, he turns
it into a metaphor for the love–death relationship that binds the two sexes.
Furthermore, in this canvas the artist was coming to terms with a dramatic
episode in his own life. In September 1902, in a violent argument with his
companion Tulla Larsen (who wanted to marry him), an accidental pistol
shot blew off a finger of Munch's left hand. The couple separated,
and the violent scene was transfigured into this historical event.

Physiognomy The artist Girodet, a student of David who hovered between classicism and Romanticism, juxtaposes two faces in the painting. The white marble bust of Raynal, with its high forehead, adheres to the classical canon for representing a thinker. Belley's face, in contrast, is depicted in black flesh tones, with hair pulled back, flattened nose, fleshy lips and a powerful jaw. These are two different and distant physiognomies, and the painter seems particularly attentive in exploring the black man's face – the object of an often excessive curiosity conditioned by prejudice on the part of French society at the time.

The independence of Santo Domingo

1697
The western part of the island of Hispaniola, Santo Domingo, becomes a French colony.

March–October 1790
The anti-abolitionist 'lobby' in the National Assembly obtains legislative autonomy for colonies that recognize political rights for whites only. Violent revolts erupt in Santo Domingo.

March 1792
The Legislative Assembly decrees political equality for Creoles and free black men.

23 August 1793
Commissioner Sonthonax frees the island's half a million slaves.

22 July 1795
Toussaint-Louverture, commander of an army of ex-slaves, conquers the Spanish part of the island. Though he declares his loyalty to France, he governs independently.

June 1799
The Directory attempts to limit Toussaint's autonomy, fomenting a Creole rebellion that is harshly crushed by Jean-Jacques Dessalines, a collaborator of Toussaint.

10 May 1802
Napoleon reintroduces slavery and sends an expeditionary force of 20,000 men to Santo Domingo. Toussaint is arrested and dies in prison in France.

1 January 1804
Dessalines successfully resists the French offensive and proclaims Santo Domingo's independence. Slavery remains legal in the French colonies until 1848.

1794 THE ABOLITION OF SLAVERY IN THE FRENCH COLONIES

ANNE-LOUIS GIRODET DE ROUCY-TRIOSON, **Jean-Baptiste Belley, Deputy of Santo Domingo to the Convention**

1797. Oil on canvas, 158 x 111 cm. Versailles, Musée national des châteaux

A first step towards equality

The Declaration of the Rights of Man and of the Citizen of August 1791 made it clear that there was a great contradiction between egalitarian principles and the practice of slavery, which had been widespread in France's colonies. This practice was particularly prevalent in Santo Domingo (today Haiti), where about half a million slaves had been deported to work on the plantations. Considering that many of the representatives of the Third Estate had possessions in the colonies, it is easy to understand that there remained considerable resistance to abolition. Only in the most radical phase of the Revolution did these principles manage to assert themselves. In July 1793, the Convention abolished the slave trade, while in Haiti, Commissioner Sonthonax freed all the slaves in order to encourage them to fight alongside the French against the Spanish and English (who wanted to conquer the island). Three representatives from Haiti were elected and sent to Paris, among them the freed ex-slave Jean-Baptiste Belley, portrayed here by Girodet. They pleaded their cause before the Convention, and on 2 February 1794, slavery was abolished in all the territory of France.

A freed slave arrives in Paris Belley is shown wearing European dress, including an elegant tailcoat with gold buttons, and a long, pale tricolour scarf wrapped around his waist. Born in 1747 on Gorée Island, Senegal, Belley was taken to the Caribbean as a slave at the age of two. When he became a freeman, he participated in the revolt against slavery and won a seat at the Convention. After 1797, he sided with Bonaparte, however, and joined the expedition of 1802 against Toussaint. But he was arrested when he arrived in Santo Domingo, after Napoleon's decision to no longer use black officials. Belley died in around 1805 while serving a prison sentence in France.

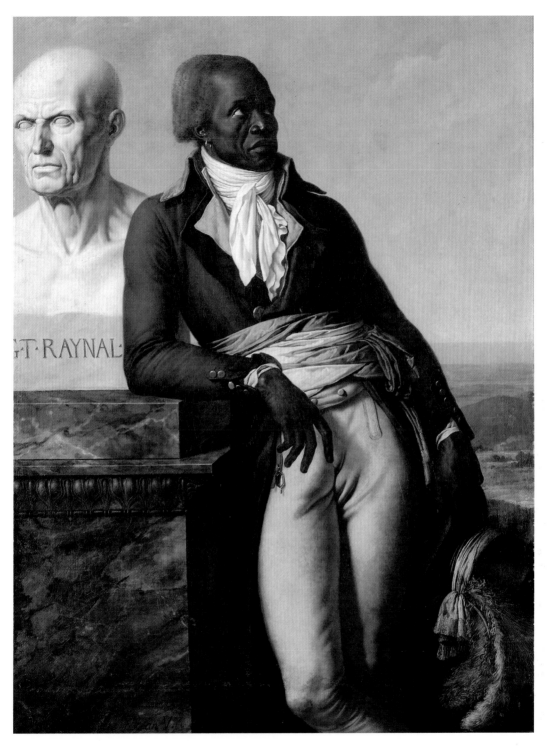

Exhibited in Paris in 1797 and the following year, this portrait of the first black deputy, Jean-Baptiste Belley, caused a sensation. Girodet de Roucy-Trioson portrays Belley in the uniform of the Convention, standing in an almost regal pose. He symbolizes the emancipation of the slaves that had been heralded by philosophy – as personified in the bust of Abbé Guillaume Raynal beside him. In 1770, Raynal had written a *Philosophical and Political History of the Settlements and Trade of the Europeans in the East and West Indies*, which was condemned by the Paris Tribunal for its explicit criticism of slavery.

The face of a hero The determination of the young military commander comes through in his intense gaze. Long hair (in the style of the revolutionaries) frames his face, and he wears the dark blue uniform with a red collar of the generals of the Republic. The whole painting conveys the heroism and patriotic energy that Bonaparte hoped to embody. It could almost be an illustration to the description given in the *Courrier de l'armée d'italie* (Courier of the Army of Italy, a newspaper for French soldiers), in October 1797, that claimed that Bonaparte 'flies like lightning and strikes like a flash. He is everywhere and sees everything.'

Victory after victory

26 March 1796
In Nice, General Bonaparte assumes the command of France's 'Army of Italy'.

12–21 April 1796
Napoleon manoeuvres between the Austrian and Sardinian armies, passing from Liguria to Piedmont through the Apennines. He defeats both armies separately and repeatedly.

28 April 1796
In Cherasco, Victor Amadeus III of Savoy is forced to accept a humiliating armistice. Piedmont is in French hands.

10–15 May 1796
The Austrians are routed at Lodi, and the Army of Italy triumphantly enters Milan.

August–November 1796
The Austrians reorganize and try repeatedly to reverse the military situation. At Arcole on 17 November, they are again defeated.

14 January 1797
Yet another Austrian defeat takes place in Rivoli Veronese. Mantua, the last imperial stronghold, surrenders on 2 February. In April, the French come within a hundred kilometres of Vienna.

17 October 1797
Dealing directly with the Austrians, Napoleon signs the Treaty of Campo Formio, which recognizes French domination in Italy and, with regard to Germany, confirms France's possession of the Rhineland. Losing its centuries-long independence, Venice is given to Austria.

1796 THE FIRST ITALIAN CAMPAIGN

Antoine-Jean Gros, General Bonaparte on the Bridge at Arcole, 17 November 1796

1801. Oil on canvas, 73 x 59 cm. Versailles, Musée national des châteaux

The rise of the young Napoleon

Placed at the head of France's Army of Italy when he was not yet twenty-seven years old, Bonaparte astounded his enemies (and the French government) with the lightning speed of his military victories. After an intense period of activity in which he led the suppression of the monarchist revolt in Paris, in October 1795, the Directory put Napoleon in charge of attacking Austria and its ally the kingdom of Sardinia, across the Padan Plain. The French politicians felt, however, that the task of actually defeating Austria should fall to the more experienced generals Jourdan and Moreau, who, at the head of two armies, would approach Vienna through the Main and Danube valleys; Napoleon was to be employed mainly in a diversionary manoeuvre aimed at dividing the adversary's forces. But instead, Napoleon and his 38,000 men won victory after victory, forcing the Austrians to abandon first Milan and then all of northern Italy. Thus began the Napoleonic epic and the myth of the invincible general, a reputation earned on the battlefield but consolidated by a considerable propaganda effort.

Antoine-Jean Gros was in Genoa in 1796, where he came in contact with Joséphine de Beauharnais, Napoleon's wife, who took him with her to Milan. There, he set down the features of the military commander between a battle and a political meeting, and executed a preliminary sketch (now at the Louvre), which Bonaparte approved. This provided the basis for the famous portrait Gros exhibited at the Salon of 1801, depicting the moment in which the general (according to the Napoleonic myth) led his soldiers in the attack at the bridge at Arcole. Grasping a banner in his left hand and a sabre in his right, Bonaparte gazes back at his troops, but his whole body is thrust forward towards the smoke of the battle.

The unsheathed sabre The hand with which Napoleon holds his unsheathed sabre is wrapped in a thick combat glove. The blade is inscribed *Bonaparte Armée d'Italie*. In the background, a few buildings emerge from the smoke and haze of battle, and towards the bottom the river can be glimpsed. In reality, Napoleon did not lead the charge at Arcole – rather, this perilous duty fell to some officer whose name has been lost to posterity.

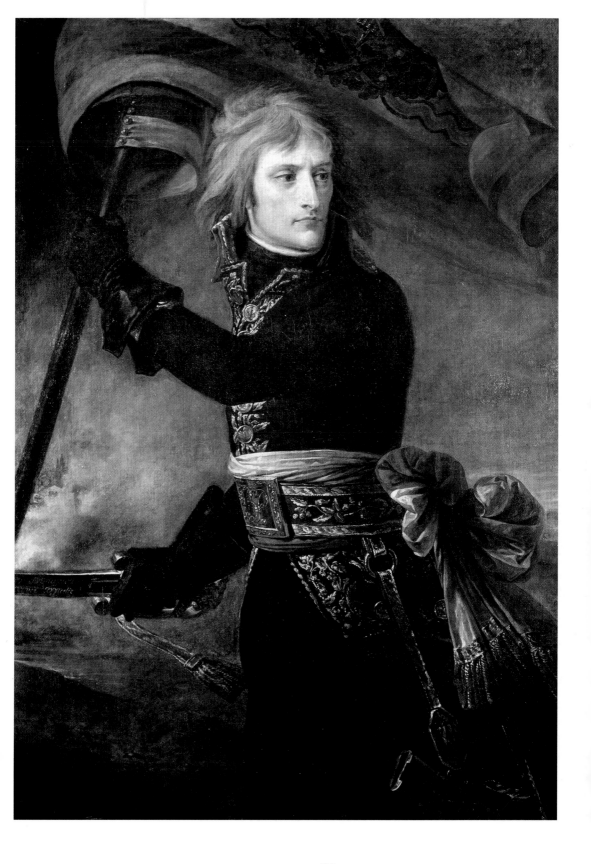

1804 THE CORONATION OF NAPOLEON

JACQUES-LOUIS DAVID, **The Consecration of the Emperor Napoleon and the Coronation of Empress Joséphine on 2 December, 1804**

1806–07. Oil on canvas, 621 x 979 cm. Paris, Musée du Louvre

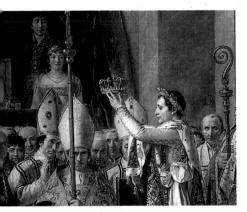

The crown, called the Crown of Charlemagne
Napoleon, the focal point of the composition, is about to place the crown on Joséphine's head. The emperor wears a gilded laurel wreath, according to Roman tradition, whereas the crown, created for the occasion, evokes Charlemagne. The detail of the sumptuous clothing, the careful division of the groups and poses, and the skilful distribution of light and shadow all contribute to giving the work the feel of a true account, while also being an idealized representation of power.

From general to sovereign

9 October 1799
Amid great secrecy, Napoleon returns from Egypt, where he had been fighting with mixed results since March of the previous year. He is greeted with great enthusiasm by the people, who expect him to provide a solution to the military crisis brought about by the Austro-Russian and English counter-offensive.

9 November 1799
In a *coup d'état* (on '18 Brumaire', according to the Revolutionary calendar), Napoleon deprives the Directory's government of power and institutes a three-member Consulate: himself, Sieyès and Ducos. The three draw up a new constitution, which confers upon Bonaparte the title of First Consul. It is ratified by plebiscite.

14 June 1800
At Marengo, Napoleon defeats the Austrians and the following year brings the war against Austria to a favourable end with the Treaty of Lunéville.

2 August 1802
Napoleon is made Consulate 'for life', with the power to name his successor.

2 December 1804
Napoleon is crowned emperor in the presence of Pope Pius VII. The usual plebiscite confirms the institutional change that had occurred.

A new emperor for the French

No one could have imagined that the transition initiated with the French Revolution in 1789 would result in another hereditary empire. Yet it was precisely due to the social upheaval of the Revolution that the person who brought this about in 1804 was the thirty-five-year-old Napoleon Bonaparte – a 'new' man from the political and military classes who could never have become so prominently involved under the *ancien régime*. Nevertheless, the Napoleonic empire was not a return to a society based on the absolutist principles of the monarchy, but rather an affirmation and consolidation of the middle-class values that had triumphed in the last stages of the Revolution. As 'emperor of the French by the will of the people', Napoleon centralized power in his hands but stabilized the new order of ownership and distribution of wealth that had emerged in the turbulent period at the end of the previous century. In addition, he entrusted the governing of France and the other territories largely to members of this renewed bourgeois aristocracy, in the process contributing greatly to the modernization of European society.

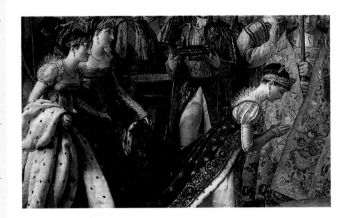

Joséphine David painted the First Lady of the Empire, six years Napoleon's senior, almost with the expression of a little girl – a faint smile illuminates her face as she prepares to receive the crown. Splendidly dressed and adorned with jewels and diadems, the lady is absorbed in religious concentration on the sacredness of the moment.

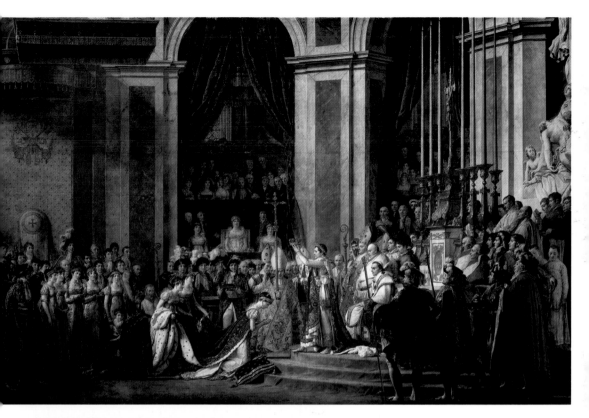

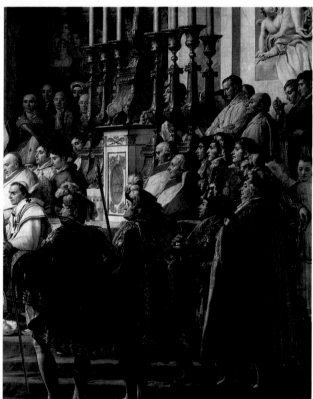

After his Jacobin enthusiasms of the revolutionary years, Jacques-Louis David gradually drew closer to Napoleon, who in October 1804 asked the artist to immortalize the moment of his coronation on canvas. Present at the event in Notre-Dame, David drew the scene from life, sketching the main groups and making notes of the details he did not have time to sketch. Then, with the assistance of his pupil Georges Rouget, he began a long labour that was not finished until late in 1807. The following year, the enormous canvas was exhibited at the Salon and received the Emperor's approval. David, 'First Painter' to Napoleon since December 1804, was named an Officer of the Legion of Honour, but in the succeeding years, various disagreements with Napoleon's administration arose over incomplete payment for this masterpiece, which emanates a solemn splendour.

Great dignitaries The idealized portrait gallery at the right in the painting includes arch-treasurer Lebrun, whose left hand holds a baton surmounted with an imperial eagle; Cambacérès, one of the fathers of the Napoleonic Civil Code, with the hand of justice; and Berthier, with a cushion on which the imperial orb topped with a cross is placed. All the dignitaries are dressed in ceremonial attire dating to the period of Henry IV – that is, the late 16th century.

Napoleonic reforms

Admired on the battlefield, Napoleon also distinguished himself through major reforms applied to the whole empire. Among these were:

The Civil Code Promulgated on 21 March 1804, the Code put an end to the legal fragmentation of the *ancien régime* and provided certainties about standards and laws to all citizens. It covered a wide range of subjects, from family law to patrimonial law, and abolished all feudal bonds in regard to ownership.

Centralized administration After the division of France's territory into departments that was initiated following the Revolution, in 1800 Napoleon introduced the role of the prefect, a state official who answered directly to the First Consul (and later, the emperor). The prefect's task was to carry out the central directives locally. This system guaranteed control and uniformity of government throughout the territory of the empire.

The school system Napoleon gave a great boost to public education, founding the lyceums in 1802 for the purpose of training the empire's ruling class. In 1808, he re-established the state university system and founded prestigious institutions like the Ecoles normales supérieures in Paris and Pisa.

Self-portrait David included himself in the act of drawing the scene, just as it had happened at the ceremony. He is among the bourgeois audience in the second gallery, far from the concentration of light at the centre.

Napoleon's sisters From left to right, dressed in white according to neoclassical tastes, are Carolina Murat, the future Queen of Naples; Pauline Borghese, the restless, sensual younger sister who would be immortalized by Antonio Canova in his marble statue *Venus Victrix*; Elisa Baciocchi; and Princess Hortense de Beauharnais. The child is Napoleon Charles, son of Louis Bonaparte and Hortense (Joséphine's daughter).

1804 THE CORONATION OF NAPOLEON

A traditional ceremony

Because of the importance of Napoleon's coronation, it was organized down to the slightest detail. The crux of the matter lay in linking the future emperor to a tradition rooted in the Middle Ages and the myth of Charlemagne, without allowing the spiritual to appear superior to the temporal. Napoleon and Joséphine had been married civilly. In view of the presence of Pope Pius VII, who was to 'consecrate' the imperial couple, they hastily wed again in a religious ceremony in the night of 1–2 December 1804. The décor for the coronation was entrusted to the architects Percier and Fontaine, who transformed the interior of Notre-Dame of Paris into a Roman temple, while Jean-Baptiste Isabey looked after the guests' clothing. An actor, Talma, taught Napoleon to walk with a solemn, regal gait, and the ceremonial protocol was strictly prescribed. In this splendid setting, Napoleon crowned himself while the pope blessed him. Then, the emperor crowned Joséphine and, when Pope Pius VII had withdrawn, Bonaparte swore an oath of loyalty to the Republic, declaring himself the 'crowned representative of the Revolution Triumphant'. The resultant ceremony successfully combined the various traditions and gave birth to a new dynasty.

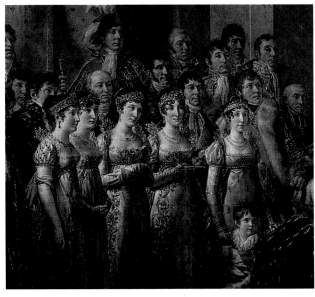

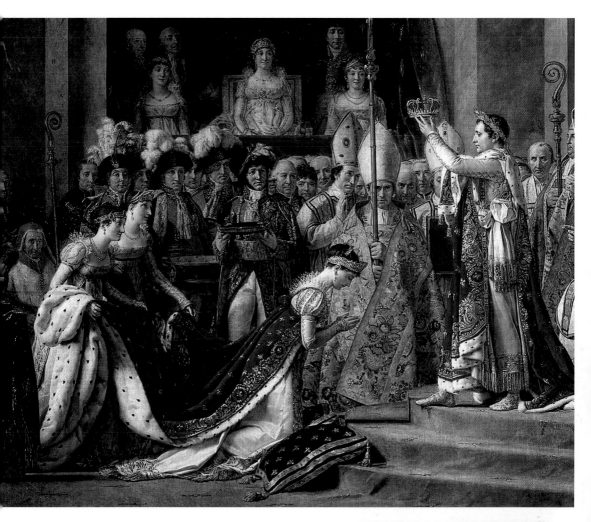

The imperial couple Napoleon's coronation of Joséphine dominates the centre of the scene: all eyes are turned towards the couple. David had initially wanted to depict the moment when Napoleon crowned himself, but at the suggestion of his student François Gérard, he decided to focus on the sealing of imperial authority. Napoleon required the artist to make some adjustments, requesting the introduction of the figure of his mother, Letizia Bonaparte (seated in the gallery behind the dignitaries), even though she had not attended the ceremony. The two maids of honour holding up the empress's splendid purple cloak are Madame de La Rochefoucauld and Madame Lavalette. The cushion on which the crown rested is in the hands of Murat.

Pope Pius VII Seated behind Napoleon, the pope gives a blessing with his right hand. It is an explicit reminder of the basically subordinate role played by the pontiff. David had actually wished to portray the pope in a completely passive pose but was dissuaded from doing this by the emperor himself. At Pius VII's side is Cardinal Caparara, who was not present at the coronation.

Sails and flags Insignias and flags flutter against the sky, while many sails have been rent by cannon fire and some of the masts tilt precariously. On his mainmast, Nelson ran up flags signalling the message: 'England expects that every man will do his duty.' Turner faithfully reproduces the flags spelling out the word 'duty'.

The apotheosis of Nelson

Horatio Nelson, a stalwart enemy of Napoleonic France, became the very symbol of British supremacy on the seas. Here are some outstanding moments in his military career:

1 August 1798
Nelson cuts off the French fleet in Aboukir Bay, near the Nile Delta, and destroys it completely. Napoleon is blocked and left isolated in Egypt.

Summer 1799
In Naples, Nelson takes part in the harsh repression of the supporters of the French Revolution. He assents to the sentencing to death by hanging of anyone who espoused the revolutionary cause.

2 April 1801
Ignoring the order to disengage issued by his commander Admiral Parker, Nelson carries the attack on the Danish and Norwegian fleet in the port of Copenhagen to a victorious conclusion. Denmark and Norway are forced to surrender.

1803–1805
Commanding the English fleet in the Mediterranean, Nelson besieges Toulon and blockades the French ships that were planning to invade England.

21 October 1805
Nelson wins his greatest victory at Trafalgar but is killed in combat. His body is transported to London and buried in a coffin made from the stump of a mast from the *Orient*, the French flagship destroyed at Aboukir.

1805 THE BATTLE OF TRAFALGAR

JOSEPH MALLORD WILLIAM TURNER, **The Battle of Trafalgar, 21 October 1805**

1824. Oil on canvas, 261.5 x 368.5 cm. London, National Maritime Museum

The war for control of the seas

Although the superiority of Napoleon's army on the battlefield remained uncontested for at least fifteen years, Britain's clear supremacy on the seas was fully confirmed at the battle at Cape Trafalgar. England's Royal Navy, under the command of Horatio Nelson, intercepted the French and Spanish fleet off the coast of Cádiz, Spain, on 28 September 1805. The two fleets had been pursuing each other between the Mediterranean and Atlantic, and Nelson, on board the flagship *Victory*, was determined not to let this opportunity slip away from him. On 21 October, as the French and Spanish set sail for Cartagena, the British attacked the enemy's centre and rearguard in two columns, unleashing a furious fray. After five hours' combat, the Franco-Spanish forces had had the worst of it, although Nelson, mortally wounded by musket fire from the French ship *Redoutable*, died before the battle was won. The English admiral immediately became a national hero, while France had to renounce all hope of rivalling England on the seas.

The *Redoutable* Turner depicts the French ship with its masts broken and about to capsize as the crew try to save themselves by diving into the water. In reality, the vessel did not sink until the next day, after the commander and survivors had surrendered to the English.

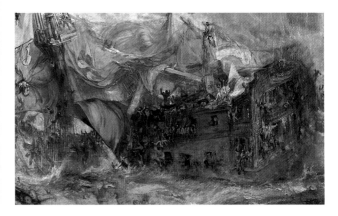

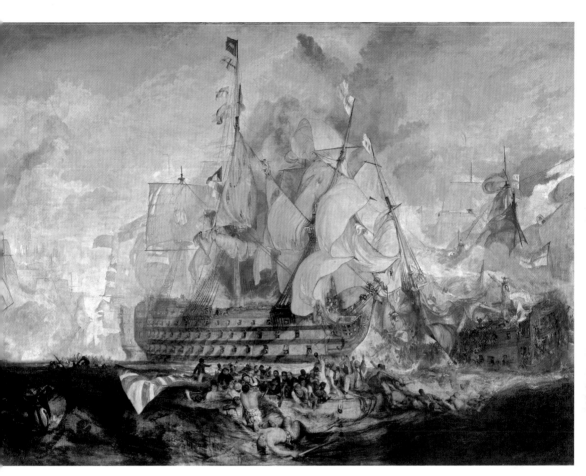

Though Turner most often painted Romantic landscapes, he made many historical paintings, whose subjects he reinterpreted by obeying his keen sensitivity to light and impressive atmospheric phenomena. In *The Battle of Trafalgar*, commissioned by King George IV in 1822, the artist sets the historical episode in a turbulent and agitated seascape, where ships, men and nature form a single entity. This was not the first time Turner had painted this subject. A previous version, painted in 1806–1808 – quite close in time to the event – focuses entirely on the dramatic death of Nelson. The later painting was poorly received when it was delivered in 1824 because of some anachronisms and because the number of English victims was considered excessive.

The *Victory* Armed with 104 cannons, the English flagship sits at the centre of the artist's composition, which makes it look more imposing than in reality. At the same time, Turner depicts the moment when the wounded Nelson is surrounded by his sailors. According to the record of the battle, the *Victory* began fighting at dawn on 21 October and withdrew in the early afternoon, its masts and hull damaged by volleys from the *Redoutable*.

A man in the face of death The focal point of the scene is a 'Christ of the people', his arms raised in a cross, his immaculately white shirt soon to be tinged with blood, his gaze dismayed and questioning. The peasant evokes the image of a martyr: on his knees before the rifles, he is gigantic compared with the other figures. At his side, a monk with a haunted look is praying.

The Peninsular War

February 1808
French troops occupy Spain on the pretext of reinforcing their position in Portugal.

May–July 1808
After the repression in Madrid, guerrilla warfare breaks out all over Spain. The French are roundly defeated at Bailén.

August 1808
English troops under Wellington's command disembark in Portugal.

October 1808
A French army of 200,000 veterans led by Napoleon himself reaches Spain. Madrid falls on 4 December and, after a terrible siege, Saragossa falls on 20 February 1809.

1809–11
Wellington takes the offensive. The French army, numbering 300,000, is worn down behind the front lines by continual guerrilla attacks. Reprisals are extremely violent.

July 1812
The French are defeated at Salamanca. The Anglo-Spanish army enters Madrid on 6 August.

Summer 1813
Combat moves into the Pyrenees, and Wellington reaches French territory in October. Spain is free of the French.

1808 THE REVOLT AGAINST NAPOLEON IN SPAIN

Francisco de Goya, **The Third of May 1808**
1814. Oil on canvas, 266 x 345 cm. Madrid, Museo Nacional del Prado

The sleep of reason produces monsters

Napoleon was convinced he could subjugate Spain without problems. In 1808, when he divided the Spanish monarchy and had his brother Joseph Bonaparte proclaimed sovereign, the Spanish army seemed to pose no obstacle. However, the arrogance and oppression of the French fostered a popular rebellion among the Spanish. The incident that led to the insurrection occurred on 2 May 1808. The French lieutenant Joachim Murat was planning to transport the Infante Ferdinand, heir to the throne, out of Spain, but the people of Madrid learned of this and rose in protest. Murat had to use the French and Mamluk cavalry (Egyptian mercenary troops) to quell the uprising, fighting street by street until Madrid was once again under French control. In the process about 150 French soldiers were killed, and Murat plotted a reprisal. The following day, 3 May, an extraordinary tribunal was called into session, and mass shootings of the rebels began. This was the start of a bloody war.

Lacerated bodies The corpses of the people who have been shot are shown in all their horror. The ground of the small hill where the slaughter took place is covered in blood.

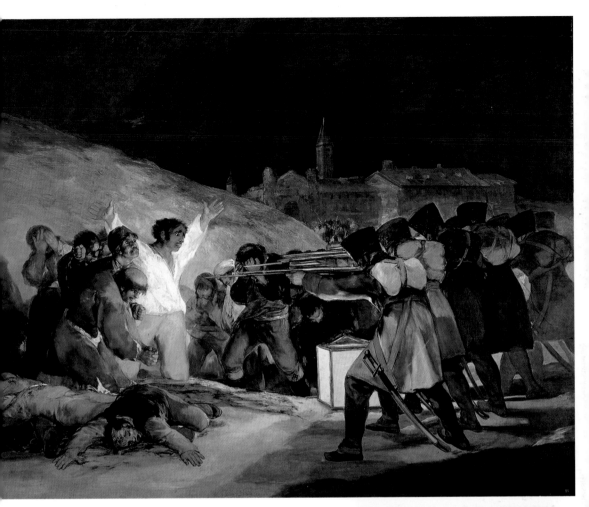

In 1814, Goya was commissioned by Spain's regent, Louis de Bourbon, to record the dramatic events of 2 and 3 May 1808. The canvases were to hang in a triumphal arch erected for the return of the legitimate king, Ferdinand VII. In the first painting, *The Second of May: The Charge of the Mamluks*, the artist celebrated the popular uprising, but in the second, *The Third of May 1808*, the focus is the tragedy of the firing squads. Goya captures the disturbing scene with a robust, thick brushstroke. In the dark of night, by the light of a lantern, the firing squad fires without respite as one group of condemned men follows another, an assembly line of death that with intense realism denounces the cruel madness produced by the violence of war.

The executioners The firing squad has no face, signifying the inhumanity of the soldiers' actions. The distance between the squad and the condemned is very short, as it was in reality.

The victims The condemned men who are about to be shot approach the centre of the scene, their faces betraying their desperation and anguish.

The giant Against the background of a stormy sky, a naked colossus with clenched fists advances through the mountains towards the horizon. For some critics, this emblematic figure represents the Spanish people who fought against the French army. The artist could have been inspired by 'The Prophecy of the Pyrenees', a patriotic poem by Juan Bautista Arriaza from 1810, in which a bare-handed titan rises against the invader in the Pyrenees.

Collapse of Napoleon's empire

1810–11
Despite the peace, the European economy enters a crisis because of the continental boycott Napoleon imposes on English ships and merchandise. The boycott is one of the causes of the rupture of the alliance with Russia.

24 June 1812
The Grand Army of 650,000 men invades Russia, reaching Moscow on 14 September. The army abandons the capital on 18 October and begins a dreadful retreat through the Russian winter. Barely 22,000 survivors make it back across the border in early December.

4 June 1813
Victory of Wellington at Vitoria; the French lose Spain.

16–19 October 1813
The Russian-Austrian-Prussian coalition defeats Napoleon in the 'Battle of the Nations' at Leipzig.

30–31 March 1814
Paris falls to the Prussian troops. Napoleon renounces the throne and withdraws to the Mediterranean island of Elba.

26 February 1815
The emperor leaves Elba and returns to continental France. The 'Hundred Days' begins.

18 June 1815
The last act in the Napoleonic epic is played out at Waterloo. Defeated, Napoleon abdicates and gives himself up to England. In October, he arrives at St Helena, a remote island in the southern Atlantic.

1808 THE REVOLT AGAINST NAPOLEON IN SPAIN

ASENSIO JULIÁ OR FRANCISCO DE GOYA, **The Colossus**
1808–12. Oil on canvas, 116 x 105 cm. Madrid, Museo Nacional del Prado

The beginning of the end

Napoleon's inability to foresee the strength of Spanish resistance contributed to the breakdown of his system. He was faced with a militarily exhausting conflict that was never resolved. The tactic of guerrilla warfare, the 'scorched earth' policy and the hostility of the people were insurmountable obstacles for an army accustomed to winning lightning campaigns on the open field. Furthermore, the Spaniards' unexpected resistance aroused anti-French feelings and fuelled nationalisms. The defeat suffered by General Dupont at Bailén in July 1808, which tarnished the myth of the Grand Army's invincibility, was greeted with enthusiasm all over Europe. Furthermore, the difficulties encountered in Spain obliged Napoleon to raise armies through conscription, provoking resistance from the French people, who began to consider him an 'ogre' that devoured their sons, while the war absorbed enormous economic resources without providing any great spoils. As Napoleon himself admitted at St Helena, 'This ill-fated war with Spain was truly a curse, the primary cause of France's misfortune.'

The crowd Terrified men and animals flee from the violence in disarray – a symbol of the tragic effects war has on civilians everywhere. In the midst of all the confusion, a lone figure remains calm: the white donkey in the foreground.

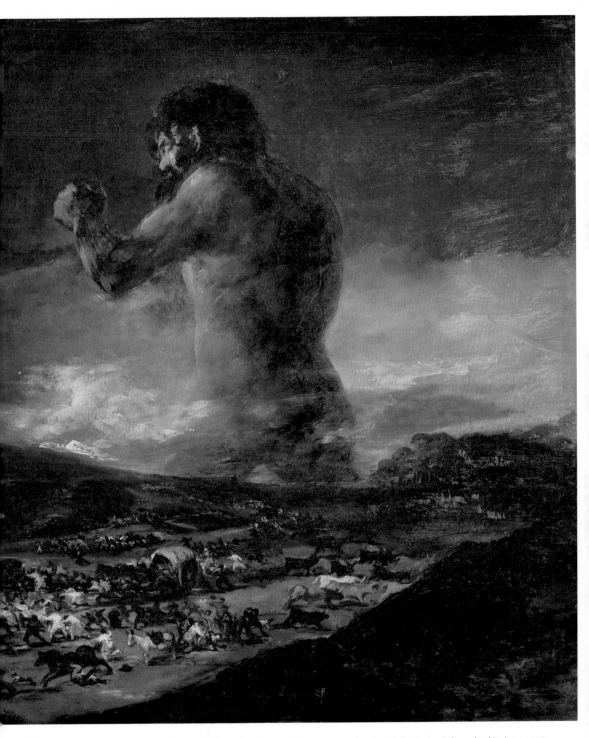

Although *The Colossus* had always been attributed to Goya, a debate concerning its attribution was launched in June 2008. Experts at the Prado in Madrid noticed what appeared to be the initials *A.J.* at the lower left of the canvas, which would point to the painter Asensio Julià, a friend and collaborator of Goya. Not all experts share this view, however. Regardless of who painted this canvas, it is a disturbing and powerful reminder of the effects of war – which certainly was a common theme in Goya's works. Between 1808 and 1812, the Spanish master produced a series of eighty prints called 'The Disasters of War', in which he denounces the torture, rape, physical violence and pillaging carried out by both the French and Spanish.

1816 THE WRECK OF THE *MEDUSA*

JEAN-LOUIS-THÉODORE GÉRICAULT, **The Raft of the 'Medusa'**

1819. Oil on canvas, 491 x 716 cm. Paris, Musée du Louvre

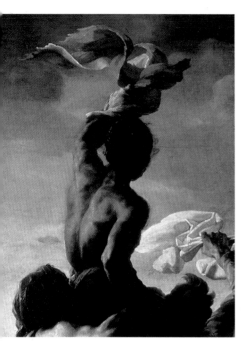

Hope The vertex of the composition is the group of men who, standing or precariously balanced, wave two tattered cloths – one red, one white – at the distant ship. All the figures in the centre of the raft are charged with an upward movement that symbolizes the rekindling of hope.

The scandal of the *Medusa*

The shipwreck launched a bitter debate in France, especially because the man chosen for command – an aristocrat exiled during the Revolution – was obviously completely incompetent. These are the main players in the drama:

Journal des débats This newspaper took up the case on 13 September 1816 by publishing the travel log of the ship's doctor, Henry Savigny, one of the raft's survivors. His memoir denounced the abandonment of the crew and the terrible conditions in which they were found.

Hugues Duroy de Chaumereys Born in 1763, de Chaumereys left France for England in 1789 and in 1795 participated in a royalist landing party in support of the rebellion in Vendée. Having returned in 1814 after twenty-five years of inactivity, he was placed at the head of the convoy of which the *Medusa* was a part and, ignoring the advice of his subordinates, steered it onto the shoals. Back in France, he was sentenced to three years in jail and relieved of all duty.

A tragedy at sea

This famous painting by Géricault was inspired by a disaster that occurred in the Atlantic Ocean on 2 July 1816. The French frigate *Medusa*, which had set sail for Senegal, ran aground in shallow water off Mauritania because of the incompetence of the captain, the Comte de Chaumareys, a nobleman who had returned to France in 1814 after Napoleon's downfall. Forced to abandon ship, de Chaumareys had the most illustrious passengers, among them Senegal's governor Schmaltz, his family and himself, board six lifeboats while he readied a 20-by-7-metre raft for the remaining 153 crew members. The raft was tied to the lifeboats with a rope, but it soon broke or was cut to make it easier for the lifeboats to reach the coast. Set adrift with almost no provisions, the men on the raft panicked and began to fight among themselves. The raft was adrift for twelve days. On the thirteenth day, it was sighted by the *Argus*, which picked up the fifteen survivors, five of whom died the following night. The survivors' accounts revealed that the shipwrecked crew had resorted to cannibalism.

The *Argus* in the distance A tiny speck lost in the middle of the ocean, the ship that would eventually take the survivors to safety is at this moment sailing in the opposite direction. The artist depicts the first sighting of the brig *Argus*, also on its way to Senegal in the convoy led by the *Medusa*, which came upon the raft only later. Géricault admirably conveys the dark strength of the billows, the hopeless smallness of the distant ship, and the shipwrecked survivors' vain efforts to attract its attention.

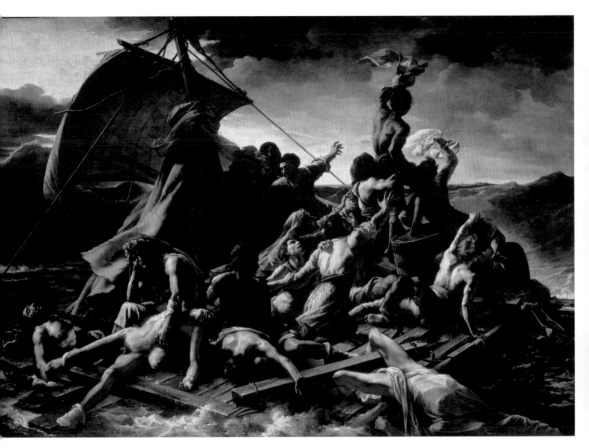

Géricault was very struck by the *Medusa* disaster and from spring 1818 to July 1819 diligently devoted himself to painting this work. He meticulously gathered information, interviewing the survivors, studying the faces and features of the dead and dying in morgues and hospitals, and going to Le Havre to observe the sea and sky. The result was a huge canvas that depicts the moment when the raft's shipwrecked passengers first sight the ship that would save them. While the scene's agitation, created by the vibrant interplay of light and dark, is a feature of Romantic realism, the sculptural relief of the bodies derives from the poses of Michelangelo, which Géricault had studied at length.

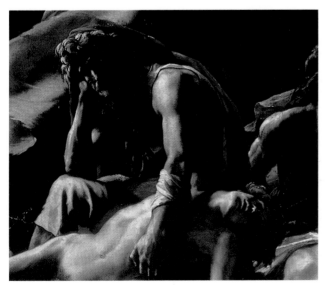

Resignation The painter skilfully graduates the state of mind of the raft's passengers. Death and resignation dominate in the group at the left. The left arm of an old man with the composure of a statue of an ancient philosopher rests on the abandoned naked body of a young man who is still wearing shoes. When Géricault exhibited the painting at the Salon of 1819, he gave it the vague title of *Shipwreck Scene*, but everyone recognized the reference to the *Medusa* and, furthermore, interpreted the work as an allegory of France 'adrift' in the climate of the Restoration.

The warrior Behind the woman, a black Turkish or Egyptian soldier, richly attired and wearing a turban, proudly plants his standard in the soil. It is the symbol of Greece's subjection and oppression.

The road to independence

1814
The Etaireia, a secret society that aimed to win independence for Greece, is founded in Odessa. In 1820, Alexandros Ypsilantis, an aide-de-camp of the Russian czar Alexander I, became the movement's military leader.

March 1821
While Ypsilantis enters Ottoman territory from the north, the Archbishop of Patras declares the war of national liberation. At first, the insurrection seemed successful.

January 1822
At Epidaurus, the Greek Assembly of Deputies proclaims independence.

1823–26
Taking advantage of the Greeks' internal divisions, the Turks request aid from the Egyptians and retake the Peloponnese and the Greek islands.

1827
The European powers (Czar Nicholas I's Russia in particular) side with the Greek uprising. The Turks recapture the stronghold of Athens, but the British-Russian-French fleet completely destroys the Ottoman-Egyptian fleet at the Battle of Navarino on 20 October.

1828
A French expedition disembarks in the Peloponnese, forcing the Egyptians to abandon the peninsula.

1830
The Protocol of London sanctions the birth of an independent Greek state under British influence.

1821 THE INDEPENDENCE OF GREECE

EUGÈNE DELACROIX, **Greece Expiring on the Ruins of Missolonghi**

1826. Oil on canvas, 213 x 142 cm. Bordeaux, Musée des Beaux-Arts

A four-year siege

In the Greek war of independence against the Ottoman empire, Missolonghi assumed central strategic importance. Linked to the sea by a shallow lagoon, the city controlled access to the Gulf of Corinth and communication between the Peloponnese and northern Greece. Moreover, it attracted various groups of survivors from encounters with the Turks in 1821 and 1822. Missolonghi gradually became a symbol of Greek resistance. Unsuccessfully attacked twice between 1822 and 1823, in January 1824 it welcomed Lord Byron. An ardent supporter of the Greek cause, the English poet came with arms and funds. After Byron's death from meningitis, Missolonghi was again placed under siege in 1825 and, finally, in January 1826. This time, the combined forces of the Egyptians and the Turks succeeded in blockading all access to the city, and the defenders of Missolonghi were reduced to starvation. In these desperate circumstances, the Greeks decided to defy the siege. The exit they attempted in the night of 11 to 12 April 1826 turned into a rout. Missolonghi fell to the Turks and Egyptians, but the military defeat was transformed into an ideal victory that, due to public opinion throughout Europe, attracted sympathy and aid.

With Romanticism, contemporary history became subject-matter for artworks, and Delacroix represents this trend perfectly: in the space of a few years, he turned twice to the pressing current theme of the Greeks' struggle against the Ottomans. In 1824, he painted *The Massacre at Chios*, inspired by the extremely harsh Turkish repression of the revolt on the island of Chios in 1822, and in 1826 he fixed on canvas the episode that ignited and stirred half of Europe: Greek resistance in the city of Missolonghi, which ended with the death of most of those under siege. In the latter case, Delacroix chose an allegorical figure, 'personifying' Greece as a woman in traditional costume, her breasts nearly bare, who seems to ask the public for compassion and respect. The same female figure reappears in Delacroix's *Liberty Leading the People*, from 1830.

A hand amid the rubble The only sign of the tragedy that has just taken place is the motionless hand emerging from the debris. Delacroix wished to recall the decision of a group of Greek combatants to return to the city after their failed attempt to leave and blow themselves up with all their ammunition rather than fall prisoner to the Turks.

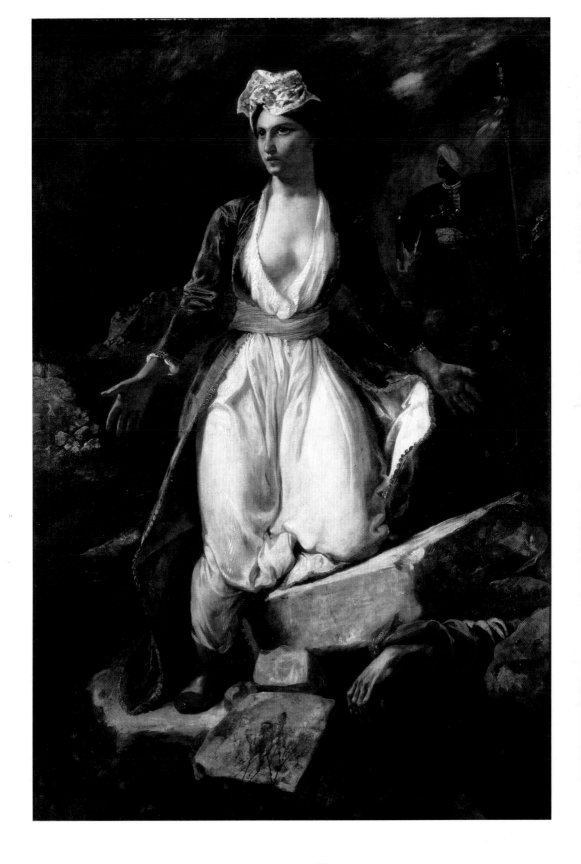

1821 THE INDEPENDENCE OF GREECE

Auguste Vinchon, Modern Greek Man after the Massacre of Samothrace

1827. Oil on canvas, 274 x 342 cm. Paris, Musée du Louvre

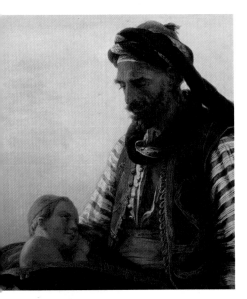

The old man The old man's inconsolable loneliness is palpable in his dejected facial expression and downcast gaze as he looks upon the child resting in his lap. The richness of the traditional costumes – always present in paintings like this, which indulge the growing fascination with the East – is contrasted with the old man's silent despair. It is a sober image that does not sentimentalize but instead compellingly conveys a feeling of protest against the horror of the massacre.

The Greek cause

The events leading to Greek independence attracted an unprecedented interest from European intellectuals, artists and patriots. All of them supported the Hellenic cause – considered a people's struggle for freedom – against the Turks, who were equated with cruel and inhuman barbarity. Some of the outstanding figures of this pro-Greek commitment were:

Lord Byron Of a noble family, this quintessential Romantic poet left England in 1816 because of a scandalous relationship with his half-sister. In Italy, he took part in the Carbonari movement. He arrived in Missolonghi in 1824 and died there on 19 April from a fever that developed into meningitis.

Santorre di Santarosa A military officer from Piedmont, he was one of the main figures in the movement that arose in Sardinia in 1821. Exiled to England, in 1825 he went to Greece, where he died in combat on 8 May 1825 defending the island of Sfactería.

The Vicomte de Chateaubriand A French writer, the standard-bearer of Romanticism, he embarked upon a successful political career after the fall of Napoleon. Dismissed in 1824, he embraced the Greek cause, becoming one of its main supporters.

The agony of the Ottoman empire

Even though in the late 18th century the Ottoman empire had undergone territorial losses – for example, the Crimea to Russia – at the beginning of the 19th century it still remained a great power. However, the Greek rebellion set its dissolution in motion and led to increasing interference from other states. Presenting itself as the 'defender' of the Orthodox faith – and hence a supporter of the Greeks in their struggle for independence – Russia pushed into the Balkans and around the Black Sea. However, the English and French could not allow Russia to become the sole power in the area and so, spurred by public opinion in both countries, took the Greek cause under their wing. It is somewhat paradoxical that the same powers that repressed liberal movements following the Congress of Vienna (1814–15) were now supporting the Greek nationalist insurrection. The fact is that the 'spoils' of the Turkish empire appealed to all the parties involved. Restoration France immediately set the example in 1830 by occupying Algeria, formerly an integral part of the Ottoman empire.

Defenceless A second corpse lying on the ground, perhaps a peasant or the husband of the dead woman, still grasps the knife with which he tried to defend the pillaged and torched house. The artist has placed him at right angles to the main group in the centre of the scene, creating a sense of depth and using the body as a transition to the vast panorama of sky that opens at the horizon.

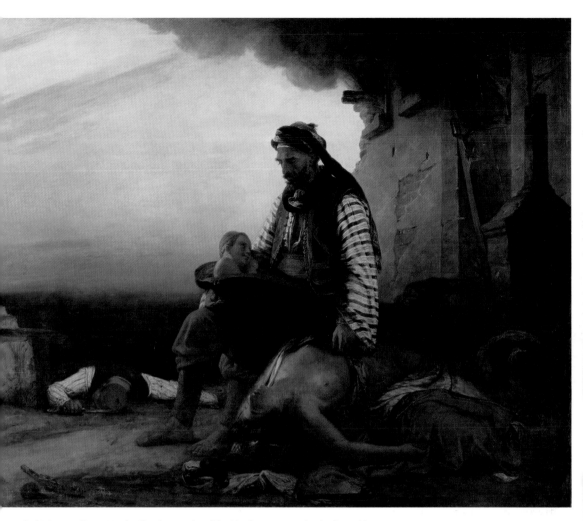

Artists' commitment to the Greek cause is evident in the many works dealing with subjects related to it. Apart from Delacroix, other painters, such as Ary Scheffer and Auguste Vinchon, also took up the theme. Vinchon in particular represented the terrible massacre of civilians carried out by the Turks in putting down the revolt on the island of Samothrace in 1821. This painting captures the pained exhaustion of an old man who holds an infant with one hand and with the other lightly touches the lifeless body of his daughter, who was killed as she nursed her baby. The tragedy is enveloped in the smoke of the ruins and the reddening sunset.

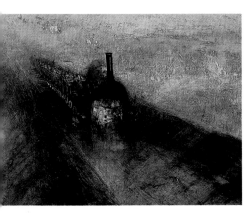

The locomotive The silhouette of a speeding Firefly-class locomotive, which could travel at more than eighty kilometres an hour, emerges through a thick curtain of fog and rain. Visible from the front, the machine's white-hot insides suggest that the boiler is fully fired. Turner was fascinated by the spectacle of speed, and the metal mass of the train together with the parallel lines of the bridge fully render the immediacy of movement, expressed with singular modernity.

The spread of the railroad

After their beginnings in Great Britain, railway systems rapidly developed elsewhere:

France The first trunk line, built in 1827, carried merchandise between Saint-Etienne and Andrésieux, in the Loire department. Though financed by public funds, the railroad was developed by private enterprise. By 1857, the system extended to 14,000 kilometres.

United States After its beginnings in 1827, the railroad expanded like wildfire, reaching 50,000 kilometres by 1860. The first transcontinental line dates from 1869.

Belgium The first railway, begun in 1833 at Malines, was a state project, but private companies soon got involved.

Germany The Nuremberg–Fürth line was completed in 1835, and by 1848 4,800 kilometres of track had been laid. The process of nationalizing the railroad companies began in 1879.

Italy The first railroad, the Naples–Portici line, opened in 1839. The various Italian states each operated their own lines until unification in 1861. By 1877, there were 8,100 kilometres of track.

1825 THE FIRST RAILROAD

Joseph Mallord William Turner, Rain, Steam and Speed: The Great Western Railway

1844. Oil on canvas, 90.8 x 121.9 cm. London, National Gallery

A technology that revolutionized the world

A decisive factor in the development of industrial society, the railway system was 'officially' born on 27 September 1825 with the inauguration of a stretch of track linking the mining centre of Darlington to the port of Stockton, England. The first twin-rail line with no means of animal traction, it was planned by George Stephenson, the engineer who also designed the famous *Rocket* locomotive. In 1829, Stephenson's *Rocket* won the contest held to choose the locomotive to be used on the new Manchester–Liverpool rail line, travelling at an average speed of twenty-eight kilometres per hour. The huge success of this line, the first used for transporting both goods and passengers, sparked the massive construction of railroads first in the United Kingdom and the United States (where by 1850 there was a network of 16,000 kilometres of track), then in other European countries and the rest of the world. The railway was a true motor of the economic and social change initiated with the Industrial Revolution: it fuelled exponential growth in the mining, iron, steel and mechanical sectors, mobilized enormous capital and allowed the movement of goods and passengers with ease at unprecedented speeds.

Ploughing Two horses and a plough can just be glimpsed in the field to the right of the bridge. They symbolize the pre-industrial reality that was coming to an end, an antiquated sight that was being left behind by the train's mechanical speed.

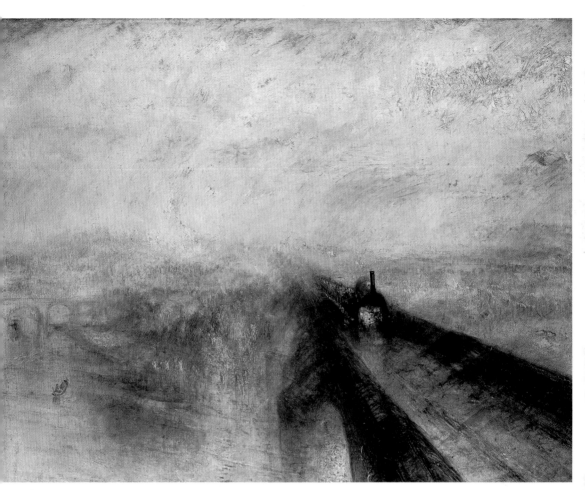

The English artist Turner – sixty-five years old when he painted this work – had already dealt with various subjects that evidenced the passing of an epoch, the transition from the pre-industrial world to the tumultuous progress of the early 19th century. In this canvas depicting his typically Romantic vision of a sublime and unsettled nature, the artist inserts a symbol of modernity, a train hurtling at full speed across a bridge over the Thames. It is a specific landscape: the bridge is the one completed at Maidenhead in 1838 by Isambard Kingdom Brunel, the most famous engineer of the time, for the London–Bristol railroad. Beginning limited operations in 1838, the line was owned and managed by the Great Western Railway company, of which Turner was a small shareholder.

The past Around the speeding train, the artist depicts a world that seems destined to disappear, an almost bucolic representation that includes a small boat of fishermen on the river and a glimpse of girls dancing on the shore. In the middle distance is an old narrow bridge with arches, in contrast to the solidity of the new bridge.

1830 THE JULY REVOLUTION

Eugène Delacroix, 28 July: Liberty Leading the People

1830. Oil on canvas, 260 x 325 cm. Paris, Musée du Louvre

Three days of glory

In a period of just three days – from 27 to 29 July 1830 – Charles X's monarchy collapsed in Paris, overturned by a popular uprising and the upper middle class's desire for a more liberal regime. Charles X of Bourbon, who took the throne of Restoration France in 1824, had pursued a somewhat reactionary course, placing parliament under his watch and curtailing freedom of the press. In these circumstances, when the troops stationed in Paris came close to closing the newspapers, the people once again took to the streets and set up barricades. In a short time, the insurgents became masters of the city, but the politicians positioned themselves between the champions of the republic and the majority of the French ruling class, who hoped to keep the monarchy but make it more constitutional. Louis-Philippe d'Orléans was chosen as the right person to fuel the people's enthusiasm and renew the monarchy. Philippe became the sovereign not 'of France' but 'of the French', and adopted the tricolour as the flag. The 'king of the barricades', as he was nicknamed, remained in power until 1848, when he was overthrown by another revolution.

The allegory of Liberty At the centre of the scene, illuminated by a beam of light from the left, the allegory of Liberty has the strength of Michelangelo's figures, which Delacroix so admired. The exposed breast, intended to make the figure more heroic, derives from classical nudes, but her Phrygian cap (the 'cap of liberty') and the urgency she wordlessly communicates to her companions bring this symbolic figure into the realm of current reality, giving her the force of a proud woman of the people.

From the Bourbons to the Orléanses

25 July 1830 Charles X issues the Ordinances of Saint-Cloud that provide for preventive censure of the press, the dissolution of the Chamber of Deputies and a new electoral law.

27 July 1830 Newspapers publish despite the prohibition. The first riots break out. General Marmont, who had handed Paris over to the anti-Napoleon forces in 1814, is appointed commander of the military stationed in the capital.

28 July 1830 The revolution spreads. The insurgents occupy the Hôtel de Ville. Charles X rejects all compromise.

29 July 1830 Two regiments go over to the insurgents' side. Marmont is forced to withdraw, and Paris is in the hands of the revolutionaries.

30 July 1830 Some moderate deputies contact Philippe d'Orléans and offer him the constitutional crown of France. Philippe hesitates at first.

31 July 1830 Philippe goes to the Hôtel de Ville, where General La Fayette, head of the republicans, welcomes him and embraces him before the people.

2 August 1830 Charles X abdicates and goes into exile.

9 August 1830 Louis-Philippe is named king 'of the French' and swears to respect the constitutional charter.

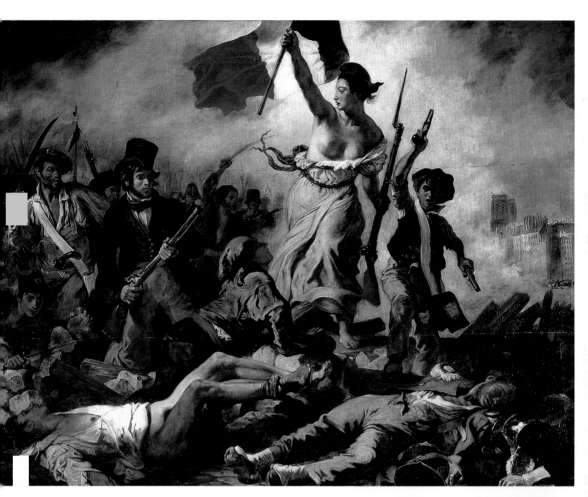

Executed by Delacroix in the months immediately following the events, *Liberty Leading the People* is a grand 'manifesto' that celebrates the people of Paris and their revolutionary drive. The work has a pyramidal composition, with the personification of Liberty at the peak, and dead bodies at the base. When it was exhibited at the Salon of 1831, its realism and the figures' distance from academic models caused a scandal. To some critics, the woman looked like a prostitute and the insurgents like common criminals. Despite this, the canvas was purchased by the state, but by 1833 it was hidden from public view. Only in 1863 (the year of Delacroix's death) was it finally put on display in the Louvre.

The people at the barricades The artist intended to represent all the social groups that participated in the revolution and fought at the barricades. The man with the top hat grasping a rifle (believed by some to be a self-portrait) is a craftsman, not a bourgeois, as can be seen from the long pants and flannel belt. The figure with the sabre is a tradesman, and the one with the headscarf at Liberty's feet, an unskilled labourer.

Young revolutionaries and the urban backdrop One of the most famous figures in the painting is the youth to the right of Liberty. Wearing a student's beret, he has a battle cry on his lips as he advances beyond the barricade with pistols in hand and an ammunition pouch that is too big for him. In the background behind him, amid the smoke of the cannon fire, are some houses and the silhouette of Notre-Dame. This may be a homage to Victor Hugo, a friend of Delacroix and the author of the almost contemporary novel *Notre-Dame de Paris*. Epic drama and factual account coexist in this canvas.

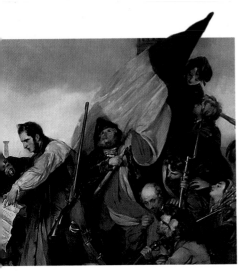

1830 THE REVOLUTION IN BELGIUM

GUSTAF WAPPERS, Episode of the Belgian Revolution of 1830

1835. Oil on canvas, 444 x 660 cm. Brussels, Musées royaux des Beaux-Arts de Belgique

The Tricolour At the top of the painting's pyramidal composition, a man is holding the Belgian flag. The arrangement of the coloured bands is vertical, as decreed by the provisional government in January 1831. During the 'Days of September', however, the bands were arranged horizontally – as they had been in the flag that had appeared over the Hôtel de Ville on 16 August during the clashes that followed the performance of *La Muette de Portici*. This flag recalls the banners of the anti-Austrian insurrection that broke out in Brabant between 1787 and 1790.

Stages of the revolution

25 August 1830
After a performance of Daniel Auber's opera *La Muette de Portici*, which extols love of one's country, popular demonstrations break out across Brussels. By the end of the day, there are many victims.

26 August 1830
Workers and the unemployed attack factories and destroy machinery. The upper and middle classes respond by organizing militias that take charge of re-establishing order in all the cities.

23–27 September 1830
King William I does not intend to concede anything to the upper and middle classes, and Dutch troops attempt to enter Brussels. After four days of fighting, they are forced to withdraw.

4 October 1830
The provisional government declares Belgium's independence.

21 July 1831
After King Louis-Philippe of France's son refuses the crown of Belgium, Leopold of Saxe-Coburg-Gotha becomes the first king of the Belgian constitutional monarchy.

The birth of a new state

The revolutionary wave that began in France in July 1830 spread to the neighbouring territory of the kingdom of the Low Countries, the state covering the territory of present-day Belgium, Holland and Luxembourg and that had been born at the Congress of Vienna in 1815. The two main parts of the country differed in religion, the Belgians being Catholic and the Dutch Protestant, while in Belgium, the French and Dutch languages existed side by side. However, the tension in the country was due to the management of political power and the division of resources and expenses, which were firmly in the control of the Dutch (even though they represented less than 40 per cent of the population) and the sovereign, William of Orange-Nassau. Thus, a strong Belgian nationalist movement developed that, once the internal divisions between Catholics and Liberals were overcome, began to claim greater rights for itself. William's inflexible and harsh response, the rising in Paris and the eruption of an economic crisis that created resentment among the poorer classes transformed the political issue into open rebellion in September 1830. After a few months, the great powers accepted the change in status quo, particularly England, once it was assured that Belgium would never be united with France.

A Baroque quotation Wappers looked to the Flemish tradition of painting, abandoning neoclassicism and returning to Rubens. The nude bodies and theatrical poses, the intense colour and the dramatic expressions give rise to an original synthesis of Baroque daring and Romantic realism.

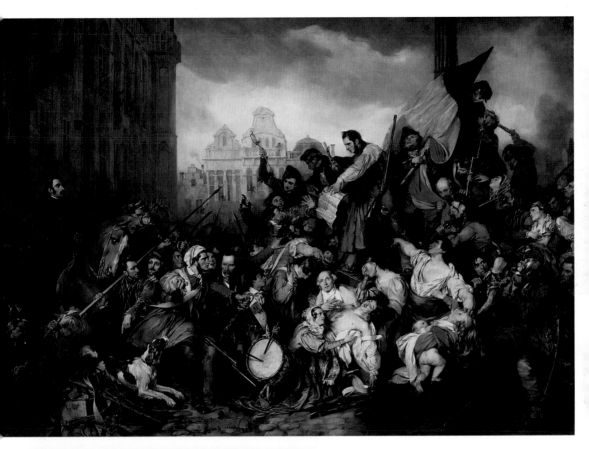

This canvas by Wappers, a Belgian pioneer of Romantic painting on historical subjects, presents an imaginary moment in the clashes of September 1830 that led to the country's independence. The commission came from the new Belgian government, and the whole painting captures the patriotic enthusiasm the young nation experienced in 1835, when the work was first exhibited in Antwerp and hailed as a true masterpiece. Though the artist may lack the energy and realism of an artist like Delacroix, the sincere love of country that the work emanates guaranteed its creator success. He won a succession of prizes and honours, and in 1839 was named director of the Academy of Fine Arts of Antwerp.

The unity of the Belgian people As in Delacroix's *Liberty Leading the People*, here too the various social classes are represented as united in the struggle for independence. In reality, the Belgian upper and middle classes were worried by the workers' uprising and did their utmost to control and direct matters towards the nationalistic goal.

1833 THE ABOLITION OF SLAVERY IN THE BRITISH DOMINIONS

Joseph William Mallord Turner, Slave Ship: Slavers Throwing Overboard the Dead and Dying, Typhoon Coming On

1840. Oil on canvas, 91 x 123 cm. Boston, Museum of Fine Arts

The international campaign against slavery

Since the close of the 18th century, a debate had been raging in Great Britain over slavery and the slave trade between Africa and America. Public awareness of the trade also increased because of court cases such as the 1783 trial involving the ship *Zong* and the deliberate drowning of 132 slaves. The conclusion to this protracted discussion came in 1833, when Parliament voted to abolish slavery in all British territories. After achieving this important goal, the abolitionists renewed the debate in quest of an international prohibition of slavery. In 1840, the first world congress to promote the abolition of slavery was held in London under the distinguished patronage of the Prince Consort Albert, Queen Victoria's husband. Turner painted this canvas at that time.

Thrown into the sea in chains As happened on the ship *Zong* in 1781, weak and sick slaves are being drowned in this painting. They are thrown from the ship still in heavy chains, which Turner curiously depicts floating on the water.

Victims devoured by fish 'Increasing still the Terrors of these Storms, / His Jaws horrific arm'd with threefold Fate, / Here dwells the direful Shark', James Thomson wrote, and Turner renders the poet's verses pictorially, showing fish and sea monsters devouring the slaves.

The events of the *Zong*

Background On the coast of Africa in September 1781, the English ship *Zong* took over 400 slaves on board for transport to Jamaica. When the voyage dragged on because of unfavourable winds, many of the Africans became sick and sixty died. The captain decided to throw all the sick Africans into the sea. One hundred and thirty-two people were killed.

The trial The owner of the ship asked the insurance underwriters for an indemnity for the 132 drowned slaves, but the insurers took them to court because the slaves had been thrown overboard deliberately.

The sentence After ascertaining the facts, the tribunal ruled that the insurer need not pay. The judges furthermore ruled that the captain committed no offence, since the slaves were 'merchandise' and not persons. The trial exposed the fairly widespread practice of throwing sick and weak slaves overboard during Atlantic crossings.

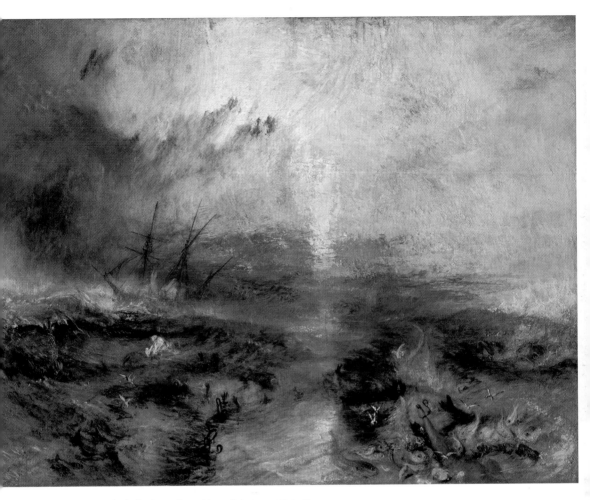

Turner's painting, which depicts a slave ship and slaves cast into the sea, was exhibited in 1840 at the height of the debate over slavery in England. In 1839, *The Times* had published in instalments Thomas Clarkson's essay *The History of [the Rise, Progress, and Accomplishment of] the Abolition of the [African] Slave-trade [by British Parliament]*, which relates the events of the ship *Zong*, and an excerpt from 'The Seasons', a poem by James Thomson describing the voyage of a slave ship endangered by a looming storm. The artist drew inspiration from these two documents to paint his own unequivocal denunciation of slavery.

The storm Turner commented on the painting with a poem of his own: 'Yon angry setting sun and fierce-edged clouds / Declare the Typhon's coming.'

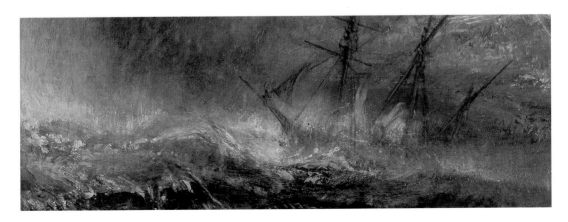

1840 THE DEVELOPMENT OF SOCIALIST IDEAS

GUSTAVE COURBET, **Pierre-Joseph Proudhon and his Children**

1865. Oil on canvas, 147 x 198 cm. Paris, Petit Palais

Contrasting views of socialism

'Property is theft.' This is the most famous sentence from the pamphlet 'What is Property?' that Pierre-Joseph Proudhon published in France in 1840. In this text, the journalist and scholar of modest background first exposes his idea of economic justice, which despite the attention-grabbing sentence does not entirely discount ownership. Refuting both the power of capital and the centralist state, he proposes a model of society based on cooperation among small production and social units. Karl Marx initially thought highly of the French thinker's reasoning and initiated a fertile exchange, but later branded Proudhon a 'bourgeois socialist' and an 'armchair reformer'. With his vision of a decentralized society and a process of revolution that would abjure violence, however, Proudhon exercised great influence on socialists who opposed the ideological rigidity of Marxism and nourished the development of anarchist thought.

An intellectual worker Courbet depicts Proudhon at work. Beside him are books and an inkstand. The simple artisan's shirt he wears highlights his egalitarian ideals. Courbet had originally included Proudhon's wife in the painting but deleted her after the exhibition of 1865, because the artist found the figure of the woman unsuccessful. Traces of the deletion are visible to the right of the thinker's head.

Learning of Proudhon's death in January 1865, Courbet immediately procured a photograph of his friend and set to work on this portrait-homage, which shows a younger Proudhon in a moment of domestic felicity. The canvas was originally entitled *Pierre-Joseph Proudhon in 1853*. The artist and the thinker had been in contact from the late 1840s. Courbet was fascinated with Proudhon's political ideas, while Proudhon celebrated his friend as the boldest, most modern French artist of his day.

Children 'Fatherhood filled a great void for me', Proudhon wrote of his relationship with his daughters, Catherine and Stéphanie. The older girl is depicted reading a spelling primer.

The course of events in early 1848

12 January

A revolt in Sicily overpowers the army of the Bourbon monarchs and reinstates the constitution of 1812. Consequently, riots and demonstrations spread through southern Italy and other states of the peninsula. Constitutions are introduced limiting the monarchs' power in the Papal States, Tuscany and Piedmont-Sardinia.

23–24 February

Fights break out in Paris between insurgents and regular troops. The Republic is proclaimed in France. King Louis-Philippe abdicates and leaves the country.

3 March

Hungarians and Austrians alike address a petition to the emperor asking for political and constitutional freedoms. The movement expands to other regions of the Habsburg empire, from Prague to Milan.

19 March

After two days of clashes, Frederick William IV, king of Prussia, orders the army to withdraw from Berlin and announces the concession of a constitution.

Adolph von Menzel, The Laying-out of the Fallen March Revolutionaries

1848. Oil on canvas, 45 x 63 cm. Hamburg, Kunsthalle

A European revolution

The revolutionary movement that swept through much of Europe in 1848, from France and Poland to Denmark and Hungary, was rooted in a political, economic and social crisis that concerned the entire continent. The second half of the 1840s had been marked by a profound economic recession accompanied by soaring food prices and, in some areas, famine. This crisis exposed and aggravated ongoing social conflicts that pitted apprentices against master craftsmen, cottage craftsmen against factory workers, employees against entrepreneurs, and rural peasants against the large landholders. These social tensions coincided with the liberal middle class's frustration over a political system that had remained essentially unchanged since the Congress of Vienna in 1815, limiting freedom of expression and social development. This explosive mixture burst into flame in the spring of 1848.

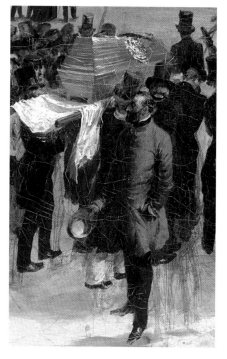

Mixing the classes As in other of his works, Adolph Menzel does not restrict himself to a representation that expresses the feel or atmosphere of the events but also captures the features of individuals within the crowd. In this canvas, he records distinguished gentlemen alongside men from the popular classes at a funeral. Menzel shared the concerns of a large part of the middle class over the 'risks' implicit in the participation of the people.

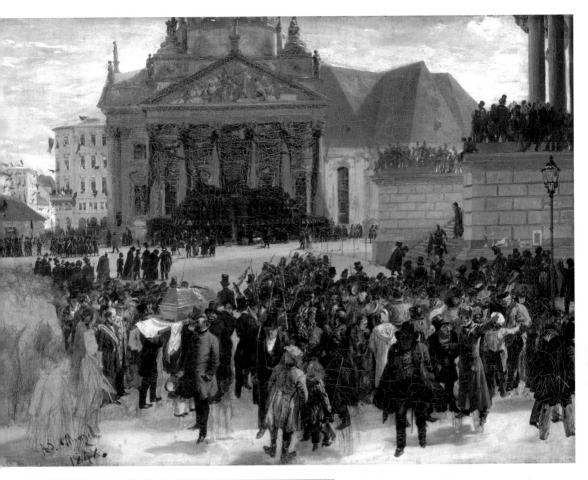

In this little canvas, which appears incomplete but is nonetheless signed by the artist as though it were a finished work, Adolph Menzel depicts the events of 22 March 1848 in Berlin. The funeral of the hundreds of citizens who died in the fighting in the previous days became an impressive political demonstration in which Frederick William IV himself took part, obliged by the crowd to honour fallen revolutionaries. The artist represents the moment when the coffins are gathered together and displayed in the centre of Berlin in front of the church known as the Deutscher Dom, before the cortège sets out on its way to the cemetery.

The Civil Guard Armed Civil Guards are present in the square. Initially an instrument of revolution, these volunteer corps were soon used by the middle class to suppress the more radical revolutionary splinter groups.

1848 THE SPRING OF NATIONS

ERNEST MEISSONIER, **The Barricade, Rue de la Mortellerie, June 1848**

1850–51. Oil on canvas, 29 x 22 cm. Paris, Musée du Louvre

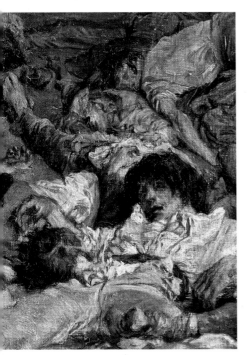

The face of death Meissonier describes death realistically, without resorting to embellishment or heroic stances.

Towards the defeat of the revolution

In almost every country in Europe, profound differences soon emerged between the supporters of the revolution. Liberals of various nationalities and languages clashed in the Habsburg empire and some regions of Germany, principally over the definition of borders between the future nation-states. In the more economically developed parts of the continent, and especially France, conflicts surfaced between the bourgeoisie, interested in a controlled process of political reform, and the popular classes – craftsmen, workers, small tradesmen – who championed radical social reforms to alleviate real economic problems. In the summer of 1848, these divisions allowed the old conservative forces to reassert themselves.

The Paris revolt of 1848

Background
On 15 May 1848, the radicals' first attempt at insurrection failed. Many republican leaders, although not directly involved in the uprising, were arrested, among them Louis Auguste Blanqui. The conservatives gained strength in the National Assembly and the provisional government.

Causes
The enduring economic crisis, along with the hopes of social improvement awakened by the February revolution, generated discontent among workers, craftsmen and small tradesmen. When the government attempted to close the National Workshops that provided work to the unemployed, a full-scale revolt broke out on 23 June.

Outcome
The revolt was repressed with bloodshed by 26 June. The National Assembly called upon General Louis Eugène Cavaignac, who had put down the uprising, to govern, conferring upon him dictatorial powers.

Even more than an artistic witness, Ernest Meissonier was a prominent figure in the events of June 1848. He served as a captain in the National Guard, which was involved in putting down the people's revolt alongside the army. Although Meissonier shared the goal of re-establishing middle-class order, the effects of the repressive actions had a strong impact on him: 'I witnessed the event in all its horror. With my own eyes I saw the massacre of the insurgents, whose corpses, shot and then flung from the windows, covered the pavement, as their blood, continuing to spurt, tinged the ground with red.'

The Tricolour In the foreground, a corpse dressed in the national colours of red, white and blue stands out from the tangle of nameless bodies. It is a symbol of the nation lacerated by civil war. This is perhaps the key to interpreting what the artist wanted to suggest with the title he gave the work when it was exhibited in 1851: *Remembrance of the Civil War*.

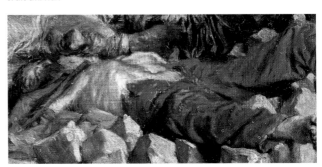

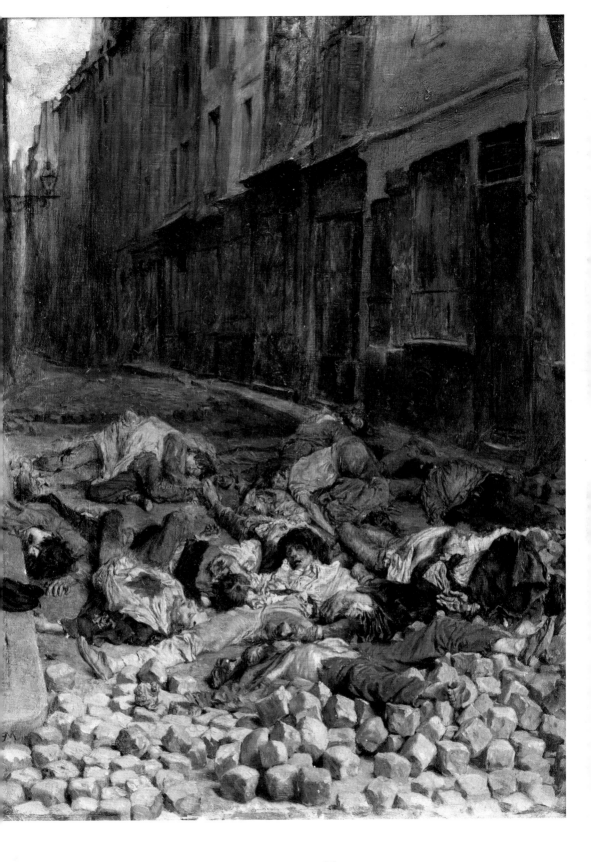

1850 INDUSTRIALIZATION

Adolph von Menzel, **The Foundry**

1872–75. Oil on canvas, 158 x 254 cm. Berlin, Alte Nationalgalerie

Lunch As work continues feverishly all around, workmen in the lower right-hand corner of the canvas eat the lunch that a girl has brought them in a basket.

From England to the whole world

The great technological, economic and social changes that are together today known as the Industrial Revolution began in 18th-century England. Following a period of increased agricultural productivity and strong population growth – which created a labour force ideal for factories – the first centres of industrialization began developing in about 1760. These centres were based around three major technological innovations: the steam engine, the mechanization of the textile industry and the first methods of steel production. From England, industrialization spread to the Continent, where the process intensified around 1850, and eventually involved countries beyond Europe as well, starting with the United States, which experienced a period of accelerated transformation after the American Civil War (1865), and Japan, where the government began promoting industrialization in 1868.

The main innovations of the Industrial Revolution

The steam engine The first steam engine for industrial use (used to pump water from a mine) was built in England in 1712. Nevertheless, only with the improvements made by James Watt in about 1769 did the steam engine become a fully efficient, economical machine for supplying energy to industrial machinery.

The spinning machine From the mid-18th century, entrepreneurs and craftsmen sought mechanisms to speed the work of spinning wool and cotton, the basis of all textile production. In 1779, Samuel Crompton perfected the spinning mule, which harnessed steam power for spinning.

Puddling Around 1784, the English entrepreneur Henry Cort developed the first industrial method for producing steel, called puddling.

The flywheel is a device for storing rotational energy, traditionally associated with Watt's steam engine. Around 1875, technologies from the early Industrial Revolution were still in widespread use, even though further groundbreaking innovations that would again revolutionize industry had already appeared, such as the Bessemer method for producing steel and the electric motor, patented in 1866.

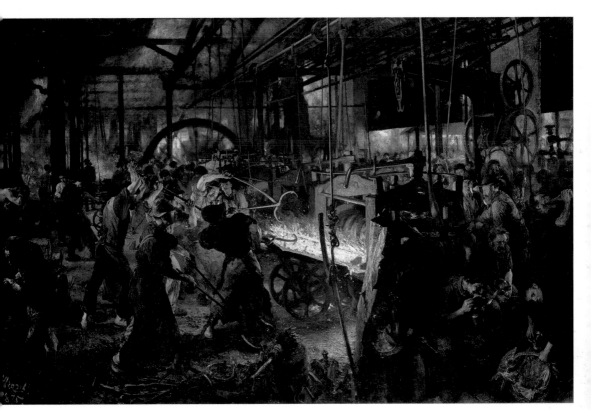

In the 1870s, Adolph Menzel, who had earned a solid reputation in the 1850s as a painter of historical subjects, turned to the depiction of modern life in the largely industrialized Germany of his day. Searching for suitable subject-matter, in 1872 the artist visited the Prussian state railroad-track factory in Königshütte (present-day Chorzów), Silesia. This region, along with the Ruhr, formed the backbone of German heavy industry. It is this factory, which employed 3,000 workers, that is depicted in the painting.

Arduous, exhausting work Menzel depicts the work process with great realism and interest. The workers push the incandescent rough iron onto the rolling mill with pincers and poles.

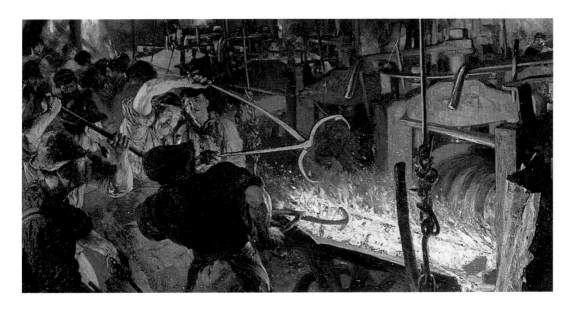

General Pélissier Pélissier, who succeeded General Canrobert in 1855 as commander-in-chief of the French troops in the Crimea, is surrounded by his men in the centre of the fortified redoubt. A tough soldier, notorious for the massacre at Dahra, Algeria, in 1845 (which left around a thousand dead), Pélissier took the offensive in the Crimean War. Following a change of strategy, he won a major victory in September 1855 by taking Malakoff Tower, the key to Sebastopol's defence. Because of this victory, Pélissier became known as the 'Duke of Malakoff', even though the actual capturing of the tower was done by General Patrice de Mac-Mahon, higher in command than Pélissier.

Wartime innovations

Sanitation and hygiene During the siege of Sebastopol, the spread of cholera, typhus and dysentery claimed more victims than the fighting itself. To remedy this and improve the terrible conditions in which the wounded were cared for, the English nurse Florence Nightingale organized the first modern-style field hospitals.

Balaklava In the Battle of Balaklava, 21 October 1854, 600 English light cavalrymen attacked the Russian position head on and were decimated. The subject of a famous poem by Alfred, Lord Tennyson and, in 1936, a movie, the 'charge of the Light Brigade' showed the limitations of cavalry and the superiority of artillery firepower.

Photographers and meteorologists Roger Fenton was the first photographer to compile a war reportage. Engaged by the British government, he took about 360 shots between March and June 1855. Following a violent storm on the Black Sea in November 1854, the French scientist Urbain Le Verrier organized the first network of weather stations linked by telegraph.

1853 THE CRIMEAN WAR

Henri Félix Philippoteaux, **General Pélissier and his Staff at Sebastopol**

1854–55. Oil on cardboard mounted on a backing, 39 x 57.5 cm. Paris, Musée de l'Armée

A conflict between great powers

The Crimean War pitted the unlikely alliance of the French, English, Turks and Sards against czarist Russia. The goal of the alliance was to thwart Russia's expansionist designs on the Ottoman empire and the Bosporus (the passage between the Black Sea and the Mediterranean). Militarily, the conflict focused on laying siege to Sebastopol, a Russian port and fortress on the Crimean Peninsula. The city did not fall until September 1855, after more than a year of fierce combat. In the peace negotiations that followed, Russia was forced to renounce its dream of free access to the open sea by controlling the Bosporus and the Dardanelles. Great Britain and France imposed tight checks on the Turkish empire and obtained neutral status for the Black Sea. And the small kingdom of Sardinia was able to present the case for political change in Italy, which at that point was still under the direct or indirect control of Austria. Scarcely twenty years after their support of Greek independence from the Turkish 'tyrant', the Western powers had aligned themselves in the defence of the Turks in order to limit Russia's ambitions.

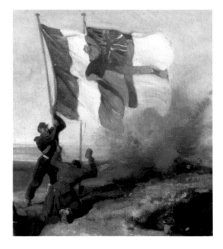

Banners flying Under enemy fire, soldiers plant the allies' flags as a sign that the position has been taken: the French tricolour and the ensign of the English navy, consisting of a cross of St George with the Union Flag in the upper left quarter.

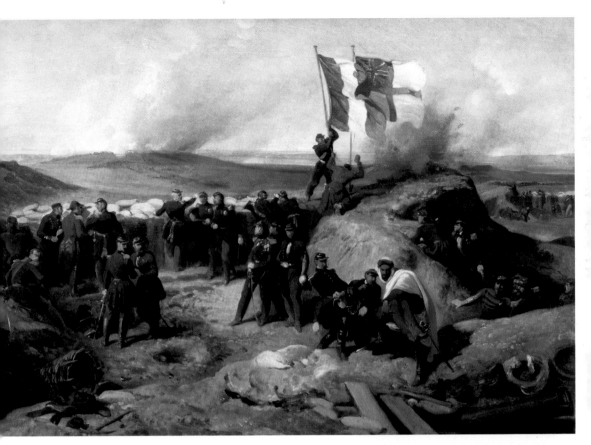

Specializing in military paintings and battle scenes, Philippoteaux had a penchant for subjects dealing with the Napoleonic era, the revolution of 1841, the Algerian campaign and the Crimean War. Here, he depicts the French general Pélissier in a redoubt probably just conquered from the enemy, as indicated by the hoisting of flags and the vestiges of battle in the foreground. Intent on celebrating the heroism of the French and their commanders, Philippoteaux clearly depicts the atmosphere of the siege of Sebastopol with strategically placed trenches and redoubts: conquering the city required tremendous force and sacrifice.

The wounded and figures in local costume
Philippoteaux depicts the transport of the wounded soldiers in a fairly conventional way, as did many painters of historical scenes at the time. The easterner who aids in the rescue, probably standing for the Turks' participation in the fighting, is represented in a stereotypical manner, in accordance with the canons of 'Orientalist' art.

Political struggle and violent clashes in Kansas

The Kansas–Nebraska Act In 1854, the United States Congress established the territories of Kansas and Nebraska, giving them the freedom to decide whether to adopt abolitionist laws or preserve slavery – thus putting an end to the 1829 moratorium on slavery in newly settled territories.

The sack of Lawrence Lawrence, Kansas, an abolitionist stronghold, had already been attacked by hostile troops in December 1855. On 21 May 1856, the city was devastated by Southern militants who destroyed property belonging to abolitionist associations and the offices and presses of two local newspapers that opposed slavery.

Four constitutions Between 1855 and 1859, four constitutions were drawn up for the nascent state of Kansas, but none was approved.

1856 THE POTTAWATOMIE MASSACRE

JOHN STEUART CURRY, **Tragic Prelude**

1937–42. Oil and tempera on canvas, 350 x 945 cm. Topeka, Kansas State Capitol

Warning signs of the American Civil War

In 1854, Kansas became the focus of a conflict between proponents of slavery and abolitionists. The issue at stake was whether this newly settled area would become a territory free of slavery or be modelled on the Southern states, with a slave-based economy. The conflict soon turned from a political contest to armed clashes. It was in this context that the Pottawatomie Massacre occurred in May 1856, when the abolitionist leader John Brown, aided by his sons and other militiamen, killed five pro-slavery settlers. This, in turn, was in retaliation for the sack of Lawrence, a violent attack by Southerners a few days earlier. The violence in Kansas raised the tension over the slavery question, which soon exploded into the American Civil War.

The frontier In the background, the artist evokes the pioneer wagon trains that crossed Kansas in the 19th century, confronting an adverse nature exemplified by a tornado and a prairie fire. At the same time, these cataclysms are metaphors of the conflict between the abolitionists and the proponents of slavery.

In 1937, John Steuart Curry was commissioned to decorate the corridors of the Kansas State Capitol building. The decorations were devoted not only to the present and future of Kansas but also to its history, as in the canvas *Tragic Prelude*. However, the decision to place John Brown at the centre of the immense painting caused no small consternation: the militant abolitionist was a controversial figure. Even though he became a popular hero in the context of the American Civil War, many considered him a terrorist fanatic not only because of the Pottawatomie Massacre but also for his attempt to organize a slave revolt in Virginia in 1859. It was because of this last act that he was condemned to death and hanged the same year.

Southerners and Unionists Facing each other to either side of John Brown, who is painted like a giant, are abolitionists with the American flag of stars and stripes and slavery advocates with the flag of the Confederate states of the South. The group of Southerners also includes Afro-American slaves.

The Zouaves Coming over the wall that has been destroyed by cannon fire are Zouaves, the colonial French troops established in Algeria in 1830. Deployed for the first time in Europe in 1854, the Zouaves were mainly Algerian Berbers, formerly in the service of the Ottoman empire. In the second war of Italian independence, they distinguished themselves above all in the Battle of Palestro on 21 May 1859, when, commanded by the Piedmontese king Victor Emanuel II, they successfully charged the Austrians. Their uniform included puffed trousers and a red headpiece.

The second war of independence

27 April 1859 Austria attacks Piedmont after it refuses to demobilize troops along the border. In keeping with the previous year's accords, Austria's aggression causes France to intervene alongside the Piedmontese.

4 June 1859 Although at first Austria is in control at the Battle of Magenta, the Franco-Piedmontese forces are eventually victorious. On 8 June, Napoleon III and Victor Emanuel II enter Milan in triumph.

16 June 1859 Gyulai, the Austrians' chief general, is relieved of duty because his strategy is considered too defensive. Command is assumed by Emperor Franz Joseph himself.

24 June 1859 Instead of withdrawing to strongholds in lower Lombardy, the Austrians change tactics and go out to meet the French and Piedmontese. The armies clash at Solferino and San Martino. More than 200,000 men are involved. Won by France and the Piedmontese, the battle claims 40,000 lives.

11 July 1859 Without advising the Piedmontese, Napoleon III signs an armistice with the Austrians at Villafranca. The French monarch feared that the Italian situation would slip out of control. Piedmont obtains only Lombardy.

1859 THE BATTLE OF SOLFERINO

ELEUTERIO PAGLIANO, **The Taking of the Cemetery of Solferino**

1866. Oil on canvas, 212 x 363 cm. Milan, Museo del Risorgimento

From the horrors of war to the Red Cross

The decisive clash in the second war of Italian independence took place on 24 June 1859. On one side, in Solferino and San Martino, were the allied French and Piedmont armies, while on the other were the imperial Austrian troops. The battle occurred almost by chance, as none of the adversaries expected to encounter the enemy at those sites south of Garda Lake. Fighting was particularly fierce and casualties were heavy. Immediately after the French and Piedmont troops had achieved victory, the Swiss businessman Henri Dunant arrived on the scene with the intention of requesting land rights from the French emperor Napoleon III for his company in Algeria. The terrible spectacle of the dead and wounded, abandoned and deprived of care, deeply affected the Swiss entrepreneur, who immediately endeavoured to organize and coordinate a relief effort regardless of the victims' nationality. This planted the seeds of the future Red Cross, which became recognized internationally in October 1863. In this way, the battle marked a decisive step forward in the humanitarian treatment of combatants.

The crosses In the foreground the artist has left a space empty but for crosses. Despite the careful composition and patriotic emphasis, the painting conveys the reality of war, with all its anguish and terror.

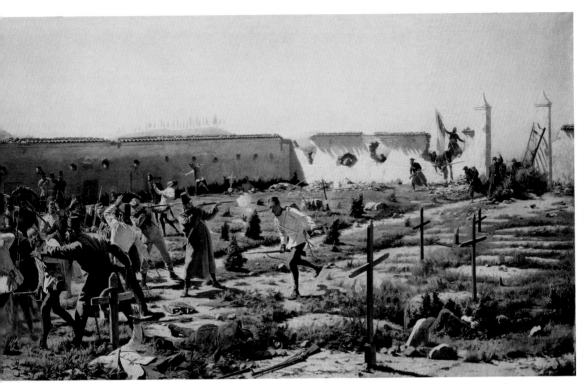

Eleuterio Pagliano was one of the mid-19th-century Italian artists who combined artistic activity with politico-military activism in favour of the country's unification. He participated in the Milan uprising of 1848 and fought with Garibaldi in the defence of Rome the following year. Having subsequently abandoned their republican aspirations, in 1859 these painter-soldiers once again fought alongside Garibaldi and the Piedmont monarchy against the Austrians – the conflict that led to the proclamation of the kingdom of Italy in 1861. A fervent patriot, Pagliano was one of the most significant exponents of historical painting on contemporary subjects and was skilled at combining the celebration of heroism with dramatic realism, as exemplified by the work shown here.

The defeated The foreground of the painting focuses on the Austrians, in white uniforms, who are forced to retreat. A non-commissioned officer peremptorily orders his subordinates to pull back as quickly as possible, while the soldiers shoot their rifles to cover their fleeing comrades, as indicated by the smoke of gunfire. Fallen soldiers lie in the foreground.

The red shirt Garibaldi wears his troops' typical uniform of a red shirt, first adopted in 1843, when he was fighting in Uruguay against Argentina. The Italian Legion, formed that year, was dressed in inexpensive red work shirts meant for Argentine butchers. From then on, the red shirt was synonymous with Garibaldi's volunteer militia, a symbol of their characteristic courage and evident irregularity. Of the 'Thousand' amassed in 1860, half were professionals and intellectuals, and the other half were craftsmen and workmen – though all had long conspiratorial and combat experience. Peasants, on the other hand, were entirely absent.

Three different men with a common cause

Camillo Benso, Count of Cavour A representative of an old noble family of Piedmont, he was raised on French and English liberalism. As prime minister of Sardinia in 1852, he initiated a thorough modernization of the kingdom. When the alliance with France was signed, he did his utmost to ensure that a kingdom of Upper Italy came into existence but took advantage of the situation to unify a large part of the country.

Giuseppe Garibaldi A republican and democrat, the 'hero of the two worlds' shifted course from insurrection against the Savoy monarchy to cooperation with it in the name of Italian unity. His most famous undertaking is the expedition of the Thousand in 1860, when, with a handful of men, he freed all of southern Italy and handed it over to King Victor Emanuel II. He tried several times to occupy Rome and the Papal States but was unsuccessful.

Victor Emanuel II The last Savoy sovereign and the first king of Italy, he supported the process of unification more out of dynastic interest than true conviction. A great combatant, he developed a personal relationship of esteem and respect with Garibaldi, whereas his relationship with Cavour was often tense.

1861 THE UNIFICATION OF ITALY

Gerolamo Induno, **Garibaldi on Mount Sant'Angelo at Capua**

1861. Oil on canvas, 64 x 50.5 cm. Milan, Museo del Risorgimento

The 'accidental' birth of the kingdom of Italy

Divided into various states subject to Austrian influence, in the mid-19th century Italy began a difficult process of unifying itself that came to fruition in 1859–60. It began with the Franco-Piedmont alliance formed in 1858. This agreement provided for the formation of a kingdom in Upper Italy governed by the Savoys, the reigning family of Piedmont, while central Italy planned a confederation presided over by the pope under French influence. However, events unfolded quite differently. Despite French and Piedmontese victories over the Austrians on the battlefield in June 1859, Piedmont received only Lombardy and not the Veneto (the area around Venice), while central Italy became an integral part of the new kingdom. In May 1860, Giuseppe Garibaldi renewed the initiative, and set out with a thousand volunteers to the kingdom of Two Sicilies. No one could have imagined that Garibaldi would prevail over the Bourbon army – but he did. Panicking, the government sent out the army to prevent him from setting his sights on Rome and the Papal States. Thus, Garibaldi's initiative was brought back in line with government policy. The unification of Italy was accomplished in late 1860 and made official in January 1861.

The Volturno After entering Naples without firing a shot on 7 September, Garibaldi finally faced the Bourbon army on 1 October 1860, when the two sides clashed in the surroundings of this river that meanders peacefully past Capua. Garibaldi was victorious and the Bourbons lost the kingdom of Two Sicilies forever.

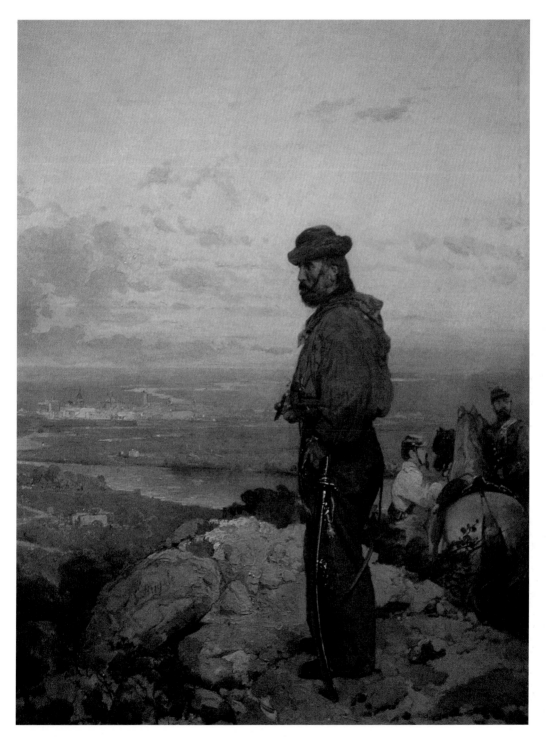

The official painter of the expedition of the Thousand, Gerolamo Induno followed all the military actions, even fighting alongside Garibaldi in 1848–49 and 1859–60. Though the artist often painted pictures that indulge the celebratory and heroic aspect of Garibaldi's adventures and the Risorgimento, he also delved deeply into more intimate and personal aspects, concentrating on the feelings and emotions that animate the combatants. This little painting captures the hero Garibaldi in a moment of reflection and meditation – whether before or after battle we do not know – in a pose that is in no way official. Capua's broad, harmonious landscape unfolds around him.

The American Civil War

Causes

The determination of the Southern states to defend the slave system, on which their society was based, against the Northern states' call for modernization.

The sides

On one side were nineteen Northern states plus five border states that, although allowing slavery, did not agree to secession – giving a total of twenty-four states with a population of about 22,000,000; on the other side, eleven Southern states with about 9,000,000 inhabitants, one-third of whom were Afro-American slaves.

Main theatres of war

Virginia, where Richmond, the capital of the Southern Confederacy, was located; the zone bordering the federal capital of Washington, D.C., which remained contested to the end of the war; the regions around the Mississippi, controlled by the Northern troops from 1863; Kentucky and Tennessee, under Northern control after the Battle of Chattanooga in November 1863. In addition, the Northern fleet blockaded the Southern coast and ports.

1861 THE AMERICAN CIVIL WAR

WINSLOW HOMER, **Rainy Day in Camp**

1871. Oil on canvas, 50.8 x 91.4 cm. New York, Metropolitan Museum of Art

The United States on the road to modernization

The debate over slavery had polarized society in the United States since the 1850s. The South, consisting mainly of large agricultural plantations, defended the institution; the North, for political, economic and moral reasons, wanted to achieve its gradual abolition. So when Abraham Lincoln, the candidate of the Republican Party, which included abolitionist leaders, won the presidential elections in November 1860, some Southern states opted for secession. This led to a devastating war, beginning in April 1861, in which both sides mobilized tremendous resources. New military technologies were used, especially by the Northern states. The result was the death of more than 600,000 soldiers, plus countless civilians. In the end, the North was completely victorious. Slavery was abolished in all the United States, even though official discrimination against the former slaves remained for a long time after. The federal government of the United States emerged stronger from the war, while the whole of American society received a big push towards modernization.

Animals The atmosphere of a military camp is rendered through the tents, covered wagon and, above all, horses lined up in the background. Closer to the foreground, a mule seems to be shaking the rain off its back.

Winslow Homer began his career in the 1850s as an illustrator for the growing market of illustrated magazines. In 1861, the major magazine *Harper's Weekly* sent him to the front lines of the war as correspondent-draughtsman. In this setting, he gathered material that in the coming years he would transform into oil paintings narrating the life of the soldiers of the Northern army. This canvas, which does not depict a real situation, is based on sketches made at the front in Virginia at various times in 1862.

Waiting Homer's war paintings often focus on soldiers' everyday lives, leaving aside the crueller, more dramatic aspects of combat. In *Rainy Day in Camp*, the soldiers seem suspended between waiting for the next engagement and homesickness, as a heavy rain falls – rendered by the artist with grey brushstrokes that descend diagonally from the upper left.

1863 THE JANUARY INSURRECTION IN POLAND

Jan Matejko, **Poland, 1863**

1864. Oil on canvas, 156 x 232 cm. Crakow, Muzeum Naradowe

The crucifix A disconsolate woman turns to the crucifix – a reference to the Catholic religion that played a determining role in forging the Polish national identity.

An unsuccessful insurrection

Since the end of the 18th century, Poland's territory had been divided among the neighbouring powers of Russia, Austria and Prussia, but Polish society did not accept foreign domination lightly. The nobility and intellectuals struggled against the three empires' oppressive regimes throughout the 19th century to establish a liberal system and national independence. The revolt of 1863 – which broke out in the Russian-controlled part of Poland – arose in the context of the reforms that Czar Alexander II had initiated after the defeat in the Crimean War (1856), which had stirred the hopes of the Polish opposition. Preparations for revolt were begun in secret in 1862 by the National Committee, which organized partisan troops. The situation exploded in January 1863 when the pro-Russian government tried to recruit Polish youths for the czarist army. The partisan groups managed to withstand the czarist troops for about a year and a half before being overcome. The Russians' reaction was extremely harsh: Poland lost any autonomy it had previously enjoyed, and the administration and schools were largely Russianized.

The Polish opposition

Various groups

Although the January insurrection was initially organized by democratically minded groups from the ranks of the minor nobility, it was soon supported by the upper nobility and more conservative forces who had initially been suspicious.

Goals

To reconstitute the Polish state and give it a liberal constitution; to abolish all forms of serfdom and to distribute land to the peasants.

Alliances

The Polish insurgents managed to involve the Lithuanian and Belorussian territories that had been part of Polish territory since 1795. They also made contact with Aleksandr Herzen and other members of the Russian opposition. The revolt was supported by many Western European liberals, democrats and socialists.

Lithuania The figure in white beside Poland, being harassed by the soldier at her side, probably represents Lithuania. The revolt had also spread into that country, which was under the domination of czarist Russia.

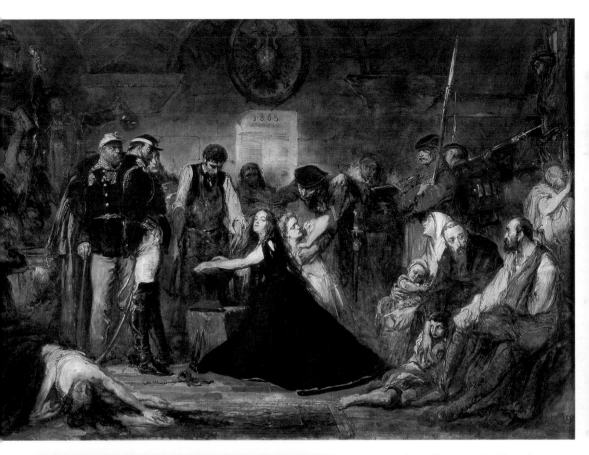

For Jan Matejko and his peers, the failure of the 1863 insurrection was a watershed. After this defeat, the Polish opposition renounced armed revolt and devoted itself to reforming the nation through cultural and civil undertakings. Matejko participated by celebrating and commemorating the great moments of Poland's past in his canvases. Exceptionally, this painting is devoted to current affairs, creating a metaphorical representation of Poland in 1863. Kneeling before a blacksmith who is about to put her in chains, the allegory of Poland in mourning at the centre is surrounded by the oppressors and Polish prisoners who are being deported to Siberia.

The oppressors Besides the Russian officer, Matejko paints a Prussian officer – a reference to the fact that Prussia, like Russia, applied harsh policies of oppression in Poland. Furthermore, the Prussian government aided the Russians in putting down the January insurrection.

The true culprits Manet's belief that France was to blame is clear from his decision to depict the firing squad and junior officer dressed in the uniform of the imperial French army instead of that of the Mexican republicans. The depersonalized brutality of the soldiers is emphasized by the mechanical, indifferent attitude with which the soldier loads his rifle.

The chronology of a drama

28 May 1864
Maximilian disembarks at Veracruz after having accepted the crown of Mexico offered him by notable conservatives who guaranteed him the support of the people. He is obliged to renounce all rights over the Austrian empire.

1864–65
The new emperor settles in Mexico City with his wife, Carlotta (Charlotte) of Belgium. In October 1865, Maximilian offers amnesty to Juárez and his supporters. When they refuse, he issues the Black Decree, which condemns all rebels to death.

31 May 1866
After the United States formally requests the withdrawal of troops, Napoleon III abandons Mexico. Carlotta returns to Europe where she vainly seeks help for her husband and descends into madness.

13 February 1867
Maximilian withdraws to Santiago de Querétaro, and the republicans lay siege to the city. After a failed attempt to flee, the emperor is taken prisoner.

19 June 1867
Despite the urgent request for clemency, Maximilian is shot. The president of the United States, Andrew Johnson, assents in order to demonstrate America's will to reject all European interference.

1867 THE EXECUTION OF MAXIMILIAN OF HABSBURG IN MEXICO

EDOUARD MANET, **The Execution of Emperor Maximilian of Mexico**

1868–69. Oil on canvas, 252 x 302 cm. Mannheim, Kunsthalle

A tragic political adventure

In 1861, in the general context of activism that characterized Napoleon III's foreign policy, the French sovereign decided to intervene in Mexican internal affairs. Capitalizing on the failure of Benito Juárez (who headed the liberal government) to pay the foreign debt, the French began a military campaign that resulted in victory and the installation of a monarchy supported by local conservatives. The crown of the new 'emperor' was offered to the Austrian emperor Franz Joseph's brother Maximilian of Habsburg, who had distinguished himself as the governor of Lombardy-Veneto in Italy from 1857 to 1859. Maximilian accepted and arrived in Mexico in June 1864. There, he instituted a moderately liberal policy, displeasing the conservatives, while Juárez continued to regard him as the instrument of foreigners. Meanwhile, the international situation changed: with the American Civil War at an end, the United States supported Juárez and his resistance until Napoleon III, preoccupied by what was happening in Europe, withdrew his troops in 1866, abandoning Maximilian to his fate. Maximilian surrendered to the republicans in May 1867, was condemned to death and shot on 19 June – a bloody warning that the Mexicans would not tolerate political interference by foreign powers.

The onlookers The absence of drama is noticeable in the spectators, symbolizing a people far removed from what was happening. With seemingly amused curiosity, they observe the firing squad from behind the wall as if it were a show.

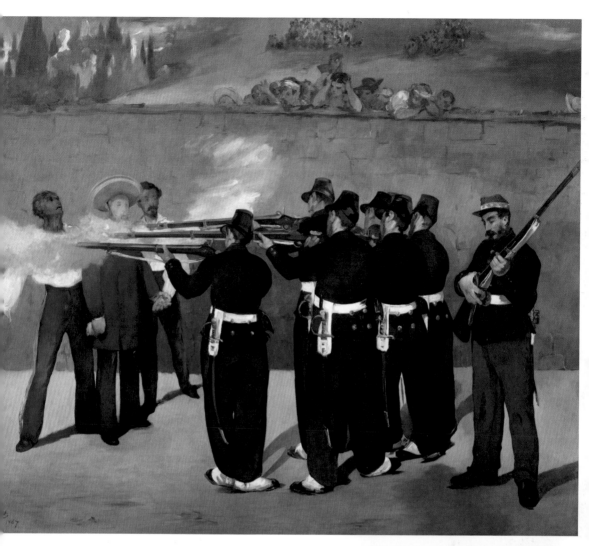

When Manet learned of Maximilian's execution, he depicted this strictly contemporary episode in various versions, thereby issuing an accusation against Napoleon III's rash foreign policy. One of these versions was presented almost immediately after the event in 1867, at Manet's solo exhibition at the Pont de l'Alma in Paris. Subsequently, however, he could no longer exhibit or sell the works, particularly the final version, painted in 1868–69 and reproduced here. The artist was a seasoned hand at provocation: the *Déjeuner sur l'herbe* and *Olympia* had already got him excluded from official exhibitions. In this canvas, though inspired by the famous firing squad in Goya's painting *The Third of May 1808*, Manet omits the emotional participation that animates the Spanish master's Romantic painting to represent the incident with dry objectivity.

The condemned Maximilian is in the centre, in dark attire, wearing a hat that exaggerates his pale complexion. Beside him are General Tomás Mejía (already hit by the discharge) and Miguel Miramón. They are both wearing white shirts and their faces are of a darker complexion. Manet intended the image to recall the crucifixion of Christ and the two thieves.

The end of isolation

8 July 1853
Four US warships under the command of Commodore Matthew Perry force their way into the port of Uraga. The shogunate (the feudal Japanese government), in the hands of the Tokugawa family, agrees to deal with Perry.

31 March 1854
The Treaty of Kanagawa (also known as the Perry Convention) opens Japan to the Americans.

1858
Japan is obliged to sign the 'unequal treaties' imposed by the United States, France, Great Britain and Russia.

1860–67
Anti-Western revolt spreads, and the shogunate is accused of having betrayed the country to foreigners.

January 1868
In office since the previous year, Emperor Mutsuhito takes power into his hands, abolishing the shogunate after 250 years. Although he does not close the country to foreigners, he rejects any 'unequal treaty'.

1868–69
Outbreak of the 'Boshin War' between the supporters of the shogunate and the pro-imperial forces, who are victorious thanks to modern training and weapons. After the rebels are pardoned, the Japanese aristocracy rallies around the figure of the emperor.

TOYOHARA CHIKANOBU, **A Concert of European Music**
1889. Woodcut, 36.8 x 73.7 cm. New York, Metropolitan Museum of Art

Change and tradition in the empire of the Rising Sun
When, in 1868, Prince Mutsuhito – who would be given the name Meiji, meaning 'enlightened governor' – took up the reins of Japan's government, it marked the end of a long period of internal strife within the classes of feudal lords of the court. The most pressing issue was how to modernize Japan without subjecting it to any foreign (specifically Western) power. In 1853, the United States had managed to break through Japan's closed-door policy, sailing four armed ships into the Japanese port of Uraga (which, like all the country's other ports except for Nagasaki, was completely forbidden to Westerners). In the following years, the Japanese government – a system of feudal lords – had been forced to sign various treaties with the United States and other Western powers that imposed major limitations on its sovereignty, and this had led to a long period of conflict. Mutsuhito resolved the dilemma by initiating a process of modernization guided from above: with feudalism abolished, a process of industrialization and the creation of a modern army based on compulsory conscription was quickly initiated. Japan's ambition now was to impose itself throughout the entire Far East.

The chorus European music was well received in Meiji-era Japan. The Western musical scale, quickly adopted and taught in the school system, was made obligatory in 1872. In 1876, the interest in Occidental culture led the Japanese government to found the first Academy of Fine Arts, where many European intellectuals came to teach.

The artist Toyohara Chikanobu came from a samurai family and was so closely aligned with the Tokugawa shogunate in the civil war of 1868–69 that he was imprisoned twice by order of the emperor. As an artist he was caught between respectful nostalgia for the past and an interest in the modern changes introduced in the Meiji era. His production alternates between historical and mythological subjects, with Kabuki theatre characters and the *bijinga* genre (portraits of women famous for their beauty) following in the footsteps of traditional Japanese painting and art prints. However, the artist also turned his attention to subjects of contemporary life, attentively examining the changes of behaviour that permeated and radically altered Japanese society.

Cherry blossom time The branches of cherry blossoms, symbolizing life's beauty that lasts for an instant and then withers, refer to Japanese tradition. Along with the full moon, they lend a Japanese frame to this otherwise quite Westernized interior scene.

Flute with piano Every attitude and posture of this young Japanese man and woman, with their European dress and hairstyles, seems to deny their country's traditions. The objects, musical instruments and score are also strictly Occidental imports. Thus, modernization did not concern only the army, factories and means of transport, but also culture and social structures, including leisure activities.

1864 Together with the Austrian empire, Prussia attacks Denmark in the War of the Duchies. They occupy Schleswig-Holstein.

1866 Due to disagreements over the administration of Schleswig-Holstein, war breaks out between Prussia and the Austrian empire. Austria is defeated and must renounce any idea of controlling the affairs of the German world, which was now under Prussian hegemony.

1867 Prussia institutes the North German Confederation, which includes twenty-two states. These maintain their own government but unite their armed forces under Prussian command. The states of the south – Bavaria, Württemberg, Baden, Hesse – sign a defensive military pact with the Confederation.

1867 France tries to acquire Luxembourg from the king of Holland. Prussian opposition brings the situation to the brink of armed conflict, but a compromise is reached defining the grand duchy's neutrality.

1868 A military coup in Spain dethrones Queen Isabella. In search of a new monarch, the Spanish approach Leopold of Hohenzollern several times, angering the French.

Wilhelm and the crowd In the background, the king is on his way to the station in a carriage. Beside him, his tearful wife hides her face in a handkerchief. However, the artist's attention is concentrated on the crowd and its varied attitudes. Two figures reading the newspaper turn their back to the monarch, against all propriety. One is wearing the visor cap of a student association, many of which were nationalist and liberal, and so may be identified as a middle-class intellectual.

1870 THE FRANCO-PRUSSIAN WAR

ADOLPH VON MENZEL, **The Departure of the Future Kaiser Wilhelm I for the Front, 31 July 1870**

1871. Oil on canvas, 63 x 78 cm. Berlin, Alte Nationalgalerie

The dispatch from Ems

The main catalyst for the Franco-Prussian War was in a certain sense a mistake – or, rather, a well-orchestrated provocation that spurred Napoleon III's France to attack first. In 1870, when the Spanish crown was offered to the German prince Leopold of Hohenzollern with the assent of Prussia, the French were vigorously opposed and, given the rise of the German kingdom in those years, considered it an attempt to surround them politically. Leopold eventually renounced the throne, but France wanted further reassurance. So, in July 1870 the French ambassador cornered Wilhelm I, king of Prussia, who was at the resort of Ems, to confirm Leopold's renunciation and commit himself for the future. Wilhelm confirmed the renunciation of Leopold, but refused to commit to the future. He mentioned the exchange in a telegram to his prime minister, Otto von Bismarck. Bismarck seized the opportunity to leak a heavily edited version of the telegram to the press, which gave the impression of a far more heated exchange between the two, with Wilhelm apparently insulting the ambassador. The French public duly clamoured for war, which was declared on 19 July 1870.

A windy day The flags flapping in the wind are those of Prussia (with an eagle), the North German Confederation (black, white and red, which would be adopted by the nascent empire) and the Red Cross (an obvious allusion to the victims of the war being fought). The red-brick tower of Berlin city hall may be seen in the distance as people on balconies and at windows acclaim the monarch's procession, waving their handkerchiefs as he passes.

Contemporary accounts tell that the departure of Wilhelm I for the front was a great event that aroused popular enthusiasm and patriotic fervour. Political prisoners were even granted amnesty on the occasion. But Menzel treats the episode as an opportunity to depict a landscape of urban life. The painting's original title, *Unter den Linden Street on the Afternoon of 31 July 1870*, suggests a lively, impressionistic representation of Berlin's middle class more than the exaltation of the militarism typical of the Prussian monarchy. The work thus contrasts with paintings like Anton von Werner's *Proclamation of the German Empire*, which glorifies German military virtues. Menzel's painting was greeted coldly by the critics of the day, who accused it of 'sentimentality'.

Differences and distractions An older proper gentleman has removed his top hat and bows deferentially to the royal couple, but the newspaper boy behind him is more interested in the dog that seems to want to play. The sovereign's parade is thus the occasion for a festival rather than the patriotic fervour recalled by the military salute of the soldier in the middle distance.

1870 THE FRANCO-PRUSSIAN WAR

Alphonse de Neuville, Bivouac after the Battle of Bourget, 21 December 1870

1879. Oil on canvas, 57.7 x 79 cm. Paris, Musée d'Orsay

An unprecedented defeat

From the start, the war went disastrously for France. Under von Moltke's command, the Prussians severely attacked the French armies, who were inferior in number and geared to a defensive war. Furthermore, although Napoleon III had been convinced of the neutrality of the southern German states, instead they joined in alongside Bismarck. With the army split in two wings, Marshal Mac-Mahon and Napoleon III tried to reach Metz, in Lorraine, where the troops commanded by Bazaine were under siege, but the Germans prevented them, inflicting a heavy defeat on the French forces in a clash at Sedan on 1 September 1870. After Napoleon III was taken prisoner, the Third Republic (proclaimed in Paris on 4 September) continued the war until the humiliating armistice of 28 January 1871. This course of events was to have important consequences. On the wings of victory, Prussia declared German unity and the German empire. The same year, the new French republic experienced the revolutionary trauma of the Paris Commune and, once that uprising had been put down, nursed deep resentment towards Germany, dreaming of military revenge until the First World War.

Cold and rubble Neuville, who knew the reality of this war from having taken part in it himself, does not indulge in the rhetoric of the 'heroism of defeat' so often found in paintings from this period. Instead, the men, weak and cold, and wrapped in whatever blankets they can find, huddle around a few improvised fires, while the debris of a bombed house indicates the violence of the fighting. The only flag to be seen is that of the Red Cross.

Here, Alphonse de Neuville, a war-painting specialist, conveys the defeated French troops' moral dejection and miserable reality. The scene depicts a bivouac after the fighting at Bourget, a series of battles that took place in October and December 1870 for control of this small, strategically important town in the outskirts of Paris. On a grey winter day, faced with the futility of their efforts, the soldiers are quartered in disorder, vainly seeking refuge from the cold.

Abandoned weapons Near the exhausted soldiers who have flung themselves on the snow-covered ground is a clutter of disparate objects – weapons, knapsacks, helmets and musical instruments – the unmistakable sign of despair and the end of all hope of victory.

A moment's calm Though the scene is dominated by confusion and the troops' squalid conditions, a few soldiers stand apart from this mood. Absorbed and composed, two pairs of military men converse, as a colonial soldier wearing a turban and cloak brings his horse to a halt. In the background is more rubble and a smokestack that indicates the area's industrial activity.

The Porta Pia The artist has depicted the impressive structure of the Porta Pia with painstaking realism. It is one of the gates in the city walls of Rome that had originally been erected in the 3rd century, in the time of Emperor Aurelian. Since then it had been rebuilt various times, including once by Michelangelo Buonarroti between 1561 and 1565. The last rebuilding had been in 1869, just a year before the events that would make it a famous landmark in the unification of Italy.

Complex political stakes

Main figures
Pius IX, pope from 1846 to 1878; Napoleon III, emperor of the French from 1852 to 1870; Victor Emanuel II, king of Italy from 1861 to 1878.

Goals
For the pope, to defend the Church's independence; for Napoleon, to placate French Catholics and limit the expansion of the kingdom of Italy (after a failed attempt to place central Italy under his protection); for Victor Emanuel, to move the capital of the kingdom to Rome.

Consequences
With the decree *Non expedit*, the pope enjoined Catholics to refrain from taking part in Italy's political life; the Italian state passed laws guaranteeing the extraterritoriality of the Vatican and the independence of the pontiff, although Pius IX refused these concessions.

Note
An agreement between the Vatican and the Italian state was not reached until 1929. The Lateran Accords, proposed by Benito Mussolini, declare Catholicism the only state religion.

1870 THE TAKING OF ROME

Carlo Ademollo, **The Breaching of Porta Pia**
c. 1880. Oil on canvas, 233 x 406 cm. Milan, Museo del Risorgimento

The Rome question

A particular consequence of the Franco-Prussian War and of the French defeat at Sedan on 1 September 1870 was the Italian occupation of Rome and the Papal States. In itself, the armed engagement was fairly insignificant, in that the Italian army quickly defeated the papal troops on 20 September. But politically it had great ramifications for the young kingdom of Italy. In 1861, the year the peninsula's unity was proclaimed, some regions remained excluded, among them the Veneto (which was then annexed in 1866) and the Papal States, whose independence was guaranteed with arms by Napoleon III's France. Pope Pius IX had no intention of renouncing his own temporal power, for he considered it indispensable to the Church's spiritual autonomy, and France quickly rushed to his aid. But after a decade of fruitless dealings and failed sudden attacks (especially by Garibaldi), the opportunity offered by the French defeat was too good to miss. Rome was occupied and became the capital of the kingdom of Italy. Pius IX enclosed himself in the Vatican, considering himself a prisoner, and refused all compromise, inaugurating a long phase of hostility with the new state.

The pontifical troops After the French contingent withdrew owing to the war with Prussia, about 15,000 men remained to defend the Papal States. Among these were many volunteers from various European countries, Swiss guards and, especially, mercenaries, all under the command of the German general Hermann Kanzler. Their resistance was essentially symbolic in that Pius IX did not intend for the events to degenerate into bloodshed. As it happened, fifty Italian soldiers and twenty papal soldiers were killed in the fighting.

An exponent of Italian Romantic-patriotic painting, Carlo Ademollo followed the military campaign that led to Italian unity – in particular the second and third wars of independence, in 1859 and 1866 – and specialized in painting large canvases that reported the key events of the Risorgimento as they happened. Here, the artist has painted the decisive moment in the taking of Rome on 20 September 1870. After intense shelling breached the city wall near the Porta Pia, the Italian soldiers attacked while the pontifical army tried to resist. The marked exaltation of the combatants' heroism is evident, but Ademollo also realistically reconstructs the way the clash unfurled, infusing movement and rhythm on the group of soldiers.

The 'Bersaglieri' A battalion of *bersaglieri*, the distinctive corps of marksmen and scouts founded in 1836 in the kingdom of Sardinia, participated in the taking of Rome. With their characteristic wide-brimmed plumed hats, they advanced at a rapid pace. This corps had distinguished itself internationally during the Crimean War of 1855 (as had the French Zouaves), and took part in all the campaigns leading to the unification of Italy.

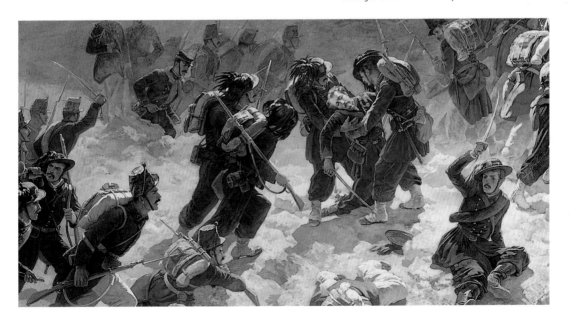

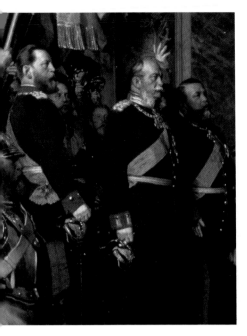

1871 THE PROCLAMATION OF THE GERMAN EMPIRE

ANTON VON WERNER, **The Proclamation of the German Empire**

1885. Oil on canvas, 167 x 202 cm. Aumühle-Friedrichsruh, Bismarck-Museum

A new major European power

Victorious in its war against France, the North German Confederation, led by Prussia, founded the German Empire together with the states of the south. The ceremony took place on 18 January 1871 in the Hall of Mirrors at the Palace of Versailles – on French soil, to emphasize the humiliation to France that this union represented. Bismarck, the Iron Chancellor, had been working towards this goal since 1862, strengthening Prussia's dominant role and eliminating all interference from the Austrian empire. Founded on a constitution that guaranteed universal male suffrage in parliamentary elections, the new state would soon become one of the greatest economic and military powers of Europe.

Acclamation of the princes Wilhelm became the German emperor – and not 'emperor of the Germans' as national-liberal opinion would have preferred – owing to the acclamation of the princes and representatives of the twenty-five German states that joined the new empire. The emperor is flanked by his son and heir to the throne Friedrich Wilhelm (at the left) and the Grand Duke of Baden, Frederick I (at the right), who leads the other princes and military men in their acclamation.

Characteristics of the new state

Internal structure Although born as a federation of German principalities, Prussia, with more than 60 per cent of the surface and about 65 per cent of the population, had the greatest weight. The king of Prussia was the emperor, and the Prussian prime minister was the empire's chancellor.

Demography With 41,000,000 inhabitants the empire became Europe's most populous state after Russia, maintaining this position until the eve of the First World War, when the population reached 67,000,000.

Economy Many regions of Germany had embarked upon the road to industrialization by the 1850s. After unification, the process accelerated: between 1871 and 1914, industrial production grew by 500 per cent, making Germany the most important industrial nation in Europe.

Raised swords The high officials who raise their swords during the proclamation were absent from the first version of the painting, which was done not long after the event and reported it faithfully. They were added for dramatic effect.

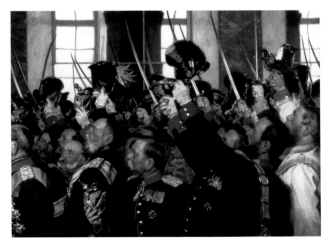

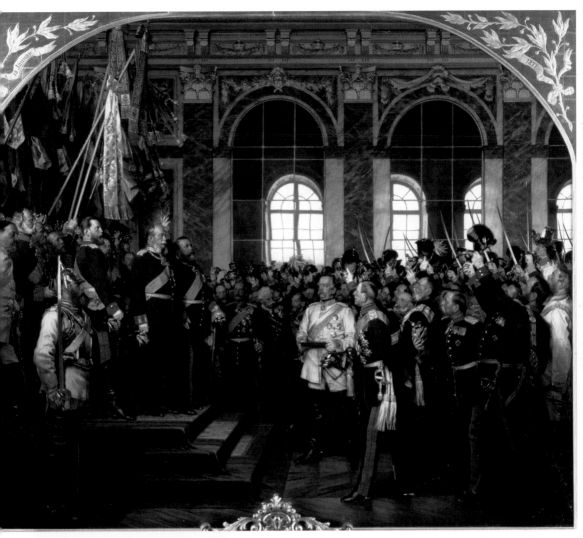

Anton von Werner, who participated in the proclamation of the German empire on 18 January 1871 at the invitation of Crown Prince Friedrich Wilhelm, made three paintings of the event in all. The first, executed in 1877, was commissioned by the Grand Duke of Baden, Frederick I, and other German princes as a birthday present for Emperor Wilhelm I. This first version, lost during the Second World War, was the most factual of the series, providing an almost photographic reconstruction of the gathering of princes and military men in the Hall of Mirrors at Versailles. The second (1880–82, also destroyed during the war) and third (1885, illustrated here) versions more emphatically underscored the solemnity of the moment.

The political artificer of unity This version of the painting was commissioned by the imperial family as a birthday present for Bismarck. Consequently, Bismarck occupies the composition's centre. He is wearing full white dress, which was not the case at Versailles.

The barricades During the fighting in the city, the Communards erected barricades in both the centre and the outskirts, using mainly the porphyry blocks the streets were paved with. However, whereas Paris during the revolutions of 1830 and 1848 was still a city of narrow alleys and streets – making barricades easy to erect and virtually unassailable – the introduction of wide boulevards under Baron Haussmann made the construction of barricades far more difficult.

The main facts

1 March 1871 The Prussians file into Paris, according to the agreement defined in the armistice stipulated by Thiers. The Parisians conceal weapons and cannons.

18 March 1871 Thiers orders the regular army to requisition the cannons in the hands of the National Guard, but the army detachments rebel and shoot their commander. The Commune starts.

2 April 1871 Paris is placed under siege by the regular troops and is constantly bombarded.

10 May 1871 The peace treaty between France and Germany is signed in Frankfurt, annexing the greater part of the Alsace and a department of Lorraine. France must pay an indemnity of five thousand million francs.

14 May 1871 Thiers refuses to exchange seventy-four hostages – among them the archbishop of Paris, Georges Darboy – for the freedom of the revolutionary Louis-Auguste Blanqui.

21 May 1871 The regular troops enter Paris.

23–24 May 1871 The Communards set fire to the city's monuments and buildings, including the Tuileries Palace. Archbishop Darboy is shot.

28 May 1871 After three days of fierce fighting, the Commune's last barricade falls on rue Ramponeau. The regular troops engage in summary executions and reprisals.

1871 THE COMMUNE

ANDRÉ DEVAMBEZ, **The Barricade, or Waiting**
1911. Oil on canvas, 140 x 107 cm. Versailles, Musée national des châteaux

The first socialist revolution

From 18 March to 28 May 1871, Paris was under the control of the Commune, the revolutionary city government that sprang up following the disastrous outcome for France of the war with Prussia. The Commune stepped in when the provisional French government led by Louis-Adolphe Thiers tried to dissolve the National Guard, the people's militia that had defended the city when Prussia attacked. The government troops disobeyed orders and fraternized with the National Guard. Thiers was forced to take refuge at Versailles. The Communard government, which combined anti-Prussian patriotism with egalitarian aspirations rooted in the socialist movement, is remembered mainly for its attempt to nationalize businesses abandoned by their owners, as well as for its forms of direct democracy. The regular army, commanded by Mac-Mahon, quickly initiated an assault and on 21 May entered the city, where fighting took place from street to street. The 'Bloody Week' ended on 28 May, with casualties estimated at about 30,000.

The enduring myth of the Paris Commune was kept alive after 1871. At the Salon of 1911 – forty years after the fact – André Devambez exhibited a painting on a topical subject from the Communard experience: the barricade. He had previously treated the event in 1907, presenting the National Guard's disordered troops in *The Call to Arms*. In this painting, too, he shows the revolutionaries waiting for armed combat in their motley uniforms. To learn about the events, Devambez gathered testimony from his father and other old veterans. He shows a natural sympathy for the Communards and their cause, which he sets out to represent realistically and factually.

The red flag The Commune repudiated the French Tricolour in favour of the revolutionary red flag, which had been adopted by the socialists and radical republicans in Paris in 1848. A glaringly provocative gesture, it is indicative of the Communards' awareness that, despite internal ideological differences, they were conducting an important social experiment, especially in the forms of managing power.

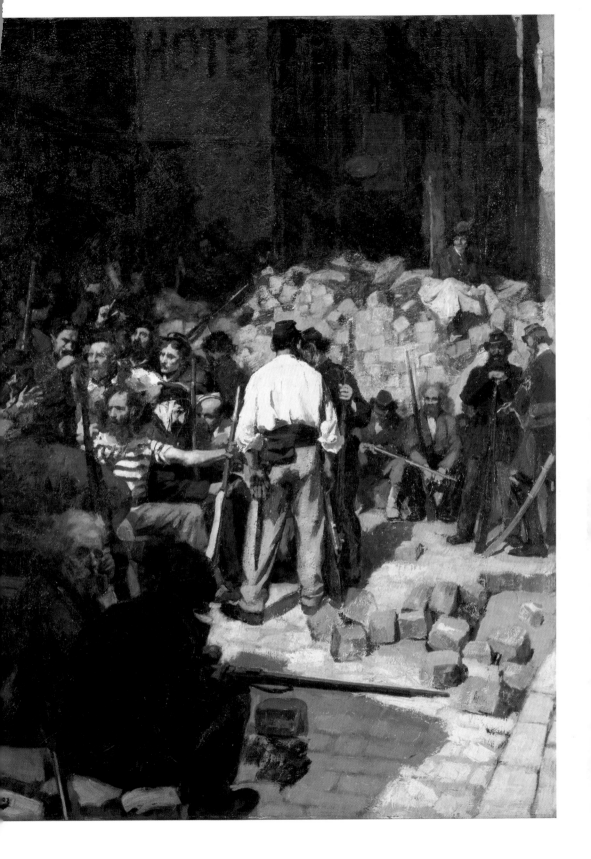

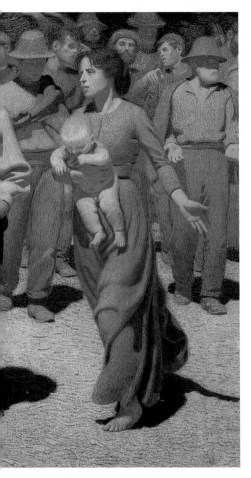

1889 BIRTH OF THE SECOND INTERNATIONAL

GIUSEPPE PELLIZZA DA VOLPEDO, **The Fourth Estate**

1901. Oil on canvas, 293 x 545 cm. Milan, Galleria d'Arte Moderna

The workers' reform movement

In Paris on 14 September 1889, a group of socialist parties from various countries founded the Second International. This hoped to coordinate the policies of the workers' movement internationally, building on the work of the First International (which had lasted from 1864 to 1874). On the same occasion, the First of May was designated as an international day honouring the struggle of labourers. The date recalled events in Chicago in May 1886, when violent clashes with the police took place following the workers' request to reduce the working day to eight hours. The Second International confirmed that, within their respective countries, socialist parties were now an important reality that intended to support a reform programme (universal suffrage, the eight-hour workday) and proposed a gradual, rather than a revolutionary, approach to socialism. So, in the late 19th century there was a growing belief in intellectual circles that society should evolve 'naturally' towards socialism and that it was the task of artists and writers to reinforce and accompany this transition. These hopes were rudely interrupted by the First World War.

The woman Leading the labourers beside the two men is a barefoot woman with her baby in her arms. Her left arm is outstretched in an eloquent gesture; her face and stride are slightly turned towards one of the men, as if in dialogue with him, expressing her dignified protest.

The men Their gaze fixed and determined, their stride resolute and decisive, the life-size figures of two men of the people advance along an ochre-coloured dirt path, followed by the rest of the demonstrators. The man on the right is dressed simply but with greater care (he is wearing a reddish vest over his buttoned shirt), while the other's shirt is open and his jacket thrown over his shoulder. Their solemn gait reflects pride and courage.

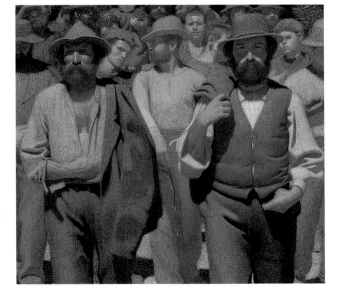

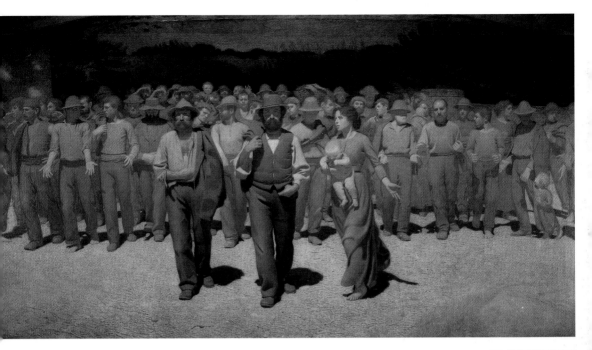

Painted by the Italian Pellizza da Volpedo between 1898 and 1901, this large painting was inspired by a farm labourers' strike in the countryside of the Padan Plain. The image became an icon of the union and workers' movement, a symbol of the social struggle of the late 19th and early 20th centuries. The picture represents the peaceful but powerful advance of the Fourth Estate – the wage-earners – from obscurity into the light ahead of them. Clearly the intention is to represent symbolically the working classes' unstoppable journey towards the 'sun of the future', socialism. The fruit of a decade's work, the canvas was shown at the quadrennial exhibition in Turin in 1902 but was not sold. Not until 1920 was it purchased by the city of Milan and placed on display in the Palazzo Marino, the seat of civic government, where it remained until recent years.

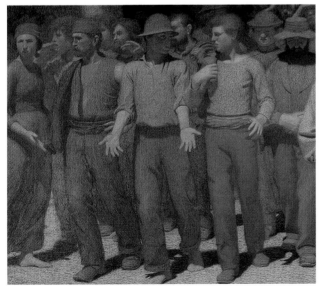

Reformism in the late 19th century

1875 The Social Democratic party is founded in Germany. It would be declared illegal by Bismarck from 1878 until 1890, when it met with great electoral success. It is the largest reform-oriented socialist party in the Second International.

1882 The Workers' Party is founded in France. Although in jail, Paul Lafargue, one of the party's founders, is elected to parliament in 1891. The various strains of French socialism would not be united until 1905.

1892 Italy's Labour Party is founded. It becomes the Italian Socialist Party in 1895. Led by Filippo Turati, it begins cooperating with the liberal government in 1901.

1900 Various elements merge to form England's Labour Party. In cooperation with the liberals, it wins major reforms such as the eight-hour workday – a common demand since the beginning of the Second International.

The force of progress All the figures in the middle distance have their own individual character. The hand gestures, the heads turned in different directions and the rhythm of the stride create a sense of movement that clearly conveys the idea of the advance of the people and their ideas.

1894 THE SINO-JAPANESE WAR

Mizuno Toshikata, Series of Woodcuts on the Sino-Japanese War

1894–95. Woodcuts on paper. Boston, Museum of Fine Arts

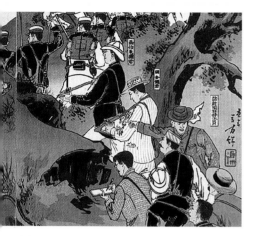

War correspondents In a print illustrating the Battle of Songhwan, right behind the soldiers in the front line are war journalists and artists – recognizable by the sketchbooks in which they are drawing – as if to suggest that Mizuno Toshikata himself was present at the events. During the Sino-Japanese War, however, photography began to take on a greater documentary role, supplanting the more idealized representations of artists. Like the soldiers' uniforms, the correspondents' attire is clearly in the Western style.

A conflict rife with consequences

The combatants
The Chinese army and fleet, modernized according to the European model, which fought unaided by other Chinese forces; the Japanese troops and fleet, organized according to Prussian and Anglo-French models, respectively.

Goals
For the Chinese, to reaffirm their influence over Korea; for the Japanese, to assert themselves as a regional power.

Immediate consequences
In the Treaty of Shimonoseki, China recognized Korea's independence and ceded the Liaodong Peninsula, Taiwan and the Pescadores Islands to Japan. Furthermore, China had to pay a war indemnity of 200 million liangs, the equivalent of 7,500 tonnes of silver.

Medium-term consequences
The Western powers forced a weakened China to sign favourable trade agreements. Moreover, Russia, France and Germany prevented Japan from occupying the Liaodong Peninsula, home to the major city of Port Arthur. Instead, this area came under the control of the Russians, who used it for expansion into Manchuria. The friction this caused with Japan led to the Russo-Japanese War of 1904–05.

The beginning of Japanese imperialism

Alongside the drive to modernize itself, begun in 1868 (see pp. 288–89), Japan adopted a more expansionist policy, determined to assert itself as a major regional power. This soon brought it into conflict with its neighbour, China, specifically over the control of Korea. Korea had traditionally been a tributary of the Chinese empire, linked to its political interests. But Koreans who wanted to modernize looked increasingly to Japan. The two powers had made a pact not to intervene with troops in Korea, but when a peasants' revolt appeared likely to overthrow the pro-China regime in 1894, the Chinese sent in troops – and consequently the Japanese did as well. When all attempts at mediation failed, the two armies officially began fighting on 1 July 1894, although in the meantime the Japanese had occupied Seoul and deposed Korea's king. The conflict was short-lived: the well-trained, modern Japanese army, together with the fleet, repeatedly defeated the poorly armed and even more poorly organized Chinese troops. The Chinese were forced to accept the humiliating Treaty of Shimonoseki in April 1895, and it was clear to all that modern Japan was a force to be reckoned with.

Chinese and Japanese face to face This print depicts the moment when Ding Juchang, admiral of the Chinese fleet, surrenders after the fall of the city of Weihaiwei in February 1895. Wearing traditional costumes, the Chinese generals bow in submission before the impeccably uniformed, erect and manly Japanese officers. The physical difference is clear, and the warlike gaze of the Japanese contrasts strikingly with the evasive looks of the Chinese figures. Even the heads of the European military advisers accompanying the Chinese are bowed humbly.

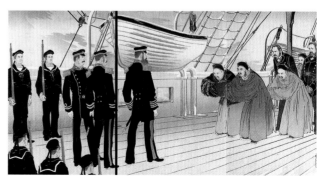

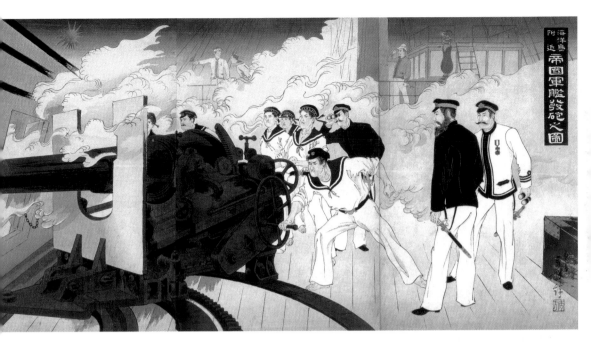

During the Sino-Japanese war, Japanese art prints depicting the development of the conflict were abundant. They are almost always idealized views, far from realistic, meant to arouse admiration for Japanese heroism and glorify victory. Mizuno Toshikata, a printmaker who enjoyed a solid reputation at that time, worked in this context. He used this traditional technique to express contemporary subject-matter, from the representation of weapons and equipment to the rendering of smoke and the violent colours of modern battle – as in this print illustrating the Battle of Haiyang Island, which was decisive for Japan's control of the seas. In the centre is a modern breech-loading cannon, mounted on a dual-rail track.

The heroic officer In this print of the Battle of Songhwan, the artist depicts the attitude and gestures of the officer commanding the attack, his sword unsheathed, his body stretched forward. Other painter-printmakers also used this popular pose to convey the heroism of the combatants and their leaders. The title of the print is the Japanese war cry: 'Banzai! Banzai! For the great Japanese empire!' In the middle distance, the Chinese soldiers have been routed.

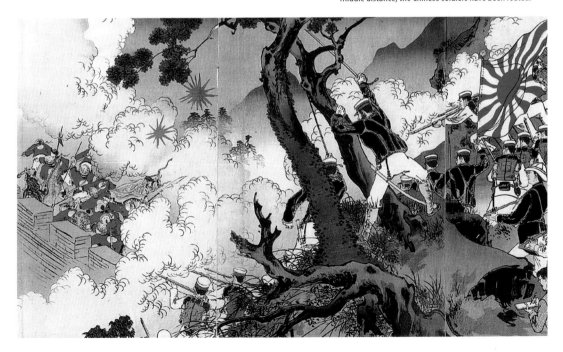

1900 THE BIRTH OF THE MODERN METROPOLIS

UMBERTO BOCCIONI, **The City Rises**

1910–11. Oil on canvas, 199.3 x 301 cm. New York, Museum of Modern Art

A sweeping change

The modern city as we might know it today, that characterizes social and economic life of large parts of the world, was born in Europe and North America between the end of the 19th century and the beginning of the 20th. The concentration of production and commerce in urban areas, the unprecedented development of infrastructures and means of transport, and the emphasis on the citizen's role in political and cultural activities, all defined and contributed to the development of the great metropolises. And while city centres changed rapidly – in Old Europe blending new and old and, in North America, developing boldly innovative approaches to building – large, poorer areas sprang up around these cities. These peripheral areas bore the burden of the cities' social and political problems. It was the beginning of an era of teeming throngs in city streets, suddenly chaotic traffic and, more generally, the need rationally to plan the life of the metropolises – the pulsating heart of the contemporary world.

Building sites and smokestacks Boccioni does not abandon reality entirely, since the background of the painting outlines the basic features of a city (or rather a suburb). The detail at the right shows a house under construction, with unfinished walls surrounded by scaffolding, and a forest of chimneys. In the detail above, an electric tram can be seen at the left, with figures following it along a rising embankment to indicate movement, as well as houses and shafts of light. The city may be identified as Milan – the artist lived there and had painted its outlying neighbourhoods various times in the preceding years.

'We ... will sing in praise of ... the night-time vibration of the arsenals and the workshops beneath their violent electric moons: the greedy railway stations swallowing smoking serpents; factories hung from the clouds by the thread of their smoke; bridges with the vault of gymnasts flung across ... rivers: fearless steamers sniffing the line of the horizon; full-breasted locomotives ... and the aeroplanes' gliding flight.' These words are from Filippo Tommaso Marinetti's *Futurist Manifesto* (Paris, 1909), heralding an artistic avant-garde that Umberto Boccioni joined officially in 1910, when he painted *The City Rises*. Boccioni wanted to raise a paean to work, represented in the foreground of the canvas by a group of men and horses straining in dynamic effort. They are building the modern city, visible in the middle distance.

Symbolism and dynamism The tangle of men and horses that animates the image symbolizes industrial development. Boccioni still uses living beings to express this, and not machines, but the painting's connection to Futurism is unmistakable in the strong colour contrasts and energetic brushstrokes. 'Support and glory in our day-to-day world, a world which is going to be continually and splendidly transformed by victorious Science', as the artist put it in his 1910 *Manifesto of Futurist Painters*. This determination is ably given form in the subject and execution of this painting.

Perspective A tall street lamp, in line with the corner of the main building, divides the work into two more or less symmetrical parts, with two clear vanishing points along which crowds bustle continually. The artist has been influenced by Futurism, grotesquely reinterpreted to transform urban life into a sort of hellish bedlam. The red lighting from an unreal, sun-like sphere increases this effect.

Technology serving the city

1863 The first section of the Metropolitan Railway is inaugurated in London: 6.4 km long, underground and (initially) steam driven. In fact, the London underground lines were electrified in 1890; thereafter followed Chicago's new elevated train (1892), and Paris (1900).

1880 A demonstration of public electric lighting delights the inhabitants of New York. Two years later, Edison – the inventor of the incandescent light bulb – distributes electricity to fifty-nine users in Manhattan.

1881 The electric tram, planned and executed by Werner von Siemens, comes into service in the Berlin district of Lichterfelde. Previously, trams had been animal-drawn or steam-powered.

1885 The first skyscraper, the thirteen-storey Home Insurance Company Building, is built in Chicago. In 1890, New York's Manhattan Building rises to sixteen storeys.

1896 The Westinghouse Company builds the first commercial long-distance power line, to connect the electrical plant at Niagara Falls with the city of Buffalo.

1900 THE BIRTH OF THE MODERN METROPOLIS

GEORGE GROSZ, **Metropolis**
1916–17. Oil on canvas, 100 x 102 cm. Madrid, Museo Thyssen-Bornemisza

The city as a product of innovation

The modern metropolises of the late 19th century arose in pace with the development of new technologies. Reinforced concrete and steel made possible buildings such as skyscrapers. Another fundamental contribution came from electricity. Not only was the appearance of streets and neighbourhoods transformed, but the introduction of light into homes and factories also changed living habits and rates of production. Besides that, electricity meant new modes of transportation, such as the tram and the subway, which increased mobility and intervened directly in the urban fabric, linking neighbourhoods to the centre and to each other. Bicycles dominated the streets and avenues until the automobile became the master of the roads, which in the United States, at least, began happening in the 1920s. New forms of entertainment also developed – the adventure of cinema was launched in Paris in 1895 with the projections of the Lumière brothers. Advertising and department stores started to fill the urban space – the consumer society had been born.

The hearse Amid the people and their grimacing masks is a hearse pulled by white horses. A skeleton sits in the driver's seat. This distortion of reality is typical of Expressionist painting, which aims at conveying existential despair and the violence of society. Such features led the Nazis to condemn painters like Grosz, and this canvas was exhibited in the 'Degenerate Art' exhibition mounted by the regime in 1937. It was sold in Switzerland to finance the Nazis' rearmament programme, but Grosz, by then exiled in the United States, was able to buy it back.

The German artist depicts the tumultuous nightlife of his native city, Berlin, during the First World War. On leave from the army for health reasons, far from the violence of the conflict and the authoritarianism of military life he so abhorred, Grosz worked frenetically, synthesizing in this painting his fascination with the metropolis and the contradictions that it embodies, being at once paradise and inferno. Citizens with distorted, grotesque faces scurry around, colliding in a dazzling synthetic vision that merges the movies, theatre, billboards, trams and crowded cafés.

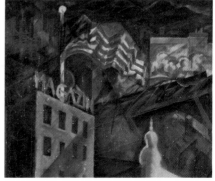

The American flag The Stars and Stripes of the United States flies from a flagpole on the roof of a commercial building. Though Grosz may have inserted this detail before the United States declared war against Germany in April 1917, it is in any case a rebuttal of German nationalism, which had reached new levels in those days.

1905 THE FIRST RUSSIAN REVOLUTION

SERGEI IVANOV, **Exchange of Fire**

1905. Oil on canvas, 69 x 62 cm. Moscow, State Central Museum of Contemporary History of Russia

Emptiness A good part of the canvas is filled with the vast empty space between the crowd and the line of soldiers. In this space we see victims' bodies and a dog that, running headlong, makes the space seem even larger.

From January's carnage to a constitution

22 January 1905
On so-called Bloody Sunday in St Petersburg, the imperial guard opens fire against a large but peaceful demonstration of workers led by the priest Georgy Gapon. Many are killed. Strikes and peasant revolts break out.

May–June 1905
Another wave of strikes and land occupations throughout the country. For the first time, workers and peasants organize into soviets – self-governing revolutionary councils.

27 May 1905
The Japanese fleet destroys the Russian fleet at the Battle of Tsushima. Russia is forced to sue for peace.

27 June 1905
In the Black Sea port Odessa, the crew of the battleship *Potemkin* mutinies (an event that would be immortalized in film by director Sergei Eisenstein). Mutinies in both the army and the navy follow.

30 October 1905
After a ten-day general strike that paralyzes Russia, Nicholas II agrees to sign the October Manifesto, recognizing some basic freedoms and providing for the election of a parliament.

Crisis in the czarist regime

The internal contradictions of czarist Russia were dramatically exposed in the revolutionary wave that broke in January 1905. Incapable of initiating liberal reforms that would appease the increasingly influential middle class, Czar Nicholas II remained faithful to the traditional autocracy. Moreover, the large working-class and peasant population had started to become more concerned about their rights, even if they still placed their faith in their ruler to alleviate their chronic poverty. In February 1904, war between Russia and Japan had broken out in the Far East over control of Manchuria. What Nicholas II had expected to be a quick and easy military campaign that would distract public opinion from internal problems quickly turned into defeat. As growing fiscal pressures and military conscription fomented discontent, in January 1905 the Russians suffered a blistering defeat, losing the city of Port Arthur. On 22 January (according to the Gregorian calendar) the revolt began.

The volley Houses seal off the space at the top of the painting, as if to indicate the impossibility of escaping the soldiers as they fire a volley. The situation was similar on Bloody Sunday, 22 January 1905. The demonstrators were heading for the Winter Palace in St Petersburg, where they intended to deliver a petition to the czar. When the crowd reached Nevsky Prospect, the imperial guard opened fire and charged the protesters with their sabres. The official report mentions ninety-six casualties; the opposition reported between 1,000 and 4,000.

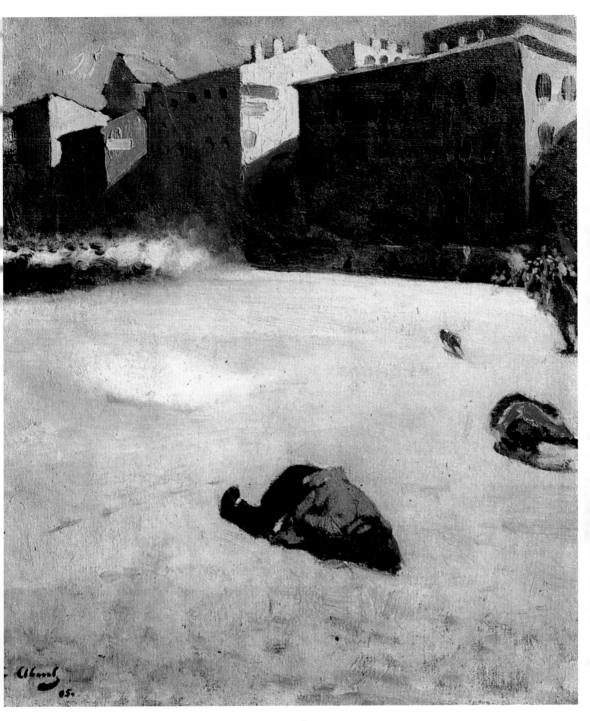

Painted in the wake of the events of 1905, this canvas energetically sums up the sense of oppression and violence the Russians felt after the massacre by the imperial guard on 22 January, when troops opened fire on an unarmed crowd of demonstrators. This is the most important and expressive work by Sergei Ivanov, a member of the Itinerants, a populist art movement that arose in the second half of the 19th century. In this painting, however, the Itinerants' didactic realism makes way for an impressionistic vision in which the scene, though almost abstract in parts, is nonetheless extremely evocative.

1905 THE FIRST RUSSIAN REVOLUTION

Ilya Repin, **Demonstration on 17 October 1905**
1907–11. Oil on canvas, 184 x 323 cm. St Petersburg, Russian Museum

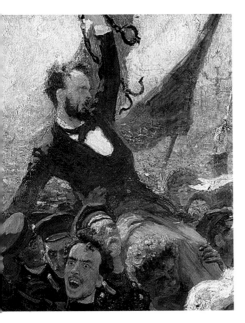

Liberty! In an atmosphere of general rejoicing, soldiers carry on their shoulders a man who shows the crowd his unlocked shackles. Though he is middle class, and the soldiers around him are from the working classes, harmony seems to reign as the crowd celebrate their newfound freedom and the end of the czar's police regime.

A compromise without prospects

After ten months of turbulence and revolts, Nicholas II yielded to the urgings of his more liberal advisers, including Sergei Vitte, and in October 1905 appeared to accept a transition towards a constitutional monarchy. The czar's concessions undid the alliance between liberals and various leftist elements, which continued to promote revolts and strikes that were harshly repressed between November 1905 and January 1906. The Duma, the parliament promised in October 1905, convened in March 1906, but lack of agreement between this new elected chamber and the government (which answered only to the czar) made the initiative completely ineffective. In view of this paralysis, Nicholas dissolved the Duma twice, until he got a more conservative one elected in 1907. It seemed that the crisis of 1905 had passed and that, except for a few concessions, the czar's power was intact. But the contradictions of the Russian system were too glaring for it to survive.

A host of revolutionary parties

Socialist Revolutionary Party Founded in 1901, this party appealed mainly to the peasant masses, advocating radical agrarian reform. It was not of Marxist inspiration, and it supported political activism with terrorist practices. With the Social Democrats, it led to the experiment of the soviet in 1905.

Russian Social-Democratic Workers' Party A Marxist-inspired party founded in 1898, it was forced to operate in secret to avoid the persecution of its militants. In 1903, during the second congress held in Belgium, it split into Bolsheviks, led by Lenin, and Mensheviks. The Bolsheviks were convinced of the possibility of immediate revolution and advocated a rigid organizational model.

Cadet Party Formed in October 1905, the Cadets represented the more radical middle class. They were in favour of universal suffrage and tended to subscribe to republican ideals. They held the majority in the first Duma but clashed with Solypin's conservative government.

Octobrist Party Moderates oriented to a constitutional monarchy, they supported Nicholas II's bland constitutional reform of October 1905.

Symbols and banners Collective euphoria at the czar's concessions brings together men and symbols that reflect profound ideological differences. The banner bears the date 17 October 1905, the day of the sovereign's proclamation according to the Julian calendar. But it is red flags that are the most in evidence. There is also a picture, perhaps an image of Nicholas II. During the ill-fated demonstrations of 22 January, demonstrators carried religious icons and portraits of the czar, towards whom devotion was very strong.

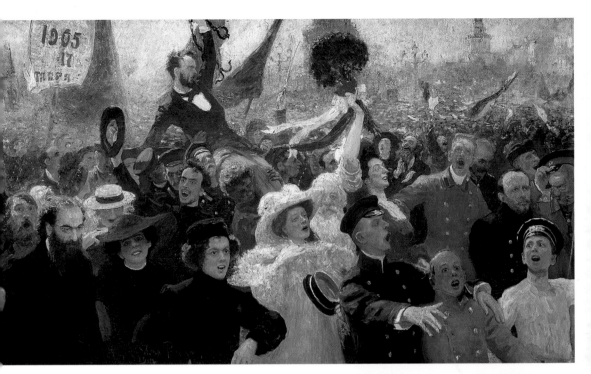

Ilya Repin's work is characterized by an adherence to truth and a total rejection of academicism. Besides painting portraits, the artist spent a good part of the second half of the 19th century recording the essential features of Russian culture – seen together, his work amounts to an astute psychological analysis of a people. His paintings also played a role in denouncing the poverty in which most Russians lived. The artist did not shrink from depicting contemporary events, especially if connected to his country's social tensions. In this painting, he celebrates the unanimous enthusiasm of the city's population at the proclamation of the Manifesto on the Improvement of State Order, which granted civil liberties and provided for the election of a parliament.

Men, women, children and the elderly Many of the people in the crowd are looking in the same direction, where a speaker is almost certainly announcing the sovereign's decree. Repin clearly shows his support for the revolutionary movement that has brought this result, even if the date of the work (1907–11) makes it obvious that he knew the event's final outcome and the substantial failure of this half-hearted attempt to modernize Russia.

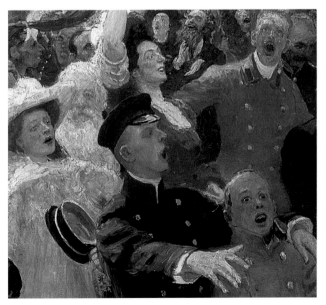

Revolutionary martyrs Standing next to a workman, Zapata displays a banner that reads 'Land and Liberty!' – an abbreviated version of the slogan 'Reform, Liberty, Justice and Law!' that he used in the Plan of Ayala on 25 November 1911. Next to Zapata, with a red necktie, is Carrillo Puerto, governor of the Yucatán and defender of Indian rights (and who was shot in 1924).

Revolutionaries and politicians

Francisco Madero A cultivated politician and idealist, in November 1910 Madero proclaimed the Plan of San Luis Potosí from the United States, calling Mexicans to insurrection. Once he became president, he lost the trust of Zapata's followers and left more and more latitude to General Huerta, who was linked to the large landowners and foreign interests. Huerta had Madero killed in February 1913.

Emiliano Zapata A legendary figure of the Mexican revolution, Zapata came from a poor family in the south of Mexico. A charismatic military commander, he advocated a political programme that combined the Indians' communal tradition with models mediated by socialism and anarchy. He controlled the south for a long time, initiating advanced social experiments in the state of Morelos. He was assassinated in 1919.

Pancho Villa First a bandit then a general, Villa was active in the north, near the border with the United States. Less well informed intellectually than Zapata, he nevertheless shared his ideals and supported him in all phases of the revolution. In 1920, he reached an agreement with the new president, Obregón, but was killed by a hired assassin in July 1923.

1910 THE MEXICAN REVOLUTION

Diego Rivera, The History of Mexico: From the Conquest to the Future
1929–35. Fresco. Mexico City, Palacio Nacional

The fall of Porfirio Díaz

Mexico entered the 20th century full of contradictions and expectations. The country had been modernizing throughout the long presidency of Porfirio Díaz (which had continued almost uninterruptedly since 1876) but the process had tended to concentrate wealth in the hands of a restricted oligarchy. However, long-term opposition by the middle class and intellectuals was now bolstered by the growing unrest of the peasant masses, who were being cheated by the *latifundios* (big landowners) that ate away at collectively farmed indigenous lands. Following Díaz's last election, in 1910, rebellion broke out all over the country. The rebel leader was the liberal Francisco Madero, who duly became president in 1911 – but then almost instantly faced opposition from many of those who had previously supported him. In particular, Emiliano Zapata, a revolutionary leader of farmers in southern Mexico, reproached him for not initiating true agrarian reform. Zapata outlined his political platform in the so-called Plan of Ayala, which provided for radical expropriation of property and collective management of the land. Thus began a period of civil war that was to last at least a decade.

The eagle A national symbol that appears on the Mexican flag, the eagle has a serpent in its beak and sinks its claws into a cactus. It represents the redemption of Mexico and signals continuity between the Indian tradition and the emerging modern state.

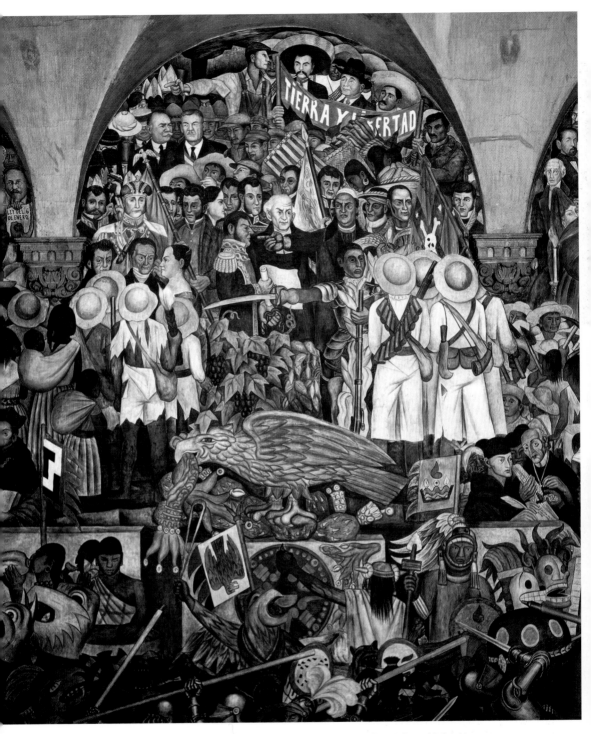

The imposing fresco cycle Diego Rivera painted in Mexico City's Palacio Nacional (Presidential Palace) is the most famous example of early 20th-century Mexican mural art. This art-form was ideal for narrating and celebrating – in simple terms understandable by all – the country's history and the events that led to revolution. The entire cycle, painted on the palace's grand staircase between 1929 and 1935, summarizes the events of Mexican history, encompassing Pre-Columbian civilizations (on the north wall), the Spanish conquest through to 1930 (on the main wall), and a vision of Mexico in the present and future (on the south wall). Reproduced here is the central arch of the main wall, with the figure of Emiliano Zapata at the top.

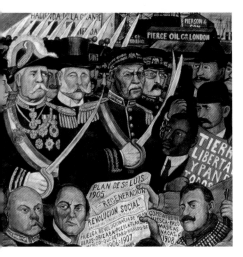

Porfirismo At the top of the mural, with all his medals and a drawn sword, is Porfirio Díaz, Mexico's president-dictator from the 1870s to the revolution of 1910. He is surrounded by generals and the upper middle-class elite that grew under his regime. In the background are foreign factories and oil wells, and large agricultural enterprises that have brought wealth to a few and poverty to the masses of workers and peasants.

Agrarian reform

The main source of Mexico's problems was the fact that, in 1910, roughly 3,000 families possessed nearly half of the country's farmland.

1910 In the Plan of San Luis Potosí, Madero promises to improve the peasants' condition.

1911 Zapata's Plan of Ayala proclaims the necessity of radical redistribution of the land.

1917 The constitution of Querétaro, enacted by Venustiano Carranza, asserts the need for agrarian reform. All possessions of the Church are declared national property.

1920 The law of the *ejidos* is promulgated, providing for land to be confiscated and redistributed to rural communities as communal property (*ejidos*).

1924–28 Land reform accelerates during the presidency of Plutarco Elías Calles.

1934 After a period of inactivity, the new president, Lázaro Cárdenas, pursues radical land redistribution. About 20 million hectares are expropriated and assigned to a million and a half peasant families in the form of over 10,000 *ejidos*.

1910 THE MEXICAN REVOLUTION

From Huerta's dictatorship to normalization

The turning point in the agitation following the fall of Porfirio Díaz was the *coup d'état* mounted by General Victoriano Huerta against Madero in 1913. However, though Madero was assassinated, the revolutionary forces renewed the war against the new dictator. In 1914, they gained the upper hand under the leadership of Pancho Villa, Venustiano Carranza and Emiliano Zapata, who signed a political agreement at Aguascalientes to run a national government that would put the Plan of Ayala into effect. But again, owing to the great divergence in the interests of the different factions, the agreement did not hold up. Carranza became president in 1915 and had his general, Álvaro Obregón, fight against Villa and Zapata. The new phase of war ended with Zapata's murder in 1919 and Villa's surrender in 1920. Carranzo's time, too, was cut short. Having alienated his generals, in 1920 he was killed in an ambush organized by Obregón, who then served as president until 1924. Mexico moved precariously towards normalization, starting to put into effect the social reforms that lay at the root of the revolutionary impulse.

This fresco, also on the main wall, depicts the events of Mexican history prior to the dictatorship of Porfirio Díaz: at the bottom, the conflict between the conquistadores and the Aztecs; then the role played by the Church, particularly through the Inquisition and the condemnation of heretics to be garrotted (a form of slow strangulation used in Spain and its colonies); above that, the Mexican people – peasants who address their demands to two groups, the oppressors (at the left) and the reformers and revolutionaries (at the right). The artist intended the narrative to demonstrate a historical pattern in the evolution of Mexican life, from its beginnings to the final goal of building a society based on Marxist ideals.

Illustrious figures In Rivera's view, the path to revolution requires the contribution of the whole of society. So, this group of revolutionaries includes men who fought each other. At the left is the liberal Francisco Madero (with black moustache and goatee); further to the right is Pancho Villa (with a sombrero and bandoliers); and below is Venustiano Carranza (with the tricolour Mexican sash and white beard), who instigated the murder of Zapata.

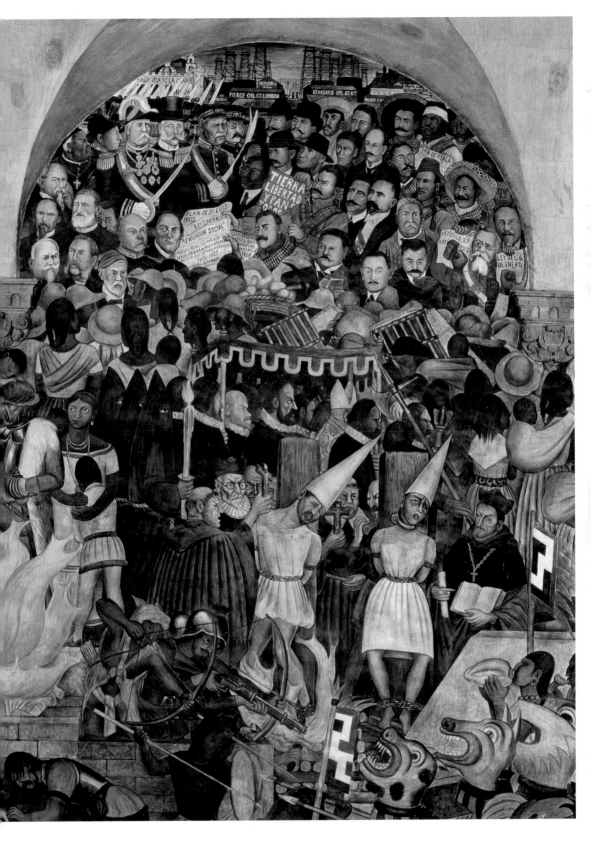

1914 THE FIRST WORLD WAR

KAZIMIR MALEVICH, Reservist of the First Division

1914. Oil on canvas, 53.7 x 44.8 cm. New York, Museum of Modern Art

The start of the conflict

As is well known, the incident that sparked the First World War was the murder of the heir to the Austrian throne, Archduke Franz Ferdinand, in Sarajevo on 28 June 1914. As a result, Austria-Hungary issued a practically unacceptable ultimatum to Serbia (which it considered to be behind the assassination). Serbia refused to accept some of the conditions, and so on 28 July, Austria declared war – unleashing a chain reaction of reciprocal alliances that dragged half the world into war within a matter of days. The deeper causes of the conflict, of course, lay elsewhere: the firmly rooted rivalry between England and France and between England and Germany (Austria's ally) regarding colonial possessions and politico-economic influence, for example, and the chronic instability in the Balkans, which was subject to interference from various powers, including Russia. None of the countries involved anticipated such a long war – nor that it would have such drastic consequences for Europe and the balance of world power.

Normality left behind
The thermometer and the stamp with the czar's portrait are real objects glued directly onto the canvas by the artist, and the writings can be read as fragments of advertisements – all signs of the normality that was fading as the war escalated.

Lost youth *Portrait of a German Officer* (1914) by Marsden Hartley commemorates the death of the American painter's close friend Karl von Freyburg in battle (his initials appear in the lower left). The young German soldier left enthusiastically for war, 'the only modern religious ecstasy' in Hartley's opinion, but died in combat after earning an Iron Cross for bravery (the medal is included in the upper centre of the canvas).

When the First World War broke out, the Russian artist Kazimir Malevich was caught up in the general climate of patriotic fervour that ignited his country and permeated all of Europe. In August 1914, he designed six successful anti-German propaganda posters. However, in this painting, where typically Cubist fragmentation of the figures is combined with the clear geometry of Suprematism (which Malevich was developing in those years), there is also a subtle unease at the prospect of the artist himself being called up – as were so many other reservists.

Lances against rifles The entire painting is dominated by a feeling of movement that develops in the mass of attacking horses and riders and in the force lines of the lances that guide the eye from right to left. The charge seems unstoppable. In the background, the enemy is overwhelmed by the lancers' advance. This is clearly an idealized, heroic vision of war, far removed from the reality of ceaseless carnage.

The Italian front

June 1915
The Italian army attacks the Austrians at the Isonzo river. It is the first offensive named after this river; ten more were to follow, though without any significant military results.

May 1916
Austria's 'Punitive Expedition' begins. The attack occurs in the mountain valleys of the Trentino and penetrates about 20 kilometres beyond the Italian border.

May–August 1917
Riots and armed revolts break out in Milan and Turin against the war and the high cost of living.

October 1917
The Italian front collapses at Caporetto under an Austro-German offensive. The commander-in-chief, Cadorna, hated by his troops for the brutal discipline he imposes, is dismissed.

October–November 1918
The Italians retake the initiative and cross the Piave river for the first time since Caporetto. The exhausted Austrian troops disperse. The armistice is signed on 4 November.

1914 THE FIRST WORLD WAR

Umberto Boccioni, The Charge of the Lancers
1915. Tempera and collage on cardboard, 32 x 50 cm. Milan, Pinacoteca di Brera

Italy, from neutrality to participant

Italy was drawn into the conflict in 1915. In fact, the country could quite legitimately declare itself neutral. It had been allied with Germany and Austria in the Triple Alliance since 1882, but that was a defensive pact, and because the hostilities were initiated by Austria, Italy was not obliged to involve itself. But beginning in the summer of 1914, the Italian government initiated a series of secret negotiations both with its old allies and with the powers of the Triple Entente (France, England, Russia) to see what it might obtain either for its continued neutrality or even for joining the conflict on one side or the other. Meanwhile, a wave of nationalist sentiment was running throughout the country, clamouring for war against the 'old' Austrian enemy, which still controlled cities and territories claimed by Italy. In April 1915, the government reached a secret agreement with France and Great Britain, who promised Italy territorial compensation in return for their collaboration. And so, despite the resistance of parliament and a substantial segment of public opinion, Italy declared war on Austria on 24 May.

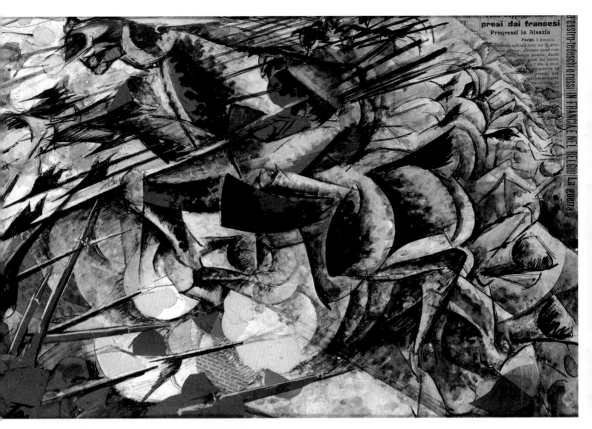

Like many Italian intellectuals of his time, Umberto Boccioni was a fervent nationalist and took an active part in the pro-war campaign. For the Futurists like him, 'war, the world's only hygiene', would sweep away mediocrity and bourgeois compromise to inaugurate a new society. A view shared by many European intellectuals, the rhetoric was swiftly undermined by the blind violence of trench warfare. In this painting, Boccioni almost romantically glorifies the charge of the cavalry, even if his personal fate was quite different. An enlisted volunteer, he died in 1916 from injuries sustained in falling from his horse during a military exercise.

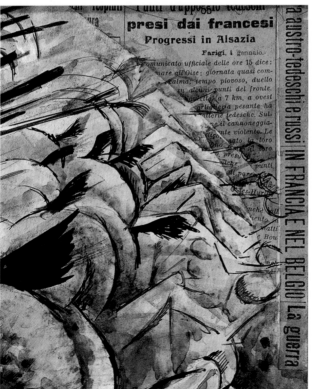

Collage Futurist artists often incorporated into their compositions bits from newspapers and magazines – it gave the works a certain immediacy, and broke down the barriers between art and other forms of expression. In this picture, Boccioni has glued onto the cardboard support clippings from Italian newspapers with reports on the war's progress.

1914 THE FIRST WORLD WAR

Otto Dix, **War**

1929–32. Oil on panel, 204 x 468 cm. Dresden, Gemäldegalerie
Neue Meister

Untold carnage

The extraordinary increase in weapons efficiency and power transformed trench warfare into a slaughter of unprecedented scale. Europe had enjoyed a long period of peace (the last major conflict had been the Franco-Prussian War in 1870) and, although there had been many technological advances in warfare, the commanders' strategic approach remained anchored in the 19th century. Troops were sent to attack extremely well-fortified enemy defence lines, inevitably resulting in slaughter. Furthermore, the scale of the deployment in the field was unprecedented. In total, about 65 million soldiers were mobilized, resulting in ever-greater numbers of casualties. At the Battle of Verdun, fought from February to December 1916, there were more than 300,000 dead and almost half a million wounded. Estimates of the war's dismal tally put the figures at about 10 million dead and 21 million wounded. In fact, the war wiped out an entire generation.

The wounded In the right-hand panel, a soldier in a torn uniform props up a fellow soldier whose head is completely wrapped in bloodied bandages. At his feet is a corpse, as well as another soldier with a furtive, frightened look. In the background the horizon is in flames.

New land weapons

Chemical warfare

First used in large quantities by the Germans in the Battle of Ypres (22 April 1915), toxic gas left its infamous mark on all the war. At first chlorine gas was used, then mustard gas (known as Yperite, from the name of the Belgian city).

Machine guns and flamethrowers

First used in the American Civil War, by 1914–18 machine guns had achieved a cadence of 500 rounds per minute, with devastating effects. Beginning in July 1915, flamethrowers were used by the Germans to flush out enemy bunkers.

Armoured tanks

Tanks were developed to circumvent the tactical problem of using foot soldiers to attack enemy machine-gun nests on terrain devastated by artillery and protected by barbed wire. They made their debut at the Battle of the Somme, 15 September 1916.

Death-like sleep The predella below the triptych depicts the bodies of three soldiers laid out as if in a coffin. The wooden walls and hanging tarpaulin recall the trenches. Yet, the men are so abandoned and inert, it is impossible to tell whether they are asleep or dead.

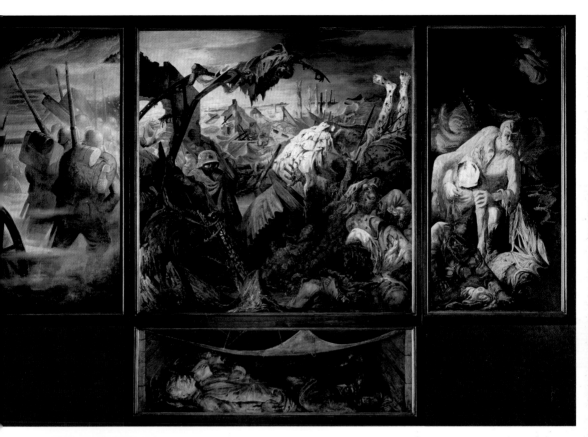

At the outbreak of the First World War, Otto Dix was enthusiastic and patriotic. He enlisted and fought as a non-commissioned officer in the German army. But his experience of the war was profoundly traumatic and, like many other veterans, he arrived at a radical pacifism.
The result is this famous triptych, *War*, painted after more than a decade's gestation. It shows the horrible reality of the war with disarming crudeness. Executed on wooden panel, it takes the form of an altar painting. But here the message of religious devotion is reversed: what triumphs is an infernal world from which there appears to be no means of escape.

Heading to the front The triptych's left-hand panel depicts a long line of soldiers marching in the mist towards battle. Their gazes are fixed and they utter few words. Their equipment is still intact.

The last years of the war

31 January 1917
Germany declares unrestricted submarine warfare. Any ship heading for an enemy port, even from a neutral country, would be attacked.

8–12 March 1917
Outbreak of the Russian revolution. Nicholas II is forced to abdicate. Russian troops are in retreat.

2 April 1917
The United States declares war on Germany. The deployment of the American contingent takes time, but the contribution in men and equipment would be decisive.

24 October 1917
The Italian front gives way at Caporetto.

3 March 1918
Bolshevik Russia withdraws from the war with the Treaty of Brest-Litovsk.

March–May 1918
The Germans, bolstered by their troops returning from Russia, deliver impressive attacks on the Western front, though fail to break through.

July–October 1918
The initiative passes to the Allies. The Germans are forced to withdraw, while the Austrians suffer Italy's counter-offensive.

11 November 1918
Germany signs the armistice at Compiègne. The war is over.

The end of an era

After more than four long years of fierce combat on all fronts, the First World War finally ended in November 1918. Europe had been changed for ever, but just as important, a new major player had appeared on the world political scene: the United States, which could legitimately consider itself the arbiter of international balances. Three other great empires had disappeared forever: the Turkish empire, whose dissolution opened unexpected scenarios in the Middle East; the Austro-Hungarian empire, from which many new and often unstable states arose; and the Russian empire, with the birth of an ambitious giant, the Soviet Union, which soon frightened the bourgeoisie in half the world with its communism. A completely different chapter in history had begun, marked by the sudden rise of dangerous totalitarian ideas.

Death The flame-charred bodies riddled with gunshot wounds are the tragic counterpoise to the militaristic ardour that had inflamed youth all over Europe. A skeleton hanging from a girder points a finger towards the gaping chasm. It is a macabre parody of the countless angels who normally inhabit altarpieces, showing the way to heaven. Here, all that remains is hell.

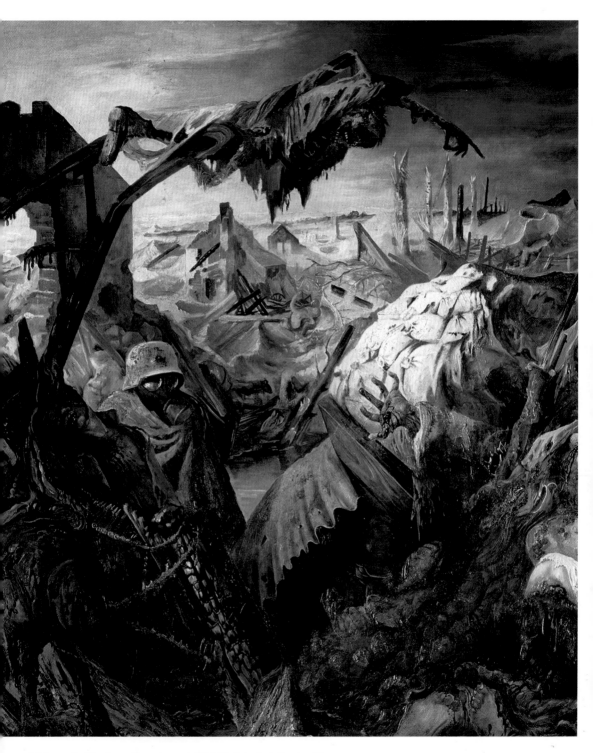

A dehumanized landscape The centre panel of Dix's *War* is dominated by a troubling vision of the theatre of war. Wrapped in a blanket, his face covered by a gas mask and a muddy helmet lowered on his head, the only living being is denied almost all human substance. All around are corpses, rubble, ruins, charred trees and a land devastated by artillery fire.

1917 THE OCTOBER REVOLUTION

Boris Kustodiev, **The Bolshevik**
1920. Oil on canvas, 101 x 141 cm. Moscow, Tretyakov State Gallery

The giant The symbol of the revolution's inexorable advance, a determined-looking giant, carries a red banner aloft. However, this image is still a far cry from the sculptural figures that would populate Soviet Realist art and propaganda in the 1930s.

The Bolsheviks take power

On 26 October 1917 (according to the Russian calendar), the revolutionary soldiers and workers' militias occupied the Winter Palace in Petrograd (today St Petersburg), the former residence of the czar and the seat of the provisional government of Alexander Kerensky. It was the beginning of the Bolshevik revolution, led by Lenin and Trotsky, which marked the final stage in the transition from czarist power – a transition that had been begun in February–March 1917, when a first revolution had forced Nicholas to abdicate. During these months, the moderate forces that headed the interim government were convinced of the need to pursue the war despite its catastrophic course. Lenin, however, was opposed to continuing. The Bolsheviks took action in a situation of considerable political instability. After the sudden attack in Petrograd, the revolution spread to Moscow and the rest of the country.

A year of continuous upheaval

Dates are according to the Julian calendar, which was in effect in Russia until 31 December 1917.

2–3 March 1917
Czar Nicholas II abdicates. Power passes to a moderate provisional government and the Petrograd soviet, made up of representatives of the workers and the soldiers.

4 April 1917
Having returned to Russia from Switzerland, Lenin expounds his programme at the Bolshevik party congress, calling for immediate peace and the transfer of power to the soviets.

3 July 1917
The war continues under the leadership of the social revolutionary minister Alexander Kerensky, but the troops in Petrograd rebel. The uprising fails, and Lenin flees to Finland.

August 1917
General Kornilov, head of the armed forces, turns his troops on Petrograd. The defence organized by the soviets saves Kerensky's government.

24 October 1917
The Bolsheviks occupy the nerve centre of the capital. On 26 October, they take the Winter Palace. Kerensky leaves Russia.

Civilians and soldiers Between the giant's legs, armed and uniformed men on foot and in a car converge from every street. They belong to the army soviets and the Red Guard, the military backbone of the October revolution.

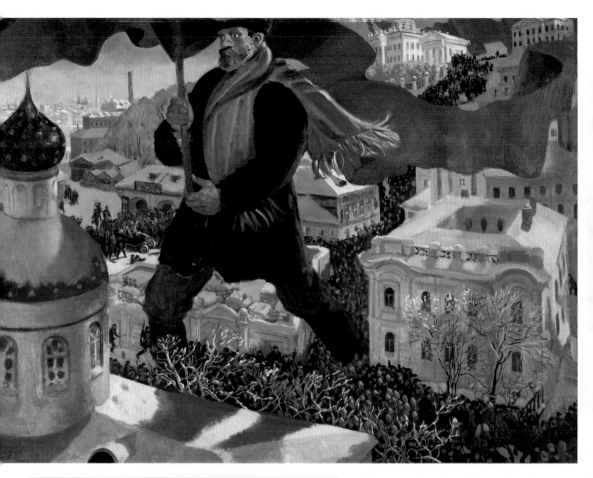

In this painting, Boris Kustodiev combines the traditional representation of the Russian people, as inherited from 19th-century populism, with enthusiasm for the Bolshevik revolution. Paralysis had confined the artist to a wheelchair since 1916, but he continued working energetically, reconstructing the reality outside his room. This painting reconstitutes a segment of the world observed through a window but enriched by the almost surrealist revolutionary giant.

The halls of power The red banner unfurls amid the buildings as a crowd descends a staircase to join the teeming masses in the streets below, forming a single procession towards the lower right-hand corner of the painting.

1917 THE OCTOBER REVOLUTION

KAZIMIR MALEVICH, **Red Cavalry**

1928–32. Oil on canvas, 91 x 140 cm. St Petersburg, Russian Museum

Revolutionaries and counter-revolutionaries

Vladimir Lenin Ideologist and originator of the Russian revolution, Lenin governed the Soviet Union (as it was called from 1922 onwards) in the difficult period following October 1917, carrying out a progressive centralization of power in the hands of the party. When he fell gravely ill in 1922, a fight broke out over who his successor should be. The victor was Stalin.

Leon Trotsky Trotsky was behind the formation of the Red Army that defeated the 'Whites'. At the end of the civil war, he opposed Stalin and the bureaucratic party apparatus in the name of a revolution that was to be carried beyond the borders of Russia. Branded a 'deviationist', in 1929 he was expelled from the USSR. He was killed in Mexico in 1940 by a hired assassin of Stalin.

Anton Denikin Commander of the anti-revolutionary Volunteer Army, in 1919 he succeeded in threatening Moscow but was defeated at Orel. His troops stained their reputation with frequent and cruel pogroms against Jews.

The civil war

When the Communists, led by Lenin, came to power in October 1917, the impressive revolutionary programme they initiated – from the distribution of land to peasants to the nationalization of banks and industries – caused an immediate armed uprising backed by many economic, political and military sectors. With the support of some European powers (who feared revolutionary expansion), the opponents assembled a variegated 'White Army', made up of Cossacks, Czechoslovakian volunteers present on Russian soil, czarist officers and leftist forces hostile to the Bolsheviks. They were opposed by the Red Army, led by Leon Trotsky, who reestablished military discipline and efficient operations. The war lasted on and off from 1918 to 1921, causing an unknown but high number of victims among both military and civilians. Though in the end Communism won out, victory was obtained through ruthless management of centralized power.

Symbols and geometry Russian avant-garde artists immediately placed themselves at the service of the new order. The revolution's top leaders at first supported the radically subversive languages used by the avant-garde as a sign of the epoch-making change in progress. This was the case with this 1920 propaganda poster by El Lissitzky, a friend of Malevich's, entitled *Beat the Whites with the Red Wedge!* Its simple geometrical forms and the background colours convey the overwhelming strength of the revolutionary ideal that erupts into the white field.

Kazimir Malevich was an emblematic case in the controversial relationship between art and revolution. A theoretician of the Suprematist avant-garde, he performed important public and pedagogical roles throughout the 1920s. But with the advent of Socialist Realism as the only form of artistic expression acceptable to the Soviet authorities, he fell into disgrace. In 1930, he was arrested and heavily censured. He then returned to figurative art, as seen to a certain extent in the *Red Cavalry*. The fine line of horsemen suggests the artist's adherence to the revolutionary ideal, despite the harsh persecution aimed at him in those years.

Between avant-garde and tradition Isolated against an empty sky, the charging cavalry seems unstoppable. The thick bands of colour that define the terrain further isolate the only real figures of the painting. Thus, elements still recalling the abstraction of the Suprematist avant-garde are combined with the re-emergence of figurative elements.

1917 THE OCTOBER REVOLUTION

ALEKSANDR DEYNEKA, **Interrogation of Communists (At White Army Headquarters)**

1933. Oil on canvas, 130 x 200 cm. St Petersburg, Russian Museum

A fine balance

Though the October Revolution set off a powerful wave of hopes and illusions around the world, its limitations and the risks of a shift to totalitarianism soon became evident. The Bolshevik regime was based on the notion of a 'dictatorship of the proletariat' driven by the party's revolutionary avant-garde, which would create the right climate for making Communist society a reality. From the outset, this led to severe restrictions on freedom and autonomy, even within the soviets – the original organizational model based on direct democracy. In addition, the outbreak of civil war created an extraordinary state of emergency, resulting in the militarization of society and a grave economic crisis caused by hasty revolutionary measures. Dreams of a society reborn were quickly extinguished.

The priest and the general The work's didactic intent is obvious. Whereas the Communist militant has a proud bearing, the priest wears an ambiguous expression and the general looks positively obtuse. The cigars and liquor on the table signify the Whites' 'corruption'.

The prostitute As sentence is passed on the revolutionary, a half-dressed woman is momentarily left aside. The Orthodox priest does not seem scandalized by her presence.

Emergency measures

Cheka The first Soviet political police was instituted in December 1917 to deal with the attempted coups that followed the Bolsheviks' rise to power. In September 1918, it initiated a massive wave of 'eliminations', targeting opponents and counter-revolutionaries.

War communism The system of economic and social measures instituted by Lenin during the civil war consisted of 'dictatorial' measures ranging from the requisition of food supplies to the prohibition of all private sales transactions, from the barring of strikes to control of the press and the reintroduction of the death penalty (which had been abolished in October 1917).

Gulag During the course of the civil war, Cheka reorganized the system of forced labour camps and prisons inherited from the czarist regime. The gulags held common criminals, dissidents, government officials accused of various crimes and members of all social classes considered to be enemies of the revolution.

Barely twenty years old, the artist witnessed and took part in the civil war, both as a militant Communist and as a journalist for the wire agency ROSTA. His memories of those events are reflected in this work that, while adhering to the dictates of Soviet propaganda art in the 1930s, depicts the episode with lifelike intensity. Its realism conveys a remarkable dramatic impact through a great freedom of composition and the monumental rendering of the figures, which highlight physical traits that attest to moral qualities and psychological characteristics.

The communist militant The realism of Soviet art in those years aimed specifically at presenting the people with clear examples of the virtues of communism and the corruption of the enemy. Here, the militant with pistols aimed at him knows his fate is sealed. Yet, he shows the pride of someone confident he is on the side of justice and even looks at his persecutors with a touch of irony.

1918 THE 1918 INFLUENZA PANDEMIC

Egon Schiele, **The Family**

1918. Oil on canvas, 150 x 160 cm. Vienna, Österreichische Galerie Belvedere

A young father Schiele married Edith Harms in 1914, and the marriage brought a greater serenity to the artist's life despite the recent outbreak of war. Expecting a child began a new phase that is reflected in the painter's eyes. However, illness would cruelly cut this dream short.

The 'Black Death' of the early 20th century

 While the First World War was still claiming victims on all fronts, the entire globe was infected with a scourge of biblical proportions, the so-called 'Spanish influenza'. The name comes from the fact that only in neutral Spain did the media report it openly, whereas the countries at war concealed the facts so as not to disclose their weakness to the enemy. Although our knowledge of this strain of influenza is still incomplete – partly because the war in progress diverted attention from it – it is reasonably certain that the pandemic first appeared in Boston in mid-September 1918. From there, the virus spread quickly through the United States, reaching peak mortality in October, and then arrived in Great Britain and the rest of Europe, carried by infected soldiers. It reached the colonies in Africa, Asia and Oceania by boat, spreading like wildfire in December 1918. There was a recurrence of the disease between February and March 1919, but it was a less virulent strain. According to conservative estimates by the authoritative Pasteur Institute in Paris, there were about 21 million victims worldwide.

Characteristics of the 'Spanish' influenza

Rate of infection

Since the flu was a new strain against which human beings had no antibodies, it is calculated that between 50 and 70 per cent of the world's population fell ill – over a billion people.

Mortality

Although it is difficult to estimate, a 2 or 3 per cent death rate among those infected may be supposed. In the United States, there were about 549,000 victims; in France, 400,000; and in Great Britain, 222,000. There is no reliable data for Austria and Germany because of the disorder generated by the military defeat. It is estimated that six million died both in India and in China.

Specificity

The disease was particularly lethal among adults between the ages of twenty and forty. Death occurred mainly from pulmonary complications that followed the influenza after a couple of days of normal symptoms.

A single exception

Only Australia succeeded in averting the first wave of the pandemic, by applying strict preventive measures. However, it was affected in the spring of 1919.

This painting is dramatic testimony to the tragedy that befell Egon Schiele's family because of the Spanish influenza. On 28 October 1918, his wife Edith Harms, six months pregnant, died from the disease, which was raging in Vienna. Three days later, barely twenty-eight years old, the great painter too was carried off by this terrible illness. The work dates from 1918 and presents a propitiatory vision of the family-to-be. It depicts, one above the other as if in mutual protection, the child that would never be born, the wife (for whom a model posed), and Schiele himself, less tormented than in many other of his self-portraits.

Melancholy and tenderness The child's imagined face and the woman's gaze combine a sense of bewilderment at the life before them and hopeful sweetness. The mood of this painting is far removed from the sensual, intertwined nudes and biting, hallucinatory visions that so strongly characterize most of Schiele's work.

1919 THE WEIMAR REPUBLIC

George Grosz, **The Pillars of Society**

1926. Oil on canvas, 200 x 108 cm. Berlin, Gemäldegalerie

From one disaster to the next

Victor and vanquished alike suffered various crises after the First World War. The Germany of the Weimar Republic, for example, had to cope with the economic, social and political disaster caused by the conflict. First of all, the republic (which took its name from the small city of Weimar, where the constitutional assembly elected in January 1919 met) faced difficult peace negotiations with the victors, after the generals and Kaiser Wilhelm II stepped down so as to abdicate themselves of the responsibility for the defeat. In addition, the republic was attacked by both left and right, with continual attempted coups and armed revolt. Finally, it had to confront the hyperinflation caused by the state's enormous debt, which reduced the mark, the German currency, to the status of waste paper. Only in 1923 did Germany regain its momentum, inaugurating a period of growth and development that lasted until 1929, when the Great Depression that began in the United States plunged the country into an economic abyss, thus opening the doors to Nazism and its extreme message.

The soldiers' sneer An ardent antimilitarist, Grosz depicted the soldiers and police with their faces distorted by violence and cruelty. Repression by the armed forces and the so-called Freikorps (Free Corps) had been constant during the first years of the Weimar Republic and was soon renewed with the organization of paramilitary corps and politicized troops.

Swastikas and chamber-pots The figure in the foreground is a militant 'veteran' of a student association. These groups were on the whole ultra-nationalist. He is holding a sabre, with which student association members duelled among themselves. Dreams of heroic combat emerge from his skull. Behind him, with a chamber-pot on his head, is a near-sighted editor, identifiable as Alfred Hugenberg, famous for his warmongering and anti-Semitic views.

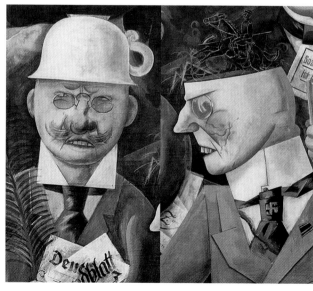

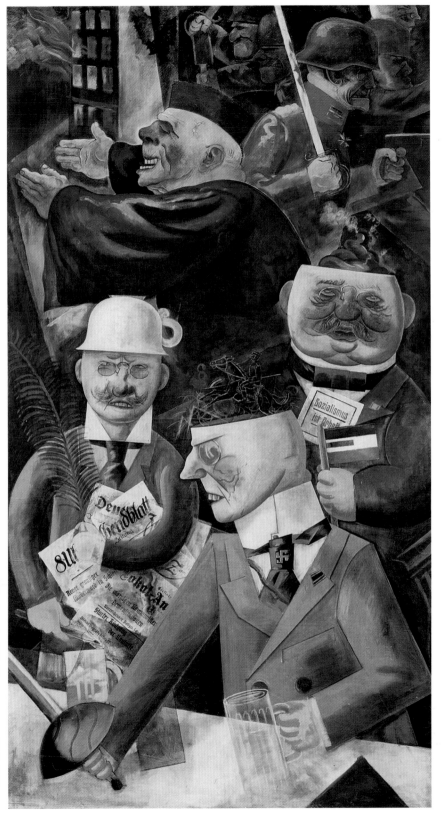

Militant in every respect, this painting is a stinging criticism from the leftist point of view of the basis of the Weimar Republic's social and political system. Grosz was politically involved, though by 1926, when this picture was produced, he had abandoned the German Communist Party in disillusionment. In this painting, with the scathing distortion of reality typical of Expressionist painting, he depicts some 'ideal types' of his time. In the foreground are a hardened nationalist, an extreme right-wing publisher, a political opportunist with excrement coming out of his head and a drunken man of the cloth, making a gesture of blessing. Behind the four of them, repressive action is being taken while a house burns. A grim prophecy of Germany's future.

1929 THE GREAT DEPRESSION

Isaac Soyer, **Employment Agency**

1937. Oil on canvas, 87 x 114 cm. New York, Whitney Museum of American Art

Resignation The feelings of the people waiting at the employment agency are obvious: self-confidence and belief in the future have vanished.

An economic crisis without precedent

In the late 1920s, an economic and financial collapse took place in the United States that, besides eroding capital and wealth, reduced millions of people to poverty and indirectly fostered the rise of Nazism in Germany. There were a number of causes. The United States had experienced a great increase in production, backed by credit, which had driven investors to the stock market. Stock prices grew beyond measure, irrespective of their real market value. When the first signs of crisis were noted in the autumn of 1929, the speculative bubble burst and shares were dragged inexorably downward. This process spilled out onto production, with closings and layoffs, plunging the country into a dark crisis that left millions unemployed. The interruption of the flow of American credit towards Europe, together with the drastic reduction in international trade, spread the crisis worldwide.

The stock market crash on Wall Street

3 September 1929

The Dow-Jones average, the main index of American stocks traded in New York, reaches the record level of 381.17 points, compared with 100 in 1923.

24–25 October 1929

After a month and a half of seesawing, shares collapse on Black Thursday, 24 October. The next day, the largest American bankers agree to buy shares and reassure the market. The situation seems to stabilize.

29 October 1929

Panic sweeps Wall Street on Monday, 28 October, and the fateful day following, Black Tuesday. The Dow-Jones falls by 25 per cent, and during the week nearly 30 billion dollars is lost. Investors rush to the bank to withdraw their savings.

8 July 1932

The Dow-Jones average falls to 41.22, its lowest level. In all, the index lost 89 per cent of its value in three years.

Poverty Ben Shahn, the creator of this small painting, entitled *Farmers*, witnessed the state of affairs in rural America during the Great Depression firsthand. From 1935 to 1941, he participated in a US government photography campaign to document the living conditions of American farmers, who were also hard hit by the economic crisis. The artist highlights the signs of discouragement and a lack of perspective.

During the grave crisis of the 1930s, American art sought to narrate the daily events of the people affected, lingering especially over their poverty and frustration. This gave rise to social realism, an art movement that recalls both realist Russian painting and the Mexican muralist Diego Rivera, active in the United States. Isaac Soyer fits within this movement.

Loss of status The crisis hit not only traditionally weak groups of American society but also specialized white workers and members of the middle class — as Soyer indicates by placing a white man in coat and tie beside a black woman, uniting them in their dejection.

20 April 1889
Hitler is born in Braunau am Inn, Austria, the son of an Austrian customs officer.

1 August 1914
At the outbreak of the First World War, Hitler, an Austrian citizen, enlists in the German army. He is decorated with the Iron Cross, Second Class.

8 November 1923
Having become the leader of the marginal National Socialist Party, Hitler attempts a *coup d'état* in Munich. The 'Beer Hall Putsch' fails and he is arrested. In prison, he dictates to Rudolf Hess his book *Mein Kampf*, in which he expounds his racist ideology.

14 September 1930
In a climate of political violence and economic crisis, the National Socialist Party obtains 18 per cent of the vote in the elections, becoming the second-largest political force.

31 July 1932
The Nazi party receives 37.2 per cent of the vote in a general election. Six months later, Hitler is the new German chancellor, thanks also to the support of President Hindenburg and other National Conservative politicians.

1933 THE RISE OF NAZISM

OTTO DIX, **The Seven Deadly Sins**

1933. Mixed media on panel, 179 x 120 cm. Karlsruhe, Staatliche Kunsthalle

The advent of totalitarianism

On 30 January 1933, Adolf Hitler was named German chancellor by the old president Paul von Hindenburg, sealing the demise of the precarious Weimar democracy and opening the way for the totalitarian Nazi regime. Hitler rose to power 'legally', despite the general climate of violence in Germany in those years. But once installed in office, he rapidly pursued the goal he had set: the radical transformation of German society in the mould of Nazism. On one hand, he concentrated all the power in his own hands, making all opposition illegal and suspending civil rights; on the other, he acted on the social front, subjugating the schools, religion and associations. He moulded public opinion through skilful use of propaganda and the communications media, convincing people of his racial and anti-Semitic ideology and preparing the way for the Second World War.

'From now on we will wage an unrelenting war of purification against the last elements of putrefaction in our culture.' These words, spoken by Hitler at the opening of the 'Degenerate Art' exhibition in 1937, defined Nazism's relationship with the avant-gardes and their exponents. Artists such as Otto Dix were to be hounded and isolated – all the more so if their works, like this one, attacked Hitler's ideology.

The 'Führer' Reduced to the dimensions of a dwarf gnawed by Envy, Hitler rides the back of a greedy old woman who represents Avarice. This painting uses grotesque distortion in a symbolic mode, as the Renaissance masters of the German and Netherlandish schools did. Incidentally, the dwarf's moustache was added in 1945, when the Nazi threat had passed.

Sloth and lust The black skeleton of death is the deadly sin Sloth, a general apathy that can result in indifference to tragedy. The lascivious woman is Lust, the bloody monster is Wrath, the man with one hand in his ear is Pride and the child entwined in sausages is Gluttony.

339

1937 THE BOMBING OF GUERNICA

PABLO PICASSO, **Guernica**

1937. Oil on canvas, 350.5 x 782.5 cm. Madrid, Museo Nacional Centro de Arte Reina Sofía

A new strategy of terror

On 26 April 1937, at around four o'clock in the afternoon, the Basque city of Guernica suffered the first true carpet-bombing in recorded history. The attack was carried out by the fighters and bombers of the Condor Legion, an airborne unit from Nazi Germany, with active support from the aeroplanes of the Italian Legionary Air Force. However, the man behind that attack was Francisco Franco, leader of the Fascists in Spain's civil war. High-yield bombs were released onto the city in three successive waves, experimenting with the technique of simultaneous bombardment to increase the destructive effect. About 10,000 incendiary bombs were also dropped. Guernica, engulfed in flames, was largely destroyed. The number of casualties is difficult to quantify. The Republicans counted about 1,650 dead, while Franco, denying his involvement, claimed it was the Republicans who had set fire to the city. For the Germans, this was an experiment – by attacking the civilians of a small town, on a busy market day, they could verify their ability to raze an entire area to the ground and terrorize its inhabitants. It was the first of the aerial attacks against defenceless populations that so dramatically characterized the Second World War on all fronts.

The horse Besides a bull, in the centre of the composition there is a horse – or, more precisely, the head of a horse, whinnying in fear. A symbol of the persecuted people, it is lit by a candle and a lamp hanging from the ceiling – emblems of a tranquil everyday domestic life forever shattered by war, which unites man and animal in suffering.

Mangled limbs The figures and objects in *Guernica* silently condemn the bombing with their symbolic force: for example, the gnashing mouth of the dead man lying on the ground, his gaze twisted and terrified, his detached arm, out of proportion with the face. Another limb, to his right, grasps a broken sword from which a flower sprouts – the only note of hope.

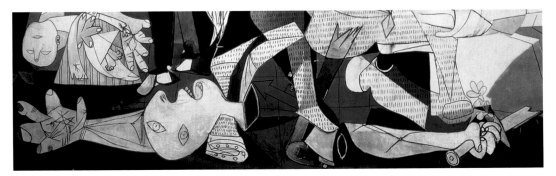

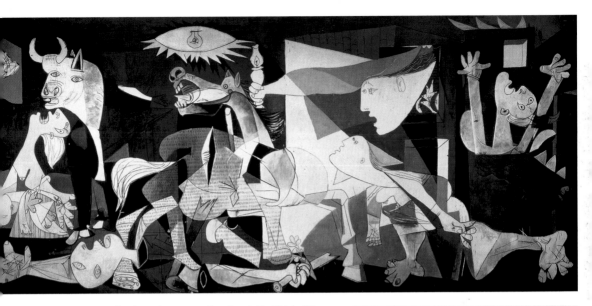

Guernica represents for the 20th century what Goya's *The Third of May 1808* meant for the 19th: humanity's cry of pain and despair in the face of the horrors of war. Picasso painted this powerful canvas in Paris in just over a month, once news of the bombardment became known. It was a commission from the Republican government to decorate the Spanish Pavilion at the Paris World's Fair in the summer of 1937. After the exhibition, Picasso declared that his painting would never go to Spain as long as Franco's government was in power. During the Second World War, *Guernica* was transferred to the Museum of Modern Art in New York. It remained there until 1981, when, with the artist now dead and Franco's dictatorship finally at an end, it was returned to Spain.

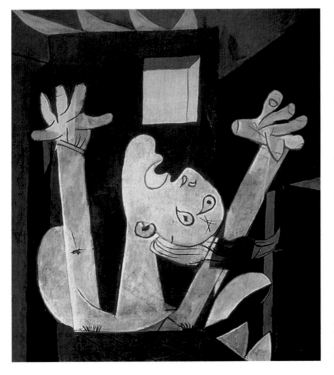

The forces at play

Combatants from foreign countries fought in the Spanish Civil War, making it the first international encounter between fascists and anti-fascists. These are the main formations:

Corps of Volunteer Troops Italian soldiers sent to Spain by Mussolini's Fascist regime. Initially commanded by General Mario Roatta, they numbered 35,000 'volunteers' in January 1937, but their numbers later reached as many as 60,000. Losses amounted to 4,000 dead and 11,000 wounded.

Condor Legion German troops sent by Hitler in cooperation with the Italians and Franquistas. Formed in October 1936 on the order of General Hugo Sperrle, the Legion included 6,500 men, a hundred bombers and fighters, 180 tanks and as many anti-aircraft cannons. They suffered about 300 casualties.

International Brigades Volunteers from fifty-three countries who fought alongside the Republicans. Led by the Russian general Emil Kleber, the Brigades were soon dominated by the Soviet Union, which supplied arms and funds. There were about 50,000 volunteers, of whom nearly 10,000 fell in battle. Intellectuals like George Orwell and Simone Weil fought in the ranks of the Brigades, while others, like Ernest Hemingway and John Dos Passos, made their contribution as war journalists.

A crucifixion The work is rich in figures that refer to tradition using a 20th-century vocabulary. As if transfixed in a lay crucifixion, a man howls in despair amid the crumbling walls of a house licked with flames.

1937 THE BOMBING OF GUERNICA

The Spanish Civil War

The war began after the victory of the leftist Popular Front in the elections of February 1936. In July of that year, the conservative powers responded with a military revolt organized by a junta of five generals headed by Francisco Franco. In September, at the prompting of France, European nations signed a non-intervention agreement and embargo regarding the Spanish crisis, which only the French government and Great Britain respected, however. Italy and Germany, on the other hand, contributed men and funds to the fascist cause, and the war turned gradually in the fascists' favour. The progressive forces lacked the unity of the fascists, being divided between Republicans, communists and anarchists, and despite the aid received by the Soviet Union and the International Brigades, they could not hold off the Falangists. In the spring of 1938, the fascists succeeded in splitting Republican-controlled territory in two, and in March 1939 they launched a decisive offensive, which concluded with the taking of Madrid and the installation of the dictatorship.

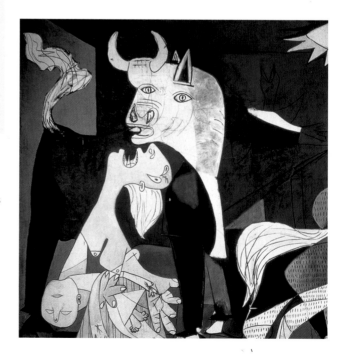

An inhuman world The work is characterized by two things: the absence of colour and the absolute two-dimensionality of the figures. The canvas is painted in a range of blacks, greys and whites that gives a diffuse luminosity, rich in contrasts between the dark backgrounds and the dramatic explosions of white from which men and animals emerge. The renunciation of volume, together with this chromatic effect, mirrors a world that has been 'flattened' by violence and has lost all its colour. In the section of the painting below the bull – an animal Picasso depicted often and a symbol of brutality – is a woman holding her dead son in her arms, a Pietà that harks back to models like Michelangelo.

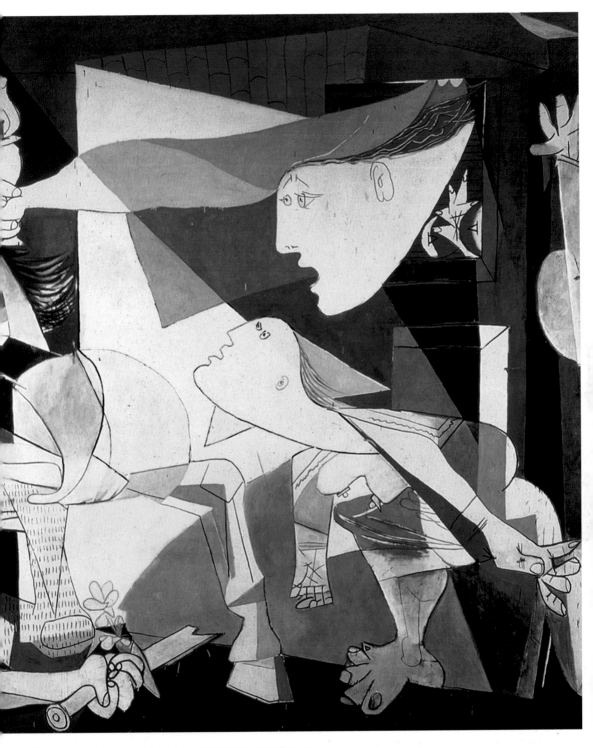

The women As the house's walls fall, two classically inspired women's faces emit a scream in their desperate attempt to flee. Perhaps Picasso wanted to fix on canvas the transfigured faces of his companions at the time: Dora Maar, who documented in photographs the execution of the painting, and Marie-Thérèse Walter, with whom Picasso had recently had a daughter, Maya. The artist frequently painted portraits of both women.

1938 THE NIGHT OF BROKEN GLASS (KRISTALLNACHT)

Marc Chagall, White Crucifixion

1938. Oil on canvas, 155 x 140 cm. Chicago, The Art Institute

Discrimination leads to persecution

Following the murder of a German government official in Paris by a young Jew on 9 November 1938, a violent attack on Jews and their property began throughout Germany. Orchestrated by the Nazi party, this pogrom was an intensification of persecution against a community that had been the object of violence since Hitler came to power in 1933 – and then systematically discriminated against by laws that restricted their freedoms and rights. On that night, thirty-six Jews were killed, thousands of shop windows shattered (hence the name Night of Broken Glass), 191 synagogues and 171 houses torched, and 20,000 people arrested solely on the basis of their 'racial' affiliation. Nazi anti-Semitism moved towards more dramatic forms: after discrimination and systematic violence, it would soon involve mass deportations and eventually extermination.

The synagogue Flames issue from a synagogue. On the ground lie furnishings, texts and sacred objects, as a figure in a brown shirt starts the fire.

Measures against the Jews in Nazi Germany up to 1939

7 April 1933
A great proportion of Jewish civil servants are fired. Heavy restrictions are imposed on Jewish lawyers and doctors.

15 September 1935
Two laws are enacted at Nuremberg: one forbids Jews to hold any public office; the other prohibits (among other things) extramarital relationships and mixed marriages between Jews and non-Jews.

5 October 1938
A red letter J is added to the passport of German citizens of Jewish origin.

November 1938
Jewish students are forbidden to attend German schools.

1 January 1939
Jews can no longer engage in business or retail. Their firms pass into Aryan hands or are closed.

The pogrom Chagall depicts the effects of a pogrom, with houses aflame and destroyed, desecrated graves, and a dead man lying on the ground who seems devoured by the flames. Below, a boatload of fugitives seek safety far from the violence. On the other hand, the violin beside the three seated men and the goat by an empty chair symbolize the continuity of existence.

In this emblematic and prophetic work, Chagall combines the experience of the pogroms against the Jews in czarist Russia and the civil war with the persecution against the Jews in Nazi Germany. Painted in 1938, the year of the Night of Broken Glass, the canvas places a Christ on the cross in the centre, symbol of all human suffering, lit from above by a beam of divine light. Around him rages the tragic spectacle of devastation, fear and flight. Above Christ, wrapped in a typical Jewish cloak, four figures float in the place of the angels – three rabbis and a woman, crying in despair at the slaughter caused by hatred.

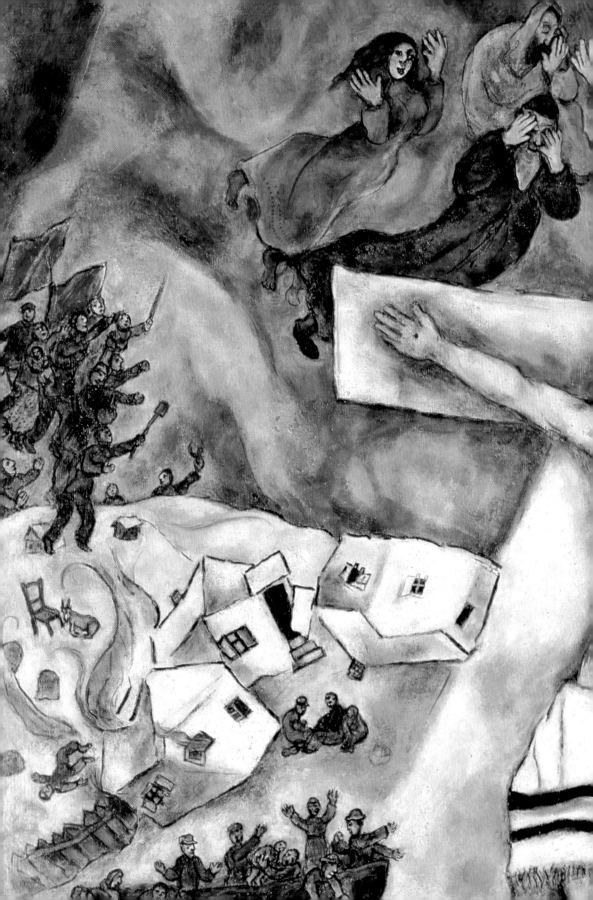

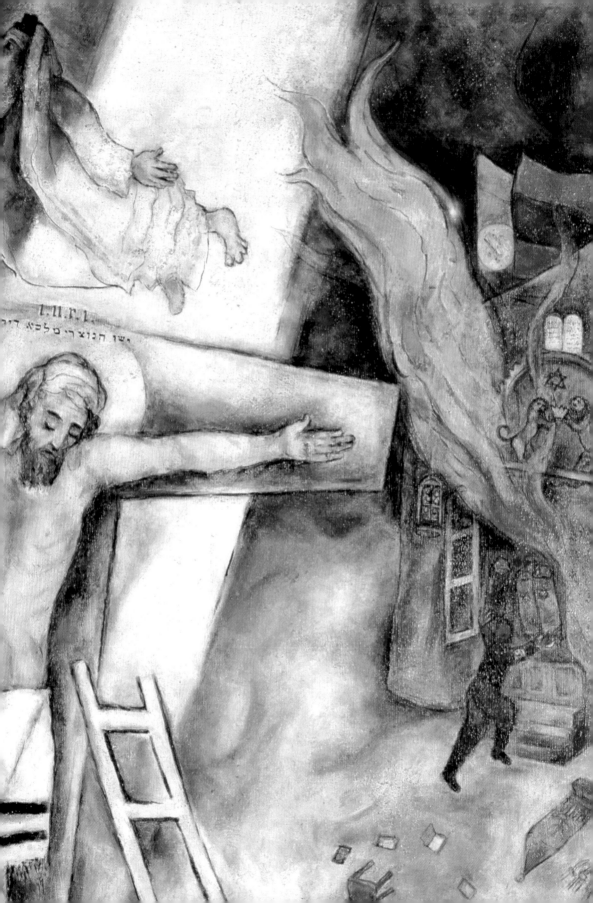

The forces in the field

The Axis powers
Called this because of a first agreement between Nazi Germany and Fascist Italy in October 1936, the Axis included Japan (which allied itself with Germany and Italy in the Tripartite Pact of September 1940) and then Hungary, Romania, Slovakia and Bulgaria.

The Allies
They represented all the nations that fought against the Axis. At the beginning of the war, it was mainly France and England (with their respective colonies) that reacted to the invasion of Poland.

The Soviet Union and the United States
The Soviet Union made a non-aggression pact with Nazi Germany in August 1939, but in June 1941, Germany broke the agreement and invaded the USSR. The United States was attacked by the Japanese without warning at Pearl Harbor on 7 December 1941 and entered the war at that point.

Salvador Dalí, **The Face of War**
1940. Oil on canvas, 64 x 79 cm. Rotterdam, Museum Boijmans Van Beuningen

Total global war

The Second World War, fought between 1939 and 1945, is the most wide-ranging all-out war in recorded history. Fighting of unprecedented intensity raged on every continent except the Americas. Furthermore, the war mobilized enormous human and material resources, requiring the systematic use of scientific and technological production methods and advances. Civilians were involved to a much greater extent than in the First World War, becoming the target of bombings and attacks, harsh reprisals, and undisguised persecutions and exterminations. Both the ideological involvement of the combatants and public opinion were very strong. The radically changed world that emerged from the war was dominated by two new superpowers: the USA and the USSR.

Serpent and wilderness Like the hideous face of the Greek Medusa, this skull is surrounded by snakes ready to snap at each other. The surrounding landscape is a lifeless desert, like the land and cities swept by war's devastating fury. This work does not stem from an ideological position but fully grasps the horror of modern war while transposing it to an almost metaphysical level, far removed from the political debate of the time.

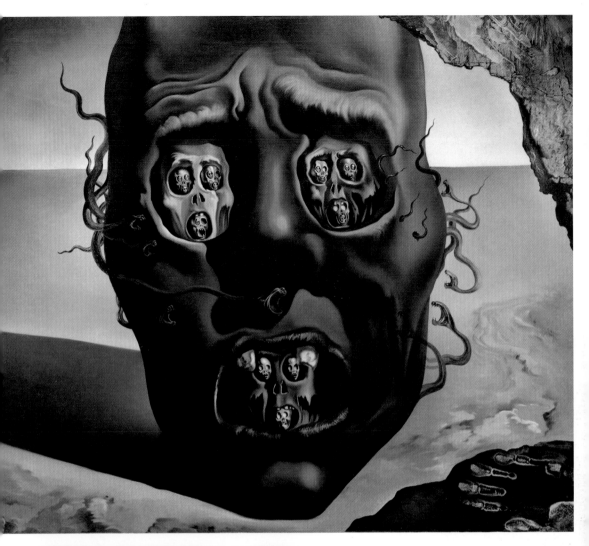

Unlike his fellow countryman Picasso, Salvador Dalí never spoke out clearly against either Franco's Spain or the fascism that had dragged the world into the world war. Although his ambiguous stance got him expelled from the Surrealist group in 1936, it did not prevent him from effectively synthesizing *The Face of War* in the visionary skull that dominates this painting from 1940, when France was occupied by the Germans and Dalí left Europe for the United States.

Medusa's gaze In this modern Medusa's empty eye sockets, the artist has painted skulls whose cavities are in turn filled with skulls. As in the ancient Greek myth, the monster's gaze petrifies whoever looks into it.

P-51 Mustang In the painting as in the comic, the fighter is flown by Johnny Cloud, an American pilot of Native American background. The plane is a P-51 Mustang, one of the most versatile and powerful fighter planes used on the European front, starting in 1941, to counter the offensive of the German air force.

1939 THE SECOND WORLD WAR

Roy Lichtenstein, **Whaam!**

1963. Acrylic and oil on canvas, 172 x 406 cm. London, Tate Modern

The German and Japanese offensives

The war that broke out on 1 September 1939 with Germany's aggression against Poland was, at least until 1942, led by the Axis powers. At that time, Germany was master of the greater part of continental Europe, while conducting a victorious advance into North Africa with its Italian allies. In the Far East, after attacking the US fleet in December 1941, Japan had extended its control from China to the Indonesian islands and a large portion of the Pacific Ocean, even threatening to invade Australia. Nazi Germany and Japan spread their totalitarian system throughout all this area, subjugating the conquered peoples, putting their racist ideology into practice and planning mass exterminations.

This large canvas by a leading exponent of Pop Art reuses a panel from issue number 89 of the American comic book *All-American Men of War*, published in 1962. Post-war mass culture appropriated the events of the world war in heroic and mythic terms, producing many series devoted to actual and imaginary people who confront enemies and do battle. Taking the comic book as his springboard, Lichtenstein heightened its chromatic and spectacular values to make explicit the transformation of the drama and violence experienced by soldiers and civilians into a fantastic account.

Aerial warfare The Second World War inaugurated massive use of aviation as an offensive weapon. From the German air raids on London in 1940 to the complete destruction of Dresden in February 1945, devastating bombing was a characteristic of the conflict. Fighters escorted bombers on surprise attacks and were used in aerial duels.

Brutish tormentors Beneath Nazis' helmets are not human faces but only cruel sneers from almost animal bodies.

1939 THE SECOND WORLD WAR

Renato Guttuso, **The Triumph of War**

1966. Oil on canvas, 126 x 186 cm. Rome, Archivi Guttuso

The Allied counter-offensive

El Alamein, Stalingrad, Midway Island and Guadalcanal: after losing these great battles on all fronts between the summer of 1942 and February 1943, the Axis powers were put on the defensive, while the Allies could fully deploy their economic and military supremacy. The war lasted another two years, owing mainly to the ideological fanaticism of Germany and Japan, whose ruling groups rejected any notion of defeat. In fact, the tragic genocide aimed above all at the Jews had free rein from 1942, as the war sowed death and destruction everywhere. With the Allies' gradual advance, partisan resistance movements within the occupied countries grew stronger, and civil wars broke out between rebels and supporters of the puppet governments aligned with the Nazis and Japanese. It took fighting house by house in Berlin and dropping the atomic bomb on Hiroshima and Nagasaki to bring this tragic war to an end at last.

The war in Europe, 1943–45

10 July 1943
The Allies disembark in Sicily after eliminating the German and Italian forces in North Africa.

13 July 1943
Hitler calls off the offensive launched on 5 June at the Russian front. From that moment on, the Russians advance continually to reach Berlin.

8 September 1943
Italy signs the armistice with the Allies. Supported by the Germans, Mussolini forms a puppet government in the north of the country. Partisan warfare begins.

4 June 1944
The Allies liberate Rome.

6 June 1944
The Allies disembark in Normandy, opening a new front. On 24 August, Paris is liberated.

16 December 1944
The Germans launch their final offensive in the Ardennes but are defeated.

25 April 1945
Russians and Americans meet up at the Elbe river.

8 May 1945
After the suicide of Hitler and the Russian taking of Berlin, Germany surrenders.

Guernica The horse in the centre is an obvious quotation from Picasso's famous painting of the bombing of the Spanish city of Guernica. The work thus summarizes all the horrors of war and recalls that the bombing of cities, first experienced at Guernica, was a characteristic feature of the Second World War.

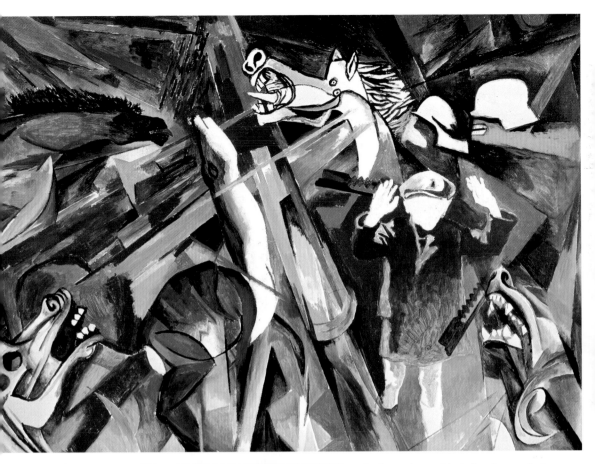

A leading militant of the Italian Communist Party and partisan combatant against the Nazi-Fascists, in 1966 Renato Guttuso returned to the theme of the war he had known firsthand, especially its cruelty and crushing of civilians. In this work, the artist – who in the post-war period developed a socially committed realist style focusing on the themes of work and social demands – combines references to the avant-garde and his friend Picasso with the quotation of photographic testimony of racial persecution.

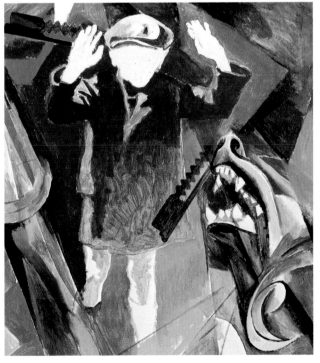

The child The artist makes reference to the famous photograph of a Jewish child forced to raise his hands in front of German soldiers. Taken in Warsaw, probably in the summer of 1943, the snapshot became a symbol of the destiny of the Jewish people under the Nazi regime.

1942 THE HOLOCAUST

Felix Nussbaum, **Self-portrait with Jewish Passport**
1943. Oil on canvas, 56 x 49 cm. Osnabrück, Felix-Nussbaum-Haus

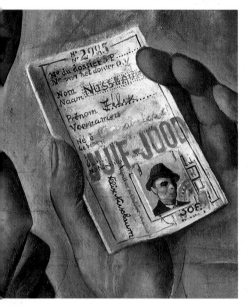

The passport The identity document Nussbaum holds in his hand is inscribed with the words *Juif* and *Jood* – 'Jew' in French and Dutch. His threadbare overcoat displays the obligatory yellow star that made him always recognizable.

The Wannsee Conference

On 20 January 1942, a meeting of fifteen high-ranking Nazi officials took place at Wannsee, near Berlin, to discuss how to approach the systematic elimination of Europe's estimated eleven million Jews. The Nazi authorities were not satisfied with the methods adopted until then – the forced emigration and massacres of the early war years. At the conference, it was decided that all Jews would be deported and shut up in ghettos (where those residing in Eastern Europe were already gathered) before proceeding to the 'final solution'. Not yet clearly defined at Wannsee, this consisted of establishing a network of extermination camps that went into full operation during 1942. The millions of people deported to these camps were quickly screened. Those able to work were exploited for slave-like forced labour, and did not long survive. The others were immediately eliminated by a death machine built according to standards of 'industrial efficiency'.

Some sites of the horror

Auschwitz-Birkenau
Located in Poland, this was the most infamous of the extermination camps. It began operating in October 1941 to eliminate the masses of deportees. More than a million people, especially Jews and gypsies, were gassed, then cremated, here. It was the first camp where the notorious gas Zyclon B was used, and it housed as many as 100,000 prisoners.

Treblinka
About 100 kilometres from Warsaw, it was dedicated to eliminating Jews from the Polish ghettos. The gas chambers, fed with carbon monoxide, were on a little hill. It is estimated that about 700,000 persons met their death here. The camp was closed in October 1943, once its sinister function had been accomplished.

Mauthausen-Gusen
Initially for political prisoners and opponents of the regime, this camp in Austrian territory was active from 1938. Though it was not properly speaking an extermination camp, more than 122,000 people died there, eliminated by forced labour and gas chambers.

The wall, the sky Imprisoned in a closed space, having sequestered himself to evade capture, Nussbaum shows freedom – the clouds, blue sky and trees – as cut off by a wall. The cut tree and flowering tree symbolize the alternating fear and hope experienced by the artist.

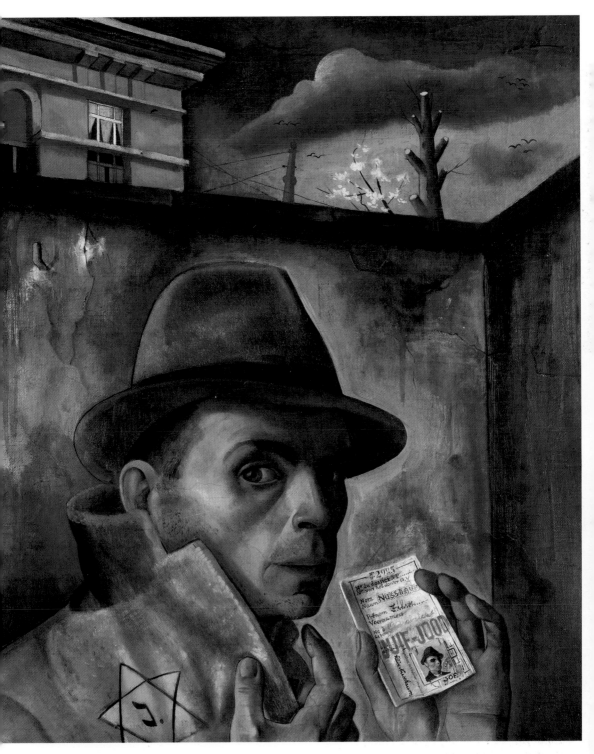

A German Jew, Felix Nussbaum fled to Belgium in 1937. When the Nazis arrived, he was first arrested but then lived in hiding in Brussels until 1944. On 20 June of that year, he was taken prisoner with his wife and transferred to Auschwitz on the last train from Belgium. All trace of him after that has been lost. This self-portrait – an icon of Nazi persecution – expresses all the fear, isolation and despair in which the artist and men like him lived.

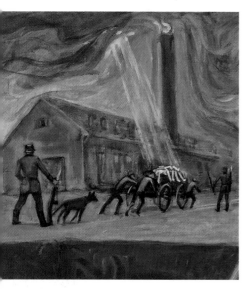

1942 THE HOLOCAUST

David Olère, **The Food of the Dead for the Living**
1946–62. Oil on cardboard, 76 x 102 cm. New York, Museum of Jewish Heritage

Nazi ideology

The genocide wrought by the Nazis upon the Jews and other ethnic groups was the literal application of the racist ideology Hitler had expounded in *Mein Kampf* back in 1924. He believed in the superiority of the 'Aryan race' (which for Hitler seemed to be limited more or less to Germans and Scandinavians) and its right to perpetrate war and violence according to its needs. From this point of view, the Germans had to conquer their *Lebensraum* (living space), expanding eastward, and free themselves from the lower 'races', the sub-humans. Foremost among these were the Jews, considered guilty of the world's evils and therefore marked for extermination. On the other hand, the Slavs were to be reduced to slavery and transformed into a shapeless mass of ignorant manpower. Other ethnic groups, such as gypsies, as well as those considered degenerate, such as homosexuals, were to suffer the same fate as the Jews. The Nazi war became the conscious application of these alarming beliefs.

The march of infamy

In the German concentration camps, all prisoners wore the same uniform and were tattooed with a progressive sequential number that replaced their personal identity. They were then subdivided into various categories identified by the following emblems:

Yellow triangle Jews were identified with two yellow triangles superposed to form the Star of David. In Nazi-occupied territories, all Jews had to wear this sign from September 1941 onwards.

Red triangle Political prisoners, often among the first to be confined in the camps.

Green triangle Common criminals, frequently used in the camps as leaders of the other detainees.

Pink triangle Homosexuals.

Brown triangle Gypsies, considered by the Nazis as the epitome of 'degeneracy' and 'regression'.

Food and games The SS allowed the members of the special units to take some belongings from the cadavers. It was one of their 'privileges', along with a less meagre diet.

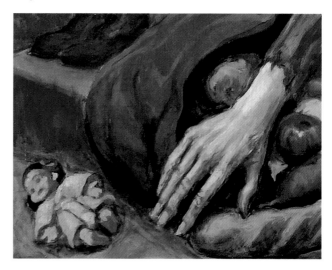

356

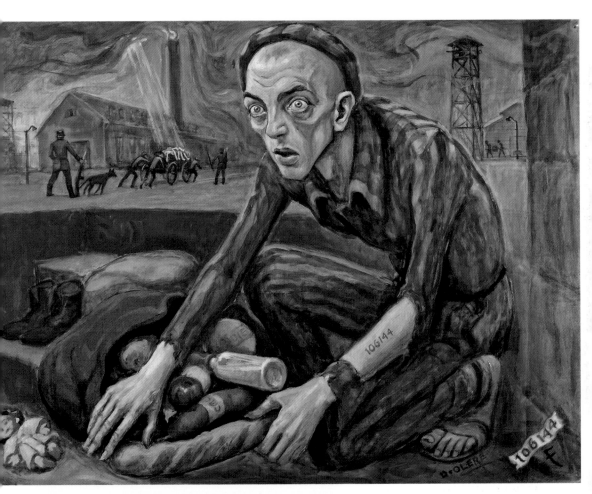

An exceptional witness, Olère was deported from Paris to Auschwitz in March 1943. In the camp, he was assigned to a special unit whose duties were to accompany new arrivals to the gas chamber, remove corpses after they were gassed and burn them in the crematoria. He is one of only a few survivors of these units, which were in turn eliminated according to regulations. After the war the artist began to paint, draw and document the horrors he had experienced, leaving a vivid and impressive testimony of this inferno. Here, Olère shows the gathering of food abandoned near Crematorium III, which he intended to throw across the barbed wire to the women's camp.

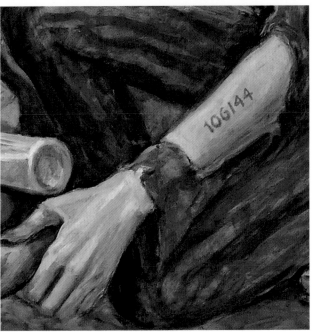

The number The number that identified Olère is tattooed on his arm. It is a low number, which indicates his long survival in the camp. In the camp, everyone was referred to by their number only and had to answer with it.

Those responsible

Reinhard Heydrich Heinrich Himmler's right-hand man, head of the entire Nazi repression and extermination system, directed the Reich's Security Bureau [Office]. He organized the 'special operations units' that followed the invasion of the USSR, killing hundreds of thousands of Jews. In January 1942, he presided at the Wannsee conference. He died in a partisan attack on 4 June 1942.

Adolf Eichmann A participant in the Wannsee conference and organizer of the rail transport of the Jews to the extermination camps, he fled to Argentina after the war. Abducted by the Israeli secret service in 1960, he was taken to Israel and condemned to death.

Josef Mengele The chief medical doctor at Auschwitz performed cruel experiments on prisoners and, among other things, focused his 'studies' on pairs of twin babies. In 1949, he sought refuge in South America, where he lived in hiding until his death in 1979.

Gates of hell The railway entrance to Auschwitz-Birkenau stands at the top of the painting. The artist's personality and existential angst are structured by this horrific emblem. He experiences everything in the shadow of this drama, from which the anxiety and insecurity of the Jewish being derives.

Portraits, quotations In the painting, Kitaj portrays the poet T. S. Eliot. In fact, the work is partly based on the American writer's famous poem *The Wasteland*. The poem's continual references to the First World War convey Eliot's vision of desolation and inner sterility. There is a self-portrait of Kitaj as well, in the small figure of a man hugging a baby in bed.

1942 THE HOLOCAUST

R. B. Kɪᴛᴀᴊ, **If Not, Not**

1975–76. Oil and black chalk on canvas, 152.4 x 152.4 cm. Edinburgh, National Galleries of Scotland

A tragic ledger

The total number of victims of the Holocaust – also known by the Hebrew word Shoah, meaning 'extermination', 'destruction' – is not firm, but most historians agree that around five or six million Jews were killed. This figure includes those who died of starvation in the ghettos, those killed by the 'special operations units' (*Einsatzgruppen*) formed by the SS and loyal volunteers in the wake of the advancing German army, and those deported and gassed in the death camps. Among the most appalling aspects of this extermination is the calculated planning of the carnage and the conscious involvement of thousands and thousands of men and women. The Nazis reserved similar 'treatment' for the gypsies, who also have a word – Parajmos – that refers to the genocide of about half a million human beings. In addition to these staggering numbers, extreme racial policies and slave-like exploitation were also inflicted on the Slavic peoples, about three million of whom died.

The question of whether the Holocaust can or should be represented – and if so, how – has concerned artists and intellectuals who did not experience those tragic events directly, as well as those who did. So monstrous is the fact that the philosopher Theodor Adorno said in 1949: 'To write a poem after Auschwitz is barbaric' (though he did later retract this statement). R.B. Kitaj, a Jewish-American painter born in 1932, also examines this theme, and his canvas *If Not, Not* uses the concentration camps as a starting point for a forlorn inner voyage.

1945 THE ATOMIC BOMB

IRI AND TOSHI MARUKI, **Fire**

1950. Ink on paper, 180 x 720 cm. Higashimatsuyama, Maruki Gallery for the Hiroshima Panels

The dawn of the nuclear age

On the morning of 6 August 1945, the Americans released the atomic bomb 'Little Boy' above the Japanese city of Hiroshima. It killed between 80,000 and 100,000 people instantly and destroyed most of the city. Three days later, on 9 August, the same fate befell the port of Nagasaki, where the victims numbered about 70,000. In shock at this new weapon, whose radiation began to claim further victims among the two cities' survivors, and facing a USSR attack on Manchuria, Japan capitulated on 15 August. The United States justified the use of the atomic bomb as the only means of forcing the Japanese generals to surrender and thus avoid an invasion of Japan that would have cost hundreds of thousands of lives. The event signalled the dawn of the nuclear age and the start of an arms race in which the weapons' destructive potential would soon reach unimaginable levels. Just four years later, the USSR had acquired a similar weapon of mass destruction.

Inferno The depiction of the flaming inferno of Hiroshima recalls traditional representations of the torments of the damned in the Buddhist vision of the afterlife.

In executing this panel and the fourteen others in the series on the nuclear inferno of Hiroshima, the Japanese artists Iri and Toshi Maruki relied primarily on personal experience. Three days after the attack of 6 August, they came to the city to help and were witness to the unimaginable suffering caused by the nuclear explosion. In 1948, the two artists began to transfer their impressions to a work of art, initially planning a single picture. However, they became so caught up in the subject that they went on painting until 1972 – fifteen panels in all – moving from a sense of indignation to a more comprehensive reflection on the destructive violence of the Second World War and of modern warfare in general.

From scientific research to the bomb

September 1942
To keep ahead of possible German research on the atomic bomb, the United States accelerates its Manhattan Project, directed by physicist Robert Oppenheimer and, on behalf of the military, General Leslie R. Groves. Physicists such as Enrico Fermi and Edward Teller take part, and Einstein is aware of the project.

2 December 1942
In Chicago, Enrico Fermi makes the first controlled-fission nuclear reactor.

1943–45
Two projects, both successful, are worked on in the secret laboratories at Los Alamos, New Mexico: an enriched uranium bomb and a plutonium bomb.

16 July 1945
The first nuclear test is carried out at Alamogordo, in the desert of New Mexico, exploding the plutonium bomb 'Gadget'.

6–9 August 1945
The two bombs produced at Los Alamos, 'Little Boy' (uranium) and 'Fat Man' (plutonium), are dropped on Hiroshima and Nagasaki.

Horror The fine strokes of the traditional art of sumi-e, which uses only various shades of grey and black ink, are employed here to depict the horror of the nuclear attack in all its brutality.

1950 THE KOREAN WAR

Pablo Picasso, **Massacre in Korea**
1951. Oil on panel, 110 x 210 cm. Paris, Musée national Picasso

From local conflict to risk of a Third World War

After the Second World War, in a Korea divided into two parts under American and Russian influence respectively, a dangerous game was played out in which the great powers of the Cold War's opposing blocs almost clashed head on. In June 1950, North Korean troops invaded South Korea and reached the capital, Seoul. A multinational force authorized by the United Nations under the leadership of the United States then began a counter-offensive that penetrated deep into North Korea. At this point, the Chinese entered the conflict, driving the Americans back to the 38th parallel (the original boundary between the two Koreas). The subsequent peace negotiations led to an agreement recognizing the division of Korea into two states, with the boundary at the 38th parallel. Despite the high losses and huge material damage suffered by both sides, the war essentially ended in a stalemate.

Helmets and arms The soldiers in the firing squad are inhuman, robotlike. Their helmets isolate them from all emotion, and their technological weapons accomplish their duty with clinical coldness.

Fear The women and children are naked before the soldiers. Fear builds up into a crescendo from right to left, from the mute astonishment of the young woman to the terror-distorted faces of the mothers.

362

Although it implies that the Korean War was an expression of American imperialism, this militant work did not win the approval of the Communist Party of France, which would have preferred a more realistic depiction or a more readily recognizable symbolism. Instead, Picasso presents a universal condemnation of war's violence, taking up the subject of the firing squad – a tradition that includes Goya and Manet.

Two Koreas contested between the USA and the USSR

August 1945
The Russians and Americans meet in Korea, which had been an annexation of Japan since 1910, and fix the boundary of their respective zones of influence at the 38th parallel.

August–September 1948
The general elections scheduled by the UN do not take place. Two states, North Korea and South Korea, are born, neither of which recognizes the other's legitimacy.

25 June 1950
North Korea attacks. The USSR and China are informed and assent. The USSR promises only supplies and materiel. The Americans take part alongside the South Koreans.

11 April 1951
US President Truman dismisses Commander in Chief Douglas MacArthur, who favours the use of nuclear arms in the face of Chinese involvement.

27 July 1953
An armistice is reached after two years of negotiations and fighting. The two Koreas have never ratified this agreement.

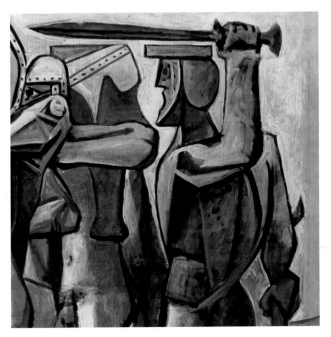

Blind ideology Behind the firing squad, the leader – the only one with his face uncovered – urges action. He manipulates the soldiers' consciences and symbolizes the capacity of modern ideologies to turn men into senseless killing machines.

1960 THE INDEPENDENCE OF THE BELGIAN CONGO

Luc Tuymans, **Lumumba**

2000. Oil on canvas, 62 x 43 cm. New York, Museum of Modern Art

Between hopes of freedom and neo-colonial chains

The Belgian Congo was one of many African countries that underwent the tumultuous process of decolonization in the early 1960s. However, this process also threw up various contradictions. Rich in raw materials and the focus of many international interests, the Congo gained its independence in June 1960 and was at first led by the charismatic young Patrice Lumumba. At the same time, however, a separatist movement arose in the rich mining province of Katanga. Directed by Moïse Tshombe, it was supported by the Belgians, French and Americans. In the turbulent events that ensued, Lumumba was killed by his political opponents, Tshombe ended his separatist venture in 1963 through the intervention of the United Nations, and Joseph Mobutu emerged as the strongman who would govern the Congo with a dictatorial hand until 1997 – enjoying the unanimous support of the Western powers.

This canvas is part of the series 'Mwana Kitoko' (good boy) painted by Luc Tuymans in 2000. The series refers to King Baldwin's 1955 voyage to the Congo (the king is the 'good boy') and the successive tragic events there. Tuymans took up the subject of Belgian colonialism at the time the former colonial power was trying to shed light on its involvement in the war in the Congo and the death of Lumumba by conducting an official inquiry. The portrait of Lumumba is sympathetic towards the tragic fate of the young politician, in whom so many placed their hopes for an independent Congo.

True hate, apparent dignity This other painting from the series 'Mwana Kitoko' shows the leader of the separatist Katanga province, Moïse Tshombe, in the centre with his finger raised. He is in the company of other civilian and military dignitaries. With the figures dressed in Western style and their faces barely sketched, the scene suggests an official character and dignity that are more for show than genuine. To defend his region's secession, Tshombe asked for help from Belgium and France, who sent mercenary soldiers. And he did not hesitate to have his enemy Lumumba brutally eliminated.

364

1963 THE KENNEDY ASSASSINATION

ANDY WARHOL, **Flash – November 22, 1963**

1968. 11 colour silkscreens on paper, 53 x 53 cm. Hamburg, Kunsthalle

The rifle Oswald fired with an Italian-made precision rifle, a Mannlicher-Carcano, which he purchased for a few dollars, probably in 1962. Warhol records the fact in detail, superimposing sales ads for the carbine over its image.

An unsolved crime

The killing of Kennedy in Dallas on 22 November 1963 was one of the events in post-war history that most shocked the world public, yet it is still shrouded in mystery. Not yet forty-four years old when he became president in 1961, Kennedy had to confront a number of complicated domestic questions such as racial discrimination against Afro-Americans. He responded to this and other problems with his New Frontier programme, a challenge he launched in 1960 against 'tyranny, poverty, disease and war itself'. A skilled communicator with a fresh, youthful style, in practice Kennedy provided controversial answers. But the fact remains that it is difficult to imagine his death as the consequence of one man's mental instability.

Chronicle of an assassination

22 November 1963, 11:40 am (local time)
The presidential motorcade sets out from the airport in Dallas, Texas, with Kennedy, his wife Jacqueline, vice-president Johnson and Governor Connally. All the cars are convertibles.

22 November 1963, 12:30 pm
When the motorcade reaches Elm Street, several shots are fired. Kennedy is mortally wounded in the head. The governor is also wounded. Kennedy is pronounced dead at 1:00 pm.

22 November 1963, 10:30 pm
Lee Harvey Oswald is charged with Kennedy's murder. He is believed to have fired the fatal shots from the sixth floor of the Texas School Book Depository Building, facing Elm Street. A precision rifle that had been fired was found there.

24 November 1963
While being transferred to prison, Oswald is killed by Jack Ruby, a nightclub manager.

27 September 1964
The Warren Commission, ordered by President Johnson to investigate Kennedy's death, concludes that Oswald acted alone.

Jacqueline Kennedy's glamorous wife was beside her husband minutes before the attack. In the hours immediately following the assassination, the young widow's mourning attracted media attention, making Kennedy's death the first worldwide media event.

In the series of eleven silkscreens devoted to Kennedy's murder (each accompanied by text from Philip Greer), Warhol plays with the images from television and the other media that covered the drama. He follows the course of events from the presidential motorcade in Dallas to the president's funeral, emphasizing the emotional wave that swept the country and the entire world due to the exceptional media coverage. Here, a clapper-board is reproduced in front of superimposed portraits of Kennedy to underline the media's transformation of the tragedy into a moment of spectacle and emotion.

The girl The breasts of the young woman with a pin-up figure are inscribed 'innocent virgin'. She, too, is being strangled by the serpent-like coils of the soldier, whose body ironically recalls that of Superman.

1964 THE VIETNAM WAR

Peter Saul, **Saigon**

1967. Oil on canvas, 235 x 360 cm. New York, Whitney Museum of American Art

The defeat of a superpower

Committed to supporting South Vietnam against North Vietnam since the collapse of French colonialism in 1954, in 1964 the United States embarked on a massive military adventure that by 1967 would result in the deployment of more than 400,000 soldiers in an all-out war. At stake in this round of the Cold War was the containment of communism, which was one of the main tenets of US foreign policy. However, the war's growing number of victims generated a large protest movement – fuelled by the presence of the media, which documented atrocities and acts of violence – and the United States was forced to begin gradual disengagement, until 1973, when the Paris Peace Accords provided for the full withdrawal of American troops. On 30 April 1975, the Vietcong and the North Vietnamese army entered Saigon, making history with the first US defeat in the post-war period and leaving Vietnam devastated after more than twenty years of war.

Public opinion against the war

The war made a deep impression on public opinion, resulting in protest movements in the United States and Europe:

Draft cards Besides the many volunteers, the US army relied on conscription – which was often racially biased. In October 1965, many draftees publicly burned their draft cards.

Tet Offensive Between 30 and 31 January 1968, the Vietnamese New Year, during which a truce was usually observed, North Vietnam and the Vietcong attacked. This action contradicted the American government's statements claiming the enemy had been subdued.

My Lai Massacre In reprisal, American soldiers killed about 350 civilians in the village of My Lai in March 1968. The event did not come to light until 1969–70. William Calley, the commander of the company accused of the massacre, served only three and a half years under house arrest as punishment.

The inscription The artist makes the canvas's message explicit in the text – 'White boys torturing and raping the people of Saigon' – and describes the corrupt and lawless climate prevailing in the South Vietnamese capital during the war.

The majority of American intellectuals and artists openly stood against the war in Vietnam from the beginning. Peter Saul was one such militant artist. This canvas conveys with deliberately grotesque vulgarity the neo-colonial attitude and sexual exploitation implicit in the US army's mission.

The soldier Far from the image of a freedom fighter and defender of democracy, the American soldier is drinking his favourite beverage as he crushes the Vietnamese people with his octopus-like tentacles.

Segregation and civil rights

Jim Crow Laws These were the body of legislation passed mainly by the Southern states from 1876 on in order to define and maintain the racial division between whites and blacks. By law, public schools, offices and public transportation were segregated, and it was made more difficult for blacks to register to vote.

Brown versus Board of Education In a landmark decision on 17 May 1954, the US Supreme Court declared racial segregation in the public schools unconstitutional.

Civil Rights Act On 2 July 1964, President Johnson enacted this federal law prohibiting all racial discrimination.

Voting Rights Act On 6 August 1965, the obstacles hindering Afro-Americans from voting – for example, literacy tests and voter enrolment taxes – were removed.

The motel balcony King was hit by a rifle shot at 6:01 pm on 4 April 1968 on the balcony of the Lorraine Motel in Memphis, Tennessee. He was there to take part in a strike called by Afro-American garbage collectors. In this panel, the fallen black leader's body may be glimpsed behind the metal railing.

The portrait The fragments drawn from other mediums emphasize the importance the communications media had acquired in forging perceptions of events and personalities.

1968 THE ASSASSINATION OF MARTIN LUTHER KING

Joe Tilson, Page 10, Martin Luther King

1969. Silkscreen and oil on canvas, 186 x 125 cm. Private collection

The hard road of non-violence

A Protestant minister who lived in the Deep South of the United States, Martin Luther King chose the path of non-violence in the struggle against the racial discrimination that oppressed Afro-Americans. In December 1955, when Rosa Park refused to give up her seat on the bus to a white man in Montgomery, Alabama, King initiated a campaign of boycotts and civil disobedience that disconcerted his adversaries and captured public attention. His highest point of visibility came on 28 August 1963, during the famous March on Washington for Jobs and Freedom and the equally famous 'I Have a Dream' speech he made on that occasion. However, the slow pace of reform, the harsh repression and the poverty in which masses of Afro-Americans lived fostered increasingly radical and violent political activity, bringing the model of integration advocated by King to a crisis. He was killed in Memphis on 4 April 1968 by James Earl Ray, who, after initially declaring himself guilty, subsequently retracted his confession.

In the 1960s, the English Pop Art exponent Joe Tilson painted an ideal gallery of heroes and martyrs from this intense season of radical political involvement. Besides the many portraits of Malcolm X and Che Guevara, the artist focuses on the figure of Martin Luther King, surrounding his image with references recalling the place where he was killed. Below, the palm of a hand marked with a cross seems to indicate the end of his life in a sort of palmistry prophecy.

1977 THE DEATH OF STEVE BIKO

HARRY HOLLAND, **Steve Biko**

1986. Oil on canvas, 137 x 122 cm. Private collection

State homicide

For South Africa under apartheid, the killing of Steve Biko at the hands of the police was a significant turning point. The authorities' indifference in the face of the obvious responsibility for this assassination contributed to arousing hostile world public opinion and isolating the South African government internationally. Biko championed consciousness-raising for African blacks and their emancipation from cultural domination by whites. To this end, he promoted political actions that were controversial because the liberal white milieu that opposed apartheid was deliberately excluded. His success among black youth was the cause of his death. Arrested on 18 August 1977, not yet thirty-one years old, Biko was tortured and humiliated. Transported to Pretoria, he died there on 12 September. The police declared the cause of death to have been Biko's hunger strike, but a journalistic investigation soon revealed the truth of what had happened.

Victim and executioner The faintest smile lights Biko's face, while the other man lets no emotion show through. The black leader's killers appeared before South Africa's Truth and Reconciliation Commission in 1997, but their partial confession did not allow the facts to be fully ascertained.

Divisions in South Africa

Apartheid

Apartheid refers to the 'separation' of the races underlying the South African political system. First applied by the National Party in 1948, from 1950 onwards it required the race of every South African to be specified. It led to legislation prohibiting mixed marriages and the frequentation of certain races in public places and structures.

Bantustans, or Homelands

Instituted in 1951, they were the lands 'reserved' for black ethnic groups. About 55 per cent of the coloured population were forcefully transferred to these apparently autonomous regions to reside.

Townships

These are the shantytowns on the outskirts of the cities where the rest of the black and mixed-race population lived. Their presence around the metropolises was tolerated because of the need for cheap labour.

Bound hands Biko's wrists are bound with a red cord. When he was transferred from Port Elisabeth, where he was being detained, to Pretoria, more than a thousand kilometres away, where he would die, he was thrown naked and handcuffed into the back of an off-road vehicle.

Harry Holland recalls the death of Steve Biko with troubling allusiveness. The English artist charges this work with the contrast between the black leader's naked, defenceless body and the bodies of two almost completely clothed white men. There is no explicit sign of violence, but the viewer intuits that the naked Biko is faced with an ominous situation. The gestures and poses of the two white men (placing a sheet over Biko's shoulders, crouching) contrast singularly with the threat implied in their cold, even cruel, stares.

5 September 1977

An RAF commando kidnaps the president of the Federation of German Industries, Hanns-Martin Schleyer, killing his chauffeur and three officers of his police escort. The terrorists demand the release of eleven of their colleagues who are being detained in prison.

13 October 1977

An aeroplane of the German airline Lufthansa, with eighty-six passengers and five crew members on board, is hijacked by Palestinians on a flight from Palma de Mallorca to Frankfurt. The hijackers make known their demands for the release of some RAF terrorists.

16 October 1977

The hijacked aircraft eventually lands in Aden, Yemen. The pilot, Jürgen Schumann, is killed. The co-pilot is forced to take off for Mogadishu.

18 October 1977

In Mogadishu, a commando of the German federal police successfully frees the hostages from the plane. Three of the four hijackers are killed in the action. The fourth terrorist is arrested. A few hours later, the terrorists Andreas Baader, Gudrun Ensslin and Jan-Carl Raspe are found dead in their cells in the maximum security prison in Stuttgart. Irmgard Möller had attempted suicide but was saved by emergency surgery.

19 October 1977

The terrorists announce that Hanns-Martin Schleyer has been killed. His body is found in Mulhouse, Alsace.

GERHARD RICHTER, **18 October 1977: Confrontation 2**

1988. Oil on canvas, 112 x 102 cm. New York, Museum of Modern Art

German democracy put to the test

Weeks of drama began for West Germany on 5 September 1977: the Red Army Faction (RAF), a small group of extreme leftist terrorists, attempted to apply pressure to the country's government and institutions by kidnapping entrepreneur Hanns-Martin Schleyer and, later, by hijacking an aeroplane. The aim was to force the government to release eleven terrorists being held for previous attacks. German democracy faced two divisive questions: is it morally acceptable to sacrifice the lives of hostages in terrorist hands on the unyielding principle of non-collaboration? And how many rights can be suspended in an emergency without endangering the very status of those rights? The outcome was in part tragic: although nearly all the passengers and crew of the hijacked plane were freed, Hanns-Martin Schleyer was murdered, and three terrorists who had lost all hope of being released committed suicide in the maximum security prison at Stuttgart.

Man Shot Dead This is the title Richter gives to this other canvas from the series. The painting (101 x 141 cm) reproduces the police photograph of the lifeless body of Andreas Baader, founder and leader of the RAF, after killing himself.

In 1988, German artist Gerhard Richter first exhibited his *18 October 1977*, a series of fifteen paintings. Eleven years after the dramatic events of the autumn of 1977, German public opinion reacted with nervous irritation. The artist was accused of turning the tormentors into victims and forgetting those who were subjected to terrorist violence. On canvas, Richter reproduces newspaper photos and police department snapshots – like this photo of the imprisoned terrorist Gudrun Ensslin – softening the outlines and transforming the originals into aesthetic art objects. Still, the artist does not create mystical or heroic images of the terrorists. More simply, he forces German society to face a series of events that had long remained an open wound.

Construction

The wall was erected beginning on 13 August 1961 to block the flight of East German citizens. It extended for 156 km, completely surrounding West Berlin within the territory of the GDR. One hundred and twenty km were in reinforced concrete; the rest was wire mesh. The first wall was reinforced by a second parallel one, with a no man's land between the two barriers.

Checkpoints

These controlled the passage between the two areas of Berlin separated by the wall. The most famous was Checkpoint Charlie, reserved for the soldiers of the Allied forces, diplomats and foreign citizens.

Victims

It has been calculated there were about 5,000 successful attempts to flee to West Berlin. There were also fatalities, either killed by border guards or else the victims of accidents. At least 128 deaths are confirmed.

1989 THE FALL OF THE BERLIN WALL

Various creators, **East Side Gallery**

1989–90. Murals. Berlin

The end of division

On 9 November 1989, tens of thousands of Berliners from the German Democratic Republic arrived at the Berlin Wall checkpoint to go to the western side of the city. The border guards were completely unable to stop them. It was the end of the wall – the symbol of the Cold War and the division of the blocs. This was the most sensational event of 1989, which marked the progressive undoing of the Soviet system. East Germany had begun to crumble in August, when Hungary opened its borders with Austria and a great many East Germans fled their country via this route. This haemorrhage did not curtail the growth of internal protest movements, however. In October, after the Russian leader Gorbachev had visited and suggested reforms, large demonstrations increased until East German citizens were finally granted permission to travel to West Germany. The intention was to control and stem protest, but the situation completely escaped the hands of the GDR's rulers. The end of the wall marked the end of their regime as well.

TEST THE BEST

NOV·9·89

The East Side Gallery was born in the wave of enthusiasm for the fall of the Berlin Wall. More than a hundred artists from twenty-four countries decorated a 1.3-km section of the wall from December 1989 to the summer of 1990, the longest section still standing, although time and neglect have considerably eroded this open-air museum. For the twentieth anniversary of the fall of the Berlin Wall, the East Side Gallery was completely repainted, involving some of the original artists. One of the most famous murals was created by the German artist Birgit Kinder: a Trabant – the typical East German automobile – smashes through the wall, accompanied by the slogan 'Test the best', recalling a German advertisement from the late 1980s. The car's licence number is the day the wall fell.

Obsession with the wall Many works evoke the division of Berlin and attempts to flee across the wall, for example *The Wall Jumper* by the Berliner Gabriel Heimler (opposite) and *Flight* by the Iranian Kasra Alavi (above). In the desolate *No Man's Land* (left), however, Carmen Leidner seems to widen the reflection on Berlin to all the world's boundaries.

Labour Union leaders and politicians

Mikhail Gorbachev

General Secretary of the Communist Party of the Soviet Union from March 1985 onwards, Gorbachev launched a reform process to adapt and safeguard the Soviet system. He obtained outstanding results in foreign policy, initiating bilateral nuclear disarmament with the United States, but could not manage the internal transition. In 1991, he was forced to withdraw from political life.

Lech Wałęsa

A Polish union leader, in September 1980 he founded the free union Solidarity, heading up his country's opposition to the Russians and the communists from a Roman Catholic standpoint. In 1981, Solidarity won the elections, and Wałęsa was the president of Poland from 1990 to 1995.

Václav Havel

A dissident Czech playwright, he promoted Charter 77, a human rights defence organization, for which he was long imprisoned. In 1989, he was a leader in Czechoslovakia's transition to democracy. He became president of Czechoslovakia in 1990 and, after Slovakia became independent, of the Czech Republic.

1989 THE FALL OF THE BERLIN WALL

The unforeseen demise of an empire

The Soviet bloc began breaking up in the summer of 1989. The satellites it had previously dominated – Poland, Hungary, East Germany, Czechoslovakia, Bulgaria – all initiated a non-violent transition that led to their first free elections in many years. Matters were somewhat different in Romania, where the regime was toppled by an armed revolt. The Soviet bloc crumbled because the reforms initiated by Mikhail Gorbachev in 1985 loosened the grip on the bordering countries and accelerated the dissolution of the Soviet Union itself. Gorbachev had intended to modernize and strengthen the socialist system, but granting greater freedom of expression and political and economic freedoms sparked debate about the role of the Communist Party, unleashed fierce conflicts between the various nationalities that comprised the USSR, and fuelled the satellite countries' hopes of freeing themselves from the Soviet yoke. In 1991 the Soviet Union imploded.

Hopes and fears Yvonne Onischke's *Berlin by Night* combines the city skyline, finally reunited, with the future's risks and uncertainties emblematically represented by a dragon. The mural has been damaged: a galaxy (at the upper left) and a road leading to the city (in the lower centre) are no longer legible.

The kiss Though poorly preserved, the mural *God Help Me Survive This Deadly Love Affair* by the Russian Dimitrij Vrubel is famous. The artist represents the 'ritual' kiss exchanged between the Soviet leader Brezhnev and GDR leader Honecker in 1979, symbolizing the two countries' indissoluble alliance and the implacable Iron Curtain that closed off East Germany.

Flood of humanity Kani Alavi painted *It Happened in November*, showing the crowd of Berliners who crossed the wall and ultimately swept it away.

Intimacy On the other hand, the Catalan Ignasi Blanch steps back from historical discourse to narrate a fragment of private life. In his *I Speak about Love*, the artist records the feelings he experienced during the Berlin adventure of 1989–90.

11 September

7:00–7:30 am
Nineteen terrorists board four flights for California from the airports in Boston, Washington (Dulles) and Newark.

8:13 am
American Airlines flight 11 is hijacked. Mohamed Atta, head of the suicide commandos, sits at the controls. Beginning at 8:44 am, the other planes are also hijacked.

8:46 am
American Airlines flight 11 crashes into the north tower of the World Trade Center.

9:03 am
United Airlines flight 175 hits the south tower of the World Trade Center. The collision is broadcast live on television around the world.

9:37 am
American Airlines flight 77 crashes into the west façade of the Pentagon.

9:59 am
The south tower of the World Trade Center collapses. The north tower collapses at 10:28 am.

10:03 am
The last of the hijacked planes goes down near the town of Shanksville, Pennsylvania, after the passengers and crew rebelled against the hijackers.

2001 THE TERRORIST ATTACKS OF 9/11

JACK WHITTEN, **9.11.01**

2006. Mixed media and acrylic on canvas, 305 x 609 cm. New York, Alexander Gray Associates

Wars and insecurity

When on 11 September 2001 three hijacked civil aircraft crashed into a wing of the Pentagon and New York's Twin Towers, causing the death of more than 3,000 people, the beginning of the millennium was marked indelibly. The terrorist organization al-Qaida, led by Osama bin Laden, was identified as responsible for the attack, and the United States military, backed by NATO, reacted immediately, attacking Afghanistan in October 2001 in the belief that it was harbouring Bin Laden and al-Qaida. In an attempt to prevent further attacks, the United States adopted a strategy of preventive war, leading to the invasion of Iraq in March 2003.

Since 11 September, the words 'security' and 'terrorism' have dominated the entire planet's political agenda, along the way also changing the meaning of other words in the political lexicon, such as democracy and freedom.

Afro-American artist Jack Whitten drew upon his personal experience in dealing with the complex theme of 11 September. He had watched the building of the Twin Towers from his home in New York, and he was also present the day of the attack. The artist elaborated this experience to reconstruct for the viewer the sensations he experienced in these dramatic hours, combining them with a comprehensive reflection on the event. In an interview in 2007, Whitten emphasized that he included 'blood, money and oil' in the picture – 'the three inescapable elements in any discussion of 11 September'. The pyramid that dominates the canvas refers to the one printed on the back of the US dollar bill.

Materials and chaos Silica, crushed bone, blood, mica, rust and ashes are some of the materials the artist used to express the chaos of rubble and debris that ensued after the towers imploded and the atmosphere was filled with shattered glass, which he recalls as his first sensation after the aeroplanes' impact.

INDEX

Artists' names and page numbers in bold type refer to the main entries.

PHOTOGRAPHIC CREDITS

Every effort has been made to contact copyright-holders of photographs.
Any copyright-holders we have been unable to reach or to whom inaccurate
acknowledgement has been made are invited to contact the publisher.

Alexander Gray Associates New York 380–381

Alinari Archives 153, 353

The Architect of the Capitol Washington DC 221

The Art Museum at the University of Kentucky 336 (Allocation from the U.S. Government)

Art Resource/Scala 69 (The Philadelphia Museum of Art, John G. Johnson Collection) 315 (Photo Schalkwijk)

Bibliotheque nationale de France 21, 117

BPK Bildagentur für Kunst, Kultur und Geschichte/Scala 81 (Wolfgang Seebach)

Bridgeman/Alinari Archives 38, 131, 181, 207, 215, 223, 297, 366–367, 373

The British Library Board 133

De Agostini Picture Library 13, 23, 165, 295, 313

Erich Lessing Culture and Fine Art Archives/Contrasto 11, 14, 17–18, 25, 31, 51, 54–55, 57, 75, 89, 92, 98–99, 103, 107, 115, 126, 141, 145, 147, 155, 175, 183, 188–189, 190–191, 193, 195, 203, 211, 219, 225, 227, 229, 231, 235, 245, 249, 267, 271, 287, 299, 305, 307, 321, 325, 333, 339, 350–351

Photo Scala 47 (Boston Museum of Fine Arts, William Amory Gardner Fund en Annie Anderson Hough Fund), 83 (Werner Forman Archive), 265 (Boston Museum of Fine Arts, Henry Lillie Pierce Fund)

Foundation Genbakunozu Maruki, Gallery Higashimatsuyama, 360–361

Harvard Art Museum, Arthur M. Sackler Museum, Gift of Edward W. Forbes/Photo: Katya Kallsen, 33

Hellenic Ministry of Culture/Archaeological Receipts Fund/National Archaeological Museum, Athens 15

Kansas State Historical Society 277

Musées royaux des Beaux-Arts de Belgique, Brussels 263

Metropolitan Museum of Art, New York/Art Resource/Scala 283 (Gift of Mrs. William F. Milton), 289
(Gift of Lincoln Kirstein)

Museo de América, Madrid 161

Museo Nacional del Prado, Madrid 187

Museum of Jewish Heritage – A Living Memorial to the Holocaust 357 (Gift of the Olere family)

The Museum of Modern Art, New York/Scala 317, 374–375

National Museum, Warschau/Photo Teresa Żółtowska-Huszcza 210

Photo Service Electa 97, 279

Photo Service Electa/AISA 125

Photo Service Electa/AKG-Images 91, 101, 143, 157, 163, 213, 269, 327, 335, 349

Photo Service Electa/Leemage 135

Princes Czartoryski Foundation 285

Réunion des Musées nationaux/Alinari 167, 216–217, 257, 275, 293, 363

Rijksmuseum, Amsterdam 171, 185, 199

State Russian Museum, St Petersburg 329

The Trustees of the British Museum 61

Van Abbemuseum Eindhoven/Photo Peter Cox 326

Whitney Museum of American Art, New York 337, 369 (Purchase with Funds from the Friends of the Whitney
Museum)